Spectacular Bodies

The Art and Science of the Human Body from Leonardo to Now

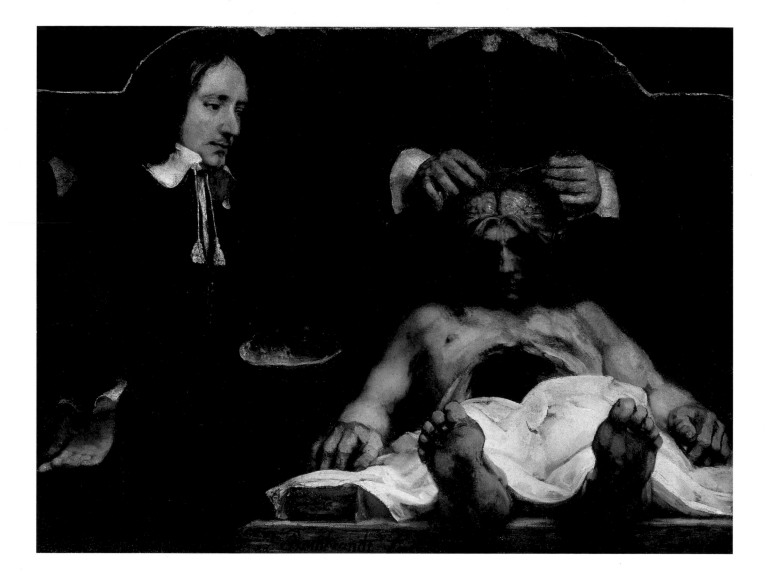

cat. **258**
Rembrandt van Rijn
The Anatomy Lesson of Dr Jan Deijman, 1656
oil on canvas

Spectacular Bodies

The Art and Science of the Human Body from Leonardo to Now

Martin Kemp Marina Wallace

Hayward Gallery

UNIVERSITY OF CALIFORNIA PRESS
BERKELEY LOS ANGELES LONDON

Jointly published by the Hayward Gallery and the University of California Press
on the occasion of the exhibition *Spectacular Bodies: The Art and Science of the
Human Body from Leonardo to Now*, organized by the Hayward Gallery, London,
19 October 2000 – 14 January 2001

Exhibition curated by Martin Kemp and Marina Wallace, assisted by Caterina Albano
Exhibition organized by Margot Heller, assisted by Sally Tallant

Architectural design by Stanton Williams

Catalogue designed by Herman Lelie
Typeset by Stefania Bonelli
Printed in England by P.J. Print

Front cover: Paolo Mascagni, *Life-size three part dissection: 'Anatomia Universa'*, 1823,
3 plates showing muscles from the front, Accademia dei Fisiocritici, Siena (cat. 231)

Back cover: Paolo Mascagni, *Life-size three part dissection: 'Anatomia Universa'*, 1823,
3 plates showing muscles from the rear, Accademia dei Fisiocritici, Siena (cat. 231)

Published by Hayward Gallery Publishing, London SE1 8XX
© Hayward Gallery 2000
Essay © Martin Kemp and Marina Wallace 2000

ISBN 1 85332 214 8 (pbk) (Hayward Gallery Publishing edition)
ISBN 0 520 22792 1 (pbk) (University of California Press edition)

This publication is distributed in the United Kingdom by Cornerhouse Publications
and in the rest of the world by the University of California Press, 2120 Berkeley Way,
Berkeley, California 94720, USA.

Hayward Gallery Publishing titles are distributed outside North and South America
and Canada by Cornerhouse Publications, 70 Oxford Street, Manchester M1 5NH,
UK (tel. 0161 200 1503; fax. 0161 200 1504).

9 8 7 6 5 4 3 2 1

Contents

Preface

In recent years a convergence between the traditionally separated disciplines of art and science has increasingly provided fertile ground for new research and the production of collaborative works between artists and scientists. *Spectacular Bodies: The Art and Science of the Human Body from Leonardo to Now*, the exhibition which this publication accompanies, contributes to these developments in bringing together an extraordinary and at times challenging combination of material from the worlds of art and science. Building upon a number of exhibitions which have looked at art and science in relation to the human body, the project's most obvious precedent is *L'Âme Au Corps*, Jean Clair's important show at the Grand-Palais in Paris in 1993–94, which remains a landmark in the field. But *Spectacular Bodies* also extends the Hayward Gallery's involvement in exhibitions which blur boundaries between art and science, *The Quick and the Dead: Art and Anatomy*, an exhibition in the Hayward's National Touring Exhibitions Programme, curated by Deanna Petherbridge in 1998, having been an important precursor to this project, and the success of which demonstrated the potential of art, science and anatomy to fire public imagination.

Spectacular Bodies is one of the most ambitious projects ever presented by the Hayward Gallery, including more than 300 treasures from some eighty art and medical museums and collections in fifteen countries, as well as works by eight contemporary artists, some of which have been made especially for the exhibition. Projects of this nature are only possible due to the generosity, energy and collaborative spirit of the numerous people involved in their creation, and *Spectacular Bodies* is no exception. We are immensely grateful to all those who have contributed to its realization and, most especially, to the exhibition's curators, Martin Kemp, Professor of the History of Art, University of Oxford, with whom we had the pleasure of collaborating on the Hayward's highly acclaimed *Leonardo* exhibition in 1989, together with Marina Wallace, Senior Lecturer, Central Saint Martins College of Art and Design, London. The exhibition has been in preparation for five years, and the energy and dedication of both curators throughout that period has been nothing short of remarkable. They have applied exceptional levels of scholarship and discrimination to the selection of historical works, and their long-term engagement with the contemporary artists in the show has resulted in each and every work establishing a thought-provoking dialogue with the historical material to which it relates. Virtually every aspect of the exhibition has benefited from their involvement, from the design of the installation to the publicity campaign, and from the public talks and events programme to the presentation of the interpretative material. We are also indebted to them both for their illuminating texts which are published here, for much of the written material within the exhibition, and for their lively contributions to the audio-guide.

The breadth and quality of material in *Spectacular Bodies* is astounding, ranging as it does from anatomical drawings by Leonardo, Michelangelo, Dürer and Stubbs, and masterpieces by Rembrandt, Géricault and Degas, to contemporary sculpture, photography and video installations, and ancient medical books, instruments and anatomical models from collections in America, England, France, Holland, Italy and Scotland. It would not have been possible to bring this material together without the over-whelmingly generous support of lenders, and we extend our heartfelt thanks to all those organizations and individuals listed on page 232. Extra special thanks are due to the Wellcome Trust and the Science Museum for entrusting such significant numbers of objects to our care for the duration of the exhibition, and to the Amsterdams Historisch Museum for allowing us to borrow its outstanding group of seventeenth- and eighteenth-century portraits of Dutch surgeons at work, not only depriving their own visitors of the highlights of their permanent collection in order to collaborate with us, but also organizing the restoration of four of the paintings in preparation for loan. We are grateful to the directors, curators, administrative and technical staff of all the museums and collections from which we have been privileged to borrow works, and we join Martin Kemp and Marina Wallace in thanking those people who helped them in their research, named in the Curators' Acknowledgements.

One of the distinguishing characteristics of *Spectacular Bodies* is the integration of historical material with new and existing works by eight contemporary artists. We would like to extend our warmest thanks to Beth B, Christine Borland, Katharine Dowson, John Isaacs, Gerhard Lang, Tony Oursler, Marc Quinn and Bill Viola for their commitment to the project and for allowing us to include such appropriate works. A number of individuals and organizations have in different ways supported the involvement in the exhibition of the contemporary artists. We are particularly grateful to the

Gulbenkian Foundation for providing research funding to Christine Borland, Katharine Dowson, John Isaacs and Gerhard Lang; to Dr Sourisseaux, Lüdemann and Partner, Darmstadt, for their sponsorship of Gerhard Lang's work; to the inhabitants of Schloss-Nauses in the Odenwald region of Germany for allowing Gerhard Lang to photograph them; to Keith Barritt and Absolute Action Ltd for providing fibre optics for Katharine Dowson's work; to Print Out Video Publishing for providing DVD production facilities to John Isaacs; to the Lisson Gallery for their support of Christine Borland's work; to Bob McCoy for his help with Beth B's installation; to Hattie Graham-Campbell for her assistance in installing Marc Quinn's works; and to Irene Bradbury at White Cube, Kira Pirov and Kimberli Meyer at Bill Viola's studio, Jim Cohan and Julia Sprinkel at James Cohan Gallery, New York, Jill Silverman van Coenegrachts at Lisson Gallery, Wolfgang Schoppman at 2021 Gallery, Essen, Lilah at Tony Oursler's studio and Haan Chau at Metro Pictures, New York. Technical advice and assistance given by Simon Bradshaw, Richard Crowe, Tom Cullen, Steve Farrer, David Leister and Tim Sandford has been invaluable.

A great many people have been involved in the practical organization of *Spectacular Bodies*, and every contribution has been vital and deeply appreciated. A few key individuals deserve special thanks for their enduring commitment to the project. Over the past year Caterina Albano has ably assisted Martin Kemp and Marina Wallace and, through her extensive research, has made a significant contribution to cataloguing the works in the exhibition. She has also been a willing helper in organizing and negotiating Italian loans. The installation design for an exhibition of this complexity and on such a scale inevitably presents numerous challenges, all of which have been beautifully and successfully met by Paul Williams and Nicola Dunlop at Stanton Williams to ensure that the huge variety of objects in the exhibition are shown to their best advantage. Lighting too plays a crucial role, here skilfully designed by John Johnson and Light Waves, and Herman Lelie contributed to the final look of the exhibition through his design of the exhibition graphics. We also have Herman Lelie and Stefania Bonelli to thank for the striking and intelligent design of this publication, undertaken with characteristic unbounding patience and goodwill. The production of the catalogue, itself a demanding task, has been meticulously managed by Linda Schofield, the Hayward's Art Publisher, and Caroline Wetherilt, our Publishing Coordinator.

At the Hayward Gallery I wish to extend particular thanks as well to Greg Hilty, who nurtured the project into existence from the time the idea for it was first muted prior to his departure, and to Martin Caiger-Smith, the Hayward's Head of Exhibitions, who has kept abreast of the exhibition's development throughout with vigilance and the highest of standards. The exhibition has been superbly organized by Margot Heller, the Hayward Exhibitions Curator responsible for it; her intellectual grasp of the subject, her creative thinking in relation to it, her attention to every detail and her profound commitment have been outstanding. Sally Tallant and, at different stages of the project, Marisa Culatto, Mary Beth Haas, Jessica White, Zoe Clipp and Sophie Allen, have each provided skilled and good-humoured assistance.

In terms of logistical arrangements, Imogen Winter's role as Registrar has been pivotal, and Neville Redvers-Mutton and Rod MacRae ably coordinated the UK loans. Keith Hardy, the Hayward's Head of Operations, Mark King, our Installation Manager, and the technical team, as ever, worked incredibly hard to ensure that the exhibits were carefully handled and appropriately installed. Alex Hinton, the Hayward's Marketing Manager, devised an impressive marketing strategy, helped by Claire Eva and Jane Lawson, and worked closely with Publicis on advertising the exhibition. We are extremely grateful to Publicis for having created such an arresting and effective publicity campaign, and particularly thank Lucy Bryn Davis, Keith Courtney, Antonia Harrison and Rob Janowski for their enthusiastic involvement throughout. Alison Wright, the Hayward's Press Relations Manager, and Ann Berni, our Press Relations Coordinator, have generated and managed an unusual, and at times demanding, level of press attention. A.S. Byatt, Antonio Domasio, Stephen Jay Gould, Susan Greenfield, Germaine Greer, Jonathan Miller and Roy Porter, are among the distinguished participants in the talks and events programme accompanying the exhibition, devised and managed by Felicity Allen, the Hayward's Head of Public Programmes. Helen Luckett, our Education Programmer, developed and produced the extensive range of interpretative material in the resource area of the exhibition, and Acoustiguide Ltd generously provided the audio-guide to the show, produced by Alan Hall, written by Robin Brooks and narrated by Jonathan Miller, to each of whom we extend our thanks.

Spectacular Bodies: The Art and Science of the Human Body from Leonardo to Now owes its existence to the creative energy of all these people and many more; the inspiration behind its title is Anthea Callen's book, *The Spectacular Body*. To her, and all others, heartfelt thanks for making this exhibition a spectacular reality.

Susan Ferleger Brades
Director, Hayward Gallery

Curators' Acknowledgements

Our work on the exhibition and this publication took us through vast and wonderful territories, some little explored. We are greatly indebted to many people in various countries who have pointed us in the right directions and have, in many cases, generously accompanied us on our journeys. Steven de Clercq was one of the first to provide a route map, and remained with us throughout, lending his contagious enthusiasm and expert guidance. Through him we were introduced to other key supporters of the project, most notably Norbert Middelkoop and Kees Grooss in Holland. Pauline Kruseman, Director of the Amsterdams Historisch Museum, provided extraordinary support in the loan of the great suite of Dutch 'Anatomy Lessons', which we are privileged to include. Dr Bouwman gave vital support in providing access to the notable collection of Wandelaar drawings in the Library of Leiden University. In Italy, Riccardo de Sanctis was a constant source of enthusiastic encouragement, and directed the television programme that is being shown in a number of European countries and in the exhibition itself. In Bologna, Annarita Angelini acted as our 'cicerone', and Prof. Fabio Roversi Monaco, Prof. Walter Tega and Prof. Franco Ruggieri provided generous advice. In Padua, we were fortunate to be assisted by Dr Maurizio Rippa Bonati, in Siena by Francesca Vannozzi, in Naples by Prof. Vincenzo Esposito and his wife, Nadia, in Turin by Prof. Giacomo Giacobini, his staff and by Prof. Paolo Tappero and Prof. Luigi Portigliatti, in Cagliari by Prof. Alessandro Riva, in Modena by Prof. Albano Albasini, and in Florence by Marco Vannini and Marta Poggesi. On our visit to St Petersburg, we were introduced to the Ruysch material by Anna Radjun, and Larissa Olshevsaya acted as our translator. The number of people who helped us to gain access to and an understanding of holdings in British collections is too numerous to mention. If we specifically thank the Right Hon. Jane Roberts of the Royal Library at Windsor, Joanna Follet and Ghislaine Lawrence of the Science Museum, Ken Arnold, William Schupbach, John Simons and Denna Jones of the Wellcome Trust and Library (from which the exhibition has been lent extraordinary treasures), Elizabeth Edwards of the Pitt-Rivers Museum in Oxford University, Malcolm Macleod and Peter Black of Glasgow University, Simon Chaplin, Tina Craig and Stella Mason of the Royal College of Surgeons, Caroline Moss-Gibbons of the Royal College of Physicians, Ian Carroll and Gillian M. Furlong of University College London, Prof. William Edwards of the Gordon Museum, Alan Humphries of the Thackray Museum, and Prof. M.H. Kaufman of Edinburgh University, this does not mean that others who have lent support are not due our sincere thanks.

No thanks are sufficient to acknowledge the contribution of Dr Caterina Albano (financed as our research assistant by the Arts and Humanities Research Board), whose well-informed and solicitous endeavours have far surpassed the call of duty. What she has contributed to every aspect of our curatorial process extends beyond what might be implied by the role of 'research assistant', and it is impossible to contemplate what the exhibition and book would have been without her. In the early stages of the research, Liz Mellings and Max Satchell undertook useful leg-work.

Our gratitude is extended to the academic institutions to which we are attached. In Oxford, Sheila Ballard and her successor, Pamela Romano, have regularly performed many essential services with characteristic willingness and efficiency. In London, Prof. Margaret Buck, Head of Central Saint Martins College of Art and Design supported Marina Wallace's applications for a research fellowship and a period of study leave. Marina's thanks go to the academic managers in the School of Graphic and Industrial Design, amongst them Brent Richards and Jonathan Barratt. On the Graphic Design Course special thanks go to her colleagues, in particular Andrew Whittle for his flexibility in dealing with her absence during the periods of study leave. Prof. Malcolm Le Grice, Head of Research at Central Saint Martins, gave his warm and understanding support, and helped actively to ensure that internal timetables were met. Without the one-year Fellowship granted by the Leverhulme Trust to Marina, the numerous and enlightening visits in the UK and abroad to museums and departments of anatomy would not have been possible. Jean Cater, at the Leverhulme Trust, was a most efficient and encouraging administrator. The Arts and Humanities Research Board, and Central Saint Martins College, assisted with a further grant to Marina at a most crucial time, to ensure the successful conclusion of the project.

Amongst other academic supporters, the European Science Foundation and William Shea were instrumental in making it possible for us to convene a symposium in Oxford in September 1998 which saw the unprecedented coming together of scholars and historians of science and art, together with a number of the contemporary artists involved in the themes of the exhibition. A book, *Know Thyself*, to

be published by the University of California Press, will result from the symposium. Many thanks are due to James Clark of the University of California Press for his support and enthusiasm. Not all the artists with whom we had fruitful exchanges over the years were finally included in the show, but all contributed with their creative knowledge to our work.

We would like to join Susan Ferleger Brades in thanking all those at the Hayward Gallery, named in the Preface, who have been involved with the project. Also, we thank Paul Williams of Stanton Williams Architects, unobtrusively but vitally assisted by Nicola Dunlop, who has exercised unfailing creative ingenuity to devise an exhibition design that serves both the space and the objects. Paul has continuously interrogated and clarified the purpose of the exhibition in its whole and Herman Lelie and Stefania Bonelli, as designers of the book, have stoically born all manner of irregularities with a good humour that has been miraculous.

Of the eight artists represented in the exhibition, four of them gained research access to primary sources thanks to a generous grant by the Gulbenkian Foundation. We are grateful to Siân Ede for appreciating the relevance of historical research for the contemporary exhibits. The long-standing exchanges we ourselves enjoyed as curators with the artists included in this show have been wonderfully enlightening and productive, revealing how deeply the historical material relates to contemporary artistic concerns. We are delighted with the hard and inspirational work which the artists of *Spectacular Bodies* invested in their creations. We hope that this exhibition will be a landmark for future collaborations in art and science.

Finally, our unmitigated gratitude goes to our friends, amongst them Pat Williams, and our respective families. In particular, Paul, Marcel and Juliette provided their support and adapted their timetable to fit a demanding, and often impossible, work schedule. We hope that the enjoyment our families and children will gain from the show, will repay the understanding and support they have given throughout the years.

Martin Kemp Marina Wallace

Introduction: 'Know Thyself'

It may seem obvious that a detailed image of a dissected body, like Joseph Towne's strikingly naturalistic model of a sectioned torso in coloured wax (cat. 290) belongs to the world of medicine. In other words, it is not what we are used to calling a 'work of art' – unless, that is, we are using the term in a casual, colloquial, or even ironic way, as we might say of an artfully presented dish in a stylish restaurant that 'it's a real work of art!'. In the context of our institutional definitions of 'Medicine' and 'Art', Towne's wax is definitely a medical image. Indeed, his model and all comparable anatomical representations in three and two dimensions are almost invariably to be found in medical museums, particularly those devoted to what in Italy is called *anatomia normale*, that is to say, 'standard anatomy'.

However, our easy confidence in classifying such historical images is misplaced. There are two immediate grounds for saying this. The first is that the world of medicine and its associated imagery occupied very different cultural territories from today's professional mainstream. The purpose of anatomical images during the period from the Renaissance to the nineteenth century had as much to do with what we would call aesthetics and theological understanding as with the narrower intentions of medical illustration as now understood. Indeed, much of the detailed anatomy was of no use to the physician, or even the surgeon, because contemporary medical practice simply did not have the means to intervene with the levels of refinement that the representations delivered. Rather, the disclosing of the 'divine architecture' that stood at the summit of God's Creation remained the central goal of anatomical representation across at least three centuries.

The second reason is that the makers of the images were, for the most part, trained as artists and continued to call themselves 'painters' or 'sculptors', sustaining the practice of their art outside the realm of medical imagery. The pioneers of wax anatomies in the late seventeenth and early eighteenth centuries, the eccentric wax-modeller from Syracuse, Gaetano Zumbo, and Ercole Lelli in Bologna, both pursued careers as makers of works for artistic consumption. Joseph Towne, working towards the end of the tradition, specifically defined his profession as 'sculptor'. Towne, who entered the field of anatomical modelling with a small model of the skeleton made for Guy's Hospital in 1826, when he was only seventeen years old, exhibited regularly at the Royal Academy between 1843 and 1866, as well as serving as the hospital's specialist modeller for some fifty-three years.

The other significant factor that dissolves our tidy boundaries lies within the world of art itself. As a key component in the revolution in naturalistic rendering wrought by artists during the Renaissance, theorists and artists of the avant-garde came to insist that it was necessary for the artist to acquire a mastery of the body as a functional system of motion and emotion. This understanding, in the hands of the more intellectually-

cat. **290** (left)
Joseph Towne
Section of the Thorax at the Level of the Heart, c.1827–79
wax

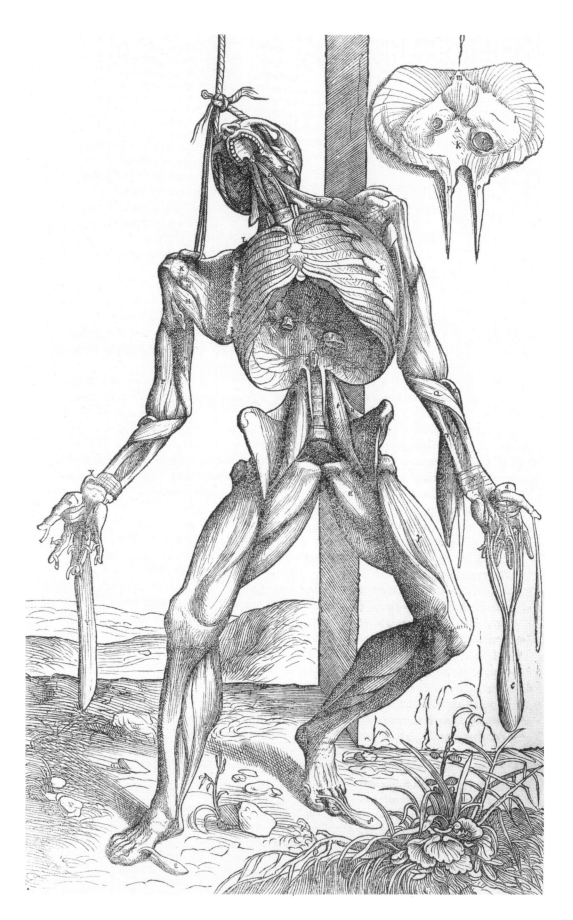

cat. **294**
Muscle Man, plate 7
from Andreas Vesalius
Icones anatomicae, 1934
(from original publication
Andreas Vesalius *De humani
corporis fabrica*, 1543)

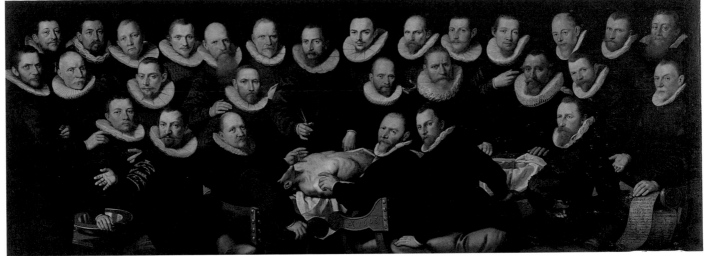

cat. **243**
Aert Pietersz
*The Anatomy Lesson of Dr
Sebastiaen Egbertsz,* 1601–03
oil on canvas

inclined practitioners, included not only the muscular and skeletal mechanisms, but also those aspects of the human constitution that resulted in the outer signs of character and emotional expression.

It was this broad quest for underlying knowledge that made possible the intimate union that developed between the visions of artists and anatomists. This union is already manifest at the highest level in the grand 'pictures' in Andreas Vesalius's large and seminal volume, the *De humani corporis fabrica* of 1543, drawn by Jan Stephan van Calcar, a Netherlandish artist who had been in Titian's Venetian studio (cat. 294). A comparable union was apparent in many of the sciences and technologies, from botany to engineering. As natural philosophers came increasingly to insist on the primacy of direct, sensory knowledge in the exposition of the physical world, they increasingly recognized the potential value of a picture as 'worth a thousand words'.

The framework of assumption was based on a philosophical stance towards visible nature that saw God's created order as designed for human understanding. Indeed, visible nature attained its intended fulfilment through the exercise of those cognitive faculties with which God had uniquely endowed human beings. The entire notion was neatly encapsulated in the favourite Renaissance tag, originating with the Greek philosopher, Protagoras, that 'man is the measure of all things'. This stance is founded on the tenets of ancient Stoic philosophy, which aspired to define the special position of the sentient human being in a nature that discloses its order for those with the will and perspicacity to see it. In a real sense, every historical image with which we will be concerned bears witness to the power of 'man as the measure of all things'. Amongst all the programmes of visual measurement none stood higher than the aspiration to 'know thyself'.

'Know thyself', expressed in this archaic form is a direct translation of another ancient tag, *nosce te ipsum*, famously inscribed in its Greek version on the Temple of Apollo at Delphi.[1] It could stand as the emblematic justification for the production of virtually every image in this book - including the work of the contemporary artists. It was much

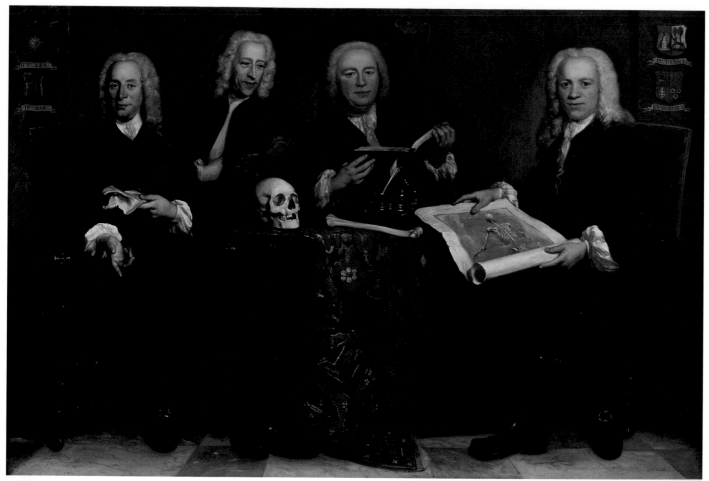

cat. **251**
Jan Maurits Quinkhard
*Four Wardens of the
Surgeons' Guild,* 1744
oil on canvas

cited in the eras of humanist medicine, not least to justify the dissections performed by the anatomists who were pictured in the great suite of 'Anatomy Lessons' from seventeenth-century Holland (cat. 157, p. 16; cat. 238, p. 62; cat. 243, p. 13; cat. 251; cat. 255; cat. 258, frontispiece; and fig. 3, p. 25). A telling commentary on the tag was provided in 1540 by Philip Melanchthon, reforming humanist and friend of Albrecht Dürer:

> Anatomical learning must not be neglected in understanding why it should be so useful to know about the fabrication [*aedificium*] of the human body. It is indeed something worthy of man to scrutinize nature and not to despise the wonderful workmanship [*opificii*] that is this world, put together with such skill [*arte*] that resembles a theatre and informs us of God and His will. But it is especially appropriate and profitable for ourselves to scrutinize the whole series, shapes, layout, powers and functions of each of the parts. They formerly told of an oracle, 'Know Thyself', which though filled with warning, signals this aspiration, namely that we should examine all that is admirable within ourselves and that constitutes the source of many of our actions. Since our actions are directed towards wisdom and justice, and true wisdom is the recognition of God and the consideration of Nature, one must admit that one must learn anatomy, through which the causes of many actions and changes are made visible. [2]

In the western cultural tradition, as in much of the art originating from other cultures, the representation of the human form has played a central role in the quest to deal with the great issues of birth, life, humanity and death in relation to the transcendent reality of the divine. This quest has not only provided a key goal in art, but has also inspired generations of investigators of the marvellous machinery of the body in the world of medicine. Vesalius's *Fabrica* is no less about the divinely privileged if mortal role of humans, often in heroic or tortured guise – set stoically within the grandeur of natural creation – than the biblical images on Michelangelo's Sistine ceiling (fig. 1).

But the centrality of the human image is even more basic and less historically specific than this. We are irresistibly drawn to looking at our fellow human beings with a sustained intensity and complexity accorded to no other field of visual activity. Neuro-science and perceptual psychology are increasingly confirming how we have been equipped with a truly extraordinary apparatus to service our perception of the most subtle and elusive of human signs, both the unspoken language of bodily posture and the tiny morphological variations in faces that allow us to read (or to think that we can read) character and emotion. Indeed, different cerebral locations are dedicated to the intricate task of recognizing one face from another on the basis of often tiny differences and to the discerning of specific expressions in all their nuanced and fleeting complexity.

We are all obsessive people-watchers, and we are all instinctive physiognomists, however often our initial diagnoses are confounded. We cannot insulate ourselves from the biologically in-built urge to react in a trice to the array of visual signs presented by another person. These range from general judgements of, say, racial origin to impressions

fig. 1
Michelangelo
The Persecution of Haman,
c.1508 – 1512
fresco in the Sistine Chapel
Photo Scala, Florence

cat. **255**
Tibout Regters
The Anatomy Lesson of Professor Petrus Camper, 1758
oil on canvas

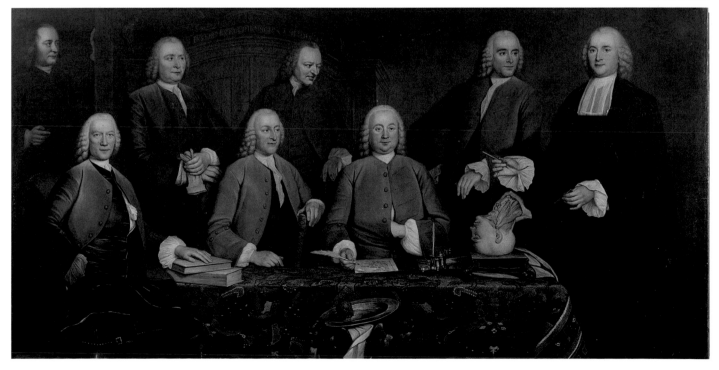

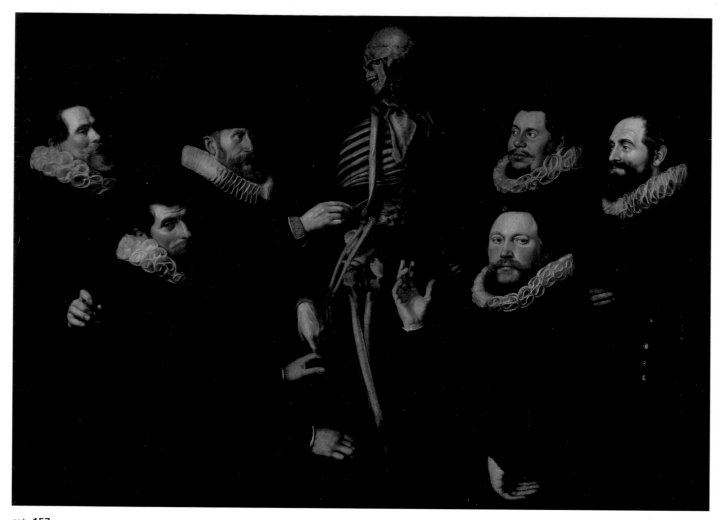

cat. **157**
Thomas de Keyser (?)
*Osteology Lesson of
Dr Sebastiaen Egbertsz,* 1619
oil on canvas

based on the tiny, tell-tale signs that suggest someone may be amenable to us – or not. How many of us have resisted the temptation to scrutinize the newspaper photograph of a rapist or notorious murderer for some discernible signs of his bestial depravity? Over the centuries, huge efforts were devoted to the explanation and codification of the exterior manifestations of inner character, thoughts and emotions – what Leonardo called *il concetto dell'anima* (the intention of the mind). If artists, like Leonardo, or nineteenth-century photographers of the insane and criminal, could not hope directly to portray the soul of a person, they could at least show us the configuration of the house that was its individually-designed habitation, so that we might learn something of the nature of the person resident therein.

These fundamentally human (and humanist) themes remained at the centre of Western art from the Renaissance to the mid-nineteenth century. But by 1880 or so, something extraordinary was beginning to happen – something that we have so come to accept that we overlook how aberrant it was within the broader sweep of visual imagery. The centres of attention in avant-garde art moved decisively into areas other than the human figure rendered within the broad spectrum of naturalism. Even when the human figure was the

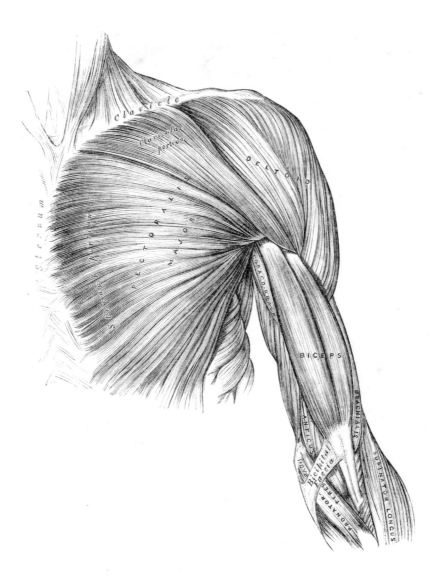

fig. 2
Muscles of the Chest and Front of the Arm, figure 152, p. 245
from Henry Gray
Anatomy descriptive and surgical, 1858
London: John W. Parker and Son
book; 26.3 × 17.5 × 6
Wellcome Library, London

prime subject of attention, it was not depicted according to the old canons of anatomical and physiognomic 'correctness'. For some artists, like Matisse and Picasso in the early twentieth century, the human figure continued to play a major role, but it was in the context of a way of making images that was little concerned with the naturalistic devices and skills that had been so hard-won over the preceding centuries. Knowing how the biceps worked with the bones to operate the levers of the arm was no longer a prerequisite for the painter or sculptor of the human nude.

At more or less the same time, hand-drawn illustrations of what was called 'gross anatomy' – that is to say, the features discernible by the naked human eye – ceased to undergo significant development. The institutionalized, unadorned style of anatomical illustration epitomized in Gray's *Anatomy* in 1858 became the persistent norm around which variations were worked by specialist practitioners of the art of anatomical illustration (fig. 2). The real excitement lay elsewhere, partly with the use of photography to

achieve direct representation of carefully arranged dissections, and more particularly with techniques of imaging that went far beyond what the unaided human eye could accomplish. Microscopy became more and more prominent, while X-rays, invented by Röntgen in 1895, provided an utterly new mode of 'visual' access to the inner body.

That these developments in art and medical imaging occurred over the same time span is not coincidental. The kinds of truth for which artists and medical researchers were mutually searching lay not just within and under the surface appearance of things, as they had for generations, but at different levels of reality, more abstract and often ever-more minute. The increasingly specialized professions of artist and doctor sought their own realities, realities that were no longer to be identified with the eye's ability to see and the mind's ability to represent within a naturalistic framework. The hows and whys behind this mutual divergence into 'deeper', invisible and more technically obscure realms still awaits wholly satisfactory explanation. For the moment, we can at least recognize that it occurred.

We can also recognize that significant numbers of highly ambitious artists in the last third of the twentieth century re-instated the subject of the human figure and began to re-open the dialogue between modes of artistic representation and medical imagery. The nature of this dialogue, to be discussed in more detail in Part III, is exemplified by the eight artists, selected here from the now huge field of those deeply involved in representation of the body. They have all devoted sustained attention to themes that can be described as 'medical', rather than opportunistically annexing medical images for occasional effect, and are all concerned with contemporary ways to express the equivalent of the 'wonder' that permeates the historical imagery. Their works exude a quality of manufacture that can stand the stern comparison with the supreme craftsmanship of the past. The prime intention has been to engage the artists in a 'conspiratorial' sense with the purpose of the project. Inevitably, the artists based in Europe were more readily available than those from America. At least three of the artists, Katharine Dowson, John Isaacs and Gerhard Lang, have been integrally involved for two or three years in aspects of the research into the historical images. The engagement of the other artists has ranged from fruitful discussions with Bill Viola and Tony Oursler about the choice of existing works for inclusion to negotiations with Christine Borland and a detailed dialogue with Beth B about works specifically made or re-cast for the project. Part III of this book will explain how alignment with the historical imagery has been conceived, though it is worth saying at the outset that the artists have not been squashed into historical boxes. The intention here is to bring their works into resonant dialogue with the kinds of images from which they are normally separated.

Earlier artists were not so much unexpected or alien visitors to scientific institutions, but natural participants in the formation of the imagery that was visible in the scientific site. To take just one example, Géricault's portraits of the insane are now firmly enshrined in the temples of art, but their natural environment is as much the asylum of the Salpêtrière in Paris, where a series of innovatory images of the insane was being created,

as the hallowed halls of the Louvre. The contemporary artists here are being re-introduced in the public eye to some of their natural ancestors. We are saying that if we look for natural historical partners for those contemporary artists who have re-instated the image of the body as central to art, we can turn to the anatomical theatre as site for performative acts of bodily disclosure, to the great collections of waxes as a kind of installation art, to the pioneer photographers for photo-works that enter into rich and complex dialogues with art, science and society, to the great anatomical picture books for the strange and terrible beauties that lie within the male and female bodies, and to the obstetric imagery for the wonder of life as conveyed in vehicles running on a high-octane fuel of social *frisson*.

For works of the complexity that we are juxtaposing, whether 'medical' or 'artistic', there is no single 'right' context. Different contexts, different juxtapositions, make things look different. This is an open exercise in contextual looking, which invites the viewer of the images to play creative and imaginative roles in thinking about images of the subject that is literally closest to our hearts and minds, that is to say, 'knowing ourselves'.

cat. **69** (following two pages)
F. Calenzuoli
Female Reclining Figure, 1831
(detail)
wax

Part I
The Divine Machine

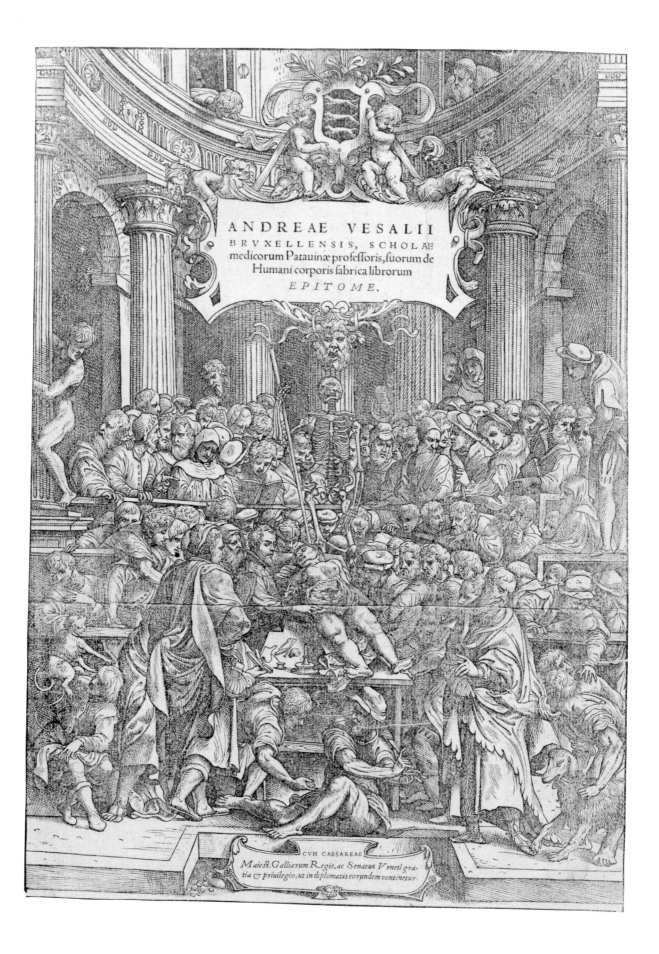

1. Men at Work: the Rituals of Dissection

Dissection of the human body – always a fraught business in any society – was for much of its history not primarily a technical process conducted for teaching, research or autopsies. Nor were dissections most commonly undertaken in the privacy of dissecting rooms in medical institutions. Rather, the opening up of a body was a ritual act, a performance staged for particular audiences within carefully monitored frameworks of legal and religious regulation. The most prominent dissections were staged as public or semi-public performances in specially constructed 'theatres' (the term still used for the room in which operations are conducted in modern hospitals). The audience was as likely to consist of curious non-specialists as aspiring or actual members of the medical profession, and the interior wonders of the body were rendered open to view in sequence according to a pre-determined choreography. The professor acted as the master of the performance, which was generally conducted according to the plot of a set text that was being read out loud to the eager press of spectators. The actual acts of cutting might well be performed by a practical dissector rather than the august professor himself, especially in the earlier centuries.[3] Such staged events, exuding an exciting aura of wonder and morbid fascination, are a far cry from the low-key privacy and professional exclusivity of the modern dissecting room in a medical school.

A series of representations give an idea of the tone of the events, even if they are not precise documentary records. The frontispiece to Johannes de Ketham's 1493 *Fasciculo de Medicina*, which includes the set text by Mundinus, shows the professor magisterially pronouncing *ex cathedra*, while his subordinates undertake the dissection and point to the features named in the read text (cat. 156). By contrast, the equivalent woodcut at the start of Vesalius's *Fabrica* in 1543 shows the master-dissector performing in his famous hands-on role (cat. 296). The image of Vesalius dissecting at Padua is designed to make a series of polemical points, above all about the primacy of direct experience of human rather than animal bodies. The real body is to become the 'book' to be read by the surgeon rather than the set text sanctioned by traditional learning. Performing within a great (probably imaginary) theatre, designed according to the tenets of Renaissance architecture in the 'ancient' style, 'Vesalius of Brussels' is openly conscious of his role as the heroic measurer of the 'divine symmetry' of the human body. He revels in his mastery of dissection of the abdomen of a woman, to reveal the majesty of God as the 'supreme maker' to his crush of Paduan spectators. It was this majesty that he aimed to disclose to a Europe-wide audience through the dramatic and magisterial pictures he conceived for his large-scale book.[4] In his text, and within the woodcut images themselves, he went to great pains to make us believe that we are actually witnessing the real thing. He outlines his procedures as a narrative of disclosure, telling us what has been removed and displayed at each stage, and he includes numerous pointers to the physical reality of his demonstrations, such as the rope suspending the cadaver

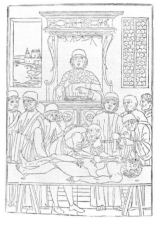

cat.**156**
Anatomy Lesson
plate from
Johannes de Ketham
Fasciculo de Medicina, 1493

cat. **296** (left)
Title page
engraving from
Andreas Vesalius
De humani corporis fabrica,
1543

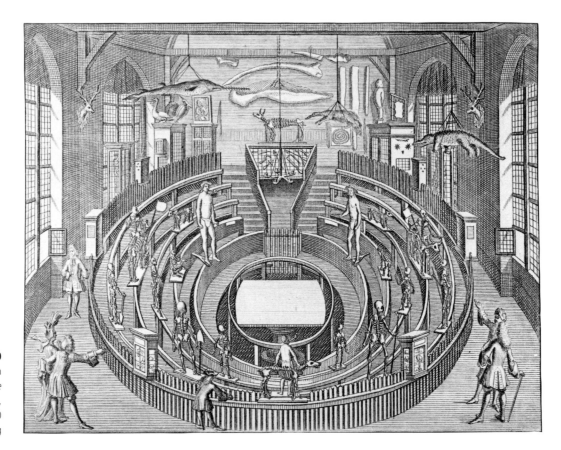

in the seventh plate of the muscles or his plate of dissecting tools arrayed on a vivisection board.

During the next century, the self-conscious successors to Vesalius in Holland were also responsible for theatrical dissections, performed annually as part of the public jamboree of Carnival. The character of the spaces for public dissection can be seen in prints of the anatomy theatre at Leiden (cat. 10) which also served as a venue for curious visitors outside the anatomy season. The Leiden theatre regaled the visitor with a striking parade of human and animal skeletons, some of which bore mottoes on banners reminding the spectators of their own transient mortality. It was a context that stressed the role of anatomy as a science that was as much philosophical as practical, a matter of meaning as much as medicinal intervention.

The permanent anatomy theatre became an architectural genre in its own right, and a conspicuous feature in a number of European seats of learning. Its canonical form consisted of tightly packed tiers of circular or elliptical balconies steeply disposed in the shape of an inverted cone. Each platform was just wide enough to accommodate a file of standing spectators, who would be granted a vertiginous view of the corpse below. Particularly notable examples have miraculously survived in Padua (cat. 150, pp. 160 – 161) and Uppsala, the former of which provides the prime locus for John Isaacs's video work.

The public anatomies in the successive theatres in Amsterdam were prestigiously

performed by elected *praelectors* (reader-demonstrators). A tradition developed that the *praelector* and his favoured colleagues should subscribe to the cost of a group portrait to be installed proudly in the meeting-room of the Surgeons' Guild, which was located in the 'Weighing House on the New Market'.[5] The great suite of surviving images, ranging from the panoramic row of portrait heads in Aert Pieterz's *The Anatomy Lesson of Dr Sebastiaen Egbertsz* in 1603 (cat. 243, p. 13) to the dramatic demonstration of the brain of the foreshortened cadaver in Rembrandt's much-damaged *Anatomy Lesson of Dr Deijman* of 1656 (cat. 258, frontispiece) are not literal representations of their public acts, but are allegorical proclamations of the surgeons as the renowned masters of the secrets of the body. One does not show an actual dissection at all but a demonstration of a mounted skeleton. In Thomas de Keyser's cleverly composed *Osteology Lesson of Dr Sebastiaen Egbertsz* (cat. 157, p. 16), the same *praelector* as in Pieterz's earlier picture points to the lower part of the rib cage, perhaps as an allusion to the creation of Eve from Adam's 'spare rib'.

In the case of the most renowned of all the 'Anatomy Lessons', Rembrandt's 1632 portrait of Dr Nicolaes Tulp and his awed colleagues (fig. 3), the specific subject of the demonstration is the mechanism of the hand, which had long been revered as the 'instrument of instruments'.[6] With his tweezers, he specifically allows the viewer to trace the superior and inferior flexor tendons that pass from the forearm to the hand, subsequently interpenetrating each other on the inside of the fingers in a piece of marvellously ingenious engineering. It was a mechanism that had fascinated generations of

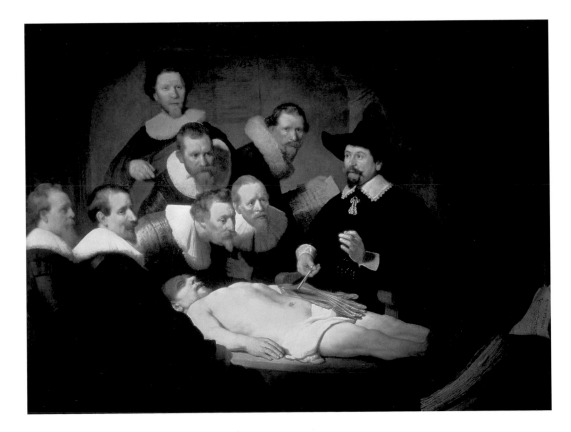

fig. 3
Rembrandt van Rijn
The Anatomy Lesson of Dr Nicolaes Tulp, 1632
oil on canvas; 169.5 × 216
Mauritshuis, The Hague, The Netherlands/Bridgeman Art Library

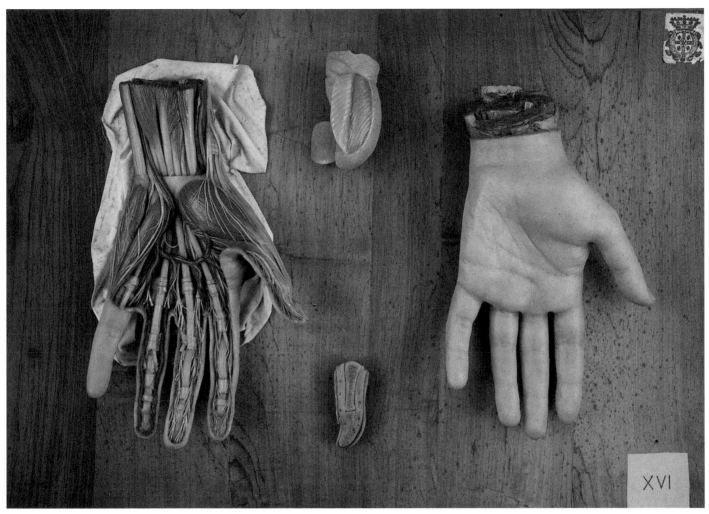

cat. **280**
Clemente Susini
Organ of touch, 1803
wax

cat. **195** (left)
Leonardo da Vinci
Studies of the Hand, c.1510
pen and ink with wash over
traces of black chalk on paper

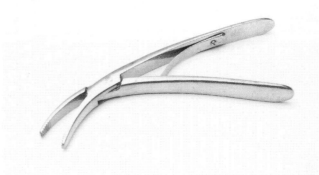

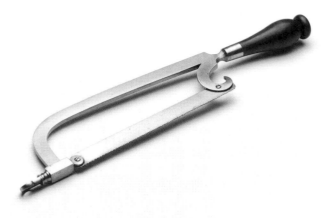

anatomists, including Leonardo (cat. 195, p. 26 and cat. 280, p. 27). For artists the hand was a communicative device second only in eloquence to the face. The refined motion of Tulp's own left hand precisely demonstrates the subtlety of this intricate piece of bodily design. As the 'Dutch Vesalius', it is appropriate that Tulp should be portrayed extolling the hand, just as Vesalius had done in the portrait image he included in the *Fabrica* (cat. 297). For the surgeon-dissector, the hand was also the maker of surgical instruments and their dextrous manipulator. Frequently the instruments themselves were designed with an elegance that befitted the status of their owner, while the great Dutch instrument-maker, Cornelis Solingen, made a classic series of designs that spoke of clean, manual functionality in a highly novel manner (cats. 269 and 271).

The tradition of Dutch surgeon portraits continued into the eighteenth century. In the more story-telling vein characteristic of his eighteenth-century genre pieces, Cornelis Troost in 1728 shows Willem Röell in charge of a knee dissection (cat. 291, p. 31), which perhaps seems an odd choice, until we notice that van Berkenrode, the seated doctor with the cane, prominently displays an unusually tattered glove. We can infer that the doctor's glove has suffered inordinate wear because a gammy knee necessitated the regular use of a walking cane.[7] The later portraits, such as Jan Maurits Quinkhard's *Four Wardens of the Surgeons' Guild* in 1744 (cat. 251, p. 14) do not so much deal with 'Anatomy Lessons' as providing group portraits of senior figures in the administration of the Guild with appropriate attributes, in this case a skull, humerus, a book on the bones by the great Albinus, and an anatomical drawing by Jan Wandelaar, Albinus's favoured illustrator. In 1758, the learned doctor and author, Pieter Camper, who was especially fascinated by all aspects of the head, was portrayed in a similar manner by Tibout Regters in 1758, with a preserved preparation or wax demonstrating a dissection of the neck (cat. 255, p. 15).

In marked contrast to the sanitized presentation of images that the anatomists propagated through text, illustration and portrait, was the reality faced by potential subjects

of the dissectors' bloody art. With the exception of aristocratic autopsies, conducted with an air of posthumous reverence, the majority of the subjects arrived on the table at the end of unedifying stories of crime and punishment. The secular and religious laws that reluctantly sanctioned dissection of human cadavers from the late Middle Ages to the nineteenth century, generally reserved the violation of dissection for those condemned to die at the hands of an executioner. To be dissected was a punishment pronounced to selected criminals while alive, serving to heap posthumous retribution onto the condemned man – and they were almost always men. Tom Nero from Hogarth's series *The Four Stages of Cruelty*, suffered the ultimate indignity of being dismembered in full public gaze, while his guts are gobbled up by a voracious dog (cat. 140). In at least one much earlier anatomical illustration from the Northern Renaissance – Hans Baldung Grien's pioneering image of a dissected head, thorax and abdomen of 1517, in the woodcut by Hans Wächtlin (cat. 111, p. 30) – the characteristics of punitive cutting were openly apparent, both implicitly in the vicious portrayal of the butchered criminal's face and arms, and explicitly in the attached inscription which records the circumstances of his dissection by Dr von Brackenau in Strasbourg. Such images also serve to remind us that the dissectors themselves needed what we call 'strong stomachs'. As Leonardo said:

cat. **297** (bottom left)
Steven van Calcar
Andreas Vesalius dissecting the muscles of the forearm of a cadaver
woodcut from
Andreas Vesalius
De humani corporis fabrica,
1543

> Though you have a love for such things you will perhaps be hindered by your stomach, and, if that does not impede you, you will perhaps be impeded by the fear of living through the night hours in the company of quartered and flayed corpses fearful to behold.[8]

cat. **140**
William Hogarth
The Reward of Cruelty,
1750–51
engraving

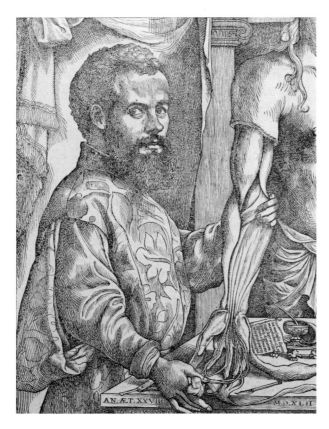

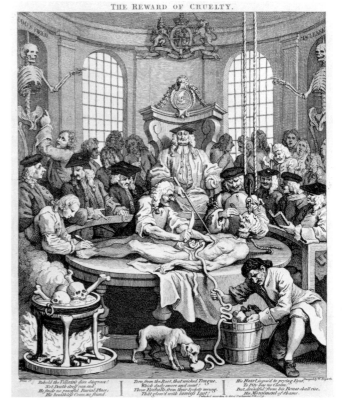

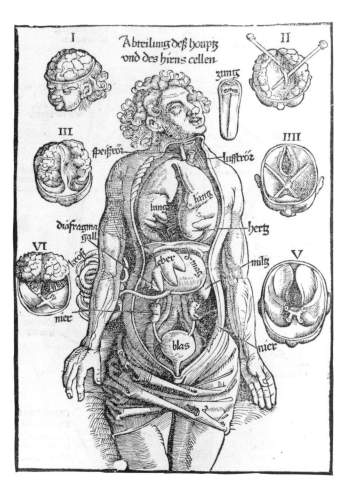

It is in this spirit that John Isaacs, in his vibrant and skilful re-working of the theme of the wax anatomies, has subverted their cosmetic aesthetics by overt allusion to the messy reality of dissection (cat. 151, p. 164).

An adequate supply of victims was a perpetual problem for anatomists. In eighteenth-century Edinburgh, a hot-bed of medical investigation and instruction with a plethora of university and private establishments, the thin supply of legally available corpses was augmented by nocturnal gangs of grave-robbers or 'Resurrectionists', most notably the notorious Burke and Hare, suppliers to Dr Knox, whose cast heads were amongst the prime specimens of evil types displayed by the Edinburgh Phrenological Society (cats. 22 and 23, p. 115). Burke and Hare not only robbed fresh graves, but also came to ensure a steady supply through the murder of vagrants and outcasts in the city.

With the increasing demand for authorized supplies of cadavers in sufficient numbers to meet the needs of the burgeoning teaching institutions in the subsequent century, new measures were put in place. In Britain, for example, the Anatomy Act of 1836, still on the statute-books, supplemented the supply by authorizing the provision of deceased 'paupers' to the anatomy schools. In the service of medicine, it also became possible to bequeath one's corpse for research and teaching within the tightly regulated confines of

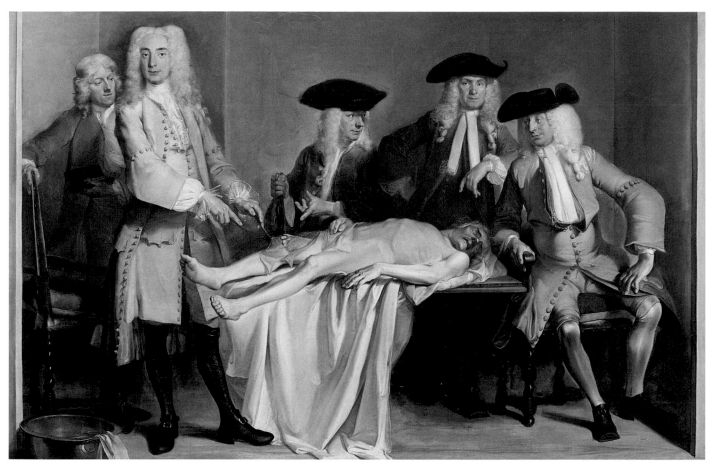

cat. **291**
Cornelis Troost
*The Anatomy Lesson of
Professor Willem Röell,* 1728
oil on canvas

the major medical schools. Dissection became the prerogative of the emotionally-distanced professional, out of public sight, and the exclusive province of the technician of the human body who learnt and practised in the climate of certified knowledge – apparently beyond serious public question until comparatively recently. As new questions have arisen about the role of medical knowledge in the service of modern surgical intervention, and the role of the patient as passive subject, so the question of the fraught relationship between our bodies and those who work on them is undergoing re-assessment, not least in the context of feminism.

In the modern teaching institution, dissection of actual corpses has become increasingly less widespread, with much of the teaching now being conducted on preserved specimens, which have been treated to render them both dry and flexible. Elaborate computer rendering of whole bodies and of particular parts are also being increasingly used to provide the student with a surrogate experience of the real body in its plastic complexity. The new animated and interactive graphics undoubtedly exhibit their own sense of drama, effectively miniaturizing the 'ingenious machine' of the body so that it can be contained within the confines of our computer screens and witnessed anywhere in the global theatre of cyberspace.

2. Waxing Eloquent: Anatomy and Style

The portrayal of the human body, however ostensibly neutral or technical the illustration, always involves a series of choices, and invariably brings into play strong sensations. Historic images of the dissected body range from the most flamboyant of the multi-coloured waxes, in which dissected figures assume the roles of expressive actors and actresses in their own timeless drama (fig. 4), to the remorselessly sober woodcuts in Henry Gray's famous *Anatomy*. All the images exhibit what an art historian would call 'style'. They are of their period, and the styles vary not only across time but also according to place of origin and the proclivities of those responsible for generating the images. For much of the time, the styles of anatomical rendering go hand-in-hand with prevailing artistic styles. This is unsurprising, given the number of shared factors, including the use of trained artists to create the anatomical depictions, the available media and techniques, the shared contexts of private patronage, and agreed concepts of how to treat the body with appropriate reverence. Even Gray's consciously un-stylish figures manifest a pronounced style – the technical, no-frills style that marked the professionalization of so many pursuits in the nineteenth century.[9] This technical 'non-style' marked a decisive divergence between the way that artists exploited their styles to depict the body in a communicative manner, and the way that anatomists sought to give absolute priority to the factual information they wished to impart.

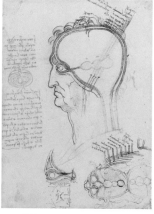

cat. **190**
Leonardo da Vinci
Vertical and Horizontal Sections of the Human Head, c.1489
red chalk and ink on paper

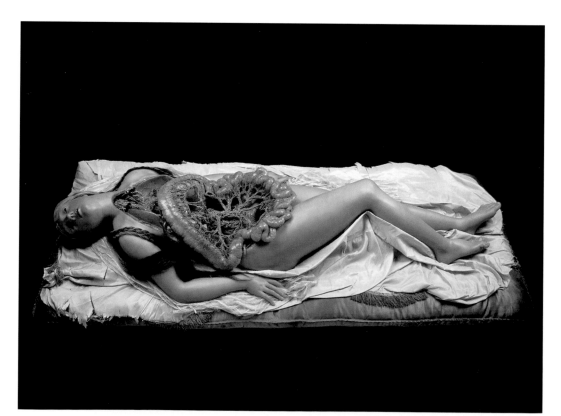

fig. 4
Clemente Susini
Reclining female figure,
late 18th century
wax
cat. XXIX, 745
'La Specola' Museum of Natural
History of the University
of Florence
Photo © Saulo Bambi

cat. **196**
Leonardo da Vinci
Study of the Tendons and Muscles of the Foot, Ankle and Lower Leg, c.1510
pen and ink over traces of black chalk on paper

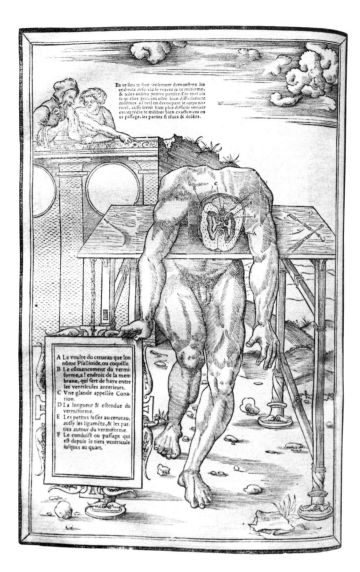

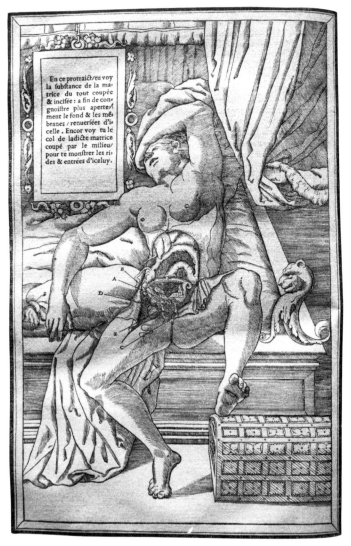

The two great pioneers of what was possible in anatomical illustration, Leonardo and Vesalius, invented or perfected virtually all the possible methods of depiction, until the advent of X-rays, scanning techniques and moving pictures. In their drawings and prints, we find direct 'pictures' that aspire to transform the spectator of the illustration into a surrogate eyewitness of the dissection or of a dissected part of the body (cat. 196, p. 33). There are also views which display various kinds of section through the whole or parts of bodies (cat. 190, p. 32). There are contrived, synthetic representations using such techniques as transparency and isolation, so that we can see, for example, a whole 'tree of the vessels' (Leonardo's term). They exploit various kinds of diagrammatic and semi-diagrammatic modes to illustrate structural, mechanical and physiological principles (cat. 194; cat. 198, p. 39). Vesalius also makes ingenious use of paper flaps to show overlying and underlying parts. And there is the use of visual analogies to explain how a part of the body functions, as when Vesalius demonstrates the rationale of the transverse ligament in the ankle. But this is to confine ourselves to technical matters of 'conveying information'.

The effective conveying of knowledge was the province of rhetoric. The 'art of persuasion' stood supreme as a method for communicating great truths throughout the era in which humanist values persisted. A high level of rhetorical exposition ensured both the power of the demonstration and that meaning was conveyed in a 'fitting' vehicle. During this era, the prime vehicle was the great humanist picture book, which not only ensured a degree of visual magnificence appropriate to the momentous subject but also gave the whole enterprise an 'ancient air'. That is to say, the polished texts, necessarily written in Latin if the author wanted to reach an international audience, were supplemented by images that made more or less explicit reference to the classicizing figure styles that were to be sanctioned in the art academies. Vesalius's heroic muscle-men disport themselves in front of rolling north Italian landscapes in which eloquent ruins have survived from Roman times. The comparably dynamic male figures (cat. 106, p. 35) in Charles Estienne's French and Latin books play out the drama of their lives and deaths on the heroic stage of outdoor settings, while his dissected women are more likely to be found

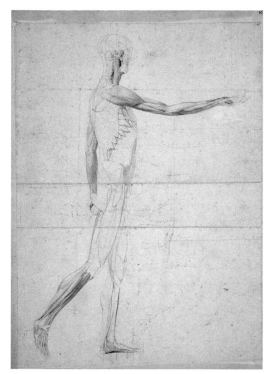

cat. **303**
Jan Wandelaar
Drawing of a figure in profile with one arm raised,
early 18th century, ink and crayon on paper.
Preliminary drawing for B.S. Albinus,
Tabulae sceleti et musculorum corporis humani, 1747

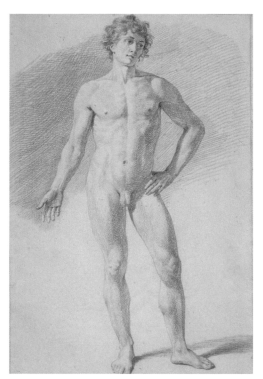

cat. **307**
Jan Wandelaar
Drawing of a male nude, frontal view, 1726
ink, crayon and chalk on paper

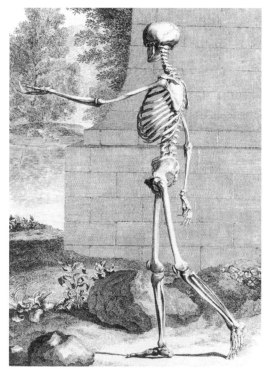

cat. **301**
Jan Wandelaar
Drawing of a skeleton, early 18th century, ink and
crayon on paper. Preliminary drawing for B.S. Albinus,
Tabulae sceleti et musculorum corporis humani, 1747

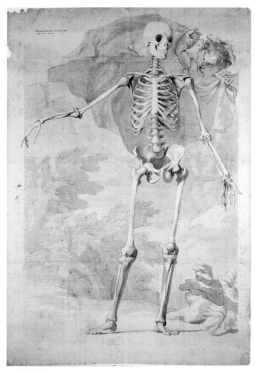

cat. **308**
Jan Wandelaar
*Life-size drawing for the skeleton with putto for
tabulae*, 1726, ink and wash over chalk on paper
pasted on fabric stretched over a wooden frame.
Preliminary drawing for B.S. Albinus,
Tabulae sceleti et musculorum corporis humani, 1747

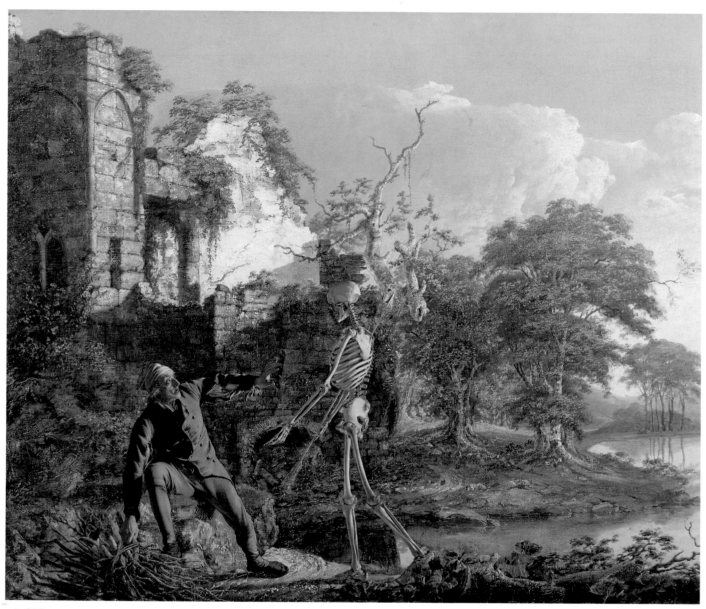

cat. **316**
Joseph Wright of Derby
Old Man and Death, c.1774
oil on canvas

in the domestic confines of a bedroom (cat. 105, p. 35). Estienne's text is particularly clear, with its cluster of Stoic references, that the narrative is concerned with the story of the human being as God's favoured being at the summit of Creation and as the designated witness of the great order of His natural world. If we recognize this narrative function, it is less surprising that Estienne has chosen to insert sections of dissected organs into woodcut blocks of animated nude figures which were in part based on Italian prints of the *Loves of the Gods*.[10]

Some 200 years later, we still see the dissected man alertly posed against grand backgrounds in Bernard Siegfried Albinus's famous *Tables*, albeit in the Enlightenment poise of a European grandee portrayed on the 'Grand Tour' or in the environs of his stately home. Albinus explained that the elaborately engraved backgrounds in his *Tables* served

cat. **191**
Leonardo da Vinci
Studies of the Vessels of the Thorax, the Heart and Blood Vessels
Compared with the Seed of a Plant, c.1501
pen and ink on a light trace of black chalk on paper

cat. **198**
Leonardo da Vinci
Studies of a Human Foetus, the Uterine Wall
& the Pronation of the Arm, c.1510–12
pen, ink and chalk on paper

cat. **7**

Anon

Harvey Anatomical Tables, c.1640

cedar wood, with varnished human arteries

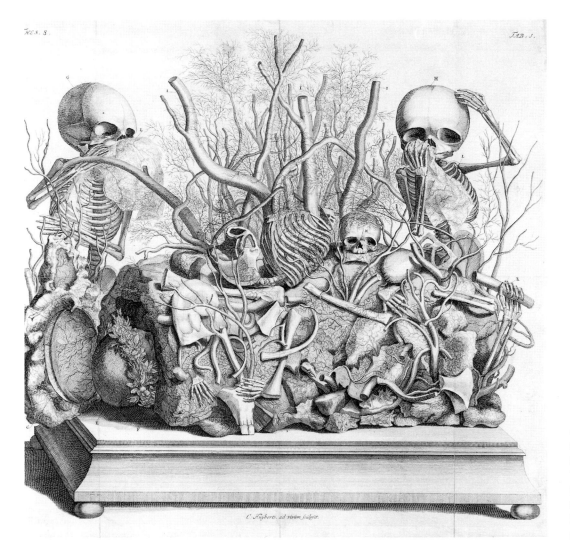

cat. **261**
Cornelius Huyberts after
Frederik Ruysch
*Table of injected vessels, stones
and infant skeletons*, 1709
engraving from
Frederik Ruysch *Thesaurus
animalium primus*, 1744

to reduce the glare of the white paper, but we cannot doubt that when he portrays one of his muscle-men standing proudly before the famed 'Dutch Rhinoceros' (cat. 313, p. 36) or in front of a monumental staircase, he is openly playing on the magnificence and beauty of the divine architecture of man as the lord of the natural and artificial worlds.[11] The series of drawings by Albinus's artist, Jan Wandelaar (cats. 301, 303, 307, 308, p. 37), testifies to the incredibly systematic assemblage (using various methods of transfer and transposition) of detailed studies into the overall compositional context of posed figures that had been drawn in due proportion with the aid of two grids of strings set up between the artist and the anatomized body. The polished results present a synthesis of all that is wonderful about God's creation. It was to Albinus that Joseph Wright turned to good effect when he needed an animated skeleton for his painting of the *Old Man and Death* in 1774 (cat. 316, p. 38).

Underlying metaphors of the kind exploited by Albinus in his text no less than in his illustrations are another integral characteristic of the humanist picture books. Perhaps the most pervasive metaphor was that of the 'Microcosm'– the notion that the human

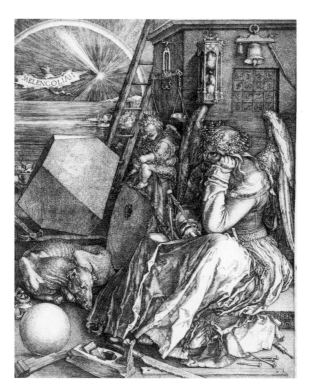

body is a 'lesser world', mirroring in its forms and functions the wider realm of the 'Macrocosm'. Leonardo's portrayal of the 'heart as seed' (cat. 191, p. 39) is more than a neat analogy; it conveys a fundamental argument about the origin of the vascular system within the broader scope of natural things.[12] A recurrent and unsurprising use of the seed analogy occurs in images of the foetus within the womb, where the containing layers are sectioned or peeled away to reveal the secrets of the fruit waiting within (cat. 198, p. 39; cat. 273, p. 172). The *Anatomical Tables*, believed to have belonged to William Harvey, and presumably purchased in Padua around 1646–49 by John Finch, mount vessels and nerves as 'trees' in exactly this microcosmic manner, as any well-informed contemporary would have recognized (cat. 7, p. 40).[13] Even the apparently more extravagant representations of infants in Frederik Ruysch's bizarre landscape tableaux of injected vessels and bodily stones, peopled with skeletal babies grieving for their precocious mortality, would have been readily understood as keying into such microcosmic themes (cat. 261, p. 41). Indeed, since the human body was dominated by the four humours and corresponding temperaments – sanguine, phlegmatic, choleric and melancholic – which themselves were locked into the four-part cosmology of the elements, seasons, ages of man and so on, the cycle of human life could not but be a mirror of larger unities in God's wonderfully ingenious universe.

The remarkable and apparently unique set of prints of *The Four Seasons* from Duke University (cat. 6), which use flaps to disclose deeper anatomical features and rotating dials to plot astrological conjunctions, presents a complex synthesis of the cosmological doctrines that dominated the human sciences and the activities of physicians until the

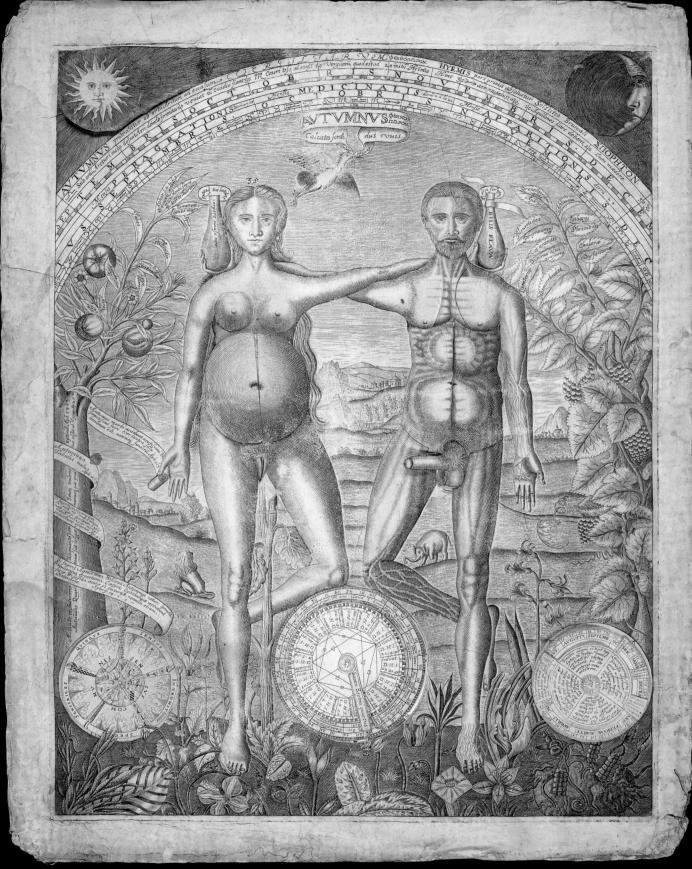

cat. **6**
Anon
The Four Seasons, early to mid-17th century
from set of four
engraving with flaps and movable parts

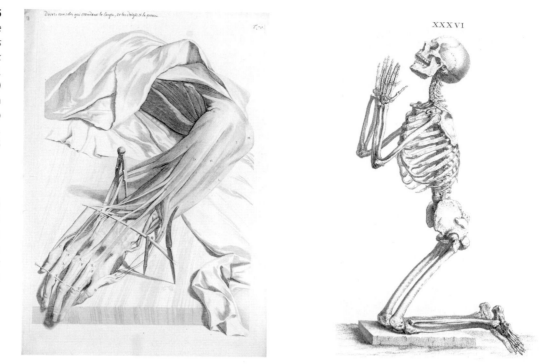

cat. **55**
Gérard de Lairesse
*Dissection of the muscles
and tendons of the back
of the hand*,
drawn 1685, printed 1739
separate plate from
Gottfried Bidloo
Anatomia Humani Corporis,
1685

cat. **75** (far right)
Praying Skeleton
plate XXXVI from
William Cheselden
*Osteographia, or the anatomy
of the bones*, 1733

late eighteenth century.[14] Such knowledge gave physicians the right to claim that their profession was founded on high learning, not least in contrast to the surgeons' manual calling. Although the philosophical underpinnings of the humours have long since been swept away, the basic categorizations, such as 'melancholic' and 'sanguine', remain part of common currency. And, in terms of historic representations, Albrecht Dürer's intricately symbolic engraving of *Melencolia I* in 1514 (cat. 102, p. 42) vividly demonstrates the potency with which the doctrine of the temperaments was translated into visual characterizations which remain psychologically compelling today.

Such general conceptions and the humanist mode of rhetorical portrayal did not prescribe a uniform style. The two main stylistic poles were deftly summarized in 1774 by William Hunter, the Royal Academy's first Professor of Anatomy, in the great volume that contained his life-size images of the *Human Gravid Uterus*:

> One is a simple portrait in which the object is represented exactly as it is seen; the other is a representation of the object under such circumstances as were not actually seen, but conceived in the imagination.

Although this type may result in a representation that is 'somewhat indistinct or defective in some parts', it will crucially exhibit the 'elegance and harmony of natural objects'. The second, which combines 'in one view, what could only be seen in several objects' is, in the final analysis, less trustworthy.

The second style described by Hunter was classicizing and synthetic, relying upon the

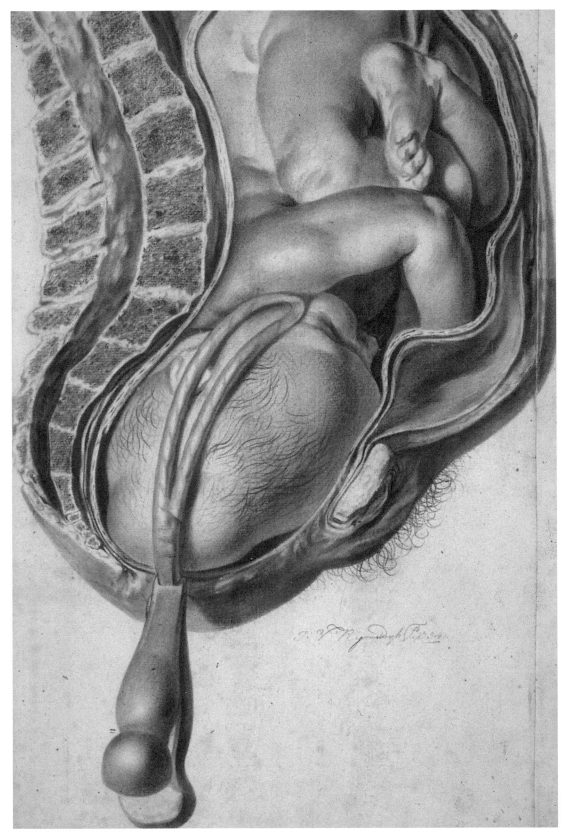

cat. **263**
Jan van Rymsdyck
Forceps Delivery, 1754
red chalk on paper
Preliminary drawing for William Smellie
Sett of Anatomical Tables, 1754

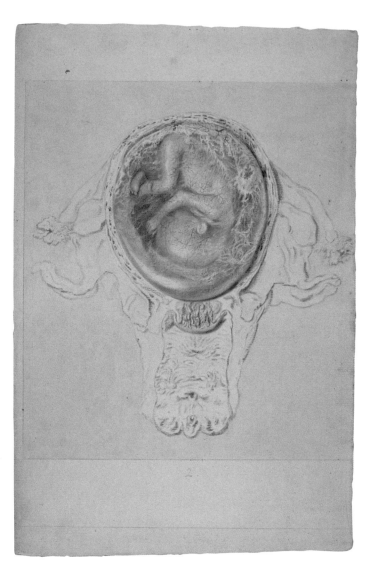

cat. **264**
Jan van Rymsdyck
Foetus in Womb at the Beginning of the Fifth Month, red chalk on paper
drawing for fig. II in William Hunter, *Anatomia Uteri Humani Gravidi, The Anatomy of the Human Gravid Uterus,* 1774

fig. 5
Gérard de Lairesse
The dissection of the abdomen with fly (detail)
engraving from
Gottfried Bidloo
Anatomia Humani Corporis, 1685
Amsterdam: Someren, Dyk et al, book
Private Collection

polished combining of data from many dissections and authorities, laced with strong implications of function. Albinus exemplifies this tendency. The first style attempts to create a 'rhetoric of reality' by devices that convince the spectator that they are seeing a particular specimen according to empirical principles of direct observation, warts and all. Gottfried Bidloo's splendid atlas of the body, published in 1684, hardly conveys the messy, flesh-and-blood reality of actual dissections, but he does encourage his illustrator, Gerard de Lairesse (the 'Dutch Poussin'), to render the surface textures and patterns of the organs, which are ostentatiously mounted on wooden blocks, draped across books (cat. 55, p. 44) and secured by realistic-looking instruments and pins.[15] When a fly is portrayed walking on an abdominal dissection (fig. 5), the doctor and his learned artist are not only stressing the reality of the scene but they are also knowingly playing on the kind of *trompe-l'oeil* illusion that was praised by the Roman author, Pliny, in his *Natural History.* A comparable device is adopted by William Hunter, when he reflects a window in the moist membrane over a foetus in the life-size images in his *Gravid Uterus,* and more

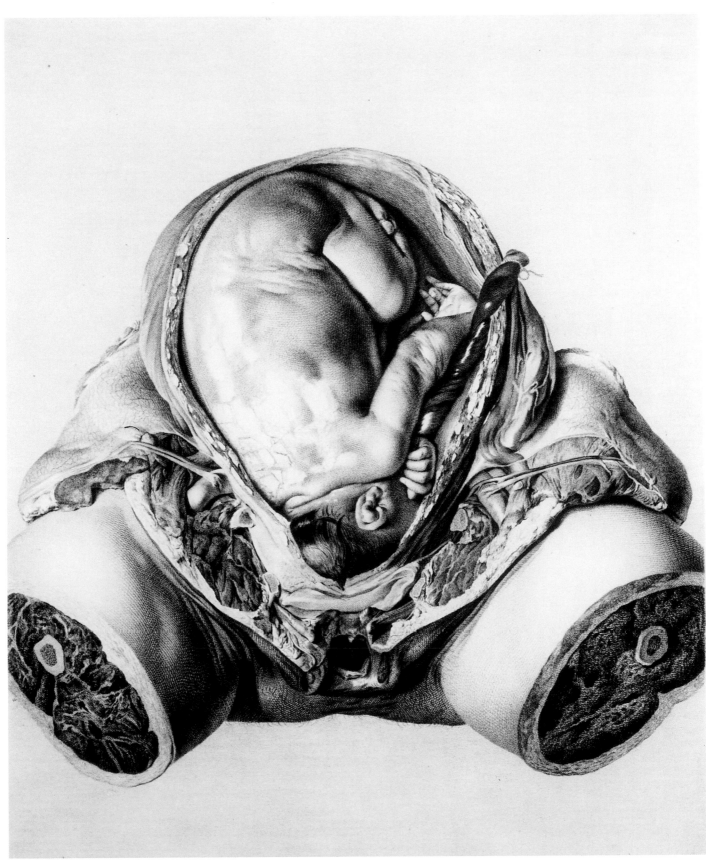

cat. **146**
Table VI from
William Hunter
Anatomia Uteri Humani Gravidi, The Anatomy of the Human Gravid Uterus, 1774

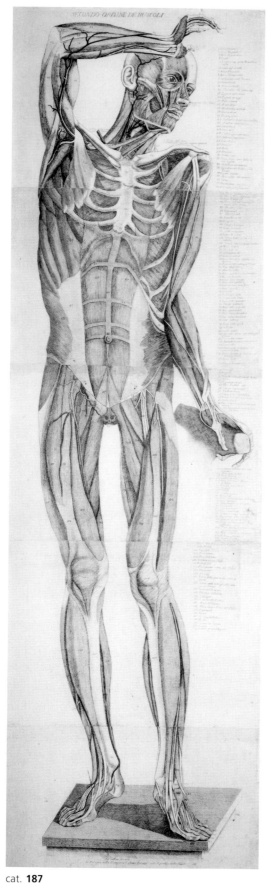

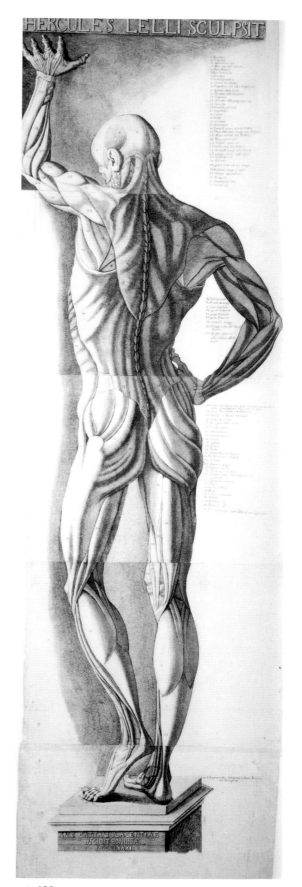

cat. **187**
Antonio Cattani after Ercole Lelli
Life size male écorché from the front, 1781
etching on five sheets

cat. **188**
Antonio Cattani after Ercole Lelli
Life size male écorché from the rear, 1781
etching on five sheets

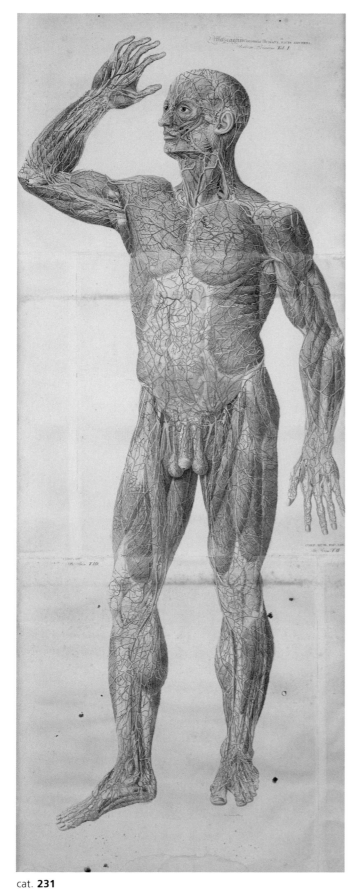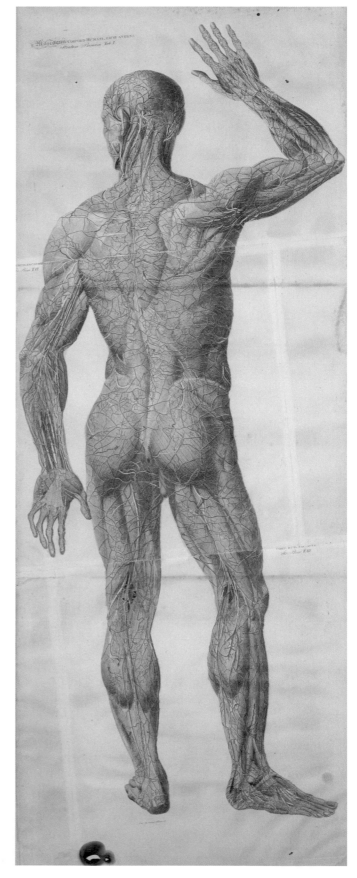

cat. **231**
Paolo Mascagni
Life-size three part dissection
3 plates showing muscles from the rear (right); *3 plates showing muscles from the front* (left)
from Paolo Mascagni *Anatomia Universa,* 1823

generally when he exhorts Jan van Rymsdyk and his other accomplished illustrators to evoke the visual quality of an individual specimen (cat. 264, p. 46).[16] This warts-and-all style was particularly characteristic of British illustration (cat. 263, p. 45). Hunter's abrupt severing of the women's legs, a standard technique in the preparation of obstetric models and other abdominal dissections, is portrayed with a raw directness that underlines the incisive real-ness of the dissection (cat. 146, p. 47).

Scale is important. Large illustrated books were prestigious and expensive, requiring a hefty investment on the part of the publisher, and substantial means on the part of the purchaser. Vesalius's *Fabrica* was a grand luxury item, way beyond the reach of average medical practitioners. The eighteenth-century picture books were not infrequently financed by subscription, and the printed lists of subscribers are more likely to be rich

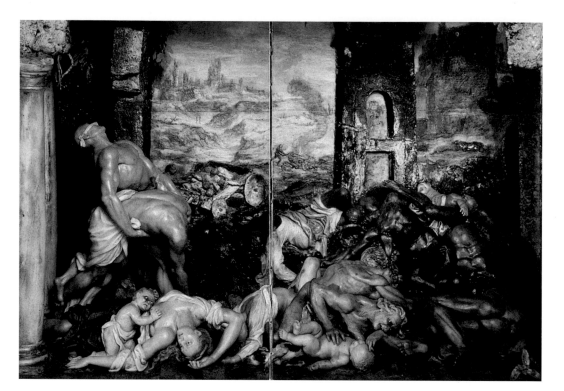

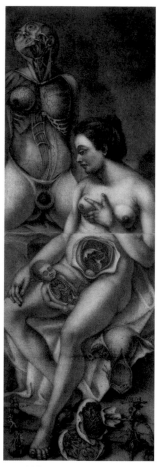

cat. **129**
Dissected Woman and Foetus
folded plate VIII from
Jacques-Fabien Gautier d'Agoty
*Anatomie des parties de
la génération de l'homme
et de la femme*, 1773

in titled nobility than in qualified doctors. William Cheselden's *Osteologia* in 1733 (cat. 75, p. 44) was a literally regal volume, dedicated to the English monarch and sold to subscribers at a pre-publication price of four guineas. It was issued in a limited English edition of 300, with a further 100 copies in Latin or French, to ensure that 'the price of the book may never sink in the possession of the subscribers'. Those grand eighteenth-century enterprises that aimed to create fully life-sized images, taking their cue from Ercole Lelli (cat. 187, p. 48), placed an even greater strain on the technology and finances of those involved in making and issuing the publications. Antonio Mascagni worked for years not only to perfect the visual quality of his huge *Anatomia Universa* (cat. 231, p. 49), with its illustrations by Antonio Serantoni in which a full-size body spans three giant volumes, but also to find a patron willing to underwrite the whole enterprise, not least the laborious hand-colouring.[17] At one point, Mascagni entertained hopes that Napoleon would support his ambitions to rule the empire of anatomical illustration.

By the eighteenth century, printed images of the body were no longer limited to black-and-white or to line engravings. One of the pioneers of three- and four-colour printing, Jacques-Fabien Gautier d'Agoty, set in train a series of colour prints of anatomy (cat. 129). Charles Nicholas Jenty in Britain was one of the most avid explorers of the new technology of mezzotint, producing a series of dramatic images that exhibited pliant textures in a rich range of tone, enhanced by hand-colouring (cat. 153, p. 50). He considered that mezzotint was 'the best means to Imitate Nature when coloured'.[18] Even when using Hunter's preferred draftsman, van Rymsdyck, the results are very different from Hunter's forensic detail.

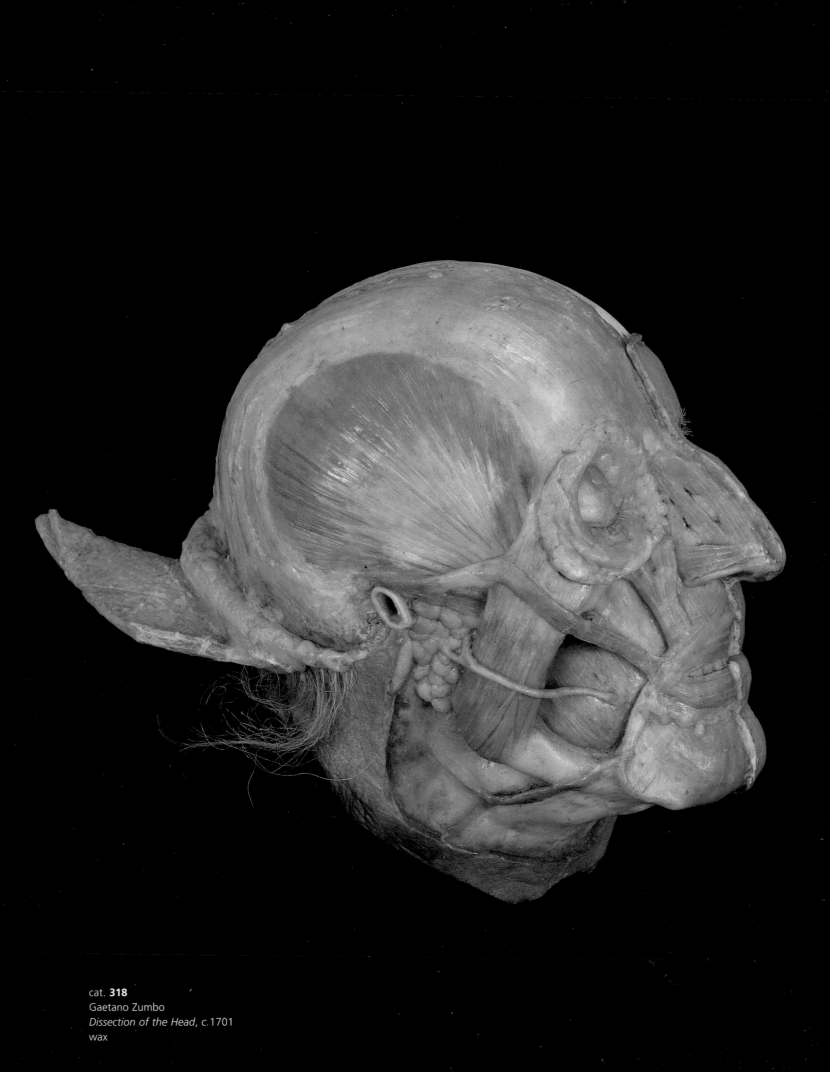

cat. **318**
Gaetano Zumbo
Dissection of the Head, c.1701
wax

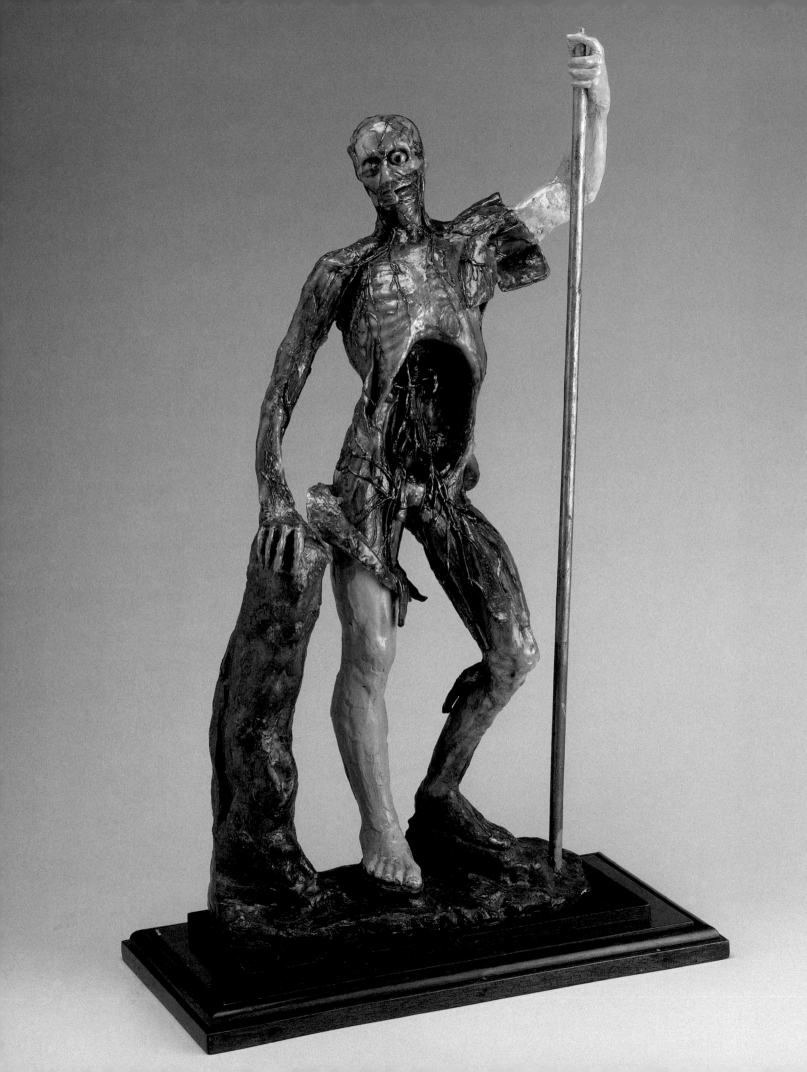

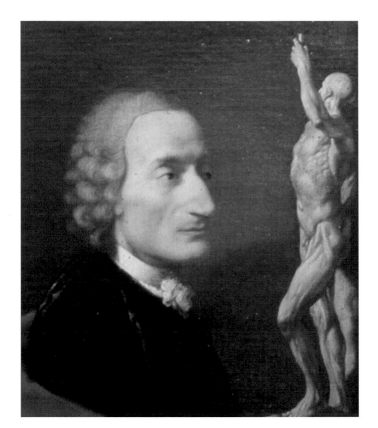

cat. **184**
Ercole Lelli
*Self Portrait with
an Écorché Statuette*, 1732
oil on canvas

fig. 7
Giovanni Manzolini and
Anna Morandi
Female face, 18th century
wax, cloth; support 36 × 35,
work 27 × 23.5
Museo di Palazzo Poggi,
Università degli Studi
di Bologna
Photo © Università di Bologna

cat. **186** (left)
Ercole Lelli or Anna Morandi
Male Anatomical Figure, 1740–80
wax

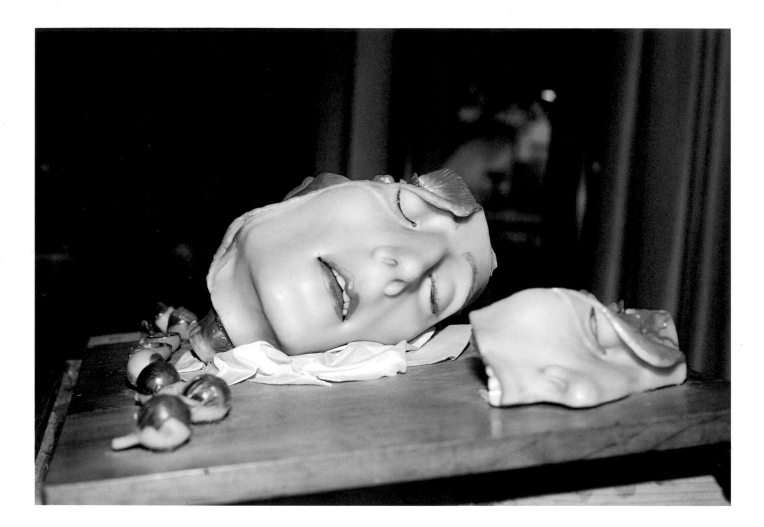

cat. **279**
Clemente Susini
Organ of sight, 1803
wax

cat. **249** (right)
André-Pierre Pinson
Anatomy of a Seated Woman,
late 18th century
wax

56

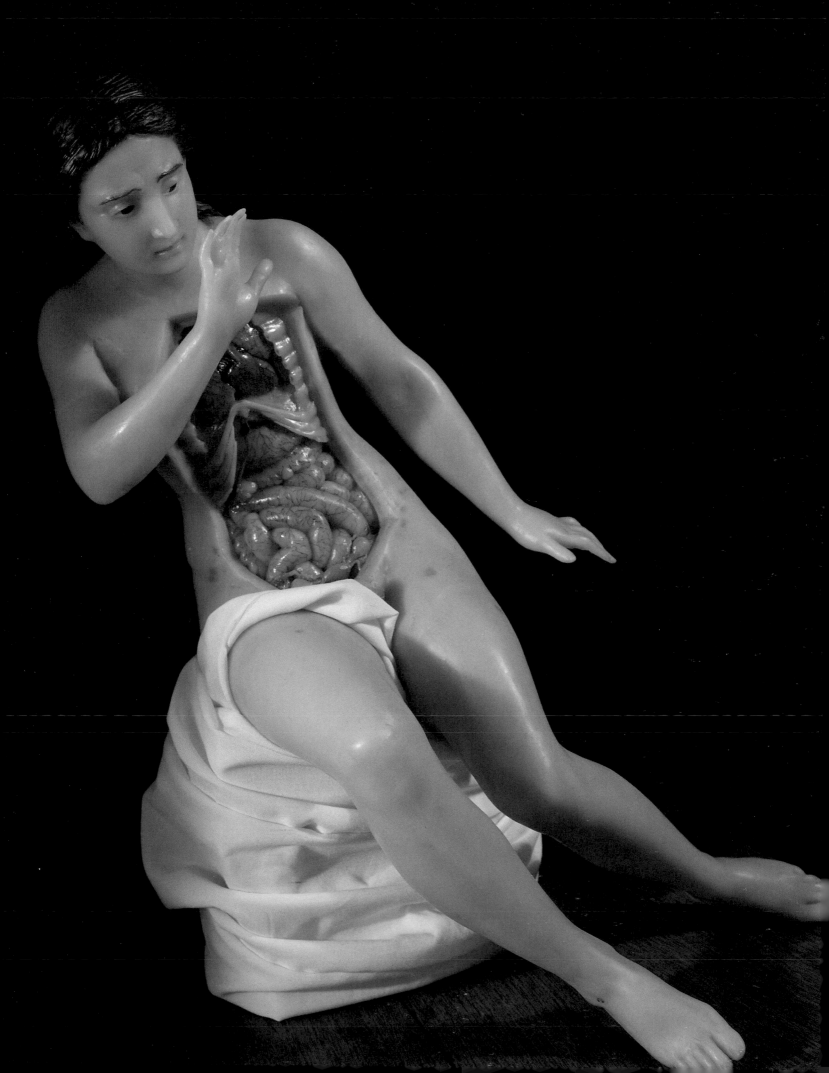

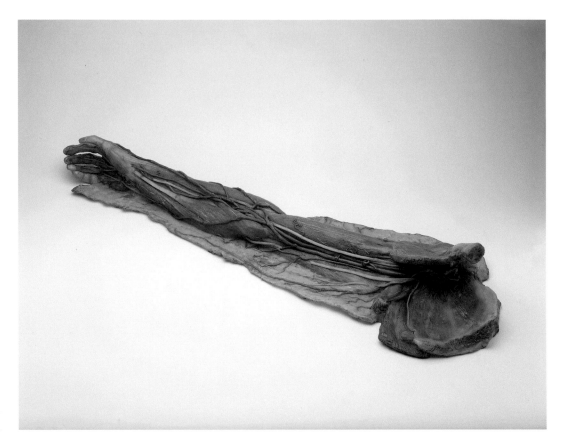

cat. **159**
Petrus Koning
Dissection of the Arm, 1817–34
wax, flax

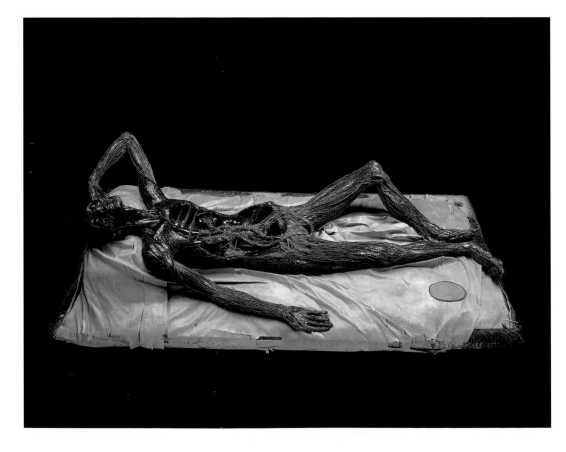

fig. 8
Clemente Susini
Reclining Male Figure,
late 18th century
wax
cat. XXVIII, 740
'La Specola' Museum of Natural
History of the University of
Florence
Photo © Saulo Bambi

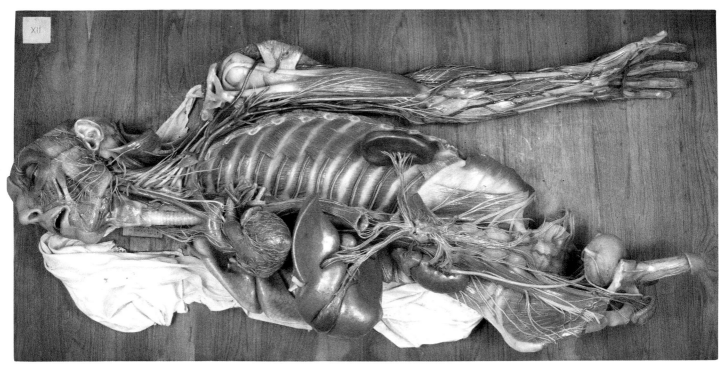

Ultimately, even the grandest and most vivid books and colour prints were trumped by the extraordinary visual force of the coloured wax anatomies, which transcended both the flatness of the page and the customarily monochrome character of standard sculptural techniques. By the late eighteenth and early nineteenth centuries, the heyday of wax-modelling across Europe, it seemed that the wondrous machine had indeed been remade in the perfection of all its parts, albeit in static form. The pioneers were the Syracusan specialist in wax sculptures, Gaetano Zumbo, who pursued a peripatetic career in Italy and Paris during the last quarter of the seventeenth century (fig. 6, p. 52 and cat. 318, p. 53), and the leading sculptor in the Bolognese Academy in the first half of the next, Ercole Lelli (cat. 184, p. 55; cat. 188, p. 48). Lelli's pupils, Anna Morandi, and her husband, Giovanni Manzolini, ensured that Bologna remained a leading centre for the production of models that appeared almost more real than the real thing itself (fig. 7, p. 55).[19] Distinctive schools of wax modelling developed in various Italian and European centres, including Naples, where the leading sculptor Antonio Citarelli produced some superb models (cat. 77, p. 51), the Netherlands where Petrus Koning was the leading modeller (cat. 159), France with Jean Honoré Fragonard and André Pierre Pinson (cat. 249, p. 57), and London with Joseph Towne.[20] The lively hues and fresh sheen of the waxen organs somehow seemed truer to the colourful vitality that we expect to find within ourselves than the dull grey-brown confusion that dominates the appearance of an actual dissection of a corpse.

This death-defying vitality was made even more manifest by openly theatrical poses. As in the great picture-books, the figures often appear to be conscious, compliant and

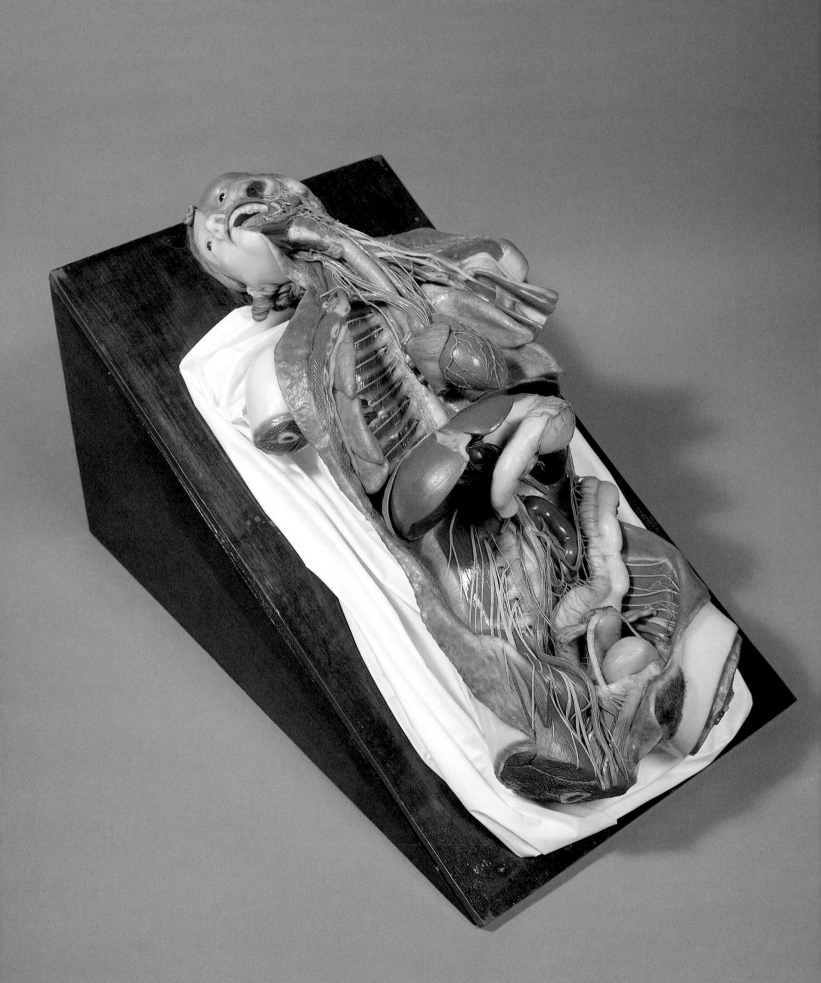

cat. **69**
F. Calenzuoli
Female Reclining Figure, 1831
wax

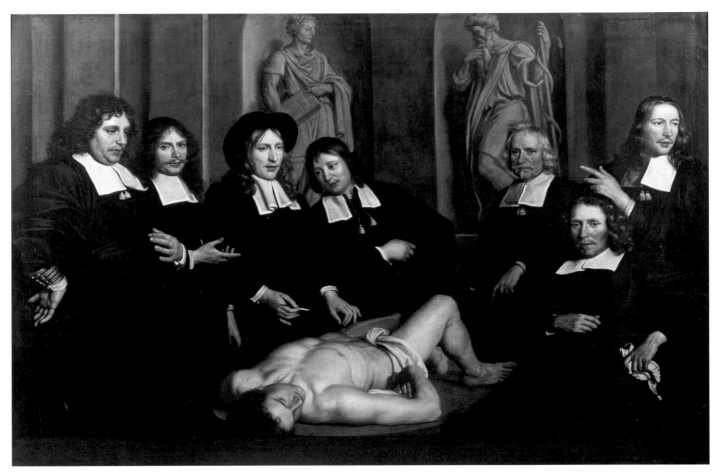

fig. 9
Adriaen Backer
*The Anatomy Lesson of
Dr Frederik Ruysch*, 1670
oil on canvas; 168 × 244
inv. SA SA 2000
Amsterdams Historisch Museum

even active participants in the great human quest to 'know thyself'. The vocabulary of form and gesture, particularly in the canonical series produced in Florence during the late eighteenth century in the workshop of 'La Specola', is that of Baroque saints, martyred to serve a higher purpose than merely living. In the dramatic images by Clemente Susini, who became the leading modeller under the medical direction of Felice Fontana, a disembowelled women lies back on her silken sheet in the attitude of expiring ecstasy as she goes to meet the 'maker' of such a divine contraption (fig. 4, p. 32), while a man displays the wonders of his internal plumbing in the heroic pose of a dying warrior or ancient river god, a noble player departing the stage of life (fig. 8, p. 58).[21] Susini's later set, produced for Cagliari (cat. 281, p. 59), and the works sent to Turin by his leading successor, Francesco Calenzuoli (cat. 69), use less overtly theatrical devices, but still vividly deprive death of its inert pallor.[22]

The spiritual reveries of the more theatrical waxes seem strange to us today, just as we find it difficult to see past the incongruity of Frederik Ruysch's preparations of

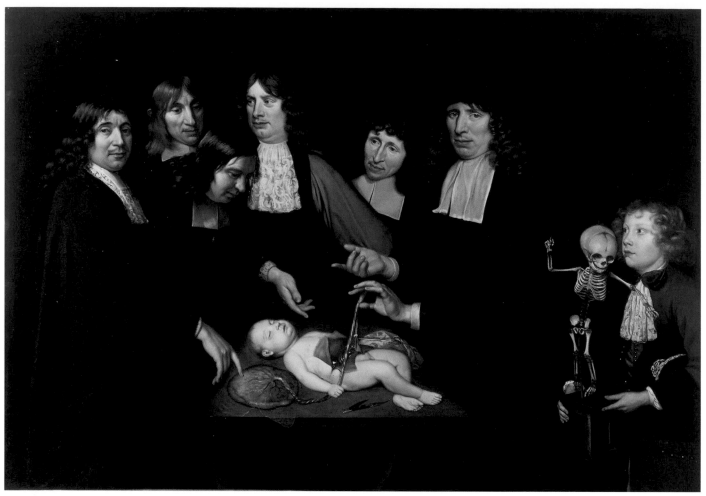

cat. **238**
Jan van Neck
*Anatomy Lesson of Dr. Frederik
Ruysch*, 1683
oil on canvas

'babes in bottles' (cat. 8) in order to grasp their purpose. The wholes and parts of his
foetuses and infants were seen as having been endowed by the great doctor with a kind
of immortality, cheating rigor mortis and even long-term decomposition. As a poem
printed in his *Thesaurus* tells us,

> Through thy art, O Ruysch,
> a dead infant lives and teaches
> and, though speechless, still speaks.
> Even death itself is afraid.[23]

During his long incumbency as *Praelector* in Amsterdam from 1667 to 1731, Ruysch
was portrayed twice in the famous series of 'Anatomy Lessons': firstly by Adriaen
Backer in 1670, with a virtually undissected body of an unrealistically beautiful youth
(fig. 9, p. 61); and then in 1683 in Jan van Neck's painting, where he demonstrates an
abdominal dissection of an infant with umbilical cord and placenta, accompanied by his
son, who holds one of Frederik's mounted skeletons of a baby (cat. 238). A famed pioneer

of techniques of injection and embalming, and collector of curious natural things, Ruysch's preparations of infants played a prominent role in the complex cabinet of curiosities he assembled in his fine city residence. Ruysch's 'museum' became a renowned visitor-attraction in late seventeenth-century Amsterdam, before it was expensively purchased in its entirety by Peter the Great for his new city of St Petersburg in 1717 (cat. 260).

Three-dimensional preparations and models possessed enormous advantage over two-dimensional images in anatomical demonstrations. To obtain a grasp (in both the metaphorical and literal sense) of the structure of the human body, it was necessary not just to obtain a recognizable picture of what was presented to the eyes at a particular stage in dissection but also to acquire a fully plastic sense of the all-round shape of the organs and how they fit together as a complex spatial puzzle when they are packed within the confines of the body. Such spatial knowledge was particularly important in obstetrics, since a knowledge of the disposition of the foetus is crucial in aiding a successful delivery. Rich series of sculptures of the gravid uterus – occasioned by the 'man-midwives' of the eighteenth century – exist in all the various media of presentation and modelling, including prepared specimens (cat. 8), wax, pigmented plaster (cat. 144, p. 65) and

cat. **260**
Jars with fish and hands
folded plate VII from
Frederik Ruysch
Thesaurus animalium primus,
1744

cat. **8**
Anon
Foetus with beads, 18th century
human preparation
in glass jar

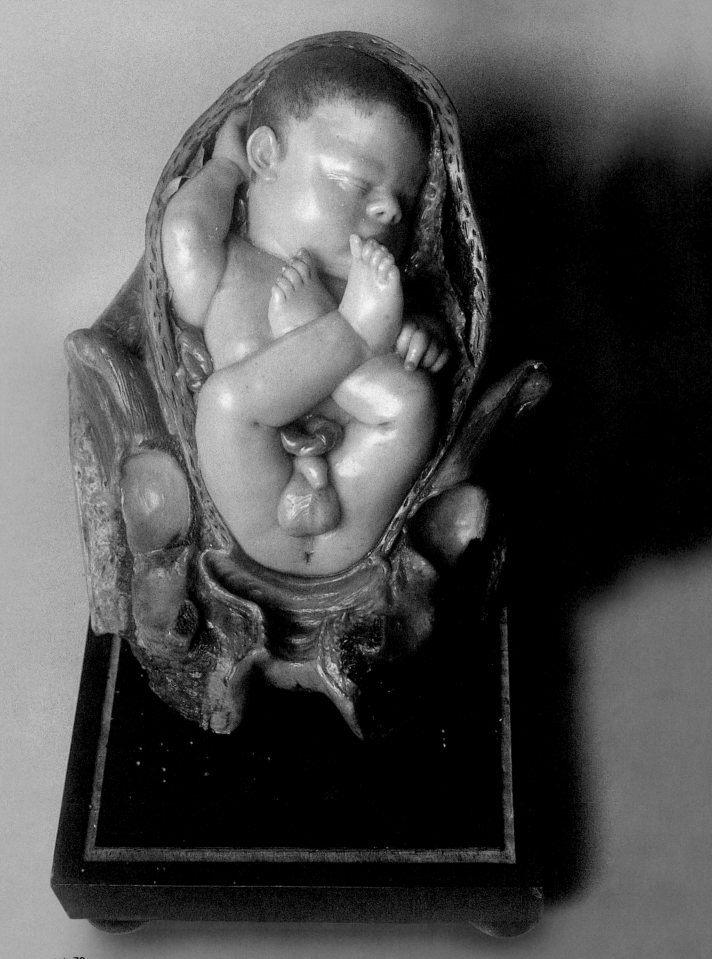

cat. **78**
Antonio Citarelli
Foetus in utero (breech birth), c.1850
wax

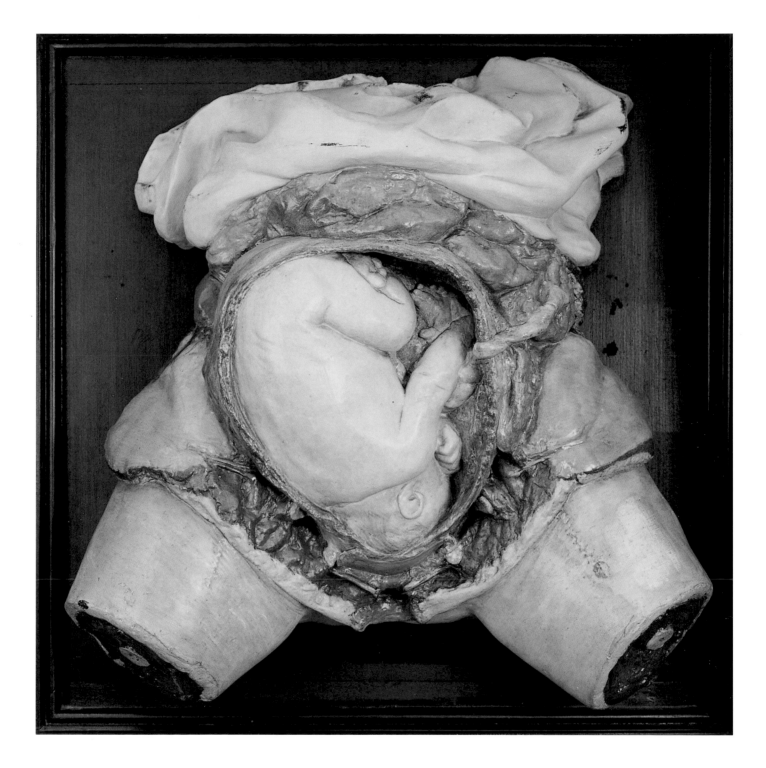

cat. **144**
William Hunter
The child in the womb in its natural situation, c.1770
coloured plaster

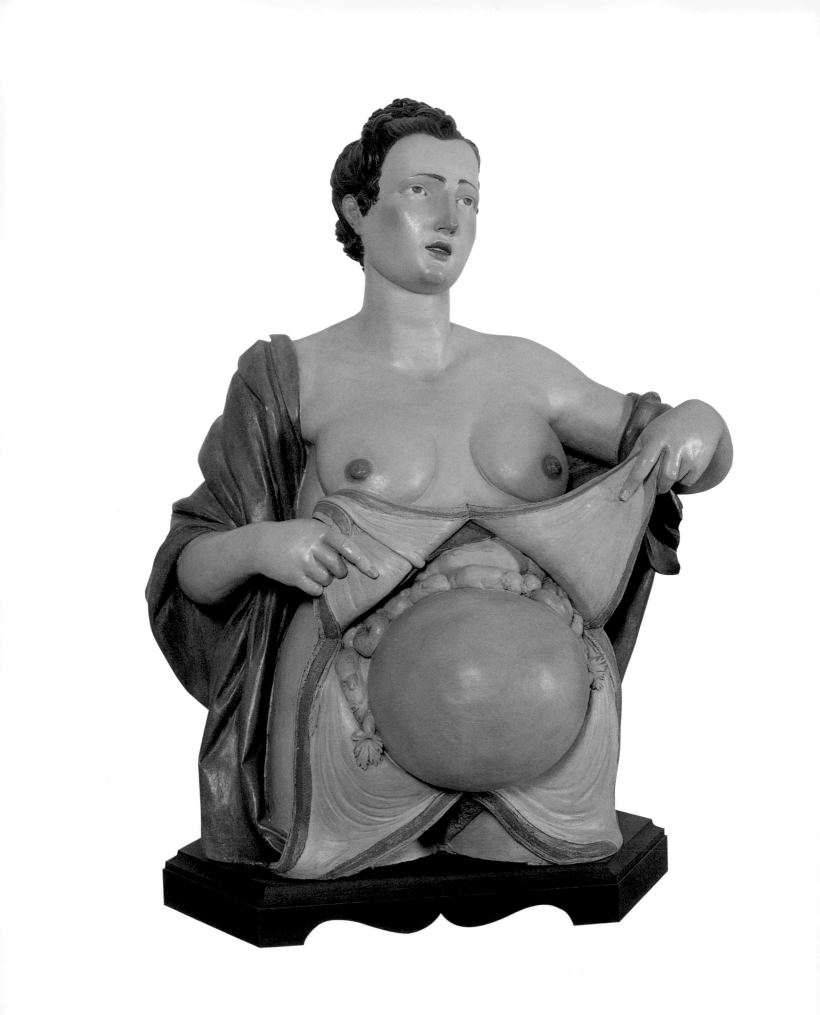

coloured ceramic. None are more engaging than the little-known set of ceramic sculptures made by the Bolognese sculptor Giovan Battista Manfredini for the anatomist and obstetrician, Francesco Febbrari, in Modena between 1773 and 1776 (cat. 227).[24] It was in this specialist area of childbearing that the anatomizing of women had traditionally concentrated. Most of the criminals available for dissection were male, and the woman's less canonical body became a necessary subject of special attention only when it did what a man's body could not.

Amongst the most attractive but functionally puzzling models in obstetrics are the miniature ivory (or occasionally marble) figurines of pregnant women that survive in some numbers (cat. 4). They would have been of little direct use in detailed instruction, but may have been used by obstetric specialists and more socially elevated midwives to provide elegant reassurance for those about to embark on childbirth. Such miniature models were also made of male anatomies, though apparently in smaller numbers, to

cat. **4**
Anon
Ivory Anatomical Figure
a Pregnant Female, with some
Removable Parts, Lying on
Cloth-Covered Bier, in Wooden
Box, c.17th century
ivory, wood and cloth

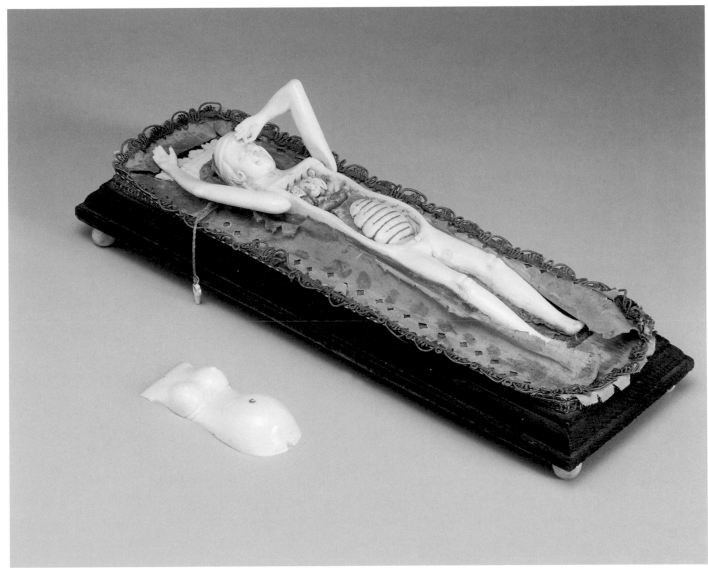

cat. **227**
Giovan-Battista Manfredini
Female bust with open abdomen, 1773–76
terracotta

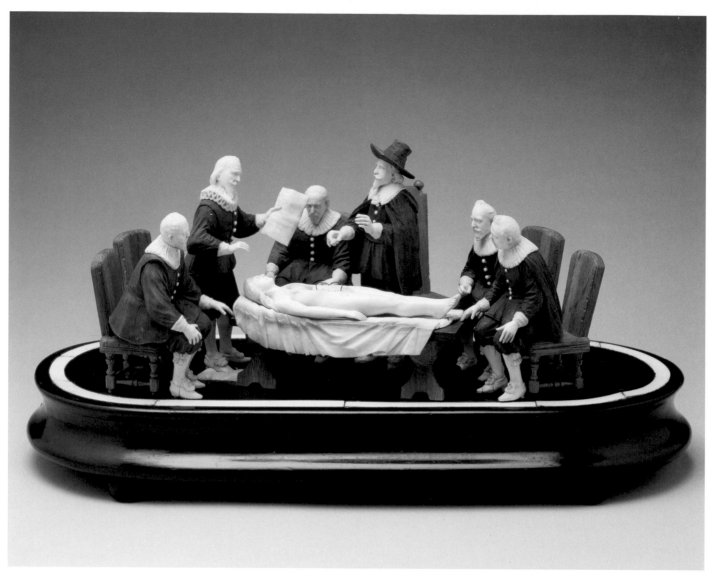

cat. **9**
Anon
*Wood and Ivory Figure Group
representing an Anatomical
Demonstration by Dr Tulp,*
18th century
based on Rembrandt's painting
*The Anatomy Lesson of
Dr Nicolaes Tulp,* 1632

demonstrate the internal organs on a schematic basis. One ivory of a woman was picturesquely set in the eighteenth century into a miniature tableau based loosely on Rembrandt's painting, *The Anatomy Lesson of Dr Nicolaes Tulp* (cat. 9). Whatever the origin of such images, they were obviously intended to function at the cultural interface between medical professionals and those on the receiving end of their ministrations.

Perhaps the most alien feature of the historical images to eyes accustomed to the apparent neutrality of modern scientific illustration is that they should exhibit so much seemingly irrelevant style and so many redundant details. Yet the stylishness and the rhetoric of presentation were absolutely integral parts of the images if they were to function effectively within their given contexts of communication. They were not simply instructional diagrams for the doctor-technician, but statements about the nature of the human being as made by God in the context of the created world as a whole. They were about the nature of life and death, and even the meanest criminal, punished by dissection, provided a means towards the profoundest understanding of the machine that had been designed to serve our soul during its sojourn on earth.

3. Artists and Academies

The earliest text that lays out the specifications for the new kind of 'learned' artist in the Renaissance, Leon Battista Alberti's *On Painting* (in Latin in 1435 and Italian a year later), already sets down the basic agenda for the anatomically-minded draftsman:

> First... sketch in the bones, for, as they bend very little indeed, they always occupy a determined position. Then add the sinews and muscles, and finally clothe the bones and the muscles with the flesh and skin. But... there will perhaps be some who will raise an objection,... namely that the painter is not concerned with things that are not visible. They would be right to do so except that, just as for a clothed figure we first have to draw a naked body beneath and then cover it with clothes, so in painting a nude, the bones and muscles must be arranged first, and then covered with appropriate flesh in such a way that it is not difficult to perceive the positions of the muscles.[25]

In his later treatise, *On Statuary*, Alberti draws an analogy with a constructor of boats:

> Who would dare to claim to be a shipbuilder, if he did not know how many parts there are in a ship, how one ship differs from another, and how the parts of any construction fit together?[26]

In a similar vein, Lorenzo Ghiberti, a practising Florentine sculptor of great renown, recommended in his *Commentaries* that 'anatomy must be witnessed, so that the sculptor may know how many bones are in the human body when he wishes to compose the statue of a man, and know the muscles that are in the human body, and similarly all the nerves and tendons in it'.[27] In his final, incomplete commentary, Ghiberti draws information about the human skeleton from the *Canon* by the Islamic medical author, Avicenna. This emphasis upon the skeletal armature for the structure and correct proportioning of the human body became a recurrent theme. When the mid-sixteenth-century sculptor, Benvenuto Cellini, laid down the foundations of *disegno* in his treatise *On the Principles and the Method of Learning the Art of Design*, he stressed the necessity of obtaining correct knowledge of the bony components of the bodily machine.

In company with the optical sciences of perspective, light and colour, anatomical mastery of the structure and motion of the human body formed the basis of the Renaissance artists' and theorists' claims that the visual arts possessed their own basis in *scienza*; that is to say, in a recognized body of systematic knowledge which was akin to other disciplines of high intellectual standing. An important aspect of this *scienza* was that it should be capable of being taught in terms of its principles. The traditional disciplines of craft training were to be given a foundation in theories of general applicability.

As with so many high-minded pedagogic injunctions, the requirement to learn anatomy in a detailed manner was probably more often honoured in the breach than the observance, but by the time that Leonardo was trained in the studio of Andrea Verrocchio in the

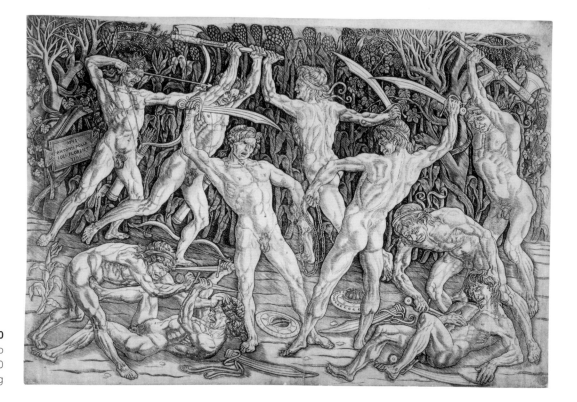

1470s no truly ambitious artist could claim to be depicting the human body according to the highest canons of expressive beauty without being able to mount a convincing display of musculature. Most overtly demonstrative was the sculptor-painter Antonio Pollaiuolo. His famous engraving, the *Battle of the Nudes* (cat. 250) was clearly made as a testament to his poised mastery of male anatomy in the manner of the 'ancients'. Whatever the actual subject-matter of Pollaiuolo's battle, the engraving bids fair to be the first 'academy study' – designed for display and teaching – as well as courting the admiration of those connoisseurs who really knew what to value in *all'antica* stylishness.[28]

At first sight, Leonardo's unrivalled anatomical explorations might seem to be a natural extension of what had become *de rigueur* in Florentine art, but as in all areas of his visual sciences he immediately extended his reach into a total understanding of the very nature of things. Thus, when he looked at the skull (cat. 189, p. 72), which was of obvious relevance for the depicting of heads in paintings, he devoted sustained attention to the location of those faculties within the brain that processed sensory input and achieved coherent perception, those that endow us with intellect and imagination, those that store memories, and those responsible for transmitting the commands of voluntary and involuntary motion. The form of localization he adopted was based on the mediaeval theory that the ventricles of the brain acted as processing chambers (cat. 190, p. 32). According to Leonardo's way of thinking, if a painter was to characterize the outer manifestations of what he called *il concetto dell'anima* (the intentions of the mind) in a great narrative painting, like the *Last Supper*, it was necessary to understand at the deepest level the inner causes of outer effects. To re-create the configurations adopted

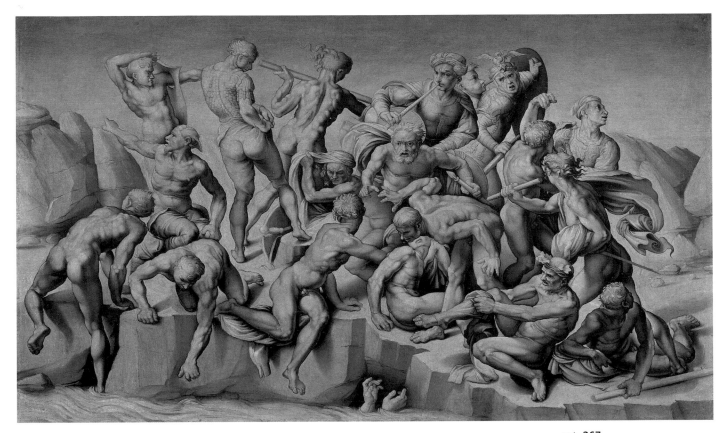

cat. **267**
Aristotele da Sangallo
Battle of Cascina (after Michelangelo), 1504–06
oil on panel

by the bodies and faces of the protagonists, it was necessary to track the ebb and flow of sensation and emotion to the innermost impulses of the characters in dramatic situations. He was aspiring, to paraphrase the great eighteenth-century polymath, Albrecht von Haller, to show how physiology was enacted anatomy and anatomy was structural physiology.

If few were to go as far and as deep as Leonardo, most leading figures in the following generation of central Italian artists sought knowledge of at least the skeletal structures and the major muscle groups through the study of flayed corpses or suitable representations. The examples of Leonardo and Michelangelo reigned supreme, not least their incomplete and now lost military histories, the *Battle of Anghiari* by Leonardo and the *Battle of Cascina* by his great rival Michelangelo (cat. 267), planned in the first decade of the sixteenth century for the Council Hall of the Florentine Republic. Jacopo Pontormo (cat. 72), his pupil, Agnolo Bronzino (cat. 66, p. 73) and Bronzino's pupil, Alessandro Allori (cat. 36, p. 72), represent a typical succession of anatomically-minded artists in sixteenth-century Florence.[29] By the middle of the century, no serious Florentine painter of the human figure would have wished to leave the spectator in doubt that he knew what was what in the structure and motion of the human body. Indeed, it was exactly this climate of self-conscious knowingness that accounts for the foundation of the first ever official Academy of Design in the city in 1563 under the patronage of Grand-Duke Cosimo I de' Medici. The moving spirit was Giorgio Vasari, painter,

cat. **72**
Jacopo Carrucci, il Pontormo
Studies of the Bones of the Shoulders and Arms,
16th century
red chalk on paper

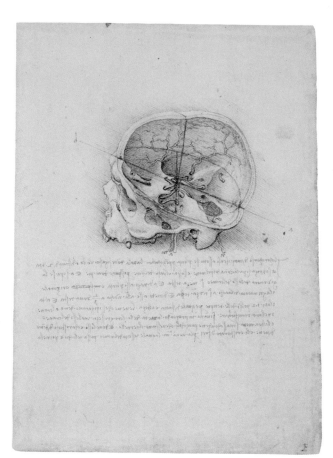

architect, author and courtly impresario of visual things, whose own voluminous writings leave us in no doubt about the elevated character of figure drawing. 'Design', in the Italian sense of *disegno*, referred to the mastery of those visual principles that governed the proportional and decorous portrayal of nature according to the highest kinds of imitation, above all the human body. These principles manifested what the Roman painter and academician, Federigo Zuccaro, punningly called the sign, '*segno*' of god '*di[o]*' in us, and were applicable universally to all those works of human artifice – painting, sculpture, architecture, engineering, town planning, and applied arts – which depended on the foundational skill of educated draftsmanship.[30]

Specific provision was made in Vasari's Accademia del Disegno for anatomical instruction, through the staging of demonstrations at the Hospital of S. Maria Novella.[31] The supreme artistic exemplar for the academicians was Michelangelo, whose early biographers had recorded his extensive dissections of human and animal corpses. Ascanio Conivi, writing his 'official' biography in 1553, tells how

Messer Realdo Colombo, a very superior anatomist and surgeon and a particular friend of Michelangelo's and mine, … sent him… the corpse of a moor, a very handsome young man…; and it was placed in S. Agata where I was and still am living, because of its being a remote

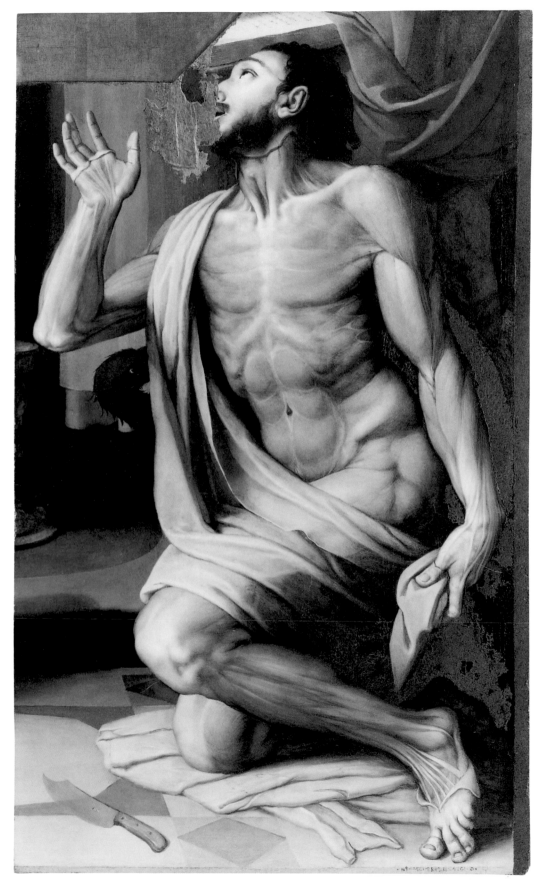

cat. **66**
Agnolo Bronzino
St Bartholomew, 1555
oil on wood panel

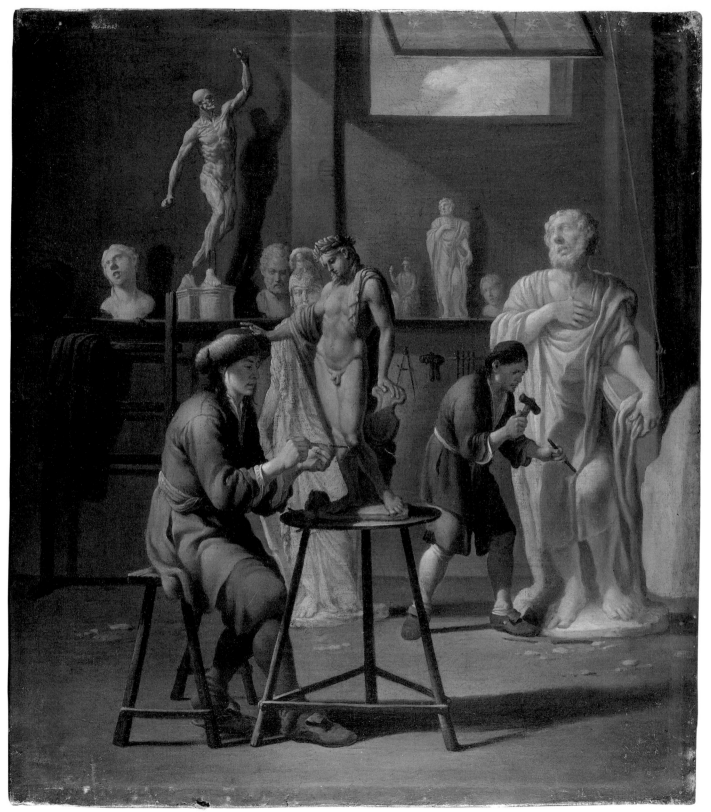

cat. **283**
Michael Sweerts
Interior of a Sculptor's Studio, c.1655
oil on canvas

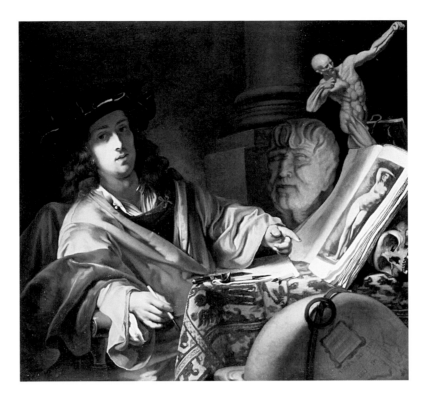

cat. **158**
Godfrey Kneller
*Self Portrait with
Écorché Statuette,*
c.1670
oil on canvas

place. On this corpse, Michelangelo showed me many rare and recondite things, perhaps never before understood.[32]

In the light of the emphasis accorded to such knowledge in the mid-sixteenth century, it became almost axiomatic from the mid-sixteenth century for illustrations of learned artists' studios and of private or public 'academies' (whether largely conceptualized or relatively realistic) to include prominent representations of models for the study of anatomy (cats. 158 and 283).

None of the Italian and later European academies that followed in succession over the centuries ignored anatomy as a key element in their curriculum for the young artist, and specialist Professors of Anatomy were generally appointed from the medical world. It was an ambition that was still very much alive in academies well into the twentieth century (cat. 265, pp. 76–77). If bodies were not readily available for direct dissection, the great picture books stood in as surrogates. Even better were the three-dimensional models of flayed figures (*écorchés*) (cat. 76, p. 78; cat. 110, p. 79) which were produced in much the same spirit as Pollaiuolo's engravings (cat. 250, p. 70).[33] Attributing models made for such purposes is never easy, but it seems that the extravagantly contorted kneeling figure traditionally attributed to Michelangelo (cat. 285, p. 80) and the highly accomplished *écorché* of a man apparently toppling backwards (cat. 284, p. 81) can best be identified as works by the Flemish sculptor Willem van Tetrode (called Guglielmo Fiammingo) during his years in Italy, *c.*1548–*c.*1567, when he worked with Cellini and other leading sculptors in Florence and Rome. Such *dimostrazioni* of anatomical mastery,

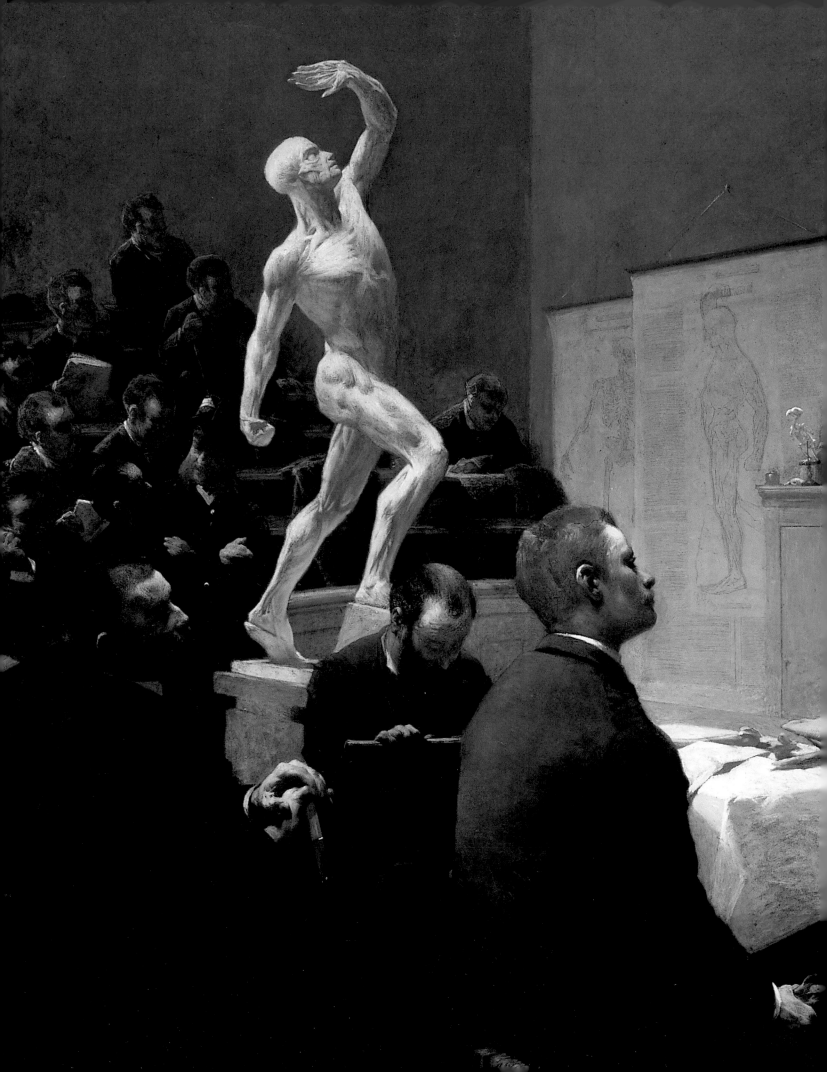

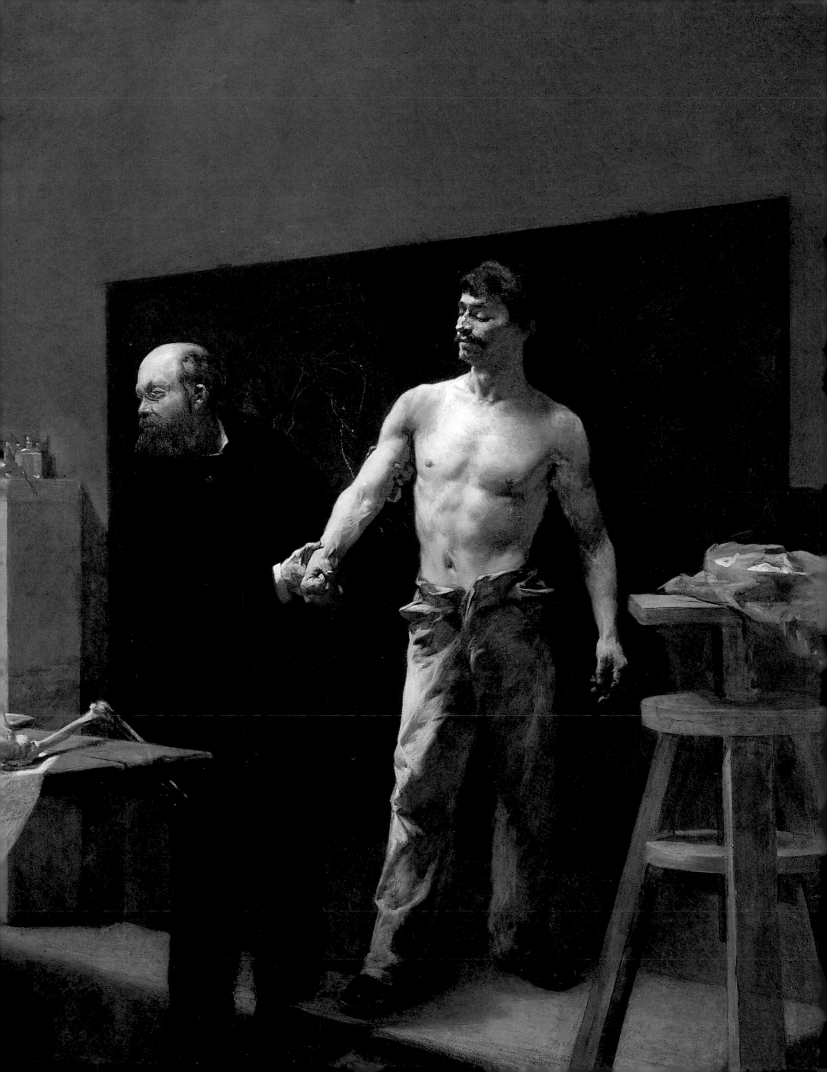

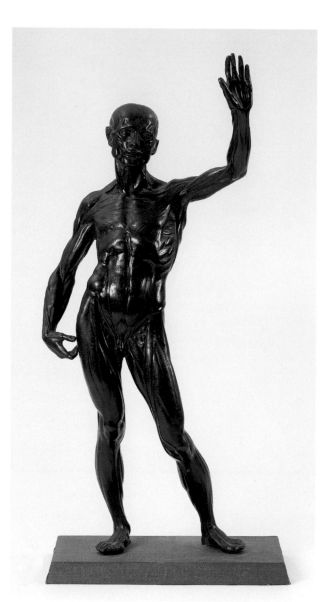

often produced in numerous versions and later variants (cat. 135, p. 80), were widely studied by draftsmen who wished to acquire or fine-tune their mastery of the human figure in complex poses (cat. 59, p. 81).

The *écorchés* of the normative male body, paraded as an exemplar of heroic perfection, became a genre in its own right, occasionally under the guise of a flayed St Bartholomew, but more commonly as a highly accomplished table-top bronze or refined wood carving to be admired as a display piece without an ostensible subject. The bronzes were undoubtedly collector's items, valued for their visual qualities in a way that transcended their didactic origins.

The greatest flowering of the *écorchés* occurred in the eighteenth-century academies across Europe. Edme Bouchardon and Antoine Houdon, in Paris (cat. 141, p. 82), and Johann Martin Fischer, in Vienna, created superb full-scale statues which stand as major

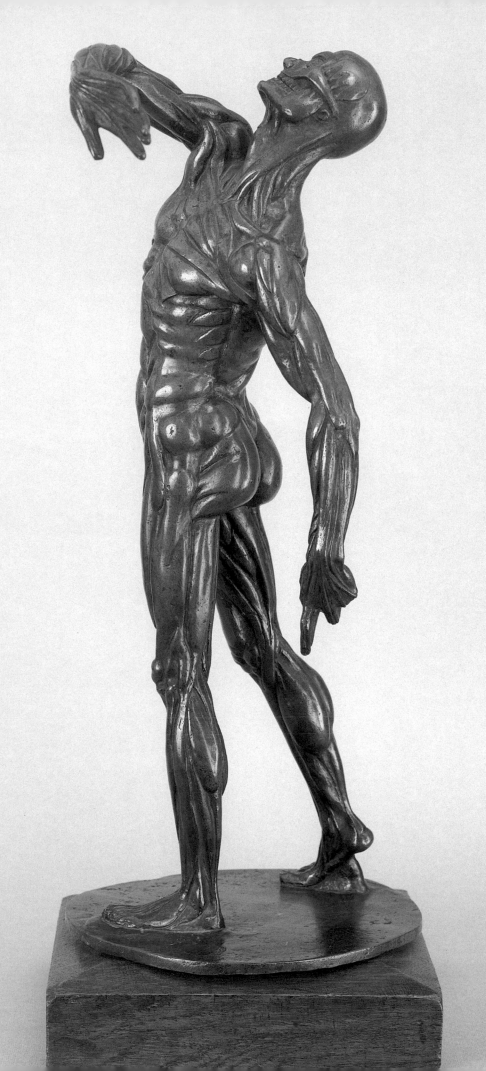

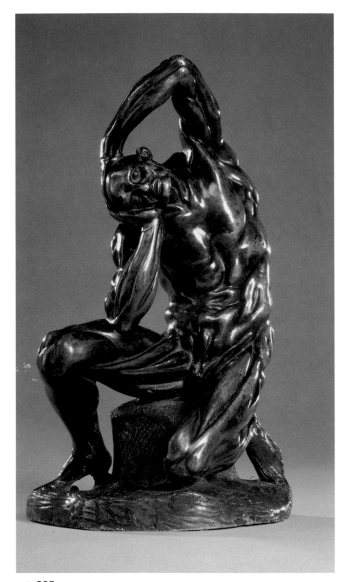

cat. **285**
Willem van Tetrode
Écorché Statuette of a Crouching Man, c.1560
bronze

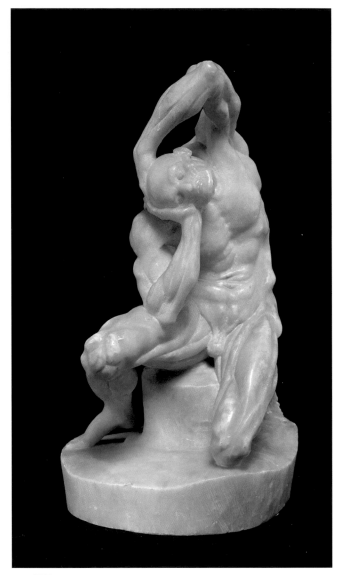

cat. **135**
John Hogan
Écorché Statuette of a Crouching Man, 1820–23
alabaster

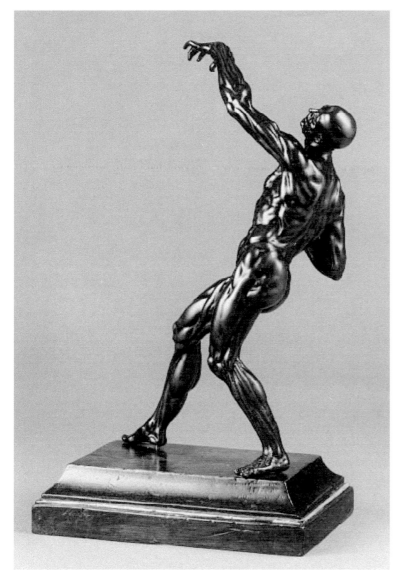

cat. **284**
Willem van Tetrode
Écorché Statuette of a 'Horse Trainer', c.1560
bronze

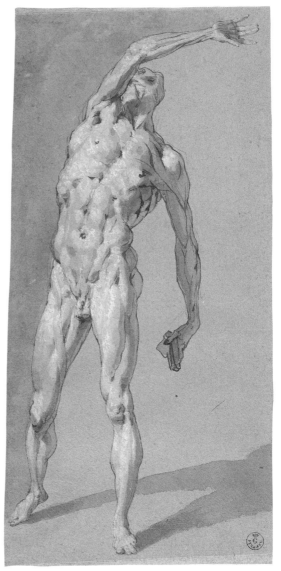

cat. **59**
Andrea Boscoli (school of)
Drawing of an Écorché Statuette,
17th century
brown ink with brown and white gouache
and black pencil on paper

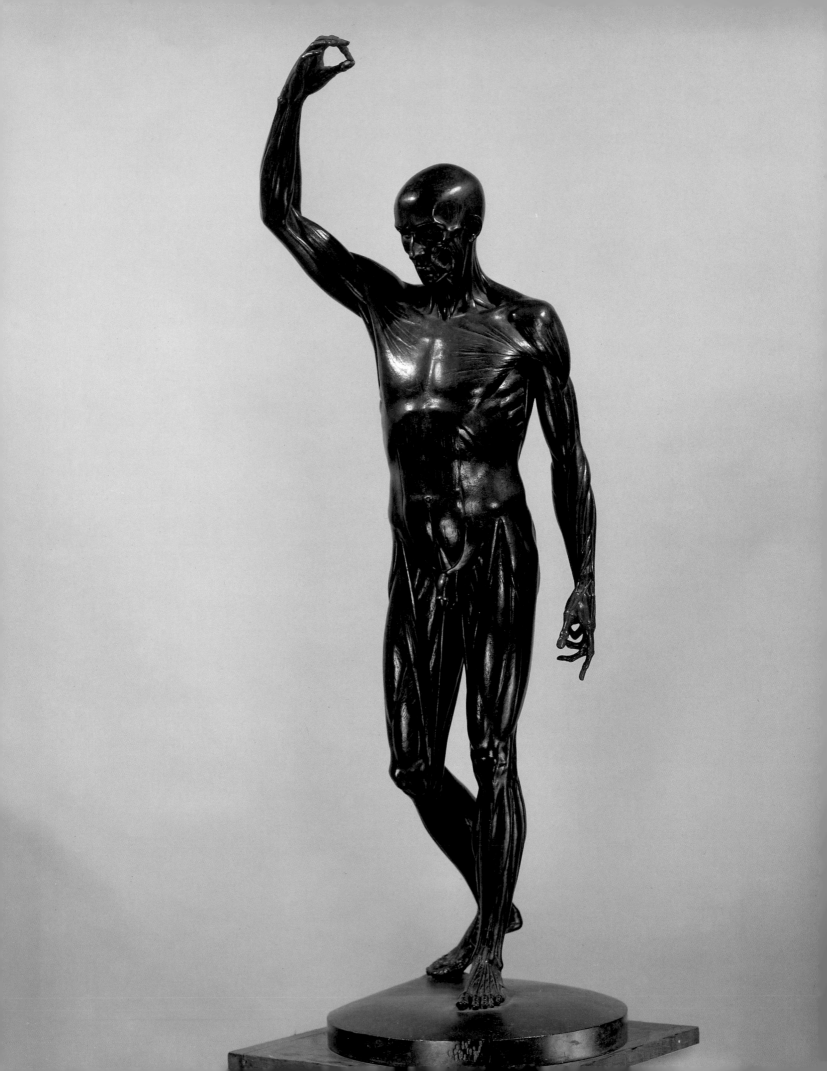

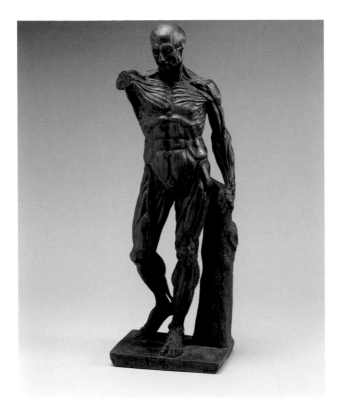

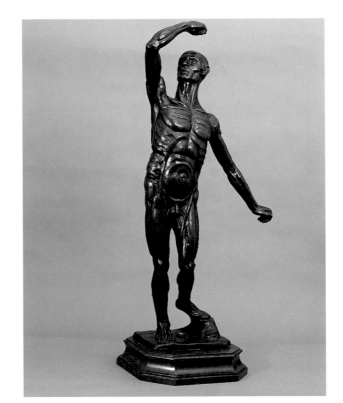

cat. **13**
Anon
*Écorché of Standing Man
(in the pose of William Hunter's
Life Cast for the Royal Academy),*
c.1770
bronze

cat. **11** (top left)
Anon
*Carved Wooden Male
Anatomical Figure Showing
Muscular and Arterial
System, Right Arm Missing,*
1731–70
wood

sculptural achievements in any context. The leading eighteenth-century *écorchés* became widely diffused through versions in plaster and print. The Houdon figure, either in complete casts or in sectioned parts, retains a presence in many academies across the world, including that of St Petersburg in Russia. It was widely drawn by young painters and provided the source for impressive sculptural variants (cat. 11). Probably the most remarkable series was created for the Royal Academy in London, founded somewhat belatedly in 1768. The moving spirit was the Academy's first Professor of Anatomy, Dr William Hunter, obstetrician to Queen Charlotte and an avid collector of artefacts from the human and natural worlds. To complement his required lectures at the Academy, he produced a cast of a flayed criminal, brought fresh from the gallows at Tyburn.[34] This particular model actually pre-dated the Academy's foundation, having been made for the lectures that Hunter had earlier delivered to the Incorporated Society of Painters. This key plaster figure has not survived, but it is represented in images of academicians and their activities within the rooms of the Academy (cat. 317, p. 85). It was also much drawn by students, including the young J.M.W. Turner. A reduced bronze version was designed by the Danish sculptor, Michael Henry Spang, and features as an exemplary object in more than one portrait (cat. 12, p. 84). The statuette of the Hunter *écorchés* became very popular and bronze versions of varied quality survive in some numbers, including one apparently unique cast at mid-scale which generalizes the anatomy in such a way that it openly serves as a heroic statue rather than primarily as an anatomical demonstration piece (cat. 13).

cat. **141**
Jean-Antoine Houdon
Écorché of a Standing Man, 1792
bronze

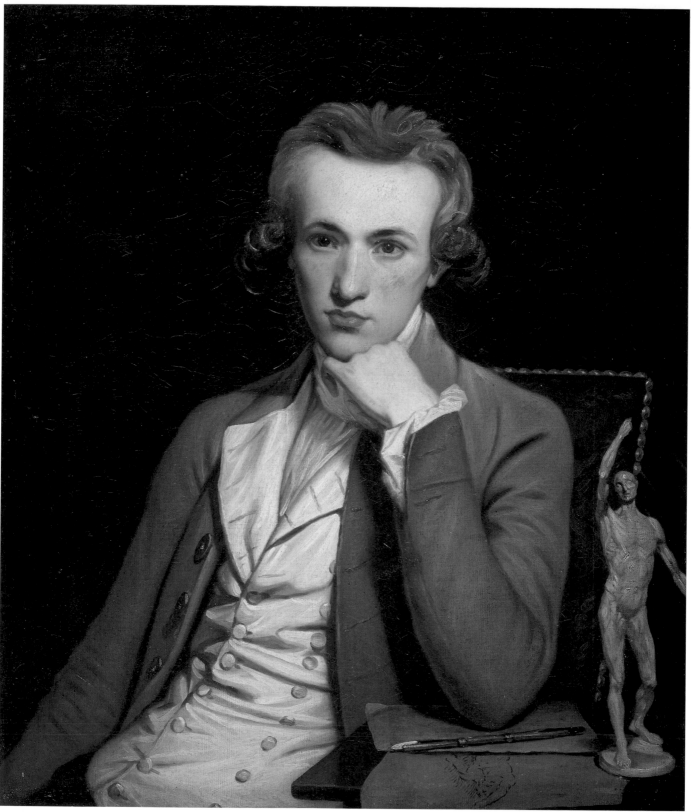

cat. **12**
Anon
Portrait of a Draftsman with an Écorché Statuette, c.1761–70
oil on canvas

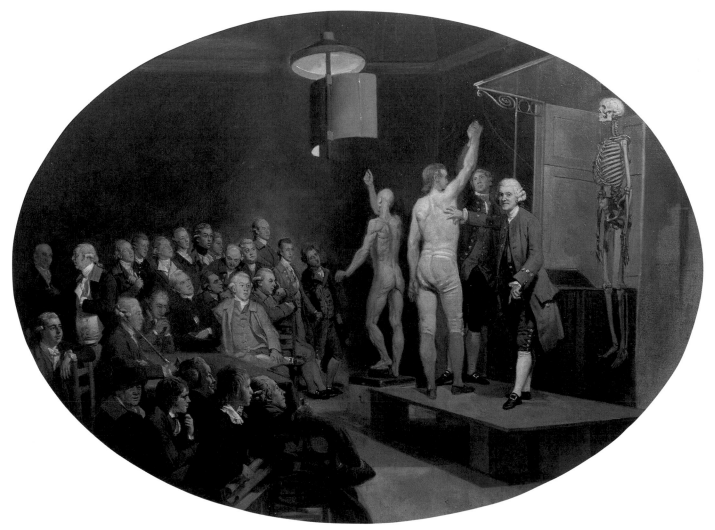

In the Life School of the present Academy Schools, a damaged plaster of a figure anatomized to two different levels also appears to originate from Hunter's era, and may have been cast from a Jewish thief he dissected in 1771.[35] Most accomplished of the Academy's surviving casts (and best preserved) is the picturesquely named 'Smugglerius', so called because the sculptor Agostino Carlini arranged with Hunter in 1775 for the flayed corpse of a remarkably muscular smuggler to be set in the pose of the famous Roman statue of the *Dying Gaul*. This famous piece, which no doubt deteriorated like all much-used plasters, was sufficiently prized to be re-cast for the Academy by William Pink in 1834 (cat. 247, p. 87). Much copied by generations of students at the Academy (cat. 199, p. 88), it perfectly embodies the triple themes of naturalism, science and classicizing aesthetics that run through the works of major figure artists in the academic tradition (cat. 266, p. 89). Even more 'theatrical' than the cast smuggler is an *écorché* version of the *Crucified Christ* (cat. 41, p. 86), made in 1800 from the body of a murderer by Thomas Banks, in collaboration with the anatomist Joseph Constantine Carpue. The initiators of this extraordinary project were Banks himself, Benjamin West,

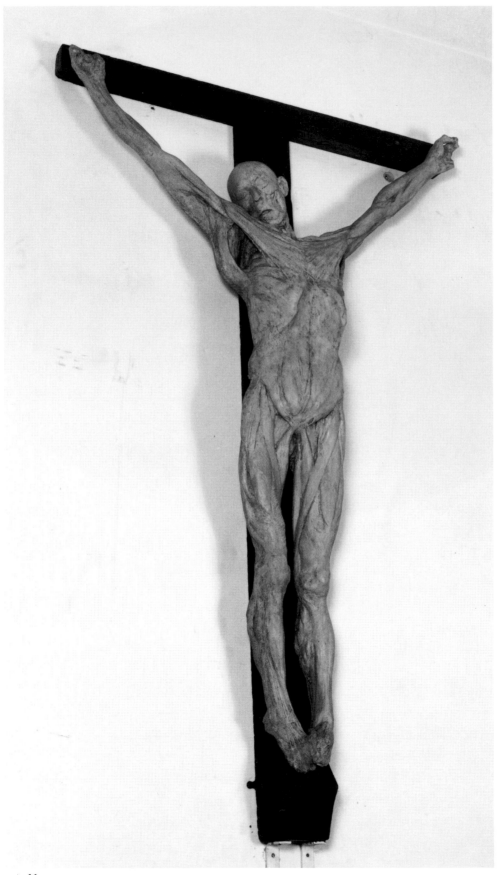

cat. **41**
Thomas Banks
Anatomical Crucifixion, 1801
plaster cast on wooden cross

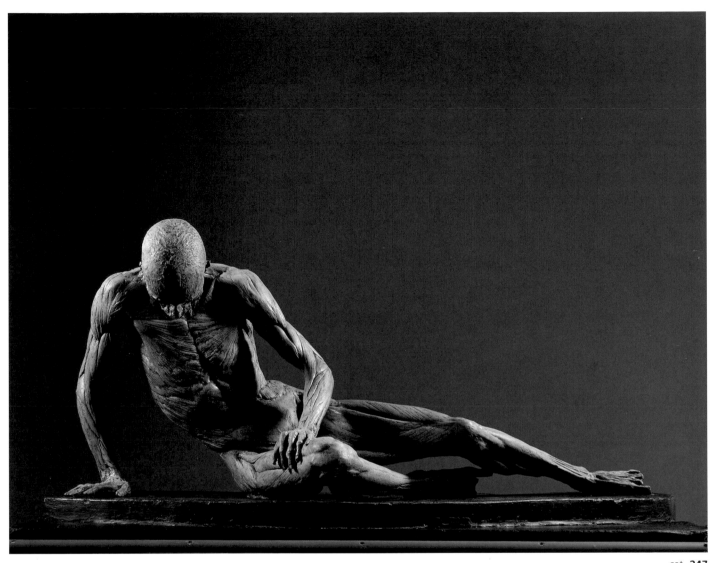

cat. **247**
William Pink after Carlini for
William Hunter
*Smugglerius, (Écorché of Man
in the Pose of the 'Dying Gaul'),*
1834 (original cast, 1775)
plaster cast on wooden support

then President of the Academy, and the painter Richard Cosway, who was a keen student of anatomical books. Their declared intention was to 'put...to a test' what really happened to a crucified body 'when... being warm' it naturally 'fell into the position that a dead body must fall into'.[36]

Although not within the official circles of the Academy, George Stubbs, amongst whose patrons was William Hunter, and who had himself illustrated an obstetric manual, undertook a remarkable series of comparative anatomies (cat. 275, p. 90). For a time, it appeared that the British artists were becoming the 'Anatomical School' to quote Robert Knox, writing in 1852 in *Great Artists and Great Anatomists*, where he decried the worst excesses in which 'death-like dissected figures' were displayed 'on the canvas'.[37] At its worst, over-exaggerated displays of musculature could become a tiresome mannerism, or in the hands of a strange genius like Henry Fuseli could serve as an expressive device almost independently of the requirements of anatomical veracity. In a

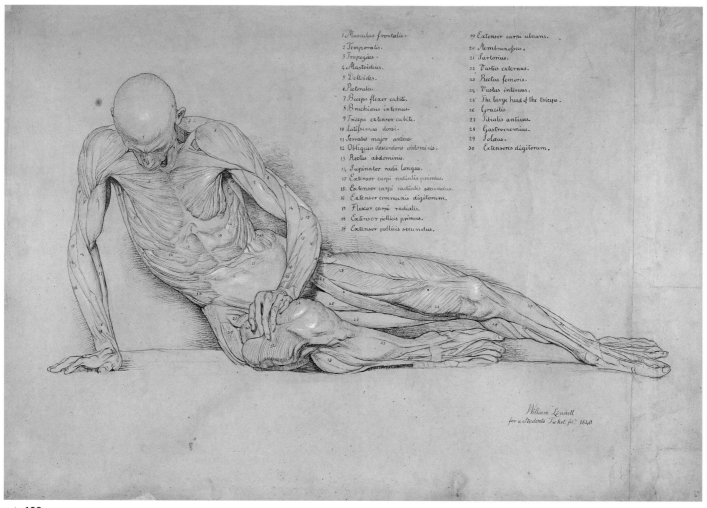

cat. **199**
William Linnell
Écorché Study after Smugglerius, 1840
pencil, pen and ink heightened with white over graphite

more sober vein, the great neo-classical sculptor and later President of the Academy, John Flaxman, grounded his art in close study of anatomical forms, owning a skeleton (cat. 1, p. 90) and making a series of studies that were engraved for the benefit of aspiring figure artists.

Knox's criticism of the dangers in becoming overly 'anatomical' was not new. Leonardo castigated those painters who over-emphasize muscles in every situation:

O anatomical painter, take care that excessive attention to the bones, chords and muscles does not cause you to become a wooden painter, in your desire that your nude figures should exhibit all their emotions.[38]

He probably had Michelangelo in mind, but, looking at a flamboyant display-piece like Golztius's engraving of the *Farnese Hercules* (cat. 132, p. 90), it is not hard to see how the anatomical style could become a kind of mannered affectation. The trick was, as Leonardo knew, to use anatomical knowledge with discretion and decorum; that is to say,

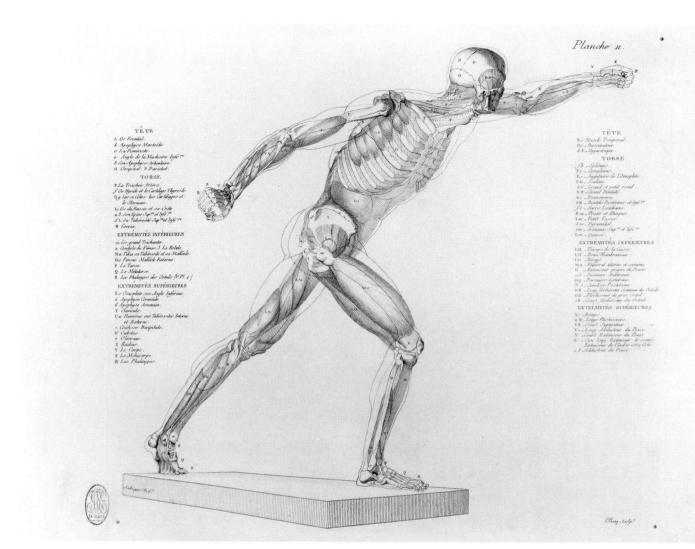

cat. **266**
Table of Muscles
plate XI from
Jean-Galbert Salvage
*Anatomie du gladiateur
combattant,* 1812

giving muscles due prominence as appropriate, when muscular figures such as warriors are in dynamic action, but according them less prominence when figures are at rest, and concealing them to greater or lesser degrees in youthful subjects and women. In a comparable way, William Hunter was alert to the problem of lifelessness if the dynamism of the muscles is not observed according to the principles of decorum:

> You will commonly observe that the general attitude of a figure is well imagined, but the particular action so little defined that you cannot tell whether it is pulling for example or pushing, raising something, or putting it down; you shall see a hand laid round a spear, sword or dagger, but seldom grasping it. This defect renders the picture in my opinion lifeless and insipid.[39]

By the mid-nineteenth century, there was a growing feeling in the circles of the more adventurous artists that the acquisition of anatomical knowledge was not an urgent necessity, just as the other academic disciplines of perspective, the geometry of light and

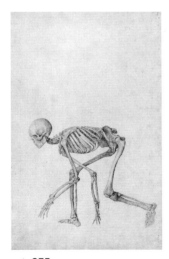

shade, drawing after the antique, and even life drawing were seeming less and less relevant to what really mattered in art. Even Realism, spearheaded by Gustave Courbet in the 1850s, was not primarily concerned with deeper anatomical structures, while the successive movements of Impressionism, Post-impressionism, Symbolism, Expressionism, Cubism, Fauvism, Futurism and so on were concerned with realities other than those of traditional academic naturalism. What the dominant movements of the first half of the twentieth-century had surrendered from their repertoire was the high potential of portrayals of the human body which exploited knowledge of the operative systems of motion and emotion to evoke deep-seated reactions in the spectator. At their best, the 'anatomical artists' could access basic human empathies in a way that few other kinds of artists could hope to do. This is a potential to which artists in the final quarter of the last century became re-alerted, though generally in distinctively different forms than those developed in the academic tradition.

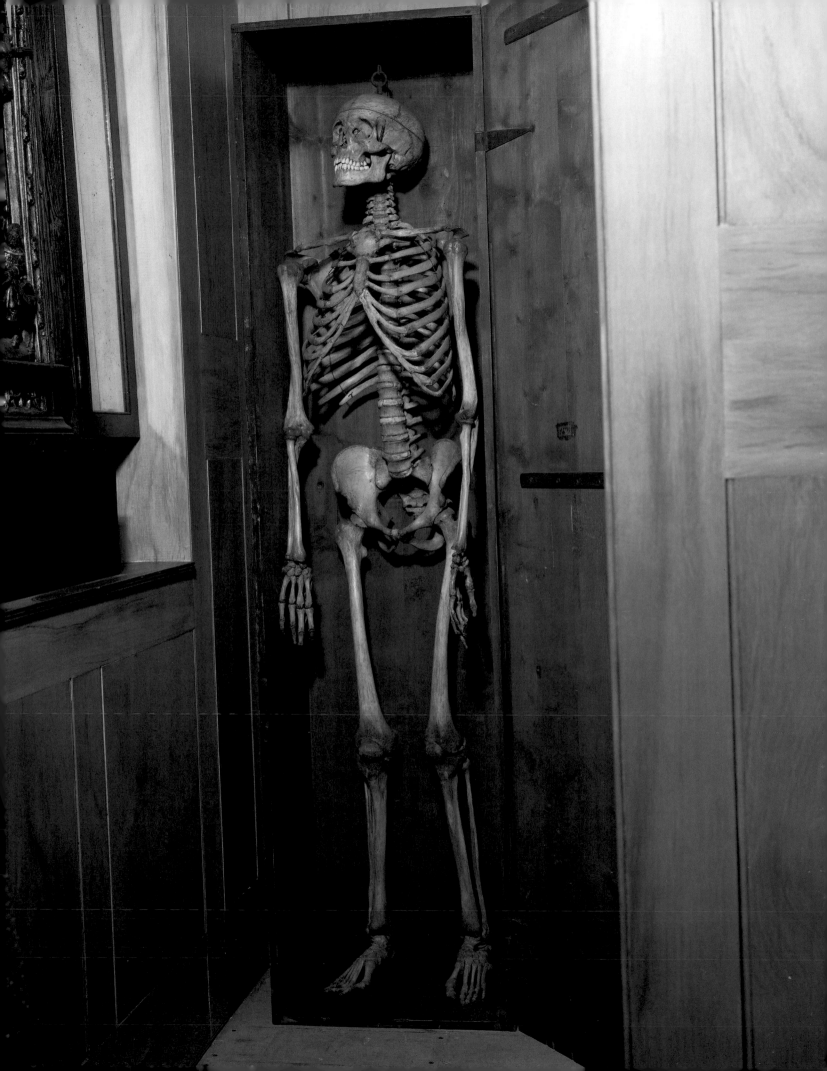

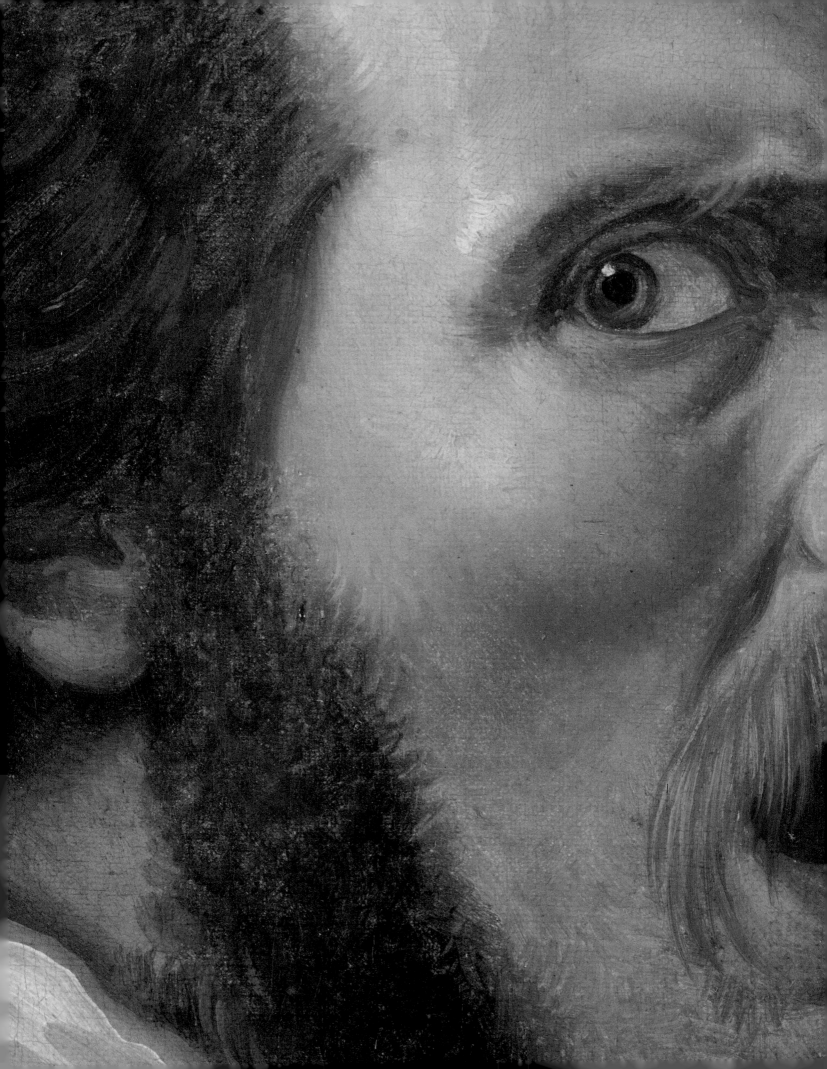

Part II
The House
of the Soul

4. Reading the Signs

We care deeply about what someone looks like, particularly about the appearance of their face. The establishing of national portrait galleries testifies to this obsession. More ubiquitously, items about the famous or infamous in newspapers or on television seem incomplete without a 'mug-shot'. When we do not have an adequately satisfying image of someone notable, like Shakespeare, we feel cheated. Yet why the facial features of Shakespeare should really matter is not at all clear. Would his plays be diminished or enhanced in our eyes if he were the possessor of a huge nose? Logic does not apply here, because we are irredeemably programmed to work from appearance at the deepest biological level. Unsurprisingly, philosophy, science and medicine have been consistently mobilized over the ages to provide a framework of explanation of how inner is expressed in outer.

For the Western tradition the foundations were laid down by Aristotle, or at least an Aristotelian author who was widely believed to be Aristotle until well into the nineteenth century. The treatise, *De physiognomia*, provided a standard point of reference for mediaeval authors, such as Michael Scot in the thirteenth century, just as it was still providing a prestigious validation for physiognomics in the voluminous writings of Johann Caspar Lavater around 1800. The basic idea is that the face serves as a field of 'signs', which, rightly read, could be used to determine the inner nature of the soul behind the façade.

Again, a series of stock metaphors, especially architectural, runs through the period. The concept of the eyes as 'the windows of the soul' – acting not only to admit light but also to allow us to peep inside – was repeated just as enthusiastically by the criminologist, Cesare Lombroso, at the end of the nineteenth century as it had been by Leonardo in the Renaissance. As Lavater clearly recognized, there were two types of sign that could be inscribed within the face, the fixed and the fleeting. The first was, strictly speaking, the domain of physiognomics, while the second fell under the embrace of pathognomics. The relationship between the two was not always clearly set out, and it was possible to argue that the vagaries of passing expressions could over the long term leave fixed marks on the countenance of someone sustainedly prone to the corresponding emotion.

The basic premises of physiognomics and pathognomics were known to Leonardo, even if the latter term was not available to him. In his projected book on anatomy he promised to write on 'the nature of complexions, colours and physiognomy' and on the '4 universal conditions of man'.[40] The framework was the doctrine of the four humours and temperaments, as embodied in the later prints of *The Four Seasons* (cat. 6, p. 43). The preponderance of one of the four humours – blood, yellow bile, black bile or phlegm – would result in the corresponding temperament becoming dominantly apparent – sanguine, choleric, melancholic, or phlegmatic. Each type would manifest its own special set of signs, ranging from details of personal appearance to the individual's behaviour. The choleric person, for example, would be irascible, bold and literally fiery, while the

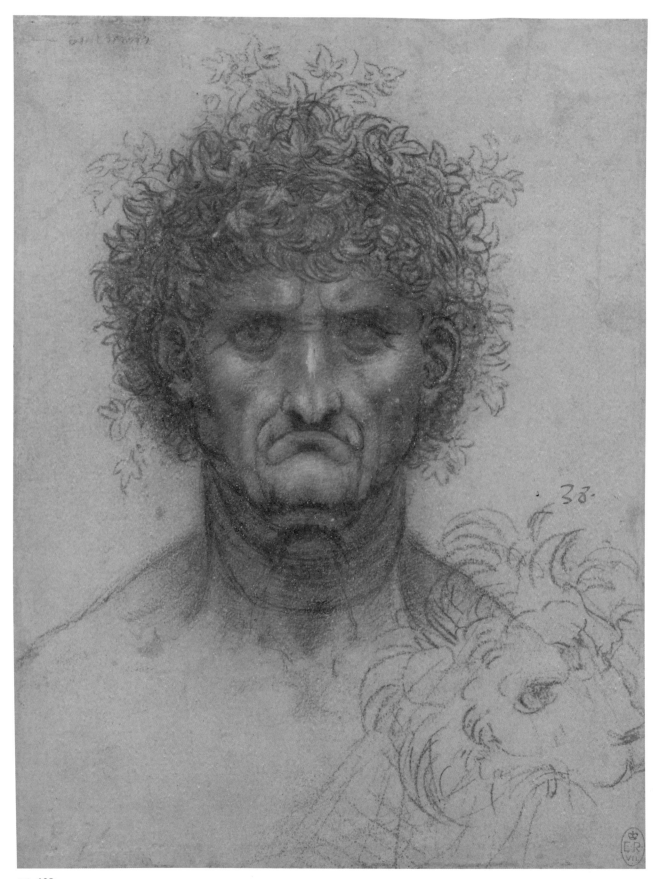

cat. **193**
Leonardo da Vinci
Head of a Man and a Lion, c.1503–05
red chalk heightened with white on pink paper

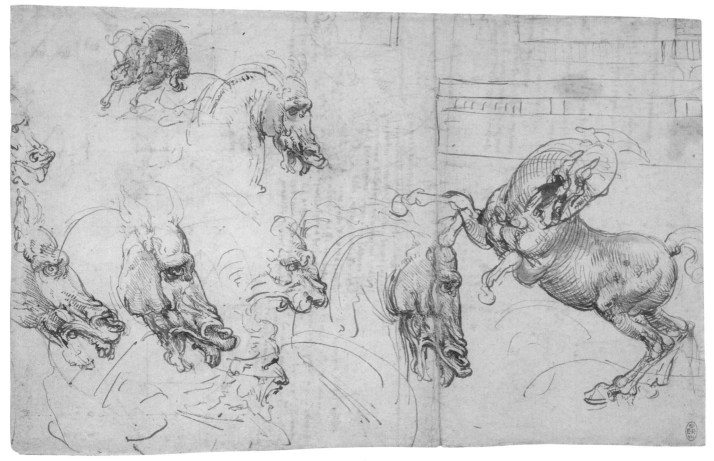

cat. **192**
Leonardo da Vinci
*Studies of Rearing Horses
with Snarling Man and Lion,*
c.1503–04
pen and ink on paper

fig.10
Niger macaque
plate from Charles Darwin
*The Anatomy of Expression
in Man and Animals*, 1872
(1873 printing) London:
J. Murray, book; 20.8 × 14.2
Wellcome Library, London

phlegmatic, like 'deep waters', would be placid and slow-moving. In terms of physical signs, the choleric would exhibit vigorous, curly hair, strong teeth and piercing eyes, while the phlegmatic would possess softer and heavier features that spoke in a contrasting way of imperturbability. Since there was also believed to be a commonality of signs that traversed the human and animal kingdoms, it was natural to elide the physiognomics of humans with that of those animals which were considered to best exemplify certain kinds of temperamental characteristics. Thus the choleric character is unmistakably leonine, with a mane of hair and carnivore's teeth, while the phlegmatic exhibits the solid, placid, bovine features of an ox. Dürer's characterizations of his *Four Apostles*, presented to Nuremberg in 1523 as his artistic and intellectual testament, are cast entirely in this light, representing John the Evangelist as sanguine, Peter as phlegmatic, Mark as choleric and Paul as melancholic. St Paul conspicuously has the same haunted look and sallow complexion as *Melencolia I* (cat. 102, p. 42).[41]

Leonardo's surviving notebooks do not document detailed explorations of these sets of conjunctions, but his somewhat parodic drawing of a leonine man (cat. 193, P. 95), underscored by a lightly sketched lion's head, testifies to his understanding of them. Similarly, a sheet of studies made around 1503 in connection with his projected mural of the *Battle of Anghiari* demonstrates how he interpreted pathognomics in an animalistic

way (cat. 192). Thinking about how he could portray man and horses ravaged by 'beastly madness' (as he called war), he observes the way that teeth are bared by both horses and riders, and, characteristically, adds a graphic meditation on the universality of such expressions by sketching in the profile of a roaring lion. Such commonalities were to be of special concern to Darwin some 450 years later in his book on *The Anatomy of Expression in Man and Animals* (fig. 10).

A number of leading Baroque artists, including Bernini (fig. 11) and Rembrandt (cat. 257), undertook intense studies of faces *in extremis*, both as cameos in their own right and to provide raw material for expressions in narrative compositions. In the eras of the art academies, when all such matters had to be formulated into rules that could be inculcated in the visual memories of ambitious students and learned spectators alike, the lead was taken by the President of the French Academy, Charles Le Brun, who lectured on both the fixed signs of the head and the communicative features of passing emotions.[42] The drawings connected to his former lessons, which involved a system of triangulation applied to animal heads and a proportional geometry applied to related human types,

cat. **257**
Rembrandt van Rijn
*Self-Portrait with
an Open Mouth*, 1630
etching

fig. 11
Gianlorenzo Bernini
*Anima Dannata (Condemned
Soul)*, 17th century
marble
Spanish Embassy, Rome, Italy/
Joseph Martin/Bridgeman Art
Library
Photo © Joseph Martin

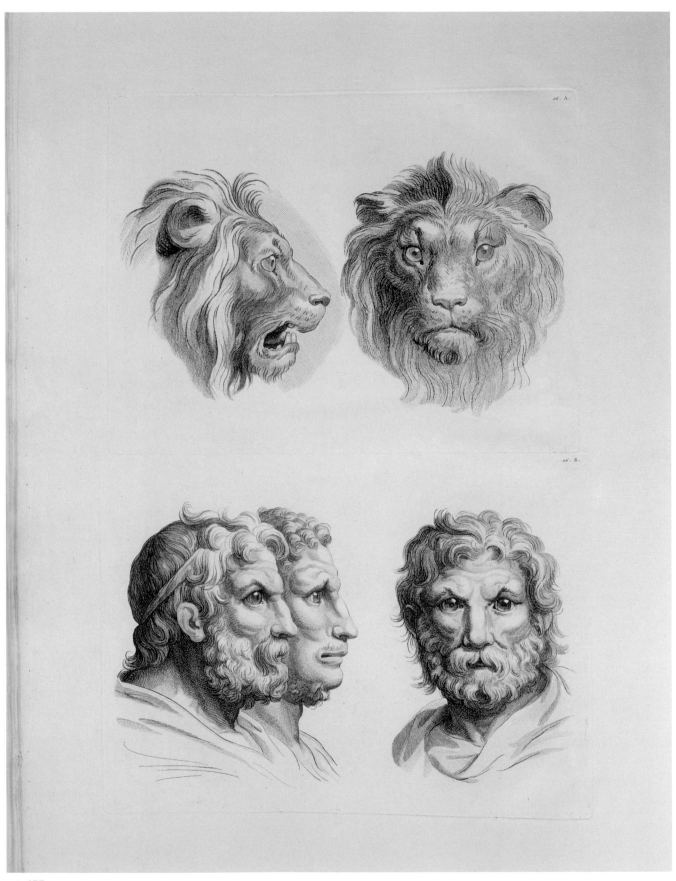

cat. **177**
Charles Le Brun
Two human heads, resembling lions, c. 1660–70
pencil and ink on paper

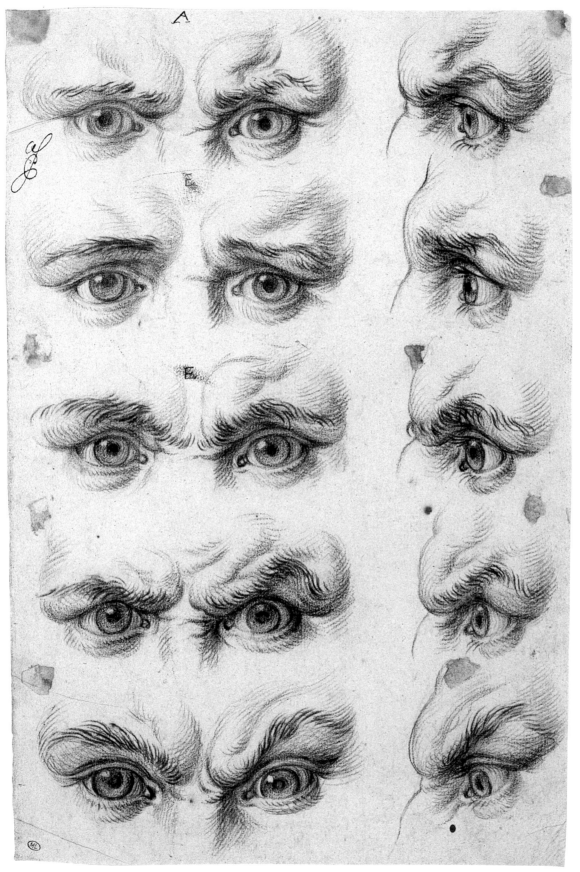

cat. **179**
Charles Le Brun
*Two human eyes, frontal
and side views*, c.1660–70
pencil on paper

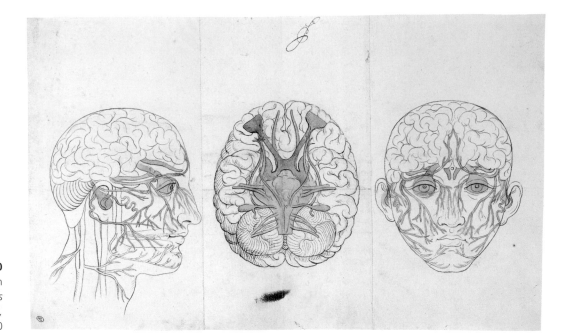

cat. **180**
Charles Le Brun
*Three human heads
with skulls removed,*
c. 1660–70

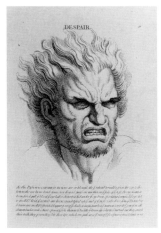

cat. **181**
Charles Le Brun
Despair
engraving from
*Heads representing the various
passions of the soul,* 1705

were not published by Le Brun himself. Amongst these drawings are spectacular studies in the della Porta mode and compelling suites of details (cat. 177, p. 98; cat. 179, p. 99). On the other hand, his vivid characterizations of particular emotional states (cats. 180 and 181) were reproduced in best-selling volumes, issued and re-issued until the early nineteenth century. Le Brun had updated the psychological framework for his studies to embrace the ideas of the philosopher René Descartes, who had argued that the seat of the soul could be identified with the pineal gland, the only non-bilateral structure within the cranium. Thus Le Brun describes the motions of the features as they are pulled hither and thither by forces emanating from this central 'controller'. In so doing, he provided a set of prescriptions with which all artists in the academic tradition had to reckon. A telling instance from the nineteenth century is the plaster bust of *Sadness* made in 1811 by the great maker of portrait medallions, David d'Angers (cat. 95).

The most extreme essays in pathognomics are the very extensive series of 'self-portrait' heads made in various media between 1770 and 1783 by the eccentric Viennese court sculptor, Franz Xaver Messerschmidt, during the reclusive later years of his life when he was reported by the Austrian Prime Minister as suffering from some 'confusion in his head' (cat. 234, p. 103; cat. 236, p. 102).[43] Apparently based upon mystical ideas that his own body was subject to 'pinching' by malicious 'invisible spirits' which governed the 'forces of nature', the busts immortalize the expressions induced when Messerschmidt 'pinched' specific parts of his own body to propitiate the assaulting 'powers'. Messerschmidt's images belong in a long succession of pathognomic self-portraits. An example is Wilhelm von Kaulbach's haunted image from 1828 (cat. 154, pp. 92–93, 104). Even the 'Realist', Gustave Courbet, working in the context of new notions of insanity in the

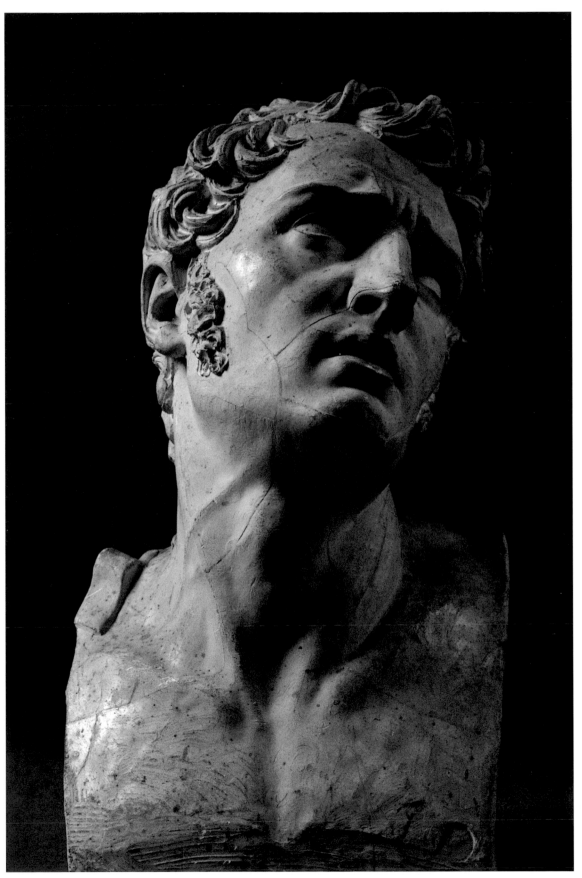

cat. **95**
David d'Angers
Sadness, 1811
plaster

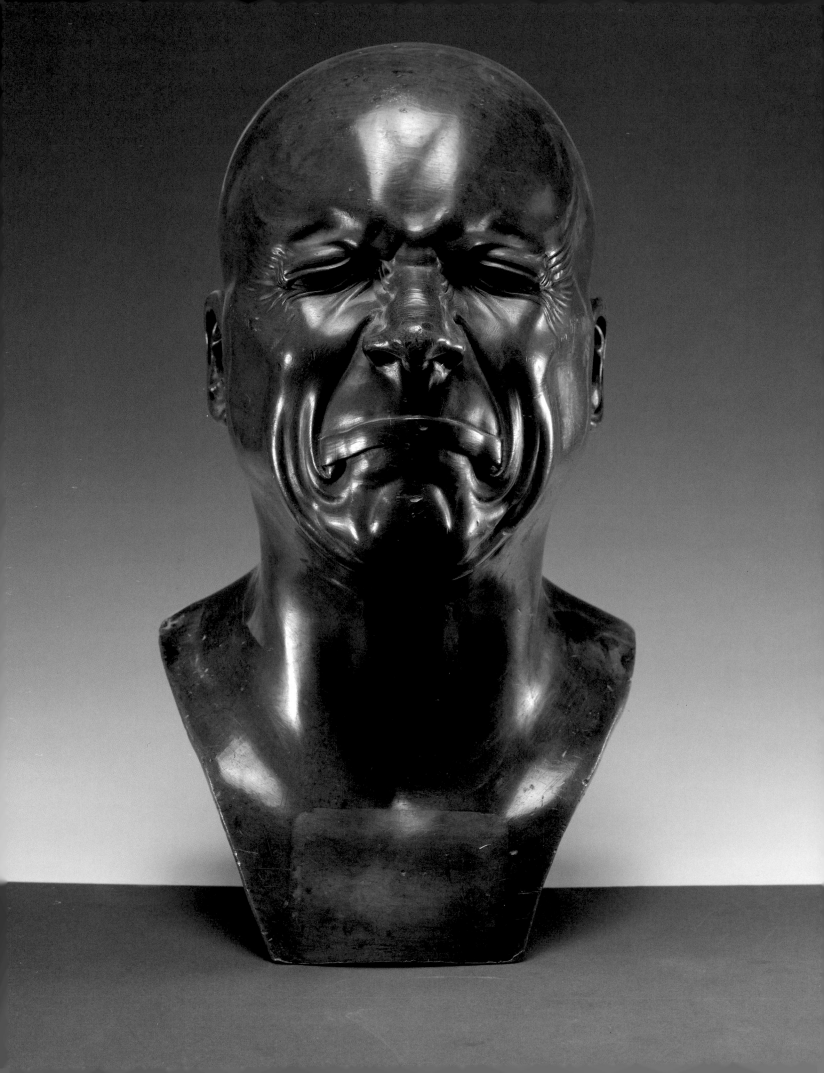

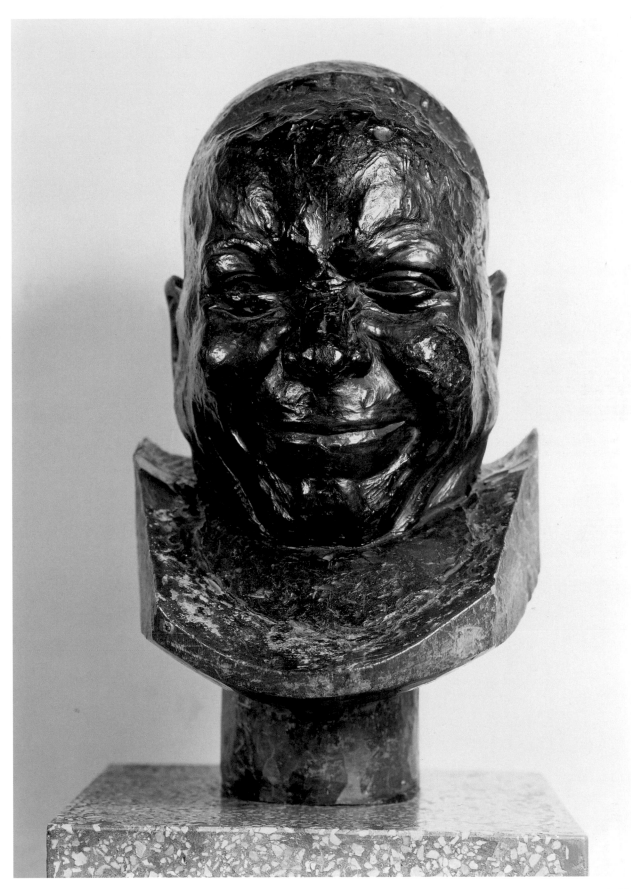

cat. **236** (left)
Franz Xaver Messerschmidt
Physiognomic Head (Head of Character no.18), 1775
lead

cat. **234**
Franz Xaver Messerschmidt
Physiognomic Head
(Old Man Smiling), c.1770
plaster

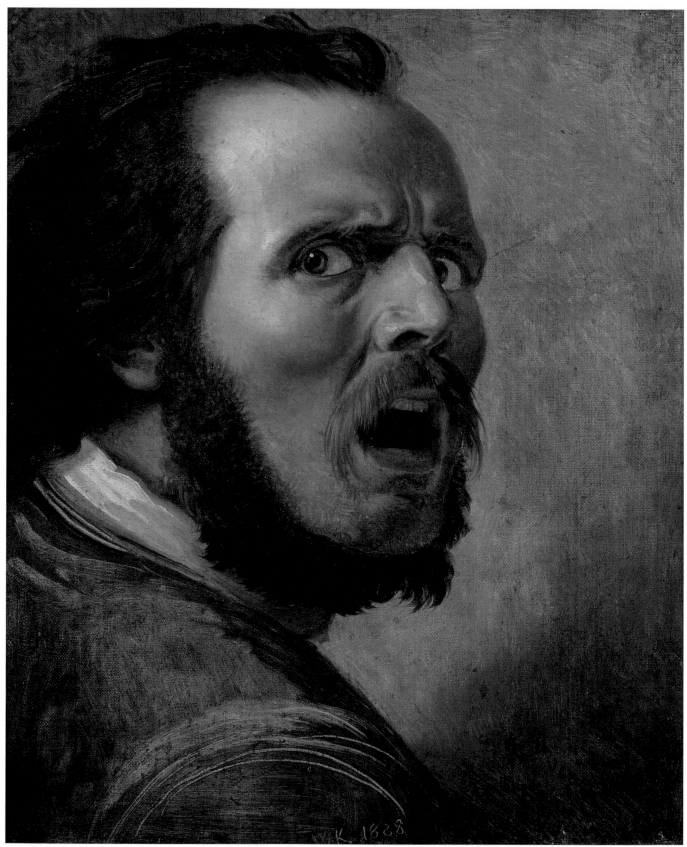

cat. **154**
Wilhelm von Kaulbach
Expressive Self Portrait, 1828
oil on canvas

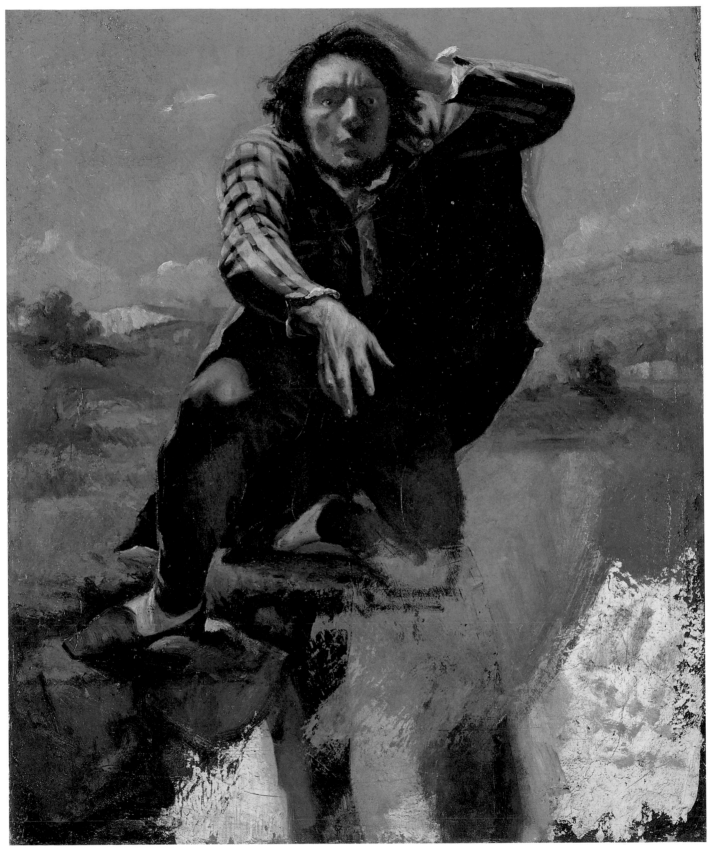

cat. **82**
Gustave Courbet
The Desperate Man, 1844– 45
oil on canvas

mid-nineteenth century, espouses essentially the same notion of how the soul is expressed in the contorted mask of someone in deepest despair (cat. 82, p. 105).[44] Two important attempts were made in the nineteenth century to place this long-standing study on a new kind of scientific basis. The Edinburgh doctor, Charles Bell, provided artists with a detailed analysis of the facial muscles of expressions, while the Parisian doctor, Duchenne de Boulogne, used an electrical device with paired electrodes to isolate the individual muscles of the communicative system, a system which he recognized had been exploited by artists since classical antiquity (cat. 100).[45]

Running alongside Le Brun as an enduring point of reference in the academic tradition was the treatise on physiognomics by the Neapolitan humanist and student of natural magic, Giovan Battista della Porta. First published in 1586, his *De humana physiognomia* was constantly re-issued in various European languages, well into the nineteenth century. Working within the inevitable framework of humoural medicine, della Porta provided a series of memorable if exaggerated animal similes (cat. 42, p. 108). The sustained vitality of this idea can be seen in the humorous but 'serious' fantasies of Grandeville, who inverts the worlds of human and animals in a way that combines the Aesopian fables of La Fontaine with Aristotelian physiognomics (cat. 109, p. 109).

Grandeville, Courbet and their great contemporary, Honoré Daumier (cat. 92, p. 111), were working at a time when physiognomics had been given its most extensive re-working by the Swiss pastor, Johann Caspar Lavater. In a series of extensive publications in the last quarter of the eighteenth century, Lavater provided an unsystematic but beguiling mishmash of traditional physiognomics, studies of past and present art, empirical observation, mathematical theory, opinions solicited from acquaintances, and often arbitrary judgements (cat. 174). He was scathing about the literalness of della Porta's ideas, but he continued to adhere to the view that common signs could be discerned across the human and animal realms. His ultimate aim was to produce an elaborate kit of proportional and linear signs, based particularly on silhouettes, that would enable an adherent 'to calculate and determine the forms of heads according to the principle of Physics and Mathematics' (fig. 12, p. 110).[46] In reality, this aspiration to construct a general set of criteria remained far beyond the reach of his eclectic procedures.

Closely associated with Lavaterian physiognomics in the public mind were the phrenological theories of Franz Joseph Gall and Johann Gaspar Spurzheim. However, Gall and his pupil Spurzheim were in the business of serious science and serious philosophy (cat. 114, p. 111), writing learnedly about the *Anatomy and Physiology of the General*

in ima fronte instar nubis prouenire scribit. ἐπισκυνιον *uocari conijcio. Pellis est superciljs, quæ obtenditur leonum oculis. Vnde leoni, cui talis facies perpetuo est, perpetuo etiam ira affectus est, & aliquid nubis instar circa supercilia prominet. Tauro semper torua frons.*

Venatici canis cum episcynio supra oculos contemplare imaginem
cum Actiolino Patauinorum tyranno.

Oppiamus venaticos canes describens, qui leones, & ferocia animalia inuadit, horribili ait supra oculos,
& supercilia pelle. Tigridi etiam similis in ima fronte laxa pellis, epyscinion dictum. Ex eodem.

OB-

cat. **92**
Honoré Daumier
L'Artiste m'a Rèpresenté, 1844
lithograph

cat. **109**
Eugène Forest after Jean-Gerard Grandeville
Singeries, Morales, Politiques
lithograph from Jean-Gerard Grandeville
La Charicature, c.1831

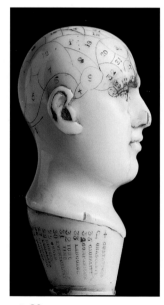

cat. **29**
Anon
*Ivory Phrenological Head
on Square Wooden Stand,*
1850–1914
ivory, wood

Nervous System, and of the Brain in Particular, with observations on the possibility of recognizing several intellectual and moral dispositions in men and animals through the configuration of their heads (to translate the title of their major French work, published in four volumes with an 'Atlas' of illustrations between 1810 and 1819). The principles on which they constructed their ideas were firstly that 'throughout all nature, a general law [decrees] that the properties of bodies act with an energy proportional to their size', and secondly that 'the form and size of the brain regulate the form and size of the skull'.[47] These reasonable assumptions were supported by reviews of anatomical and physiological science, and by studies of the development of human and animal brains and crania. This was supplemented by the extensive gathering of empirical data. As Spurzheim explained, 'if the head of any individual presented any protuberance, which was evidently the result of cerebral development, Gall endeavoured to be acquainted with the talents or dominant character of the person'.[48]

Although Gall and Spurzheim objected to the way that their system was 'treated as an art of prognostication', the practice of reading the 'bumps' on someone's head became a craze in both scientific and popular circles (cat. 29; cat. 39, pp. 112–113) – practised, feared and satirized in equal measure. Phrenological societies sprang up in many leading

cat. **114**
Brain
plate IX from
Franz Joseph Gall and Johann
Caspar Spurzheim
*Anatomie et physiologie du
système nerveux en général
et du cerveau en particulier,*
1810–19

cities, not least in Edinburgh, where George Combe and his brother, Andrew (later one of Queen Victoria's physicians), followed Gall's advice to assemble a museum of life- and death-masks, and casts of the heads of notable individuals.[49] The collection ranged from the great and good, such as Sir Isaac Newton, Jacques-Louis David, the painter (cat. 20, p. 114), and Gall himself (cat. 21, p. 114), to the notorious and evil, not least the infamous Edinburgh 'Resurrectionists', Burke and Hare (cats. 22 and 23, p. 115). It is hardly surprising that this popular science, with Lavater's physiognomics, provided a ready source of information for artists who wished to refine traditional physiognomics in the light of up-to-date science (cat. 112, p. 116 and fig. 13, p. 117).[50]

What the systems of Lavater and Gall and Spurzheim aspired to accomplish was to place the ancient and instinctual business of reading the 'signs' onto a basis that was 'scientific' by late eighteenth-century standards. Not only could they draw upon the latest anatomy and physiognomy, but they were also able to access the burgeoning science of primatology – the study of those apes and monkeys that manifested more human characteristics than any other animals.[51] The orang-utan, also traditionally called the 'pigmie' or '*homo sylvestris*' (man of the woods), was studied particularly closely, not least by the Dutch doctor and polymath, Petrus Camper, who was one of the successors of

cat. **39** (following two pages)
William Bally
*Wooden case containing sixty
small phrenological heads,*
1831
case: wood; heads: plaster

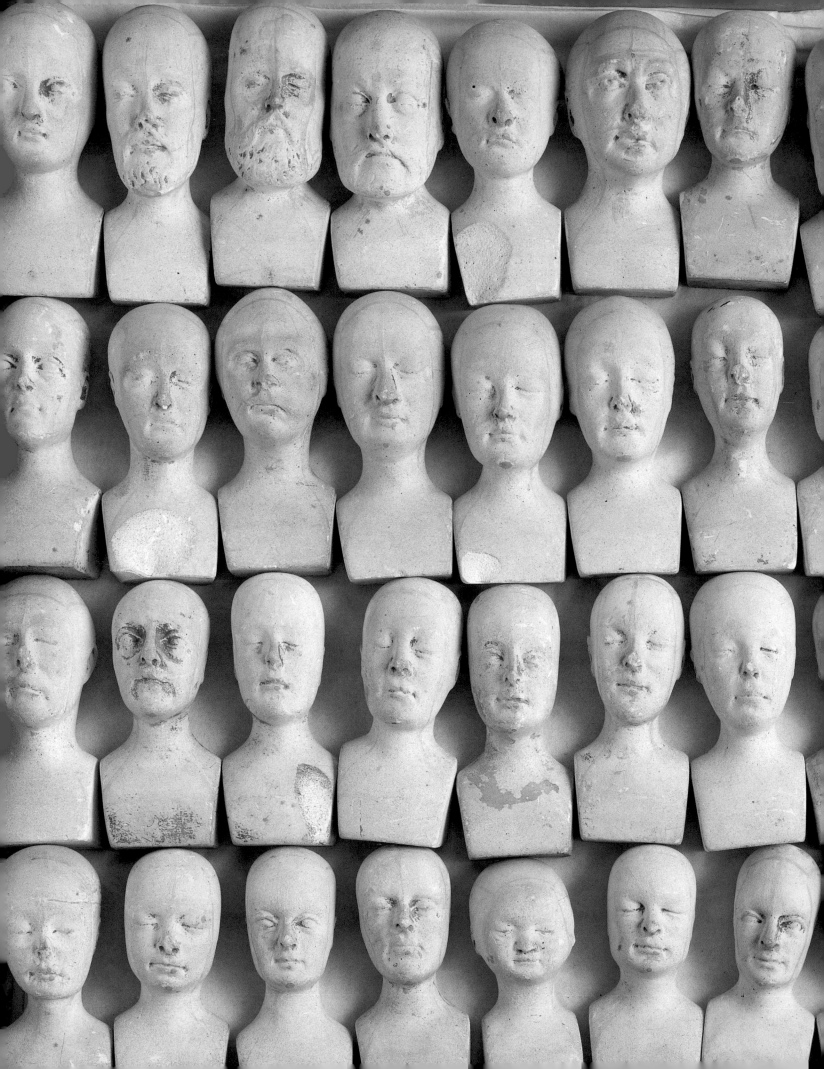

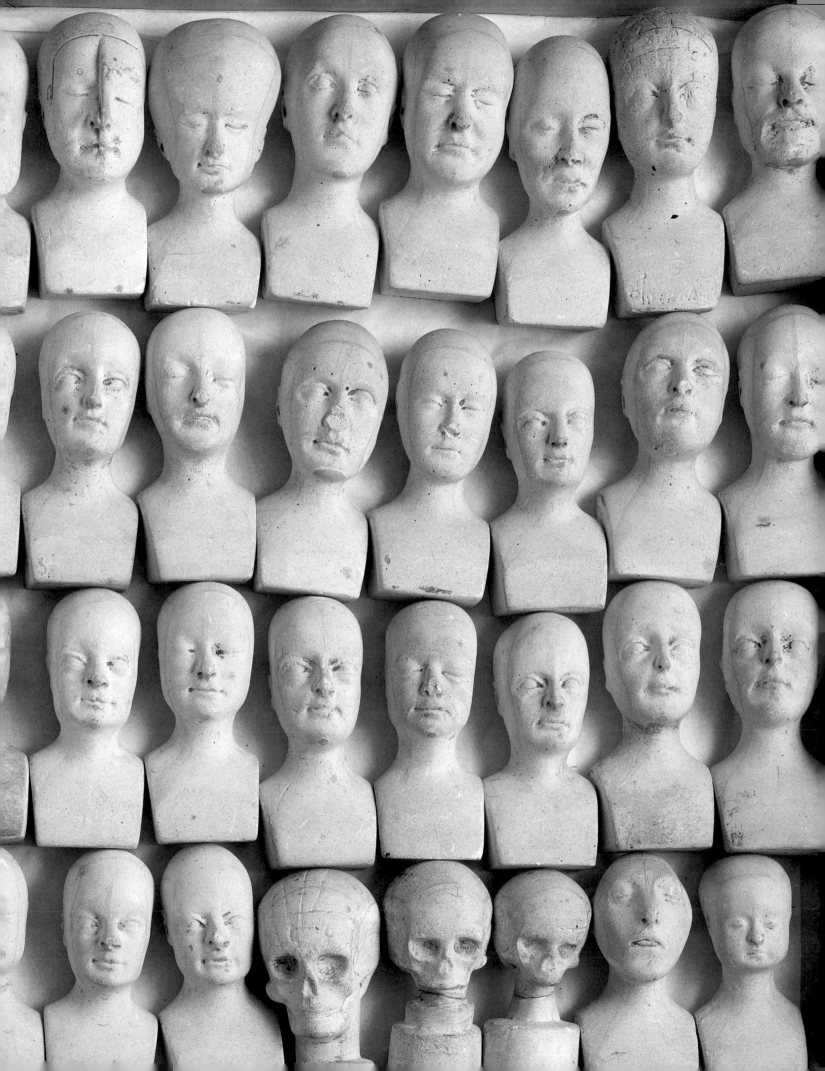

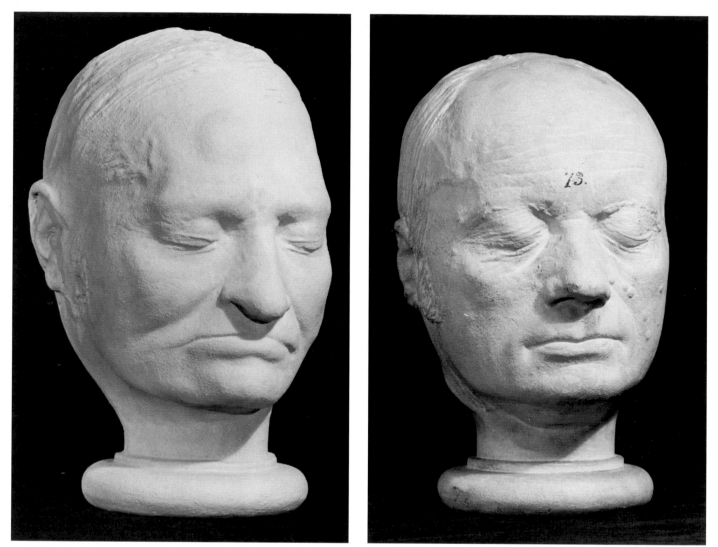

cat. **20**
Anon
Death Mask of J.-L. David, 1825
plaster cast

cat. **21** (above right)
Anon
Death Mask of J.-F. Gall, 1825
plaster cast

Tulp as *praelector* in anatomy at Amsterdam. In an attempt to rectify poor portrayals of the various races of humans, he composed a *Dissertation on the Natural Varieties that Characterise the Physiognomy of Men* (1791). An avid dissector, draftsman and collector, Camper assembled and arranged a collection of crania 'in a regular succession: apes, orangs, negroes, the skull of a Hottentot, Madagascar, Celebese, Chinese, Moguller, Calmuck, and divers Europeans' (cat. 71, p. 118). [52]

The key measure, using a system of proportional analysis reminiscent of Dürer, was the facial angle, which ranged from 42° in a tailed monkey, through a 'negro' and Calmuck at 70°, to the Caucasian angle of 80°, which could be exceeded by the 'rule of art alone', as demonstrated by the Apollo Belvedere at the head of his sequence. With hindsight, it is all too easy to see Camper's sequence as corresponding to judgements of mental rather than aesthetic value, and to align it in a temporal progression. However, this was not something that Camper, a pious creationist, was prepared to contemplate. He expressly

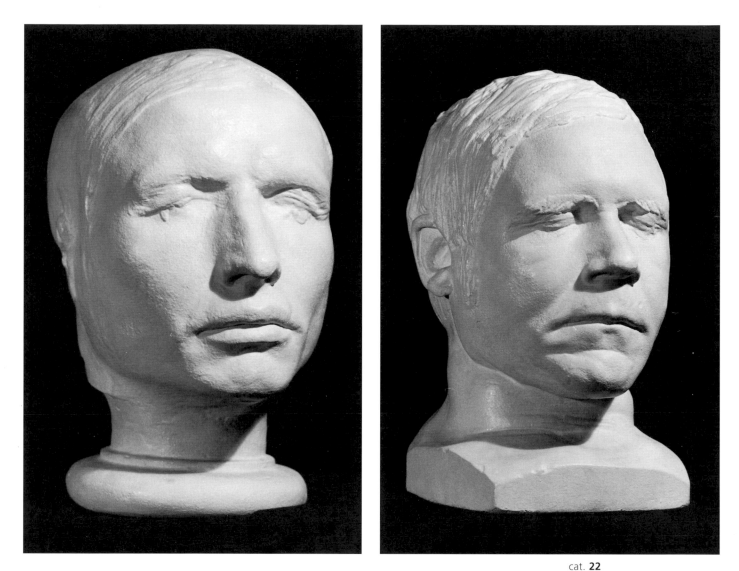

cat. **22**
Anon
Life Mask of W. Burke,
c.1828–29
plaster cast

cat. **23** (above left)
Anon
Life Mask of W. Hare,
c.1828–29
plaster cast

refuted 'the extravagant notion' that 'the race of blacks originated from the commerce of whites with orangs and pongos; or that these monsters, by gradual improvements, finally become men'.[53]

However, it is not hard to see how Camper's sequence, combined with the diagnostic physiognomics of Lavater, could be used judgementally on a broader basis. An early move in this direction was made by the Manchester doctor, Charles White, in his *An Account of the Regular Gradation in Man, and in Different Animals and Vegetables, and from the Former to the Latter*, in 1799 (cat. 314, p. 118). Although he disowns the 'pernicious practice of enslaving mankind', he is in no doubt that the cranial sequence he illustrates corresponds to an ascent in intelligence. Indeed, the farrago of 'evidence' that he gathers about 'Africans' and American blacks, such as Jefferson's slaves, convinced White that there were a number of separate 'species' of humans. In this, he was drawing inspiration from the first systematic attempt to define distinct races of humans by Johann Friedrich

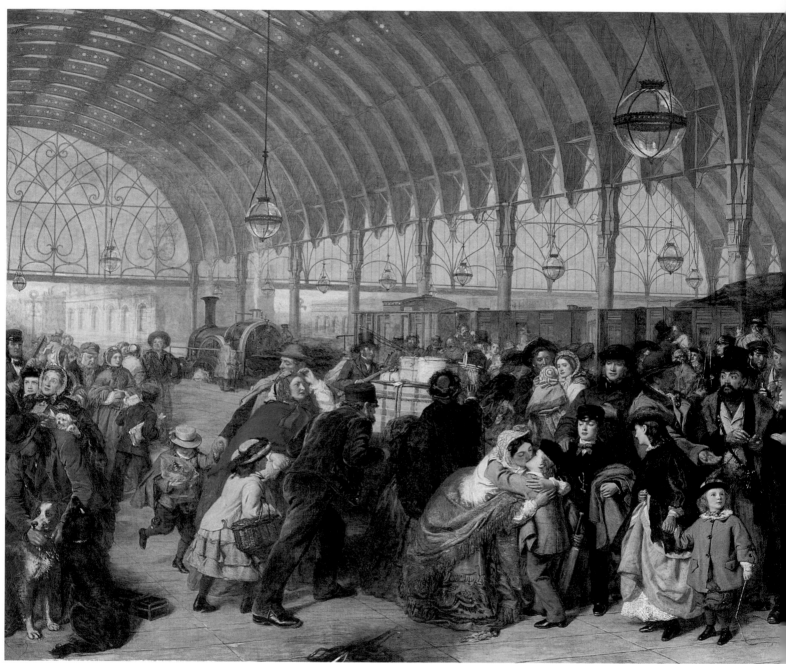

cat. **112**
William Powell Frith
The Railway Station, 1862
oil on canvas

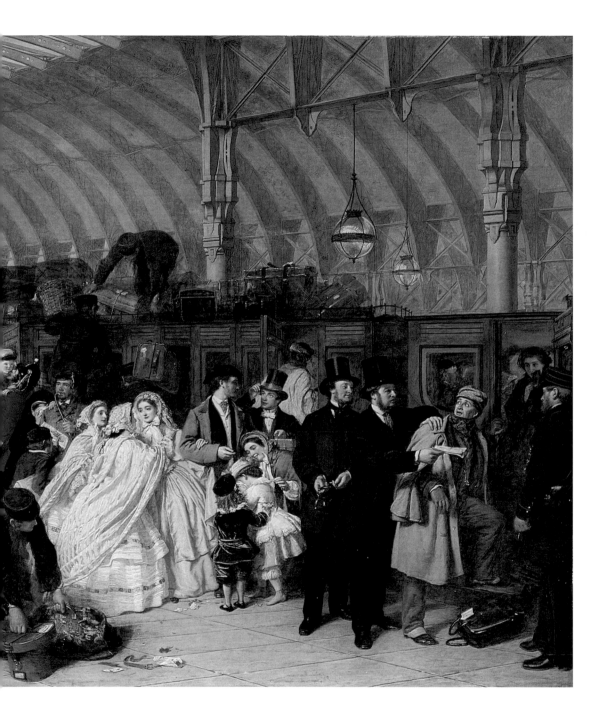

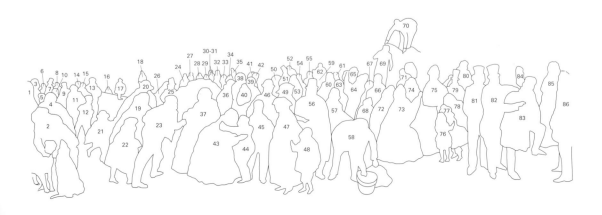

cat. **71**
*Cranial types,
arranged by
facial angles*
folded plate,
table III from
Petrus Camper
*The works of the late
Professor Camper,
on the connection
between the science
of anatomy and the
arts of drawing,
painting, statuary,*
1821

cat. **314**
Facial Types
plate II from
Charles White
*An account of the
regular gradation in
man, and in different
animals and vegetables,*
1799

Blumenbach in his *On the Genesis of the Native Varieties of Humans* in 1776, where he proposed five fundamental types: 'caucasian, mongol, etheopian, american and malayan'. In arranging his types in sequence, White was consciously proposing a series of regular 'gradations' in which discrete species of humans step gradually towards a gradated sequence of primate species, and so on to even more remote and inferior products of creation, ending with the bird-brained snipe.

It was in such a climate that the new sciences of anthropology and eugenics were created. Information about the physical characteristics of the races of mankind was assembled on a huge scale, above all quantitative data based upon measurement. In America, Samuel Morton in his *Crania Americana* (1839) and *Crania Aegyptica* (1844), working with the Swiss polygenesist, Louis Agassiz, took extensive measurements of skulls with the aim of literally demonstrating the 'cranial capacities' of different races. As stressed by his phrenologist friend George Combe, Morton's collection of over 600 crania only possessed a value beyond 'mere facts' if it could be used to elucidate 'the mental qualities of people'.[54] The greatest quantifier of all, Paul Broca, founded the vigorous and influential Société d'Anthropologie in Paris in 1859, issuing huge bodies of data which the statistical methods of the time could manipulate to yield the desired result, namely that European crania served to demonstrate the innate superiority of European brains over those of 'primitive' races (cats. 64 and 65).

Given the data related to three-dimensional objects, the prominence of sculpture in ethnographic representation is understandable. One leading French sculptor, Charles Henri Joseph Cordier, became a specialist in anthropological portrait busts (fig. 14, p. 121),

cat. **65**
Paul Broca
Instructions Craniologiques et Craniométriques de la Société d'Anthropologie de Paris, 1875

cat. **64**
Brain of a young male chimpanzee (left)
Brain of the 'Hottentot Venus' (right) from
Paul Broca
Mémoires d'Anthropologie, 1871–88

cat. **163**
For John Lamprey
Male Nude (white man) from the front, 1868–69
photograph, albumen print

cat. **239** (top right)
Negreti & Zambra
*South African Zulus, Model
Group at Crystal Palace*, 1860s
photograph

fig. 14 (bottom right)
Charles Henri Joseph Cordier
African Venus, 1851
bronze; 42 × 39
The Walters Art Gallery, Baltimore

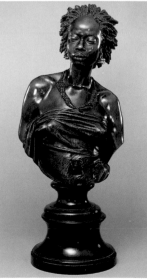

creating a series of unusually sympathetic and often nobly idealized images of exemplary members of the races of mankind in the 1850s for the Musée National d'Histoire Naturelle in Paris.[55] 'Exotic' races provided suitably diverting and 'educative' subjects for display at the international expositions that proliferated in the nineteenth century (cat. 239).

Unsurprisingly, in the quest to assemble images and information on a massive and world-wide scale, the new art of photography was pressed into service, particularly in Britain, where the reach of Empire facilitated private and official schemes to document all the manifold varieties of facial and bodily types (cat. 148, p. 122; cat. 149, p. 190; cat. 163, and cat. 230, p. 122).[56] In such nineteenth-century quests for data-gathering on a massive scale, photography possessed three enormous advantages. Images could be made with greater speed and in larger numbers than drawn or painted representations. The same images could be replicated in near-identical form so that widely separated observers

could be eyewitnesses to the same visual data. And the supposedly impersonal nature of the photographic record meant that 'trustworthy' images could be gathered from sources far and near. In Germany, the large photographic enterprise of Carl Dammann in Hamburg, which involved both taking and collecting as many photographs as possible of ethnic types, proceeded according to these assumptions. Selections from his huge visual paper museum of types were published in large reference albums, and made more publicly accessible in 1875 in the smaller compilation, *The Ethnographic Gallery of the Races of Men* (cat. 85). Like other burgeoning enterprises of ethnographic photography and publishing, Dammann's 'Gallery' tended at best to parade other races as curiosities and at worst to feed the prejudices of those who wanted their caucasian superiority to be confirmed.

In retrospect, we can sense that it was not a pretty picture that was beginning to be painted, courtesy of the new medium and old ignorance. How ugly the picture could become will be apparent when we next look at the more extreme end of reading the signs, namely the categorization of insane and criminal types.

Man, aged 30.

Boy, aged 14.

Man, aged 22.

Man, aged 30.

cat. **85** (left and bottom)
tipped-in albumen prints from
Carl Dammann
Frederick Dammann
*Ethnographic and Photographic
Gallery of Various Races
of Man,* 1875

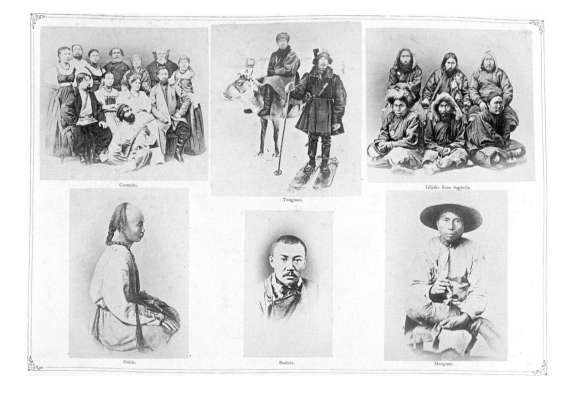

Cossacks.

Tunguses.

Giljaks from Saghelin.

Golde.

Buriate.

Mangune.

5. Mad and Bad; Addled and Atavistic

The diagnostic and, indeed, judgemental aspects of those sciences that claimed to be able to read the signs of the head became progressively entangled with new initiatives in the science of insanity. Around 1800 there was a general shift from 'madhouses' as quasi-prisons to 'asylums' in which psychiatric specialists promoted their new branch of medicine. From the mid-eighteenth century onwards, various forms of insanity were increasingly subject to serious analysis, not least within the framework of the growing obsession with large banks of data which could be sorted and arranged according to categories or 'types'. In the physician's art, these tendencies were expressed through an increasing emphasis upon diagnosis according to recognizable sets of pathological symptoms, particularly those syndromes that spoke most vividly and directly of certain kinds of breakdown within the bodily machine. The syndromes for insanity consisted of behavioural characteristics and physical signs, above all the signs legible in that most communicative of visual fields, the human face.

Works by two artists a century apart typify the way that the insane were classified visually. The final print in William Hogarth's *Rake's Progress* in 1735 (cat. 136) shows the interior of Bedlam peopled by individuals manifesting different types of delusion.[57] As

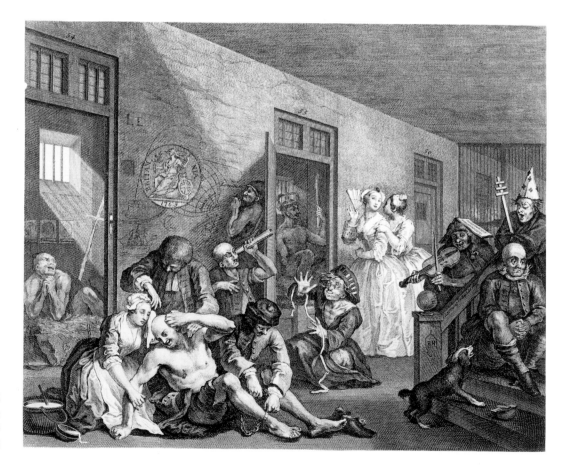

cat. **136**
William Hogarth
Bedlam, 1735
engraving

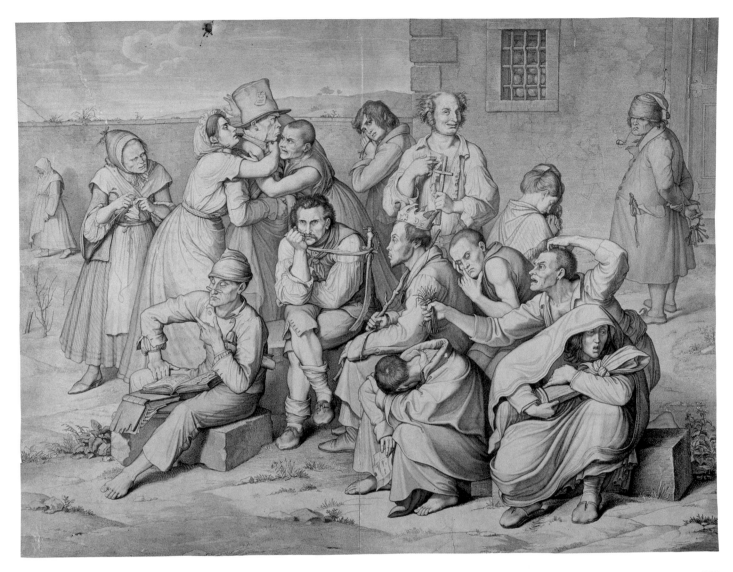

cat. **155**
Kaspar Heinrich Merz
after Wilhelm von Kaulbach
Madhouse, c.1834
engraving

examples, in the cells on the left we can see a praying 'hermit' who is subject to religious mania, while his neighbour harbours delusions of kingship. A hundred years later, Wilhelm von Kaulbach reassembles a comparable cast of 'aliens' in the exterior yard of his *Madhouse*, including another self-proclaimed monarch (cat. 155).[58] For both artists, we may perhaps sense that the delusions of the asylum and the pretensions of 'normal' society are not too distant from each other.

For the young science of psychiatry in the early nineteenth century, it was a short step from Lavaterian physiognomics and the more firmly-based science of phrenology to the belief that the nature of insanity could be read in precise detail from the features of afflicted persons, and, even more decisively, that insanity resulted from physical defects. It was in precisely this way that Philippe Pinel in his *Medico-Philosophical Treatise on Mental Alienation* in 1800 attempted to define the 'degradation' of the ideal Caucasian into lesser types who exhibit Mongol characteristics (cat. 246, p. 126). Pinel, like Gall, was

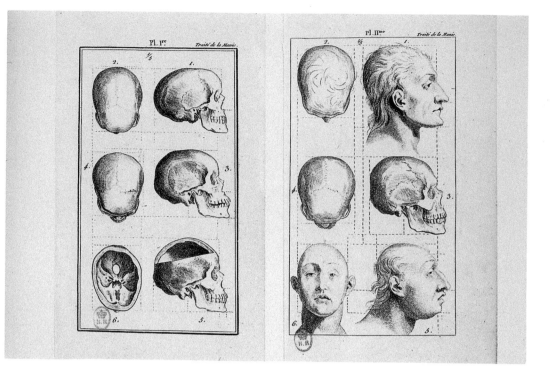

cat. **246**
plates from
Philippe Pinel
*Traité médico–philosophique sur
l'aliénation mentale*, 1801

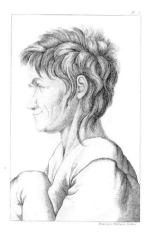

fig. 15
Ambroise Tardieu
Side profile of a 'maniac', c.1838
engraving, plate X from
Jean-Étienne-Dominique Esquirol
Des maladies mentales, 1838
Paris: Baillière
book; 24.3 × 16.3 × 1.5
Wellcome Library, London

cat. **245** (right)
Philippe Pinel
Demonstration Skull, 1796
wood, metal stand and
human skull

not a marginal eccentric, but a serious student of the nervous system and pioneer of psychiatry (cat. 245). It was indicative of his status that he was working at the hospital of the Salpêtrière in Paris, which became the centre for a series of major initiatives during the nineteenth century. It was at the Salpêtrière that Jean-Étienne-Dominque Esquirol, Pinel's successor, created his pioneering portrait images of the insane, drawn by Amboise Tardieu and Georges-François Gabriel for a series of publications between 1814 and 1838 (fig. 15). We have already noticed the experiments to isolate and photograph the action of individual facial muscles conducted by another doctor at the hospital, Duchenne de Boulogne (cat. 100, p. 106). And, most spectacularly, in terms of visual impact, it was for a former intern under Esquirol at the Salpêtrière that Theodore Géricault painted his famed series of portraits of inmates with various kinds of 'Monomania'.[59]

Géricault's painted studies were undertaken between 1821 and 1824 at the instigation of Dr Étienne-Jean Georget, who had become medical officer at Esquirol's private asylum at Ivry. Five examples survive of what was reputed to be a set of ten. Each is a portrait of an individual and of a 'type', since each represented and externally manifested the signs of a particular 'Monomania' – defined by Esquirol as a focused obsession which leads their possessor to indulge in compulsive behaviour of a specialized kind. Géricault's surviving paintings represent stealing, envy, child kidnapping, military command, and gambling. Given what we know about Georget's interests in physiognomics and expression from his book, *On Madness* (1820), we can be reasonably clear such 'deviant' features as the haunted, sideways glance, asymmetrical sag of the mouth and hollow cheeks of the child abductor (cat. 130, p. 130) were regarded as characteristic of his type of condi-

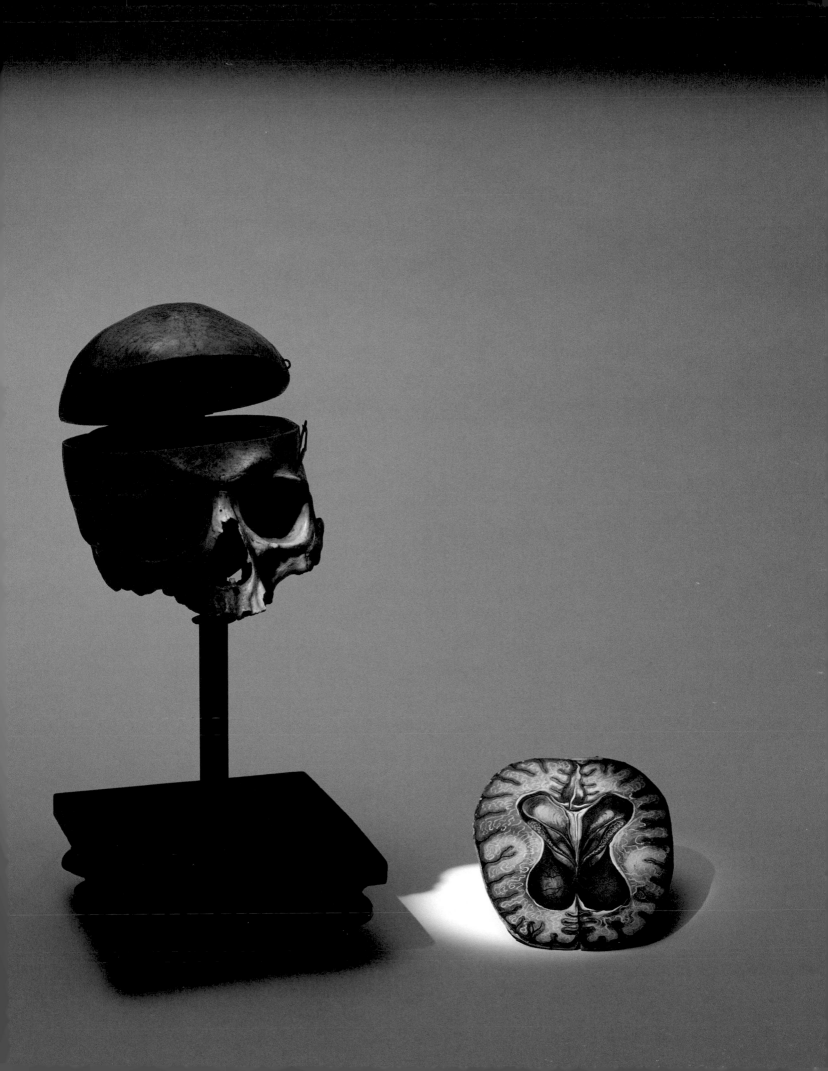

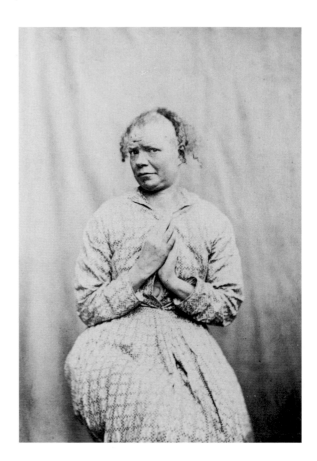

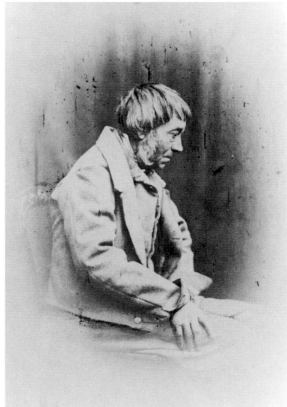

cat. **98**
Hugh Welch Diamond
Photographs of the Insane, 1850s

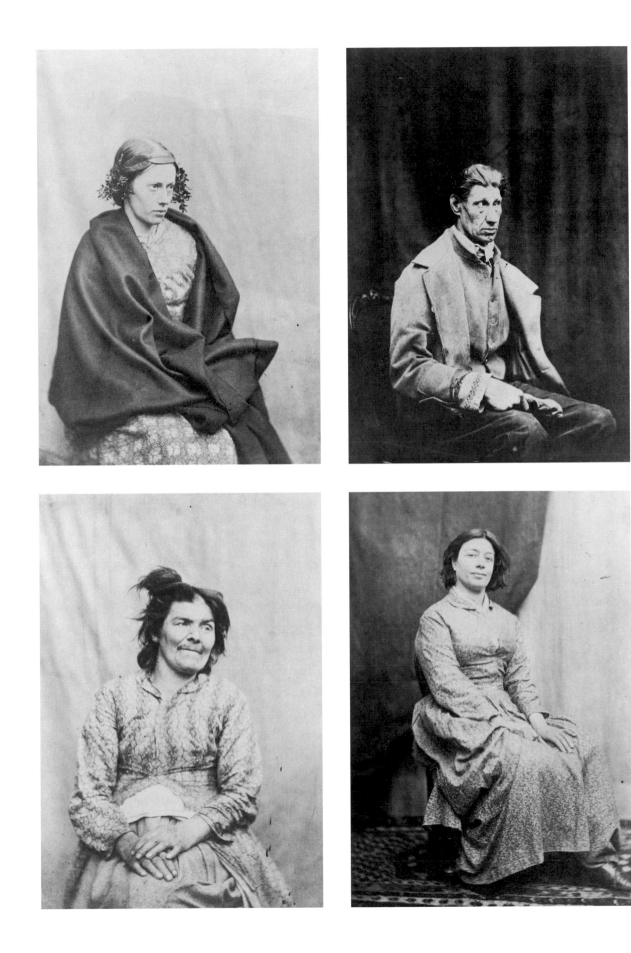

cat. **74**
Jean-Martin Charcot
Diapason Électrique, c.1870
wood, brass and steel

cat. **130** (right)
Théodore Géricault
*Man with the 'Monomania'
of Child Kidnapping*, 1822–23
oil on canvas

tion. The problem of using an artist of Géricault's subtlety is that what we instinctively feel to be the deeply humane nature of the renderings makes the schematic extraction of general signs more, rather than less, difficult. For his part, Géricault would not have needed reminding of the uncomfortable ancient topos that 'there is no poetry [or art] without a touch of madness'.

Unsurprisingly, the art of photography subsequently provided a ready tool for the visual categorizing of the insane. The pioneer was Dr Hugh Welch Diamond who worked in the women's section of the Surrey County Asylum in Twickenham. As a founder-member of the Royal Photographic Society, Diamond possessed the technical skills to assemble images which not only 'arrest the attention of the observer' but also transcend the limitations of verbal description, since, as he claimed, 'each picture speaks for itself with the most marked impression and indicates the exact point which had been reached in the scale of unhappiness'.[60] Staged in the manner of studio portraits, with some of the more 'respectable' of the women wearing their 'best', Diamond aspired to capture for a knowing audience those aspects of expression and demeanour that fell outside the social norms, both in real life and more particularly within the conventions of middle-class portrait photography (cat. 98, pp. 128 – 129).

Diamond's relatively small-scale enterprise was subsequently placed on a more extensive base at the Salpêtrière by Duchenne's successor, Dr Jean-Martin Charcot, who set up a minor industry in visual representations of the insane.[61] Like his French predecessors, Charcot was keenly aware of the pedigree of his enterprise in historic art. He devoted two books specifically to *Demoniacs in Art* (1887) and *Deformities and Sicknesses in Art* (1889), produced in collaboration with Paul Richer, the artist with whom he worked in

a sustained way to perfect the visual iconography of the insane. They trawled historic images for instances where artists had effectively characterized the 'exterior accidents' of complaints that Charcot could now claim to diagnose.

In forging their *New Iconography of the Salpêtrière* from 1862 onwards, Charcot and Richer were joined by Désiré-Magloire Bourneville and Paul Regnard, who from 1878 ran a specialist photographic unit at the hospital. The future historian of medical photography, and the inventor of a number of innovatory cameras, Albert Londe, arrived in 1882 to work under Charcot's wing, and developed a series of sophisticated prescriptions and routines for the systematic taking of photographic records.[62] Whatever doubts arose about Charcot's psychological theories after his death in 1893, there can be no doubt that he set new ambitions for techniques of visual recording in psychiatry, ranging from Richer's eloquent line drawings to sequential and often secret photographs of patients put into cataleptic and transfixed states by various techniques, including musical vibrations (cat. 254; cat. 74, p. 130). It is now easy to see the images as staged and contrived according to the rhetorics of artistic representation which Charcot and Richer knew so well, but they were pleased to think that their images stood in a great tradition of visual truth. Indeed, Charcot was himself the hero of a great 'modern history painting', in which a hysterical female patient dances to order according to the magisterial doctor's tune, in front of a distinguished audience (cat. 67, pp. 178–179).

Rivalling the institutional enterprise of Charcot for the innovative use of photography in reading the signs of the face and body was the highly individualistic British endeavour

cat. **254**
Lethargy: Patient with Diapason
plate XX from
Désiré-Magloire Bourneville and Paul Regnard
Iconographie photographique de la Salpêtrière, vol. III, 1876 – 80

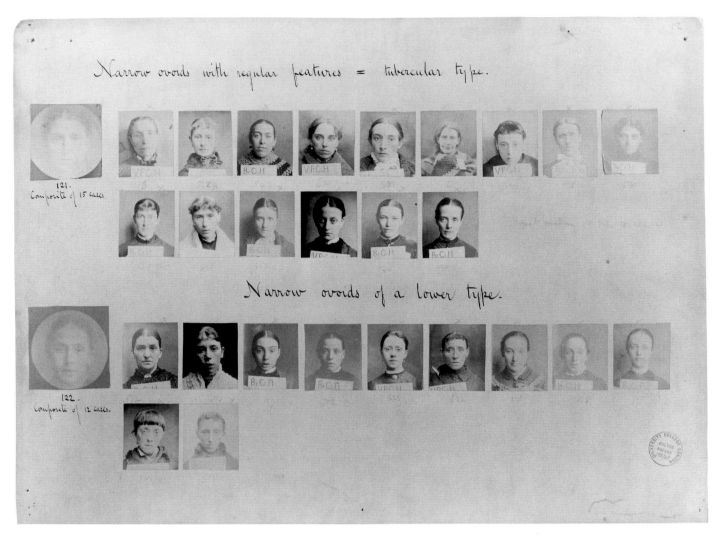

Narrow ovoids with regular features = tubercular type.

121.
Composite of 15 cases.

Narrow ovoids of a lower type.

122.
Composite of 12 cases.

cat. **118**
Francis Galton
Narrow ovoids with regular features: tubercular type, line of 15; narrow ovoids of a lower type, line of 11, 1880s
photographs mounted on card

of Francis Galton, Darwin's cousin.[63] Galton was an obsessive gatherer of information and quantified data, including statistics on which cities in Britain boasted the most beautiful women: Aberdeen ranked lowest, with London seemingly most favoured. He undertook campaigns of craniological measurement with specially devised instruments (cat. 124, p. 132), with results that did not always satisfy his expectations about the correlation between head size and intelligence. Quantified information fed his appetite as a compulsive compiler of rankings, patterns and taxonomic orders. It was the result of his prolific writings, not least his *Inquiry into the Human Faculty* in 1883, that the science of eugenics entered the public realm. In his quest to establish a new science of human nature, Galton not only saw how photography could help him gather eugenic records on a previously unimagined scale, but also envisaged how the very process of the medium itself could be turned to advantage as an experimental procedure.

The story of Galton's use of photography as an analytical tool begins in 1877 when he obtained from the Home Office a series of portraits of convicts (cat. 120). He noted that

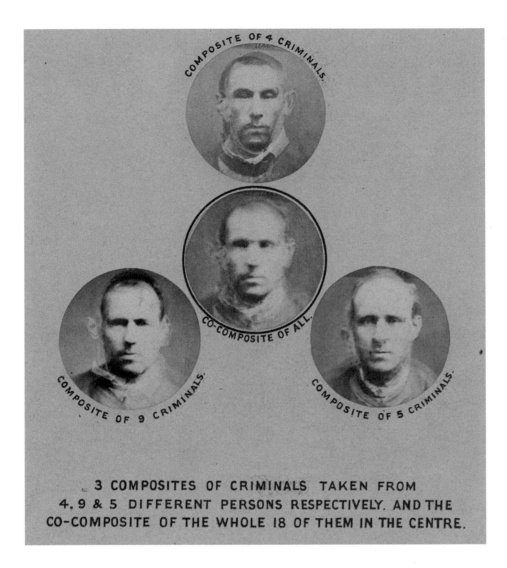

COMPOSITE OF 4 CRIMINALS.
CO-COMPOSITE OF ALL.
COMPOSITE OF 9 CRIMINALS.
COMPOSITE OF 5 CRIMINALS.

3 COMPOSITES OF CRIMINALS TAKEN FROM 4, 9 & 5 DIFFERENT PERSONS RESPECTIVELY. AND THE CO-COMPOSITE OF THE WHOLE 18 OF THEM IN THE CENTRE.

cat. **120**
Francis Galton
3 groups of criminals taken from 4, 9, and 5 different persons respectively and the composite of all 18 of them in the centre, 1880s
photographs mounted on card

'certain natural classes began to appear, some of which were exceedingly marked'. Arranged in three groups – those convicted of killing, felons, and sexual offenders – he was able to see how the types meshed with 'different physiognomic classes'.[64] What he then devised was a way to use photography to extract the characteristic physiognomies from the many individuals in each class – not only criminals but also Westminster schoolboys, Jews, types prone to disease and insanity, and so on. He made multiple, very short exposures on a single photographic plate in such a way, as he hoped, that a synthesis of the characteristic type would automatically emerge (cat. 121, p. 136; cat. 116, p. 137).

Fired with enthusiasm at the potential of his 'objective' method, he collected photographs with untramelled zeal (cat. 117, p. 192). He also devised huge projects to assemble bodies of visual data on British families. Galton explained that 'the act of systematically collecting records of thriving families' was 'to secure the general intellectual acceptance of eugenics as a hopeful and most important study'.[65] Armed with his data, he hoped that science would

cat. **121**
Francis Galton
*6 mounted portraits
from Bethlem Asylum,* 1880s
photographs mounted on card

provide a means to 'co-operate with the workings of nature by securing that humanity shall be represented by the fittest races. What nature does blindly, slowly and ruthlessly, man may do providently, quickly and kindly'. In the light of what happened in later eras, it is easy to be appalled by Galton's ideas, but if we realize that he was trying to make sense for the human race of Darwin's revolutionary theories, his notion that we should tactfully assist the 'survival of the fittest' rather than letting it run a random course becomes more understandable. However, Galton's end was inevitably conceived as ensuring the eugenic heritage of those like himself who embodied the very essence of civilization and higher mental capacities (in the literal sense).

cat. **116**
Francis Galton
*Photographs cut out from
Cambridge boating party
and others,* 1880s

In the context of the story we are tracing, as in so many other stories, Darwin's impact was seminal. As soon as species are not seen as distinct, God-given entities, but as capable of evolving, one into another, the kinds of sequences proposed by Camper and White can be seen in a quite different way. Even for White, there was no question of apes (or ape-like creatures) evolving into men. Once it became possible to think that the Camperian sequence corresponded to an evolutionary 'ascent', two main consequences followed. The most obvious was that those facial types most readily characterized as 'simian' denoted the more 'primitive' races. The second consequence was that it became possible to think that members of any race who behaved in a 'bestial' manner were 'regressive' types or 'throw-backs' whose constitutions had reverted to the condition of their animal ancestors. This was precisely the conclusion drawn by the hugely influential Italian criminologist, Cesare Lombroso, whose *L'uomo delinquente* (*Criminal Man*) of 1876 was translated into most European languages (cat. 223, p. 138).

His daughter, Gina Lombroso Ferrero, in her *Criminal Man According to the Classification of Cesare Lombroso* in 1913, retells the story of the moment of revelation which

cat. **223**
Portraits of Italian and German criminals
table XIII from vol. I
Cesare Lombroso
L'uomo delinquente, studiato in rapporto all'antropologia, alla medicina legale e alle discipline carcerarie, 1889

cat. **222** (above left and right)
Cesare Lombroso
The Skull of Villella,
late 19th century
human skull

her father credited with opening his eyes. Cesare was scrutinizing the skull of Villella (cat. 222), described as the 'Italian Jack the Ripper' when he suddenly found that the truth was staring him in the face:

> At the sight of that skull, I seemed to see all of a sudden, lighted up as a vast plain under a flaming sky, the problem of the nature of the criminal – an atavistic being who reproduces in his person the ferocious instincts of primitive humanity and the inferior animals. Thus were explained anatomically the enormous jaws, high cheek bones,... handle-shaped ears... insensibility to pain, extremely acute sight.[66]

In particular, he observed in Villella's skull that 'where the internal occipital crest or ridge is found in normal individuals,' there was 'a small hollow, which he called *median occipital fossa*... the vermis was so enlarged that it almost formed a small, intermediate cerebellum like that found in the lower types of apes, rodents and birds'. Although this peculiarity, he tells us, is also present in '40 per cent of the Aymara tribe in Bolivia and Peru', it was 'prevalent in criminals' of all races. The criminal, in short, was an 'atavistic' individual, formed in such a primitive or regressive way as to be predisposed to criminal behaviour. Although Lombroso allowed for disease and environment to play roles in the making of a criminal type – particularly in response to robust later challenges to his theory – he clung to the core of his revelation that the criminal exhibited atavistic traits as a residue of our animal origins.

Lombroso recorded, with exaggerated precision, that 45.7 per cent of criminals are prognathous, and that their chins are 'often small and receding, as in children, or else excessively long, short and flat, as in apes'. In an unmistakable echo of the canon of the

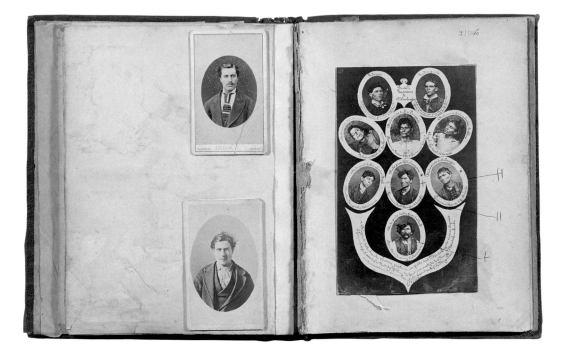

four-square Vitruvian man, the man inscribed in a square and a circle as described by the Roman architect Vitruvius, he notes that 'the span of the arms exceeds the total height, an ape-like character'.[67] The morphological differences could even be discerned at a microscopic level: 'in born criminals and epileptics there is a prevalence of large, pyramidal and polymorphous cells, whereas in normal individuals small, triangular and star-shaped cells predominate' in the cortical strata.[68] Epilepsy was itself a common trait of criminals. Unsurprisingly, photographic records supplied key data on a large scale about the characteristic physiognomic and phrenological signs (cat. 201), though hand-drawn images continued to play their role, particularly when larger-scale images were required (cat. 232).

What Lombroso aspired to create was a foolproof bank of recognizable 'stigmata' that could be used diagnostically in criminal science, even to the extent of helping to determine whether someone accused of a crime was guilty. The 'stigmata' included both the congenital signs of atavism and cultural manifestations of uncivilized tendencies, such as the number of criminals who sported tattoos, decorating their bodies in the manner of 'primitive peoples'. In particular, they tended to exhibit 'obscenity of design and position and furnished also a remarkable proof of the insensibility to pain characteristic of criminals, the parts being tattooed being the most sensitive of the whole body, and therefore left untouched even by savages'.[69] It is conspicuous that many of the 'stigmata', like insensitivity to pain and acute visual and auditory senses in the manner of animals, were the same as those that had been used earlier to stigmatize lower races in anthropology.

A striking testimony to the penetration of Lombrosian theories of atavism was provided, unexpectedly in our eyes, by Edgar Degas's now popular sculpture of the *Little Dancer,*

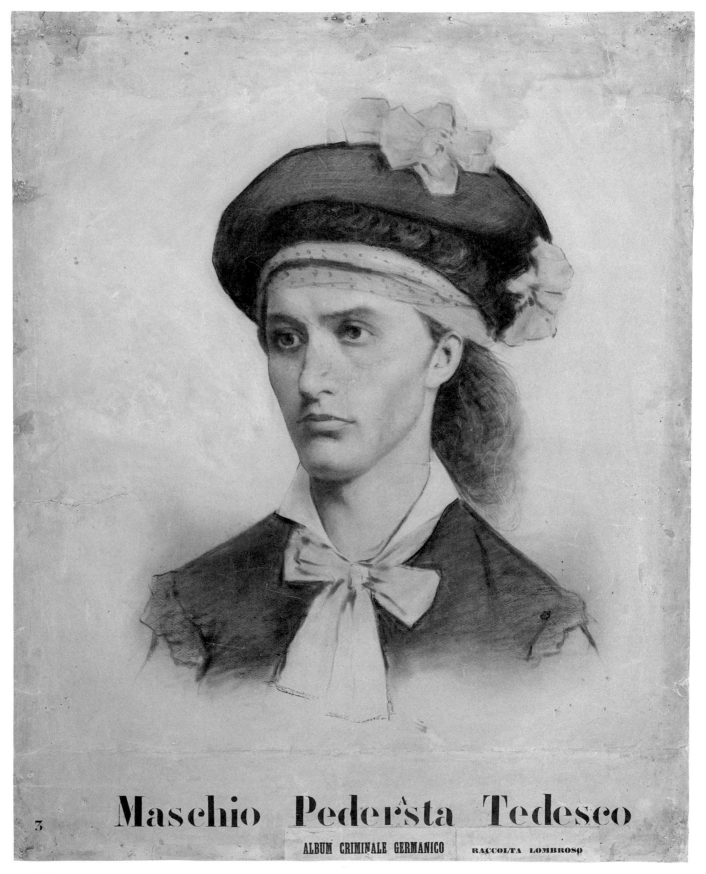

Maschio Pederâsta Tedesco

3

ALBUM CRIMINALE GERMANICO RACCOLTA LOMBROSO

cat. **232**
attributed to Antonio Masello
The German Pederast, late 19th century
charcoal on paper

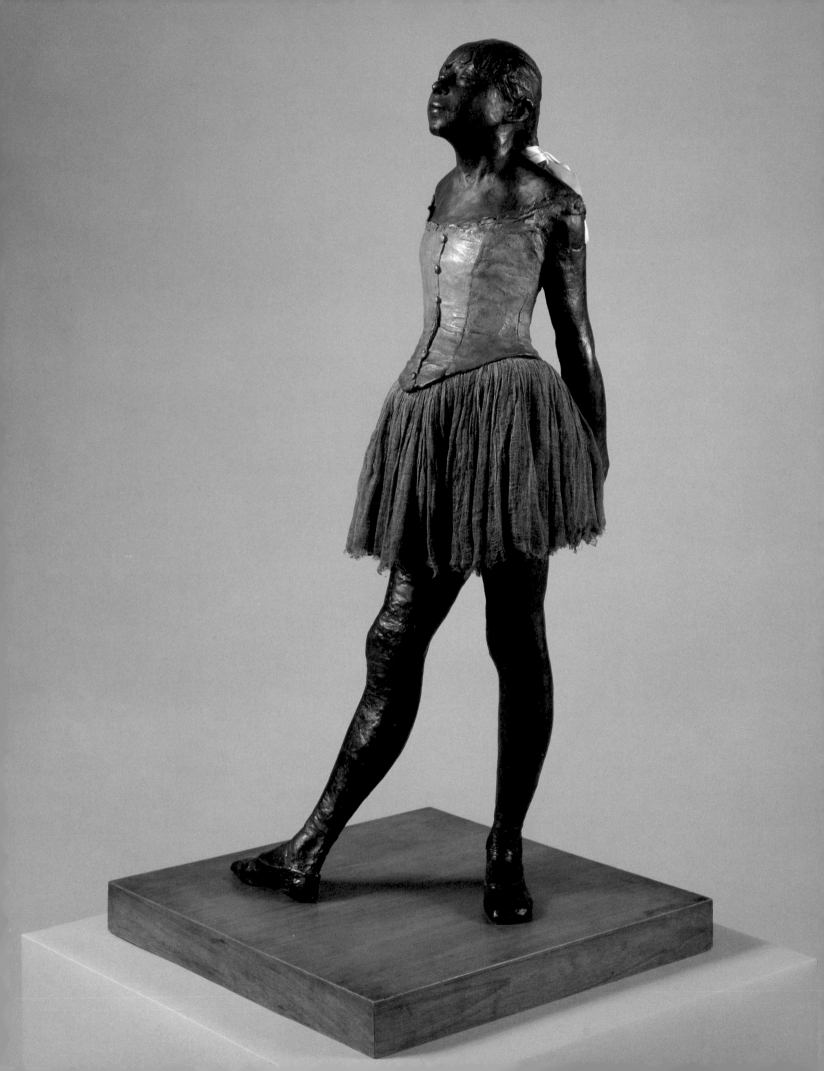

cat. **104**
frontispiece from
Havelock Ellis
The Criminal, 1890

Aged Fourteen (cat. 96). When it was finally exhibited in 1881 within the museum-style vitrine provided by the artist, critics were thoroughly unsettled.[70] One writer declared that the piece was unfit for an art gallery, belonging rather in the Musée Dupuytren, the popular Parisian public display of anatomical and physiognomical sculptures which advertised itself as 'visible for adults of both sexes'. The adverse reaction centred not just upon its original use of colour and real materials (foreshadowed by polychrome anatomical and ethnographic sculpture), but more profoundly by signs the critics readily recognized as signifying the 'primitive' traits of the girl. Particularly conspicuous are her prognathous tendencies and the ignoble cast of her forehead. In case anyone should fail to locate Degas's characterization within the appropriate conceptual framework, the sculpture was exhibited with his own pastel sketches of criminal heads in profile. However, if the context for the identification of the signs is clear, the overall 'message' is less so. Looking at the sculpture, it is difficult to believe intuitively that Degas intended it to speak only of crude racial and eugenic stigmatization. If he had so intended, he could have done so without opening the possibility of the sympathy and pathos which seem invited of the spectator. As with Géricault's portraits, the human subtlety of the characterization in a complex work of art presents an open rather than closed field of interpretation, and the artist would have been aware that he was casting his image into a very different arena for reception than an illustration in a scientific text or even a sculpture in the Musée de l'Homme.

The main public reach of Lombroso's theories and other contemporary ideas of 'degeneracy' and 'regression' can be witnessed in photographic imagery. Havelock Ellis's widely read *The Criminal* of 1890 (cat. 104) played a significant role in persuading readers to think that such traits as homosexuality were clearly inscribed in the photographic

cat. **96** (left)
Edgar Degas
Little Dancer Aged Fourteen
(cast c.1922), 1880–81
painted bronze with muslin
and silk

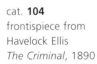

143

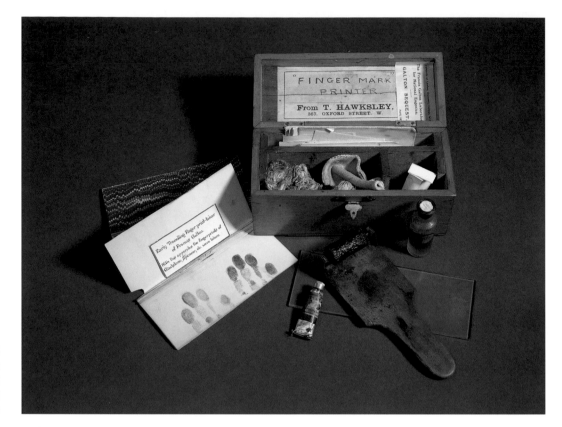

images of inmates in prison. The photographing of criminals became (and still is) a major police industry. The most avid proponent was Alfonse Bertillon at the Préfecture de Police in Paris. A pioneer of finger-printing – a technique invented by the indefatigable Galton (cat. 126) – Bertillon was above all concerned to devise a system whereby those more invariant aspects of a person's appearance might be codified and discerned, even with transformations due to age or deliberate disguise. He instituted a massive programme of photography and measurement of criminals (cat. 50, p. 197) and the scenes of crimes, distributing photographic and written records to such places as points of entry and exit from France, so that criminals in transit or those expelled from France could be apprehended. The iris of the eye was a particularly tell-tale sign of identity, as was ear-shape (cat. 48, pp. 146–147). Beyond such data-banks of individual physiognomic characteristics, Bertillon sought a more general system for the characterization and recognition of facial idiosyncrasies, in a distinctly Lavaterian manner, so that members of the police force would become virtuosi in the mental storing of features (cat. 52). What we now assume to be the standard method of recording the appearance and statistics of an individual was instituted by Bertillon, and applied, as a specimen technique, to his own features (cat. 54, p. 147).

Our own identity photographs, on passports, credit cards, driving licences and such like, use just one half of this technique. Photographed frontally under revealing light and told not to smile, it is difficult to avoid looking 'like a criminal', to use the popular

formulation. Indeed, if our passport photographs were to be reproduced on the front page of a newspaper with a caption indicating that we were notorious murderers, we may wonder how many of us would be confident that our mug-shot would testify to our innocence. It is certain that readers would search for obvious 'stigmata', and it is likely they would find them. This is, whether we like it not, how our scrutiny of faces and facial images works according to deeply ingrained instincts.

cat. **52**
Alphonse Bertillon
Tableau Synoptique des Traits Physiognomiques, 1901–16
photograph

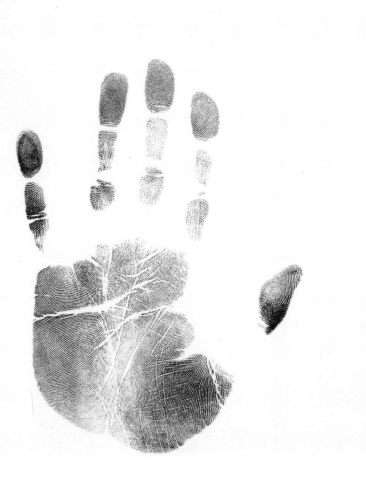

Mallet arthur Joseph
né le 7 mai 1885 Luçon (Vendée)

Main gauche

cat. **46**
Alphonse Bertillon
Left-hand print of Mallet, Arthur Joseph,
7 Aug. 1885
paper

TABLEAU des NUANCES de l'IRIS HUMAIN

ées suivant l'intensité croissante de la Pigmentation jaune-orange d'après la Méthode
de M. Alphonse BERTILLON

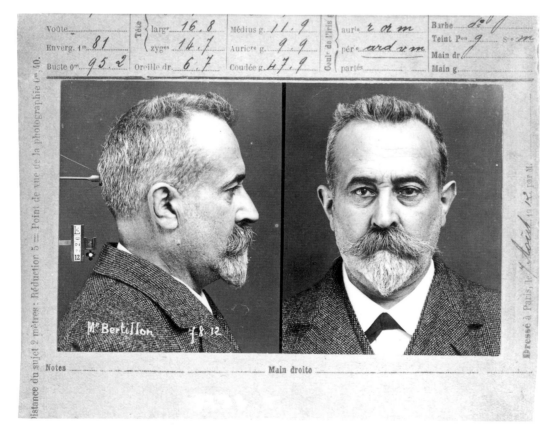

New Bodies

6. Modernist Absence and Post-Modern Presences

The body in art and science, as defined here, is both spectacular and particular. It is a spectacle distinct from what we know as 'Body Art', which emerged in the 1960s and 70s. It is also different from some current 'sensational' art that uses human and animal bodies – generally dissected or revealing their inner functions – to push voyeurism to the limits, exploiting the traditionally macabre side of anatomy. Our angle here is that of the body in art in direct relation to its detailed particularities as pictured in the medical sciences. This, in itself, immediately serves to provide a sharp focus on certain kinds of bodily-oriented art and to rule out others.

In current art practice, the relationship between artists and medical practitioners is very different from that of the Renaissance, Baroque and Enlightenment when fruitful collaborations between artists, draughtsmen and scientists produced rich fields of shared imagery. It is true, though, that artists are now aided by a greater public receptivity to the socio-cultural dimensions of historical and current medicine. This awareness enhances the potential for some artists to engage with research material in the specialist and public domains. Deanna Petherbridge maintains that 'it is only in recent years that medical history has established a *rapprochement* with cultural theory, and medical museums and libraries have become a resource for artists'.[71]

New techniques in art and design have served medical science most prominently in the creation of innovatory imaging techniques to assist the teaching of anatomy. However, this infusion of art into modern medical imagery is the exception to the rule. Whereas historical artists working with doctors could expect to see their images appearing in a medical context, contemporary artists have represented the human body almost exclusively within the contexts for the display of 'Art'. As Ken Arnold says in his review of some contemporary artists operating within the art-science area, their works 'take science as a starting point but they are artworks in their own right, not illustrations of science' (fig. 16).[72]

The distinctions often made between different types of recent art that refer to the human body are not as immediately and easily definable as the stock formulations might suggest. It will therefore be useful to attempt a more systematic differentiation of the specific characteristics of various forms of representations of the body in art, from their virtual disappearance in Modernism through to their re-emergence in Feminist, Conceptual and Performance Art, and a wide variety of post-modern manifestations.

Major trends in modernist art since the late nineteenth and early twentieth centuries found expression through the construction of new spaces and of geometric and abstract forms that moved away from direct representations of the human body. One prominent trend in Modernism had been to eliminate touch and other signs of manual construction. For example, the Rietveld chair, used as a potent symbol of modernist design, referred to the body through its absence, the 'Rietveld joint' bearing no relationship whatsoever to organic joints. However much the legacy of the nineteenth-century art academies

and of French naturalism retained a tacit presence in Cubism and Constructivism, the representation of the human body was no longer central to the art that developed in Europe and the USA from the 1930s to the 1950s, with the most notable exceptions of Dada and Surrealism.

Surrealist and Dada artists worked around ideas that fed on psychological themes and consequently employed representations of the human head and body as metaphors, as bearers of unconscious meaning. The art of the 'insane' was valued by artists such as Max Ernst in the 1920s, and Freud's and Jung's notions more generally exercised a powerful impact on Surrealism. Salvador Dali, the only Surrealist with whom Freud was impressed, acknowledged the theme of the unconscious in relation to his paintings of the human figure in varied states of transformation, as if undergoing putrefaction, petrification, and liquefaction. A number of artists who adhered to the Surrealist aesthetic used psychologically-oriented titles such as *Sensitive Portrait* (Wilhelm Freddie, 1940) and *Romantic Paranoid Landscape* (Vilhelm Bjerke-Petersen, 1936).

The theme of unconscious sexual desires served to reintroduce imagery of the 'medical body', whilst at the same time relegating the representation of women to a ghetto of unresolved references, consistent with the Surrealists' unashamedly chauvinist view of women. The first issue of *La Révolution Surréaliste* illustrated on the cover page a photomontage of the young anarchist and murderess, Germaine Berton, portrayed in the manner of Bertillon and surrounded by photographs of the Surrealists. In their tribute to Germaine Berton, glorified for having killed a royalist, the Surrealists celebrated the

fig. 16
Jeff Wall
Adrian Walker, artist, drawing from a specimen in a laboratory in the Dept. of Anatomy at the University of British Columbia, Vancouver, 1992
photograph
Courtesy: Marian Goodman Gallery, New York
© Jeff Wall, 2000

tension between revolt and despair. In 1928, the Surrealists referred directly to contemporary medical studies and experiments involving women by declaring an interest in hysteria, widely thought at the time to be an exclusively female disorder. It had been famously investigated under hypnosis at the Salpêtrière in Paris by the psychiatrist Jean-Martin Charcot, with whom Freud had studied briefly in 1885. Charcot provides a key point of reference for one of the eight contemporary artists discussed below, Beth B, who refers to the theatrical performances involving women choreographed in hysterical poses by Dr Charcot and his assistants (cat. 67, pp. 178–179).

Notwithstanding the persistence of the human body as a significant subject in Surrealism, the art of the 1950s and '60s did not primarily involve the human body. Taking the classic Gulbenkian-Tate exhibition, *54–64: Painting and Sculpture of a Decade*, as a touchstone, we can see that the minority of artists who represented the human figure in some shape or form fall into some broad categories. Alongside the 'enduring humanists', such as Alberto Giacometti and William Coldstream, were the group of sculptors who abstracted from the human form to greater or lesser degrees, such as Henry Moore, Reg Butler, César, Jean Ipousteguy and Germaine Richier. There were the more figurative of the gestural expressionists, most notably Karel Appel, Asger Jorn and Francis Bacon. The Pop generation was emerging with Roy Lichtenstein, James Rosenquist, Richard Lindner, Peter Blake, David Hockney and Allen Jones. A few 'eccentrics', such as Craigie Aitchison, Richard Diebenkorn and Renato Guttuso seemed not quite to 'fit' anywhere. Direct concern with the anatomical form and physical function of the human body as a traditional vehicle for figurative expression played an extremely minor role in the show as a whole. There was little or no sense of anyone having profited from hours of drawing in the 'life school' or from poring over images of human anatomy.

But this was to change with astonishing rapidity. The body as a physical reality reappeared with ever-increasing vigour from the 1970s. It is worth noting, by means of comparison, that the Tate Modern opened in May 2000 with a section devoted entirely to the body, drawn from the gallery's own collection and including Henri Matisse, August Rodin, Lucian Freud, Sam Taylor-Wood, Sarah Lucas and Bill Viola. Oddly enough, in spite of the fact that the 'nude' in art is clearly one thing, and the 'body' another, as is frequently argued in recent art history, the Tate Modern display has been assessed by Linda Nochlin under the aegis of 'the Nude'. [73] Some new definitions of the body in art may therefore be in order.

References to the human body in art re-emerge in the 1960s and 1970s, first and foremost with feminist art. Referring to the female body in the 1960s was, for an artist, a matter of challenging areas that were traditionally under male control, and the widespread expression, 're-appropriating the body', aligned itself with a campaign for a more general socio-political 're-appropriation'. The taking control of sexuality, reproductive functions and other life-choices co-existed with the setting up of medical family planning clinics, surrounded by heated debates about abortion, and contraception. The male scientist in his white coat became the object of criticism by feminist groups who defined the 'private'

as 'political'. The invasion of the female body by male institutional science, which included the practice of administering electro-shocks particularly to women who showed signs of depression or instability (a practice inherited from nineteenth-century medicine), was strongly criticized by the women's liberation movement. In parallel, the so-called 'opening of mental hospitals', pioneered by the Italian psychiatrist, Franco Basaglia, in Gorizia in the late 1960s and in Trieste in 1971, and, contemporaneously, by R.D. Laing in Britain, were significant events in the history of medical institutions. These were part of a progressive attempt to democratize society in an anti-authoritarian wave that served as a background for an increasing focus on personal liberties. The mounting inclusion of the body in art can be seen as integral to a series of these and other radical shifts in society.

In the 1970s, feminist artists concentrated particularly on the exclusion of women from major exhibitions and the general marginalization of women from history. This concern led a group of women gathered by the American artist, Judy Chicago, to produce *The Dinner Party*, 1974, 1979, an installation of colourful ceramic plates lavishly modelled on female genitalia each dedicated to an illustrious and creative woman in history, and each a floral allegory of the woman's own particular intellectual and artistc constitution. This monument to womanhood was championed as the epitome of feminist art but also criticized as reactionary for its 'ghettoising' of women's creativity and its blanket association with their sexual organs. In any event, the project provided a number of potent signals for women working in the art world. The identification of each illustrious woman with a ceramic plate portraying female genitalia clearly denoted that part of the human body which distinguishes the two sexes and constitutes one of the most ingrained taboos in our society. It may be recalled that women only featured in most of the anatomical 'picture-books' when their reproductive organs needed to be portrayed. Chicago's memorable monument to womanhood employed an image of mutilation that later became a central theme to much feminist art. It may not be coincidental that one of the women artists represented in the *Sensation* exhibition at the Royal Academy of Art in London in 1997, Mona Hatoum, projected an endoscopic image of her own digestive tract on to a ceramic plate laid on a white table-cloth. A great deal of other feminist art blossomed in the 1970s, often finding its expression in the representation of the body. This manifested itself as a part of other forms of art such as performance art and body art, often using photography and film in a strong conceptual connection with the social content of the work.

It was in the 1970s that performance art acquired a status in its own right. The 'performing body' extended into wide territories, involving dance, theatre, and bodily processes, including shock tactics and enacted rituals. Explorations of spatial limits and boundaries led new dancers of the 1960s, such as the Judson Dance Group in New York, to align themselves with minimalist art whilst referring back to Futurism, Dadaism, Isadora Duncan and Rudolf von Laban. Amongst the various forms of 'happenings' of the 1960s and '70s were amalgams of movement, dance and music, epitomized by John Cage's collaboration with Merce Cunningham. Others searched for an alternative spiritual

expression (Yves Klein, Piero Manzoni, and Joseph Beuys). Some dealt with the body in relation to its formal properties, *vis-à-vis* space and time (Vito Acconci and Dennis Oppenheim). Yet others aimed to eliminate the distinction between life and art (Gilbert & George) or concentrated on the more emotive and expressive nature of the human body by staging performances that demanded extreme physical endurance (Hermann Nitsch, Carolee Schneeman, Stuart Brisley, Franko B, Chris Burden, Otto Mühl and the 'Viennese Actionists').

Increasingly body art became the name for that form of performance art in which artists used their own bodies as the protagonists of actions that often included inflicting cuts and wounds on themselves. It spanned representations of both men and women, using photography, film and video to document live performances in a visual language akin to popular culture. Here too the representation of the female body carried strong feminist associations, extending the tactic of violating taboos linked to the sexuality of the female condition. Gina Pane in Paris in 1972 ritualistically cut her back as a way of denouncing self-abuse, observed in psychologically-disturbed patients. Marina Abramovic worked on a comparable theme by exposing her own naked body to the abuse of spectators in a gallery in Naples (*Rhythm O*, 1974). The medium of photography, exploited by nineteenth-century phrenologists, criminologists, anthropologists and psychologists, was used in the early 1970s as a means of representing a distanced view of the artist's body transformed, distorted, fragmented, and mutilated. Valie Export's *Action-Jeans-Genital Panic*, 1969, was conceived as a live action and a poster. Silvia Eiblmayr observed that the artist had used a method that referred to a photographic process:

> Export cut a triangular piece of cloth out of her jeans to reveal the triangle of her sex. As a method then, this completely taboo-surrounded exposure of the female genitalia functioned according to the principle of opposites, which is comparable to the relationship existing between negative-positive in photography.[74]

Many prominent women artists continued throughout the 1980s and '90s to use their own bodies in performances and photography, from Alexis Hunter and Cindy Sherman to Annie Sprinkle, from Elke Krystufek to Orlan, who uses her body, reshaped through cosmetic surgery, as the medium of her art.

Alongside these approaches to the body in art, there are large numbers of disparate artists who cannot be reconciled under one banner, but who have in common the practice of casting from the body to produce sculptures that hover between a new humanism and a self-assured narcissism, most conspicuously George Segal, Duane Hanson, John De Andrea, Gavin Turk, and Antony Gormley.

A prominent stand in post-modern art has been the body as metaphor. Some, like Dorothy Cross, Charles Mason, Kate Smith and Paul Emmanuel, allude to the absence of the body and its traces in a post-modern world, while using a predominantly modernist language. Others adopt the image of the body as a carrier of socio-political signs which

are also gender-related. Leora Farber's elaborately-developed sculptures of women's bodies and medical instruments return to the powerful metaphor of femininity. Jenny Saville's distorted images of her own body allude to prevalent notions of normality and acceptability. Metaphorically the body has also been aligned with other entities in nature, embracing the concept of microcosm and macrocosm, as in Anna Hill's work, *Foetalspace*, 1999, where Doppler and ultrasound technologies are employed to produce a composite image of the earth from space and of the human foetus.

This technical dimension signals the important role in recent body imagery of 'new technologies' and new modes of representation in science. A number of performance artists and dancers have worked with these themes, notably Rosemary Butcher, with her minimal choreographies around the mechanics of the body, Isabelle Choinière, who creates complex dances fusing a real and an electronic body, and Stelarc, with elaborate technological appendages to his own body. Stelarc says of his practice, which originated in the late 1960s with performance and body art:

> I came at the end of the increasing minimalisation of the art object which meant that – after conceptual art – what was left but to turn the body itself into a means of expression? These performances are initiated by this modernist ending.[75]

In 1993, Stelarc produced an 'internal sculpture' inserted inside the stomach cavity, turning the body into a container, 'not for a self or a soul, but simply for a sculpture'.[76] In recent work, Stelarc elaborates on the concept of the 'cyborg', not as a body with implanted metal parts, but as a system of 'a multiplicity of bodies – spatially separated – but electronically connected'. [77]

The 'shock factor' blossomed in the commercially successful art of the 1980s and '90s. Jake and Dinos Chapman's monstrous bodies, collaged from artistically-engineered body parts, make reference to current developments in genetic engineering, with explicit erotic nuances. They were in a cordoned-off space at the *Sensation* exhibition at the Royal Academy in 1997 to ward off the innocent eye of the uninitiated visitor. Potentially offensive body mutilations and dissections, albeit of animals, have consistently helped to position Damien Hirst in the most sensational of places in the current pantheon. The majority of contemporary viewers, unaccustomed to anatomical demonstrations, experience a sense of wonder and perhaps revulsion, whilst a trained eye would distinguish between Hirst's rough butchery and the clean precision of professional dissection. The heavy-handed nature of his procedures stands in sharp contrast to the latest scientific methods, and even to the best historical techniques of sectional anatomy. Hirst's success resides in the sort of instant impact that is efficacious within the contemporary art scene. A fair amount of blood and gore, served with a good dose of cynicism and irony, are, at one level, functional for any display that courts publicity. It was just so, but in a different context, at the time of the public anatomies from the Renaissance to the eighteenth century when equal measures of fascination and repulsion guided the spectator. [78]

Even though the sensational body is not deeply involved with scientific concerns, artists such as Hirst or Joel-Peter Witkin are, at a public level, perceived to represent a *rapprochement* of art and science. Witkin's photographs centre on the motifs of death and the *memento mori*, as do Hirst's installations involving butterflies and flies. Witkin's photographs of dramatically-staged scenes including mutilated and dissected bodies were set alongside works by Sally Mann, Jenny Saville, John Coplans, Melanie Manchot and Andreas Serrano amongst others in a recent television programme, *Vile Bodies*, with its accompanying book and exhibition.[79] In a comparable vein, *Psycho: Art and Anatomy*, an exhibition held at the Anne Faggionato Gallery in London in 2000, brought together anatomy and horror in one broad sweep, associating cannibalism with medical dissection, and included images of corpses from Buchenwald, bodies portrayed by Francis Bacon, and, of course, those by Joel-Peter Witkin and Damien Hirst. The question of the intention of the display is crucial in the case of shocking or horrific material. It seems that the contemporary art world relishes the consequences of infringing bodily taboos.

A different route lies in a more personal and intimate approach, particularly in recording the medical conditions of the artists themselves. Jo Spence, whose breast cancer forced her to re-evaluate her health and 'normal' body, used photography to chart the changes which ensued with her illness and mastectomy. Maud Saulter filmed her own hysterectomy, whilst John Bellany recorded the aftermath of his liver transplant from his hospital bed, using the media of painting and drawing. Susan Hiller traced the time and progression of her pregnancy in *10 Months-Six*, 1977–78, while Melanie Manchot questioned the concept of medical authority by documenting the fluctuations of her own pregnancy. Manchot was following in the footsteps of Mary Kelly who, in the 1970s, produced her *Post-Partum Document*, 1973–78, with the explicit aim of assuming personal control over her maternity. Donald Rodney's work centred on the inherited blood disorder almost exclusive to Afro-Caribbean people, sickle-cell anaemia, that had affected him from infancy until his death in 1998. His *Visceral Canker*, 1990, became the object of a debate with the local council which, on ethical grounds, refused permission to issue the artist with real blood to be pumped in the art work. Questions of public morality and medical ethics become central to an art that operates in fields other than the traditionally prescribed ones.

With the shocking advent of AIDS in the 1980s and '90s, a number of artists felt compelled to produce visual commentaries on the HIV virus and its ravages. They stressed the difference between the physical and emotional impact of the disease (Richard Sawdon-Smith), or emphasized the social and personal consequences of the epidemic. In this latter group, Donald Moffett, David Wojnarowicz, Adam Rolston, Robert Farber, Felix Gonzalez-Torres, Keith Haring, Jenny Holzer and the collective which went under the name of Gran Fury are notable examples.[80]

A number of art-science organizations and scientific and academic institutions in Britain, such as the Wellcome Trust, the Gulbenkian Foundation, the Royal Society,

Imperial College and the Medical Research Council, have recently sought to stimulate work by artists who are prepared to cross boundaries between the two disciplines. For example, *Body Visual*, promoted by the Arts Catalyst in 1996, included work by Helen Chadwick, Letizia Galli and Donald Rodney, shown alongside contributions by scientists. The exhibition was dedicated to the memory of Helen Chadwick, who died in 1996. Her work, which included elements of performance, was almost invariably about the body, often exploiting metaphorical and *memento mori* associations. In the last years of her life Chadwick also worked specifically in relation to medical themes, profiting from a residency at King's College Hospital, where she produced a work based on the science of *in vitro* fertilization, setting up an analogy between the artificially-fertilized egg and a fabricated work of art (*Nebula*, 1996).

A number of contemporary artists have been involved in sustained dialogues, direct or elliptical, with the imagery and techniques of medicine seen and felt through our normal, unaided sensory apparatus, in such a way as to evoke direct resonances with our common experiences. We can look to the works of Mark Francis, Julie Roberts and Annie Cattrell as testimony to the vitality and variety of current practice across the art-science boundaries. The eight artists involved in the *Spectacular Bodies* exhibition (2000–01) – John Isaacs, Katharine Dowson, Marc Quinn, Beth B, Christine Borland, Gerhard Lang, Tony Oursler and Bill Viola – have researched the history of science, and scrutinized medical texts and practices. Their closeness to the world of science is, in some instances, underpinned by a period of study in biology, medicine or psychology, or by an association with members of the medical profession. Their interest in scientific and medical issues is often fuelled by the belief that science should not be restricted to a 'neutralized' scholarly context'.[81] They are the kind of artists who 'are deliberately challenging the professed dispassion of museological discourse... and are subjecting museological material to new kinds of public display within the aestheticized but critical space of an art gallery.'[82]

7. New Eyes

John Isaacs

The concept of anatomy, and the method and practice of human dissection, are seen by John Isaacs as forming not only the basis of medical science, but also as emblematic of all Western human thought and activity. The prevailing concept of a fragmentary world, with constituent parts coming together to form a whole, is the focus of much of the artist's critical enquiry. Isaacs believes that language functions as a contributing unifying factor, naming the parts in an attempt to present a complete picture. He views the early acts of anatomical investigations, which were inextricably linked with the act of naming, as somewhat innocent:

> Rembrandt's *Anatomy of Dr Tulp*, portraying the surgeons in the 'act' of dissection – the early stages of learning the 'language' of human anatomy – is permeated with a lost innocence when compared to the contemporary scientist's fluency in gene sequencing, and the range of medical techniques and knowledge available to doctors today. [83]

Isaacs's *The Cyclical Development of Stasis*, 2000, merges the image of the historical anatomical theatre in Padua with that of a contemporary, state-of-the-art theatre in Essen as seen from the point of view of the corpse (cat. 151, pp. 160–163). The work encompasses 'both positions of objectivity and subjectivity, the dissector and the dissected'. Transported into the space of the anatomical theatres filmed by Isaacs, 'the viewer will be looking from the position of the dissection table'. Isaacs maintains that:

> the fundamental difference between art and science is that the methodology of science describes and institutionalizes the 'other', while art naturally leans more towards an articulation of 'self', but, as can be seen in Rembrandt's painting, both are prone to equal vanity.[84] (fig. 3, p. 25)

Dissection – taking apart in order to classify – was fundamental to the birth of modern science, often in conflict with religious imperatives yet in harmony with other forms of intellectual enquiry. Isaacs's own investigations, moving from biology to art, speak powerfully of the fact that, as Ken Arnold writes, 'both art and science are expressions of a common intellectual curiosity – the profound human desire to know things, which often starts with the possibility of envisioning and therefore of making a picture of them'.[85] Taking things apart, making pictures of them, pointing at them and reciting their names: the ritualization of knowledge and the visualization of ourselves begins, according to Isaacs, with what Jonathan Sawday defines as the 'dissective culture'.[86]

For Isaacs, the process of making art is about constructing 'parts', fragments of realities to be re-assembled in different contexts. In works that precede *The Cyclical Development*

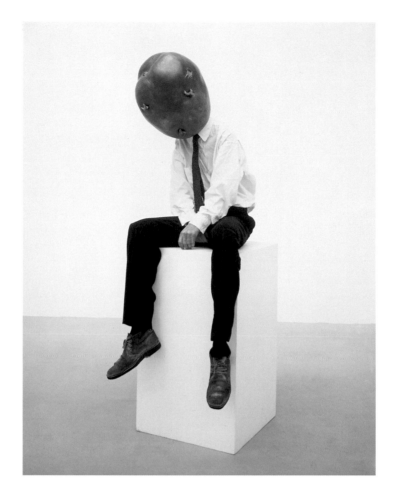

fig. 17
John Isaacs
In Advance of the Institution,
1996
wax, fibre glass, cloth;
185.5 × 66 × 82 cm
Saatchi Gallery
© John Isaacs, 2000
Photo © Stephen White, 2000

of Stasis (cat. 150, pp. 160–163), Isaacs formed figures and body parts out of wax moulded from real bodies, sometimes his own. Body parts identifiable as human invite us to recognize ourselves in them. An unsettling differentiation begins with parts of the body that do not resemble our own, as in, *Say it isn't so*, 1994, where a white-coated scientist possesses a head cast from the body of a plucked chicken or, in *In Advance of the Institution*, where a clothed male figure seated on a white plinth displays a potato-shaped head (fig. 17). This coming-and-going of the familiar and the odd is crucial to Isaacs who views identity as problematic and dialectical in nature.

Wax effigies, used prolifically throughout history to represent the human body, exude an uncanny air of reality.[87] Isaacs's recent encounter with the waxes at the Museo La Specola, in Florence, proved to be of great relevance to his own working methods and ideas. The historical waxes were hybrid objects, situated half way between art and science, modelled by well-established artists under the guidance of anatomists, commissioned and avidly collected by patrons (the Habsburg and the Medici in Vienna and Florence). The highly-theatrical settings – particularly of the life-size anatomical waxes (fig. 18, p. 164) – also inspired Isaacs whose figures are set within carefully constructed scenarios. Isaacs's own anatomical wax, *A Necessary Change of Heart*, 2000, (cat. 151, p. 164), composed of parts cast from his own body, speaks of the ambivalence that an outgoing,

cat. **150** (following four pages)
stills from John Isaacs
*The Cyclical Development
of Stasis*, 2000
video installation with sound

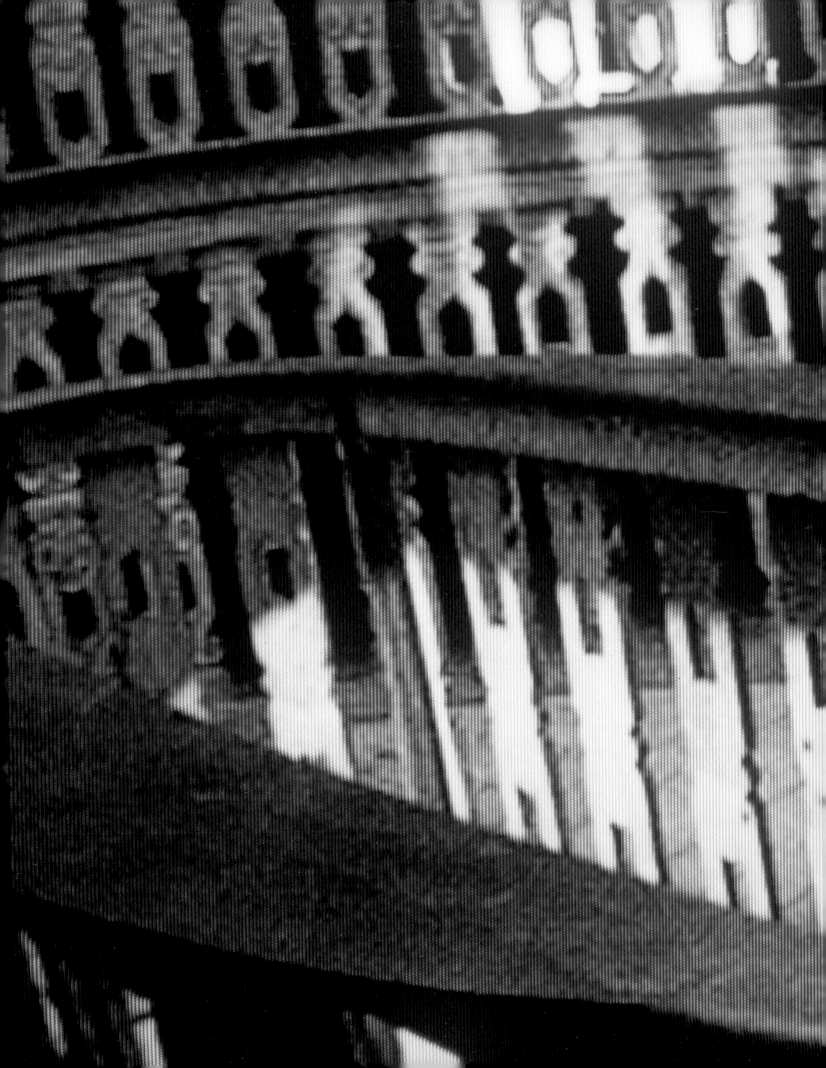

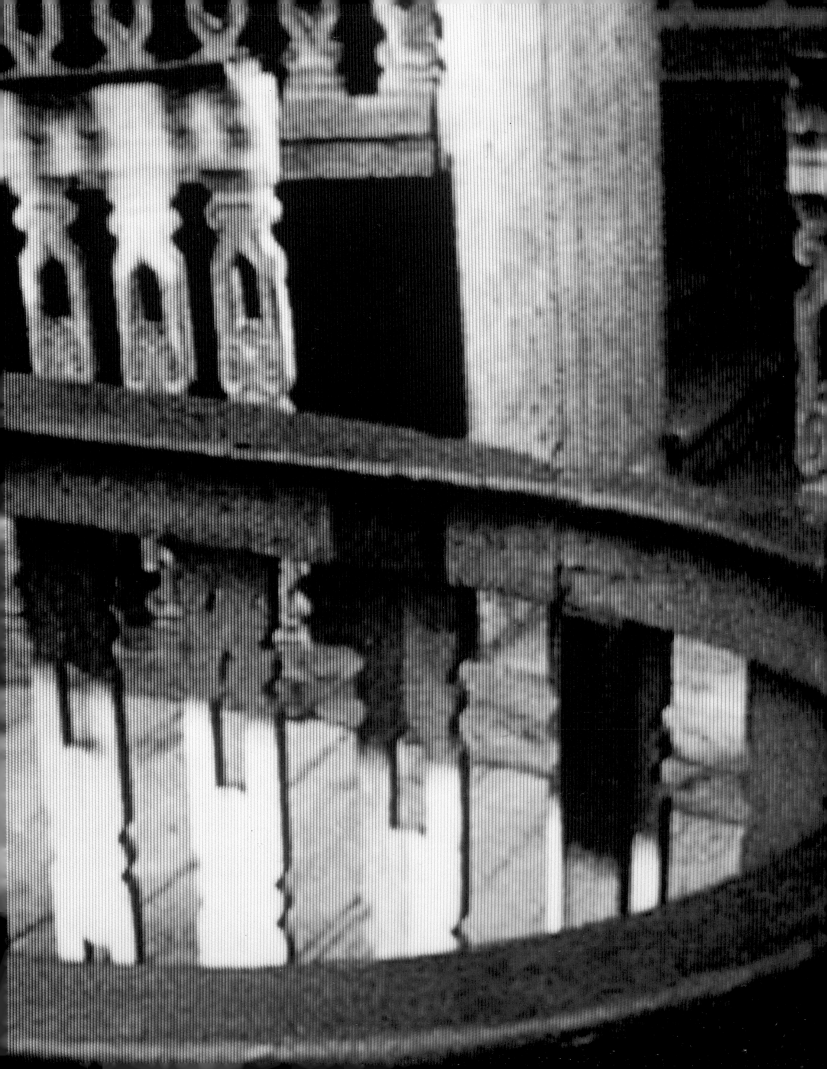

cat. **151**
John Isaacs
*A Necessary Change
of Heart*, 2000
wax

young and healthy man has towards life. Created not as a commission but as a response to his research visit to Florence and Padua, *A Necessary Change of Heart* must be viewed as a remarkable and successful attempt at not only mastering a sophisticated technique but also transferring a representational mode into a contemporary context, where the artist is both the model and the modeller. When first shown in Basel, the figure was set against a backdrop referring to colonial conquests, the naming of the parts of the land to mark territorial appropriation being likened to the naming of parts of the body in a comparable quest for ownership. Camporesi has appositely observed that in the Renaissance:

> the body of man becomes a land of edifying discovery and devout mission, a tangible and immobile New World open to meditation and exploration. [88]

The analogy between the discovery of the body and that of the land reigned undisturbed in the sixteenth and seventeenth centuries, forming a crucial framework for cosmographers and anatomists. Atlases and anatomical treatises both employed the comprehensive rubrics of '*theatrum*' and '*fabrica*'.[89] In his anatomical book, *De Humani Corporis Fabrica* (Venice, 1627), Adrianus Spigelius 'asserts the necessity of a "mental map" for the body as the enabling condition of correct knowledge', as observed by Caterina Albano:

fig. 18
Clemente Susini
Reclining male figure,
late 18th century
wax
cat. XXV, 445
'La Specola' Museum of Natural
History of the University of
Florence
Photo © Saulo Bambi

> A correspondence is established between the whole and the parts, between the inside and outside, allowing this somotographia of corporeality to serve as a preliminary mental map of knowledge. [90]

164

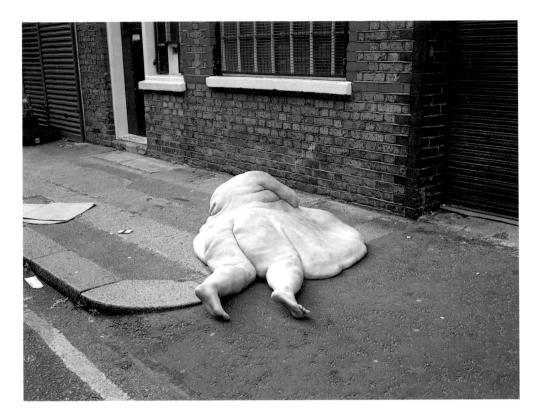

fig. 19
John Isaacs
The Matrix of Amnesia, 1997
mixed media (wax and resin);
200 × 130 × 60 cm
Courtesy Olbrich Collection
© John Isaacs, 2000
Photo © Chris Draper, 2000

It is intriguing to look back at other works by Isaacs in this light. In his *The Matrix of Amnesia*, 1997, (fig. 19) the artist places a 'primordial' body in different locations, thus changing meaning and connotations. His ingenious ostrich sculpture, *Untitled (Ostrich)*, 1993, (fig. 20), modelled as a life-size figure in mixed media, feathers and all, buries its head in the sand exposing its rear end. A revolving terrestrial globe, placed within the animal's body, is viewed through the anus by means of a reversed telescopic lens. Ironically here, Isaacs's figure literally *embodies* the analogy between geography, anatomy, and the concept of distant lands, the ostrich as an emblem of exoticism, and the lens as the tool of discovery. Interestingly, in the case of what is hailed as the most triumphant scientific enterprise of our time, the 'human genome project', analogies with 'mapping' and 'God's' (or nature's) language of life continue to be absolutely central.

In *A Necessary Change of Heart* (cat. 151), the arresting and unsettling nature of the waxen body, the skinned corpse, with the suggestion of fresh blood – in contrast to the 'blood-less' historical waxes – and the mutilation of the leg are, according to Isaacs, part of the sculptural choices made in the process of forming the figure. The work must be seen first and foremost as an extraordinary reference to the historical waxes, drawing in all the connotations that those carried, and accordingly avoiding its more obvious location within the contemporary realm of the 'sensational body'.

fig. 20
John Isaacs
Untitled (Ostrich), 1993
mixed media, electric motor,
light bulb;
140 × 100 × 80 cm
Private Collection, Basel
© John Isaacs, 2000
Photo © Heinz Pelz, 2000

165

Katharine Dowson

Another fundamental concept that runs through the history of the representation of the human body is that of the body as a small world, as a symbol of microcosm and macrocosm. In the introduction to his *Microcosmographia* (1615) – a synopsis of earlier anatomical texts – Helkiah Crooke explains that the body is:

> an epitome of the whole creation [because its] admirable structure and accomplished perfection… carrieth in it a representation of all the most glorious and perfect works of God. [91]

Before Crooke, Leonardo da Vinci had written extensively of analogies between the structure of the human body and the natural world, some of which had been adopted earlier by Mondinus. At work on his dissections, Leonardo observed that:

> the whole plant has its origin in its thickest part and in consequence the veins have their origin in the heart where it is of the greatest thickness…and this is to be seen through experience in the germination of a peach which arises from its stone.[92]

Other powerful analogies describe blood vessels as irrigating and maintaining a supply of 'vivifying' humours to all regions of the body, and use phrases such as 'the breathing of this terrestrial machine' and 'the veins of the waters'.[93]

The body as a 'lesser world' has consistently engaged Katharine Dowson (fig. 21). The artist refers to the texture of internal organs, with a textile analogy, as the 'lining and padding' of the human body, which she compares to stones, corals and vegetation. The materials she employs – wax, resin, silicon, glass and latex – and the ways she presents

fig. 21
Katharine Dowson
Spine, 1992
resin, glass, wax, wire, silicon; 91 × 36 cm
© Katharine Dowson, 2000

fig. 22
Katharine Dowson
Examine, 1995
resin, wax, glass, magnifier, light; 48.5 × 37 × 28 cm
© Katharine Dowson, 2000

them to form her sculptures, recall medical laboratory contexts and anatomical museum displays (figs. 21, 22 and 23). [94]

Dowson is captivated by Leonardo's anatomical drawings, his visual stylization and his ability to isolate and represent individual blood vessels, muscles and bones. As an artist who considers the visual field central to the acquisition of knowledge, Dowson values greatly the vision and visualization epitomized by Renaissance art and science, and the pre-eminence accorded to sight by Leonardo amongst others.[95]

In her fundamentally ocular enquiry, drawing upon comparisons and metaphors, Dowson made an analogy between landscape and the human body when she first saw 18th century life-size anatomical wax figures by Clemente Susini in Florence. She identified fluids and rivers in the life-size male figure that displays the lymphatic system – referring to 'the skin pealed back revealing a whole landscape'.[96] The artist collects a variety of images and materials from the natural world, compiling a sort of 'cabinet of curiosity' from which she composes some of her installations. Her assemblages of natural forms employ analogical criteria: the bone of a Nile perch is placed side-by-side with a young palm leaf, emphasizing how many forms, in their morphogenesis, share similar characteristics.

Dowson's reaction to the way in which body parts have historically been preserved in fluids and displayed under glass in the context of small private museums in the houses of anatomists, princes and gentlemen, shares the wonder of the original collectors. In the course of her recent research, she came across Dr Frederik Ruysch who published a richly-illustrated ten-volume catalogue of his own collection, the *Thesaurus Anatomicus* (1690).[97] Ruysch's specimens, viewed by himself as 'artworks', 'were considered legitimate works of art and purchased for large sums of money by collectors such as Peter the Great and Hans Sloane'.[98]

The displaying of body parts in artificial combinations together with stones, spiders and other natural elements, both animal and botanical, interests Dowson beyond the specific historical context. Her belief that diverse cultural factors intervene to invert our perceptions underscores much of her thinking. The skinned corpse of a dog hanging outside a restaurant in Canton is viewed differently by Westerners who are familiar with the public display of carcasses of cows, sheep and chickens, but not of pets (fig. 24, p. 168). A growth on a tree trunk or on a rock is perceived differently from a cancerous growth on human tissue. Reversing perceptions alters our thinking and challenges preconceptions, certainties and dogmas. Beauty and horror can serve as two sides of the same coin, which can be flipped either way by acts of viewing. According to Dowson, Ruysch's anatomized babies-in-bottles belong to this very view of the world: 'fragile and at the same time robust, life is never perfect; that is its beauty'.

The use of lenses and glass in Dowson's work also relates to the question of altered perceptions. Focusing on different combinations of lenses, life can be looked at in detail or as a whole. Dowson treasures medical and broadly scientific images produced with the aid of new technologies which allow us to picture the inside of the body and the

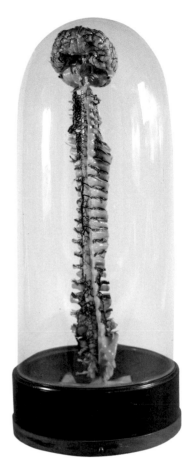

fig. 23
F. Calenzuoli
Spinal cord
Museo di Anatomia Umana.
Università di Torino
Photo © Roberto Goffi, 2000

depths of the waters with non-invasive imaging techniques. 'Supernovas' exploding in space resemble, to Dowson's eye, the egg 'exploding' from the human ovary. She produces evocative shadows cast from the bones adjacent to the soft tissue, in an echo of radiography revealing the hidden world inside us.

Pia Mater, 2000, (cat. 99) is composed of vertebra-like forms in blown glass suspended in space. The title derives from the *pia mater* (tender mother), the delicate, permeable membrane which envelops the brain and the spinal cord. The sculpture is lit by white fibre-optic beams that infiltrate it and suggest new associations of life through the creation of mobile shadows. The shadows cast from the glass brain evoke the electrical processes that enable thought. Glass represents for Dowson the very essence of transparent forms, simultaneously holding on to the external form and revealing its interior structure. The glass shapes are made by the artist to contain imperfections – opaque traces of elements, pigments, sand and other materials.

As in a preceding work, *In Vitro*, 1996–98, which also uses glass and laser lights, the interior inner world of the glass is made visible. The shadows move, echoing the act of breathing. Dowson's unique way of preserving in glass, light and shadow the images of the 'inner life' she so passionately speaks of, recalls Ruysch, who addresses his readers by stating that he:

carefully dissected and preserved numerous human and animal bodies, encountering fleshy as well as softer tissues (such as the brain) to reveal all the splendid inner details to the eye. [99]

Marc Quinn

Revealing the inner beauty of living bodies through the preservation of dead ones was Ruysch's specialism. Human bones, tissues and bladder-stones were used to compose his extravagant 'skeletal tableaux', now extant only in printed form. Here, handkerchiefs are held by the little skeletons as if to wipe away their metaphorical tears (cat. 261, p. 41). Ribbons and laces (in his preparations of new-born babies in bottles) were included to add grace to the body parts. Unusual *memento mori* devices, such as a scorpion crushed by an infant's foot, were intended to remind us of the fallibility of the human condition, vice and illness, the brevity and instability of life, and the inevitability of death (reflected respectively in prostitution and syphilis, high infant and prenatal mortality rates) (cat. 260, p. 63 and fig. 26). A head cast in six pints of his own frozen blood, *Self*, 1991, (fig. 25) is one of Marc Quinn's ways of preserving the form and the substance of life, providing a sort of contemporary *memento mori*. Unlike medical preparations, depending for their survival on the 'mummifying' properties of formaldehyde or Ruysch's balsamic fluid, Quinn's head sculpture depends on its own support system:

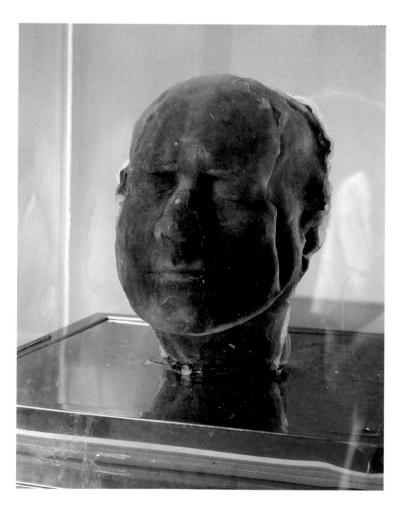

fig. 25
Marc Quinn
Self, 1991
blood, stainless steel, perspex,
refrigeration equipment;
208 × 63 × 63 cm
The Saatchi Gallery, London
© Marc Quinn, 2000

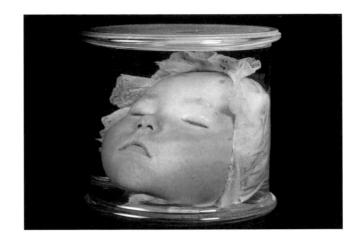

The thing about the preservation of *Self* is that it is reversable. It is simply kept frozen and thus totally dependent every moment on the freezing mechanism to keep its form.

That is dependent on the infrastructure of electrical supply, so it is kept preserved by our society, one moment at a time. [100]

The substance of our existence has constantly been the subject of study and investigation of science and philosophy. Contemporary artists, like concrete philosophers, realize installations with materials that echo and reflect their ideas. Ruysch's 'installations' were considered works of science and art, and were viewed by large numbers of people in specially-made museums (fig. 26). An undoubtedly common element in Ruysch's and Quinn's work is that of the curiosity and wonder raised by assemblages which use human form and substance as indivisible and 'immortal'.

Quinn's 'alchemical' repertoire extends to head-shaped frozen coconut milk (coconut milk is employed in emergency transfusions for its compatibility with human plasma), and bread dough baked in the shape of human hands. It also includes a latex cast from the artist's body resembling an empty skin, and a life-size body sculpture which slowly evaporates, transferring the substance of the sculpture to the lungs of the viewers. This range of media serves to confirm Quinn's fascination with the representation of the human body through associated transformative processes.

Quinn's work refers to the preservation of life's most fundamental characteristics, even when it does not directly depict the human body, as is the case of *Eternal Spring (red)*, 1998 (cat. 252, p. 173). The freshness of a luscious bunch of red flowers is preserved in a frozen state, immersed in totally transparent silicon. Petals and leaves appear untainted by time and atmosphere, alert and fresh, as if they had only just been picked. Julie Hansen's words on Ruysch's specimen might equally refer to Quinn's installation:

always perfect, without wrinkles and discoloration [Ruysch's preparations] appeared to defy death… In this way Nature was not merely imitated, but improved with artifice. In addition, each specimen was required to be displayed in an artful and surprising fashion that revealed the skill on behalf of the collector. [101]

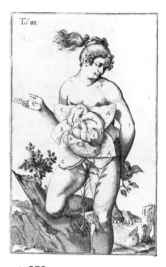

cat. **273**
Female figure with open uterus
table IV from
Adrianus Spigelius
De Formato Foetu, 1626

Earlier analogies between botany and human anatomy are common, particularly in relation to women's bodies. In *De Formato Foetu*, by the Belgian anatomist Adrianus Spigelius (1627), illustrated with Giulio Casserio's plates, the female abdomen is shown open like the petals of a flower, complete with stem and leaves, set in a watery landscape, revealing its inner organs arranged as seeds and stamens (cat. 273). As Caterina Albano points out:

> The conceptual orders of both geography and anatomy find expression in their allegorical use of the female body. In Spigelius' *De Formato Foetu* (1627) this process is exemplified in four plates showing the gradual uncovering of the uterus. The skin of the abdomen and the placenta open to the viewer's gaze like an unfurling flower. Spigelius imagines the uterus as a field whose ground needs to be properly fertilised and irrigated: a secluded plane crossed by a large navigable river forms the background landscape to a literally and emblematic blooming womb.[102]

Allusions to modesty and reproductive functions were common both in flowers and women's bodies. These counteracted the 'darker' associations of women's bodies, particularly their genitalia, as dangerous and devilish. Some of Clemente Susini's obstetric waxes in Cagliari emphasize the shape of the ovarian tube opening up as a small flower.[103] This feature bore the anatomical term of *morsus diaboli* (the 'devil's bite') through its comparison with the root of a plant with the botanical name of *scabiosa succisa*.

Marc Quinn's own 'artifices' span the form of the human body, and the expression of the face, embracing our other main focus, the human head. *Emotional Detox: The Seven Deadly Sins*, 1994–95, (cat. 253, p. 175), a series of sculptures realized by Quinn in cast lead and wax, recalls historical *écorché* statues on the one hand (cat. 110, p. 79 and cat. 76, p. 78), and Messerschmidt's busts on the other (cat. 235, p. 174). Also redolent of Messerschmidt's heads are Quinn's series of busts, some in bronze, others in baked bread dough, *Louis XVI and Marie Antoinette*, 1989, *Character Head*, 1989, and *Dr. Pangloss*, 1990. Messerschmidt's 'expression heads' were private works realized by the artist alongside public commissions of busts of members of the Austrian Imperial Court and the nobility. Their essentially personal nature was linked by contemporary commentators to the sculptor's own mental instability, and his belief that the 'evil spirit of proportion' could be fought away by pinching the very parts of his body affected, according to a sort of 'spiritual' homeopathy.[103a] Staring into a mirror, the artist recorded his extreme facial contractions in sixty-four varieties of grimacing heads (of which forty-nine have survived).

Messerschmidt's own tortured expressions, his face wrenched and pinched, left, right and centre, are the register of his human condition in its raw, unmitigated form. Both Messerschmidt's heads and Quinn's *Emotional Detox*, look as if they were made to 'exorcise' their inner 'spirit' or 'demons'. In this, they share much with one of Beth B's crucial concerns, namely the old view of hysteria as a 'demonic possession'.

cat. **252** (right)
Marc Quinn
Eternal Spring (red), 1998
stainless steel, glass, frozen
silicon, flowers and
refrigeration equipment

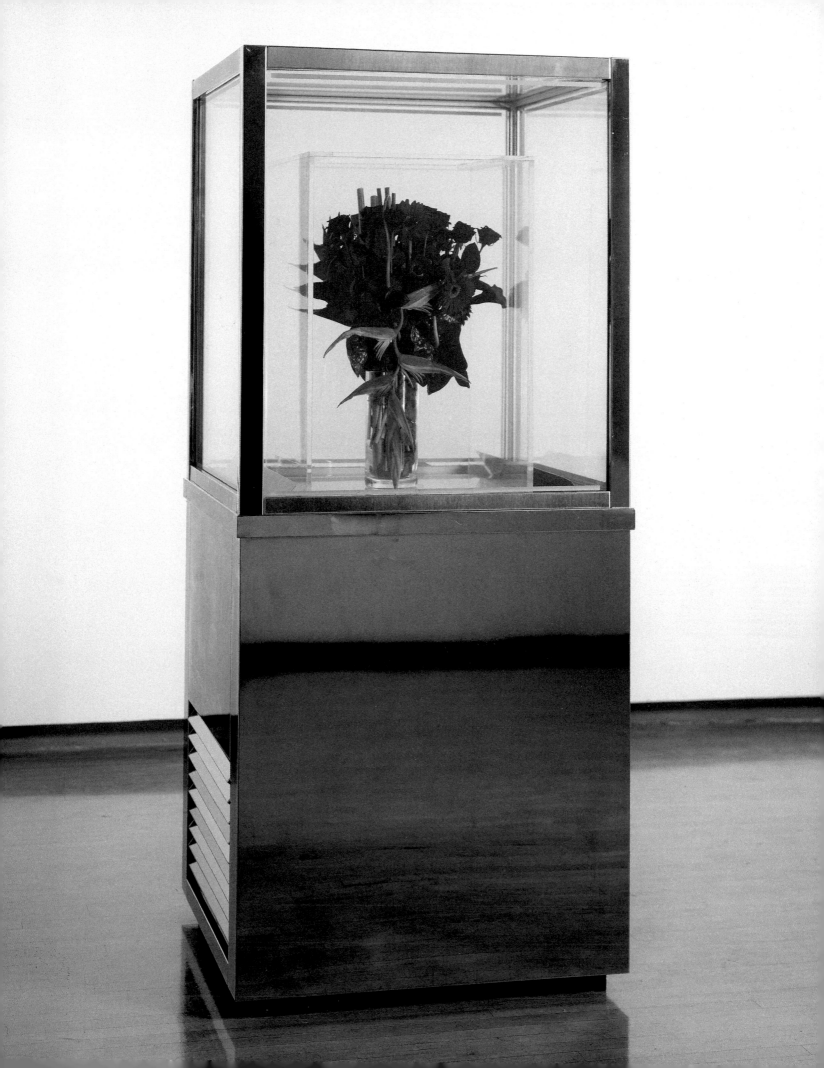

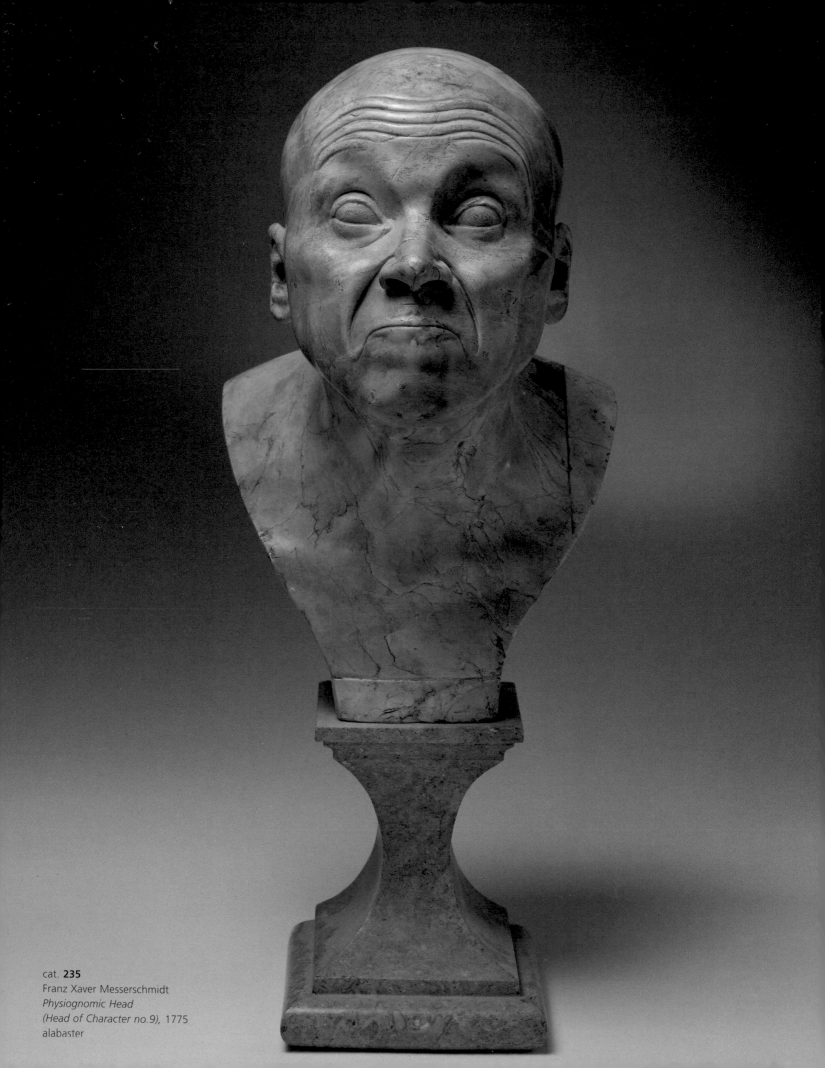

cat. **235**
Franz Xaver Messerschmidt
Physiognomic Head
(Head of Character no.9), 1775
alabaster

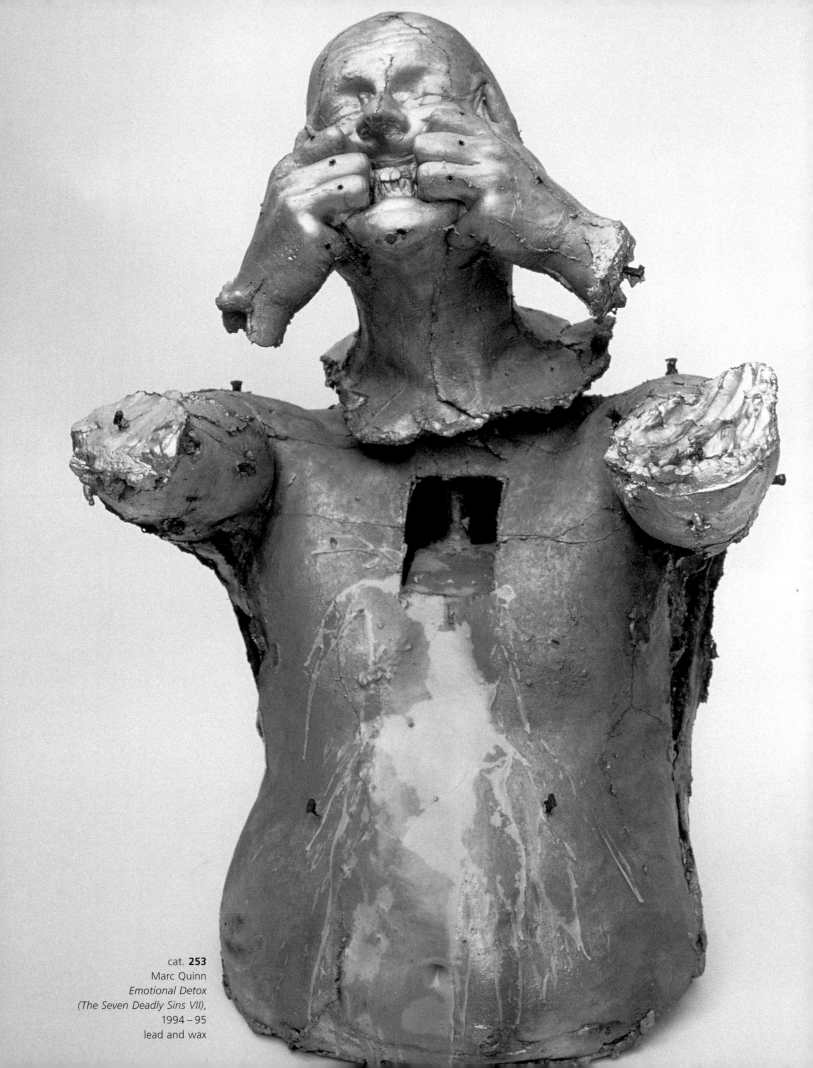

cat. **253**
Marc Quinn
*Emotional Detox
(The Seven Deadly Sins VII)*,
1994 – 95
lead and wax

Beth B

In 1887, Dr Jean-Marie Charcot and the artist Paul Richer published an illustrated book, *Les démoniaques dans l'art* (fig. 27). In it they declared their desire to show 'the place that the external form of hysterical neurosis took in art at the time when [hysteria] wasn't considered as an illness but rather as a perversion of the soul, due to the presence of demons and their agitations.'[104] The book's preface introduces the idea of 'the great hysterical neurosis' as the 'illness of the century', and disputes the notion, widespread amongst 'the spirits of the greatest names', that hysteria is an essentially feminine illness. 'It has been demonstrated today that it can also be found in men'.[105] The publication precedes by two years another Charcot-Richer illustrated book, *Les difformés et les malades dans l'art*, in which hysteria features in the opening chapter on 'the grotesque in art'. It is clear that Dr Charcot placed a huge value on the role of images in the recording of the visual vocabulary of hysteria and other 'deformities'.

In spite of Charcot's declaration that hysteria was also a condition common amongst men, the great majority of the representations are of women. The definitive depiction of Dr Charcot at work, painted on a grand scale by André Brouillet in 1887, features a known woman, the doctor's 'star' patient, Blanche Wittman (cat. 67, pp. 178–179). Her hysterical 'performances' were enacted for the all-male members of Charcot's neurology department at the Salpêtrière.[106] In the early twentieth century, the identification of hysteria as a male illness became generally linked with traumatic disorders during the First World War. So-called 'Battle Fatigue' was characterized as a post-traumatic neurosis.

fig. 27
Variété démoniaque de la grande hystérique, contortions
p. 104 from
J.M. Charcot and Paul Richer
Les démoniaques dans l'art, 1972
(unchanged reprint of the
original edition, Paris, 1887)
Amsterdam: N.B. Boekhandel
& Antiquariaat, B.M. Israël
book; 24.7 × 21.5 cm
Private Collection

In male cases, therefore, the hysterical condition had a specific *raison d'être*, causing a weakening of virile traits, and, furthermore, it was seen as curable. Far from disappearing from the popular vocabulary in recent times, the word hysteria has come to be associated with extreme states of excitement, manifesting itself mostly in women's shrieking, in loud and histrionic behaviour. Some newly-defined illnesses, such as Myalgic Encephalomyelitis (ME) and Chronic Fatigue Syndrome (CFS), are the modern successors to the illness known to the Victorians as neurasthenia, and are in turn other examples of myriad presentations of hysteria. That ME is modern neurasthenia is very probable. Whether or not either are hysteria equivalents continues to be debated with vigour and passion.[107]

It is partly within this historical context that Beth B has realized her work *Hysteria*, 2000 (cat. 38, pp. 177, 180). This multi-media installation incorporates elements that relate to nineteenth-century definitions of hysteria, women's position in society, the illness's image and its associations, and the means and tools for 'curing' it. Beth B's work employs a variety of visual media to vary the modes of address available to the viewer, with the aim of offering 'a number of entry points into the particular critiques…; these critiques focus both on the adequacy and the role of representation itself in the face of medicine and the treatment of women'.[108]

The idea of presenting multiple views is of crucial importance in Beth B's sculpture, photography and film, as well as in her multi-media installations, such as *Hysteria*. The artist's interest in issues surrounding women's emotions and sexuality, and their social manifestations, finds fertile ground in the literature and the visual portrayal of hysteria through the centuries.

As Elaine Showalter observes in her review of the theatrical staging and screening of

cat. **38**
Beth B
Hysteria, 2000 (detail)
foam core, wax, wire, motors, video monitors and video projection, padded wall, vibrators, strait-jacket, ovarian compressor, cots, live performance

cat. **67** (following two pages)
André Brouillet
Une leçon de clinique à la Salpêtrière, 1887
oil on canvas

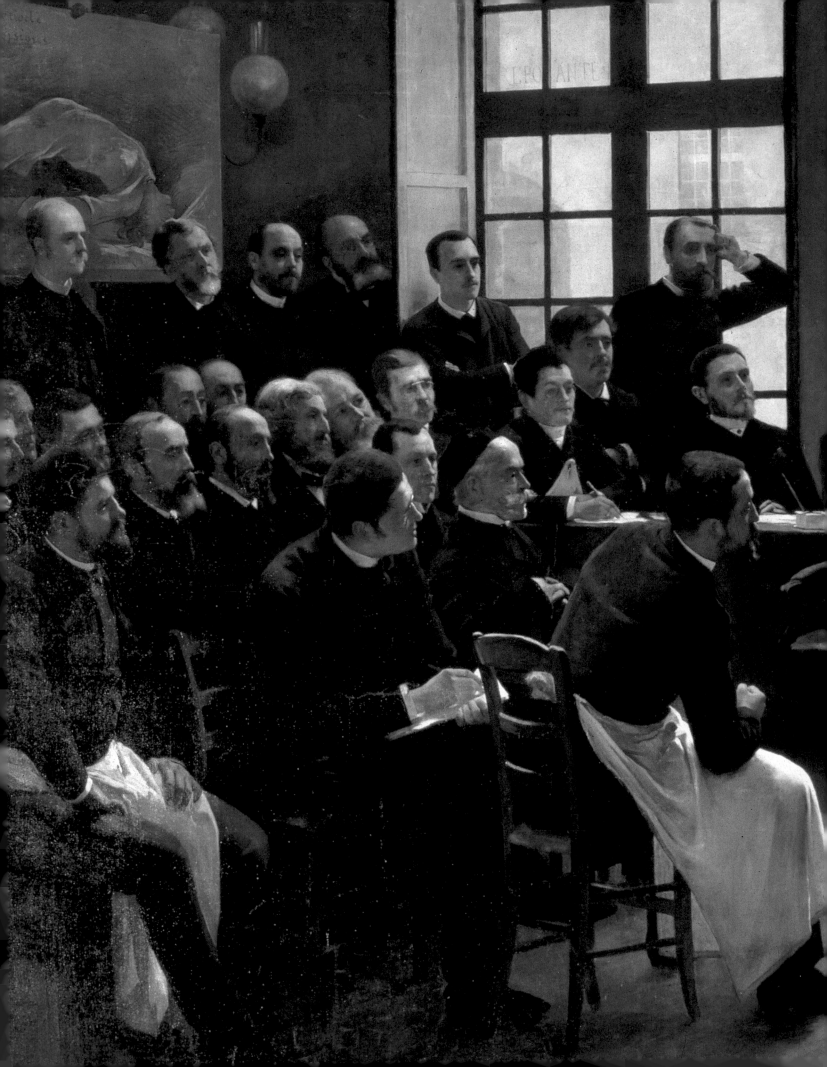

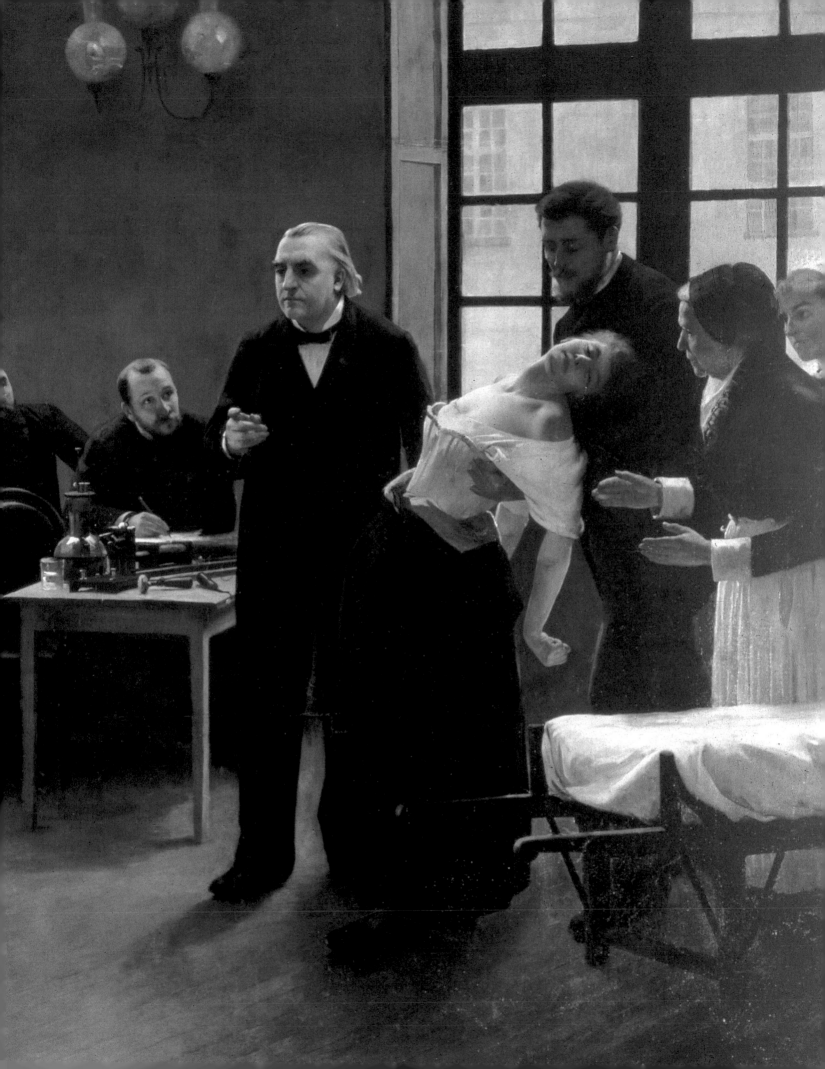

cat. **38**
Beth B
Hysteria, 2000 (details)
foam core, wax, wire, motors, video monitors and video projection,
padded wall, vibrators, strait-jacket, ovarian compressor, cots, live performance

fig. 28
Beth B
Trophies 9 (Anorexia Nervosa),
1995
wax, wood, glass, wire;
274.3 × 121.9 × 182.8 cm
© Beth B, 2000

hysterical narratives of hysteria, 'Charcot was certainly not the last to take advantage of the photogenic appeal of the hysteric.' Showalter quotes the *The Guardian* film critic, Lizzie Francke, who writes, 'There is a tendency in films about female madness to indulge in the spectacle of… disintegration as if there were something inherently cinematic about the woman hysteric.' [109] It has been pointed out that 'cinema was invented in the 1890s, at the time the hysterical woman became a cultural icon.' [110] Women with their mouths open wide in 'unformulated cries' match both the institutionalized image of the hysteric and images of religious ecstasy.

Beth B is alert to the employment of hysterical poses and characters in American television programmes and Hollywood cinema, something which has been analysed as a 1950s phenomenon, linked to the political witch-hunts and social hysteria of the McCarthy era. [111] As a film maker and independent producer, Beth B has worked on films on sexuality and intimacy (*Two Small Bodies*, 1994, and *Visiting Desire*, 1996). Her most recent film, *Breathe In/Breathe Out*, 2000, centres on the trauma caused by war in three Vietnam veterans and their adult children.

Beth B's sculptures have included representations of women's bodies in relation to medical conditions like anorexia nervosa, (*Trophies 9 (Anorexia Nervosa)*, 1995 (fig. 28)) and different forms of social restraint, such as Chinese foot binding, female circumcision, the fashion for corsets, and cosmetic surgery. The sculptures of women's bodies subjected to restrictive practices are made in translucent wax, installed in medical glass cabinets or contained in illuminated show cases. They hover between the anatomical figure and the

religious icon. A sort of iconic status is granted to the female body in those features that differentiate it from the male body. Breasts and genitalia are celebrated in their inescapable manifestation and in their particularity, as in *Monuments*, 1997, monumental and archetypal sculptures of nude female torsos, conceived as part of a public art project across the USA, and *Portraits*, 1997, where a collection of black and white photographic images of vulvas invokes a taxonomy of molluscs or exotic flowers (fig. 29).

In a previous installation, *Out of Sight / Out of Mind*, 1995, Beth B explored the institutional treatment of insanity through a five-minute montage of archival footage of bizarre dare-devil stunts, with commentary and media clips concerning the case of a thirteen-year-old boy who murdered a four-year-old boy and was refused the insanity plea. He was then tried and convicted as an adult. Her installation *Hysteria*, 2000 (cat. 38, pp. 177, 180) comparably uses historical medical devices, sound-bites and imagery 'that catapult certain human behaviours and attitudes into the limelight without apparent consciousness of the consequences'. *Hysteria*, furthermore, constructs a space that both separates and connects the viewer to the events performed within. In the central video sections several nude women wearing medical devices assume the postures associated with the hysterical attacks described by Charcot and pictured in Richer's *Étude Clinique sur la Grand Hysterie ou Hystero-Epilepsie*.[112] Access to the heart of the installation is gained only through one of the three doors cut into the padded wall. Small glass windows inserted into the doors enable the viewer to look into another room. The act of stepping through the doors reveals that the padded wall is nothing but a thin façade, a temporary set for a mere performance. The padded cell is a common symbol of institutionalized insanity and deviance from the accepted norm. In reproducing some of the salient elements of the nineteenth-century iconography and language associated with the hysterical condition, Beth B scrutinizes images and treatments 'that have influenced contemporary

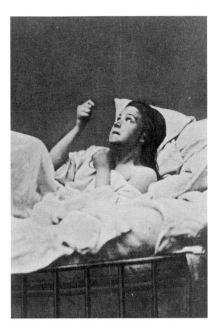

fig. 30
Ovarian Compressor
p.165 from
Desiré-Magloire Bourneville
and Paul Regnard
*Iconographie photographique de
la Salpêtrière*, vol. II, 1876–80
book; 24 × 20.5 cm
Photo by kind permission of the
Royal Society of Medicine

cat. **254** (top left)
Delirious, hysterical epileptic
plate from
Désiré-Magloire Bourneville
and Paul Regnard
*Iconographie photographique
de la Salpêtrière*, 1876–80

attitudes to women and their bodies', and analyses 'the psychological long-term impact that medicine, the media, and general oppressive images and attitudes have on women'.

The pristine outer surface of the padded wall, with its rough inner construction exposed on the other side, stands for the system of beliefs and institutionalized dogmas that ruled over the establishment of hysteria as an identifiable illness. Further into the space, paper and wax female figures rotate, suspended from the ceiling, whilst a video projection inter-cuts three elements: interviews with women, shown from the neck down, speaking about their bodies; talking heads of men quoting doctors' clinical analyses from the eighteenth to the twentieth centuries; and close-up images of women's faces in expressions of hysterical paroxysm (cat. 254).

In her multi-media bombardment of visual and audio clips, Beth B's work comments on hysteria as a mirror image of our culture, challenging accepted views of truth and falsehood, reality and delusion, with an attentiveness to social and psychic history as projected through seemingly 'sane' medical institutions as well as societal morays.[113] The artist asks that her work 'be perceived and interpreted as asking questions rather than creating a form of resolution or solution.' Beth B's work is never meant 'to accuse, but rather enlighten in the hope that we can use the past to inform the present'.

Hysteria re-presents the questionable idea of the 'cure'. Trends dominate the world of medicine as well as that of fashion, and cures are characterized on the basis of the current context. They are established through a complex system of interactions between patients and doctors in personal, scientific, and institutional contexts. These mechanisms have recently become the object of study in medical anthropology and epidemiology. Ovarian compression, suspension and vibration, which seemed to be acceptable cures for hysteria in Charcot's time, appear to be ludicrous in our eyes (fig. 30).

Christine Borland

Christine Borland uses her art to bring new perspectives to bear on medical matters. She too aims to reconstruct visually the events that lead to the identification, definition, and description of serious and widely-known diseases. In her installations she often includes evidence and data linked to her research, as in *Second Class Male, Second Class Female*, 1996 (fig. 31). Here, the last two human skulls commercially available in Britain, obtained by the artist, were exhibited in the same boxes they had been sent in, complete with accompanying documentation.

In her early work, Borland investigated the damage caused by weapons fired at various objects and materials. She sought the help of the police and carried out forensic-type enquiries. In this she resembles Gerhard Lang, who investigates police methods of identifying criminal faces. Making the transition from forensic artist to artist-spy, Borland obtained permission in 1996 to draw – but not photograph – in the Montpellier Anatomical Museum in France. She ignored the prohibition, and toured the museum surreptitiously taking pictures of human specimens using a hidden microfilm camera. The blurred results were exhibited in a work titled *Cet être-là, c'est à toi de le créer! Vous devez le créer!*, 1996 (fig. 32). Since then, residencies and awards, together with sustained research in medical libraries and museums, have enabled the artist to further refine her knowledge and skills in the field.

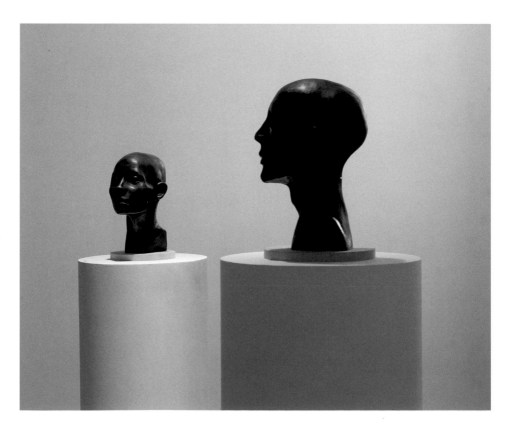

fig. 31
Christine Borland
Second Class Male, Second Class Female, 1996
installation;
dimensions variable
Private Collection
© Christine Borland, 2000

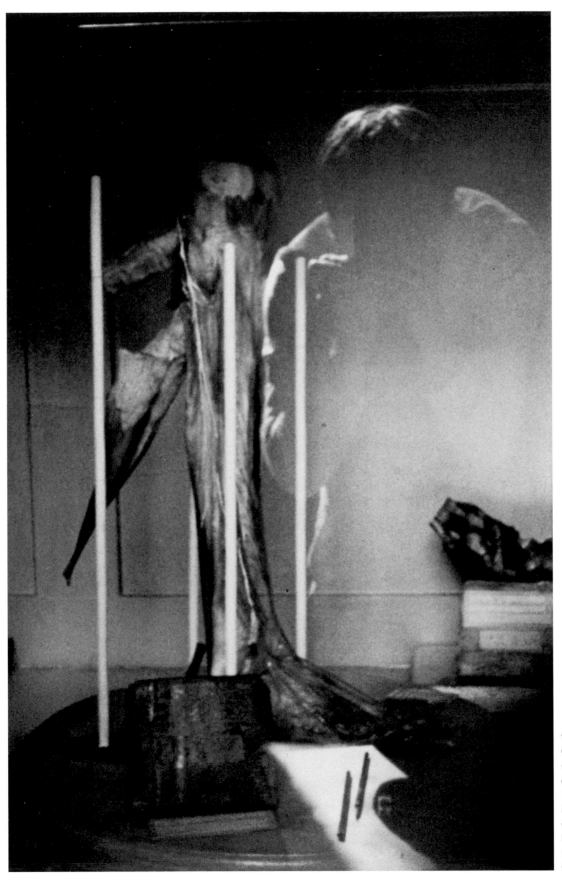

fig. 32
Christine Borland
Cet être-là, c'est à toi de le créer! Vous devez le créer!,
1996
installation;
dimensions variable
Frac Collection – Languedoc /
Roussillon
© Christine Borland, 2000

As a sort of 'artist/epidemiologist', Borland covers wide territories, availing herself of the support and collaboration of medical institutions such as the Medical Research Council's Social and Public Health Sciences Unit at Glasgow University – where she was based as a fellow for nine months from 1998 to 1999. Borland explains:

> The Unit provided the ideal context to continue with a process of working in dialogue with others. A broad examination of the human condition led towards an interest in genetics.[114]

She examined the technologies of predictive testing used in pregnancy to identify foetal abnormalities. At the Institute of Medical Genetics, Yorkhill Hospitals in Glasgow, Borland gained more first-hand experience of how families are affected by congenital abnormalities such as muscular dystrophy, an invariably fatal disease. Since its pattern of inheritance is not yet to the point of being predictable, the primary method of intervention is antenatal diagnosis and termination. Borland looked at the historical identification of muscular dystrophy through the work carried out by Duchenne de Boulogne, Dr Charcot's teacher, colleague, and friend, nineteen years his senior. It is telling that Charcot, to whom Freud referred as '*visuel*', collaborated with Richer, and that Borland, as an artist, collaborates with scientists and medical institutions.

Charcot inherited from Duchenne his systematic and meticulous method, and a penchant for incessant observation, description, experimentation, and over-enthusiasm for new cures. Duchenne taught Charcot the importance of the photographic record to document the different stages of conditions such as muscular atrophies, locomotor ataxia, and multiple sclerosis. Interested in the effects of electricity on muscle activation, Duchenne used photography to document discreet and fleeting muscle contractions. For his book *Mécanisme de la Physionomie Humaine* (1862), Duchenne engaged patients and actresses. Charles Darwin borrowed photographs from Duchenne in his *Expressions of the Emotions in Man and Animals* (1872). Learning from Duchenne, Charcot professed to be nothing more than a photographer ('I only observe, nothing more... All I am is a photographer'[115]). To broadcast his practice, Charcot made ample use of imagery, employing, for example, an especially-made life-size wax of a female patient with muscular dystrophy. For his part, Duchenne was an accomplished amateur artist, drawing his patients on a regular basis, and collating masses of visual information with meticulous descriptions. It has been argued that 'what makes Duchenne so famous is the prodigious amount of material collected in order to build an imperishable scientific monument.'[116]

Sir William Gowers (1845–1915) extended Duchenne's studies of muscular dystrophy. Like his French predecessor, Gowers had an interest in art, not only illustrating his own case-notes but also exhibiting his paintings at the Royal Academy. Gowers's description of muscular dystrophy is Borland's starting point for her work *Progressive Disorder*, 2000 (cat. 57, pp. 188–189).

The disease is one of the most interesting and at the same time most sad, of all those with which we have to deal: interesting on account of its peculiar features and mysterious nature; sad on account of our powerlessness to influence its course, except in a very slight degree. [117]

Borland was struck by the tragic nature of a disease that appears to reverse the natural process of growth and development in childhood. Gowers's description continues:

It is a disease of early life and of early growth. Manifesting itself commonly at the transition from infancy to childhood, it develops with the child's development, grows with his growth – so that every increase in stature means an increase in weakness, and each year takes him a step further on the road to helpless infirmity, and in most cases to an early and inevitable death. [118]

Using the image of a small boy who was a patient of Duchenne de Boulogne, Borland animates and expands the three phases described by Gowers. The artist feels that the use of animation is poignantly appropriate to a disease which progresses from movement to loss of movement and to complete immobility. Borland's figure, originating from static illustrations, moves through a series of hundreds of laborious drawings, each of which retains the eloquent simplicity of the original line engravings. To construct the sequence the artist followed Gowers's observations that, when getting up, patients

first put their hands on the ground (1), then stretch out the legs behind them far apart, and, the chief weight of the trunk resting on the hands, by... pushing the body backwards, they manage to get the knees extended... (2). Next the hands are moved alternately along the ground backwards so as to bring a larger portion of the weight of the trunk over the legs. Then one hand is placed upon the knee (3), and a push with this and the other hand on the ground is sufficient to enable the extensors of the hip to bring the trunk into the upright posture. [119]

Borland's animated figure goes from bending over on all fours, to lying flat on the ground and back again, each sequence lasting around twenty seconds. The haunting little boy punctuates the observers' space, serving as a moving reminder of the precarious complexity of our upright gait. Duchenne's and Charcot's sets of tools are seen by Borland as being more humane than today's gamut of sophisticated neurological techniques, which include biochemical examination of the cerebrospinal fluid, electromyographic procedures to test nerve conduction, and neuro-imaging techniques used for the anatomical assessment of brain tissue structures.

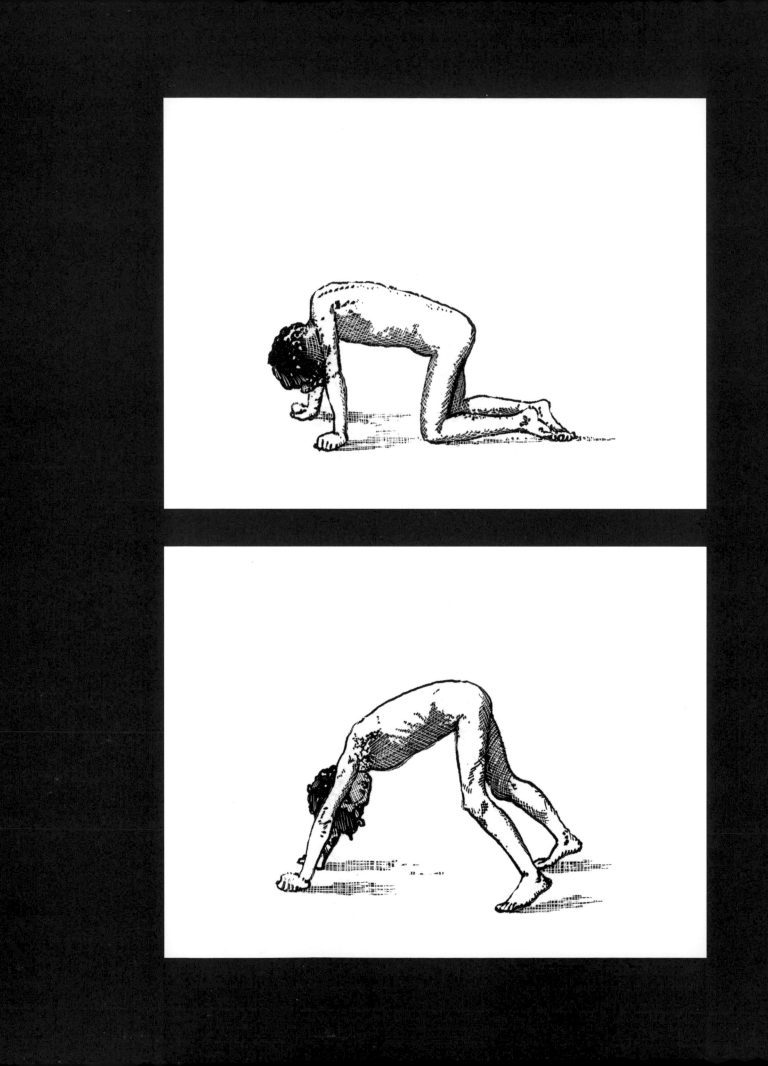

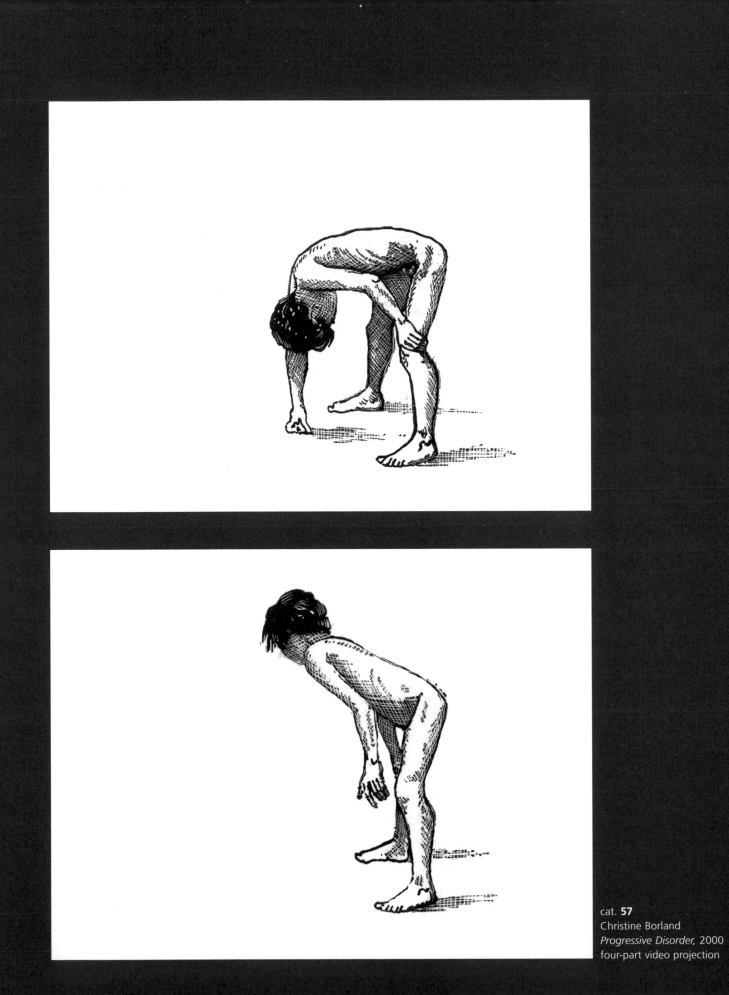

cat. **57**
Christine Borland
Progressive Disorder, 2000
four-part video projection

Gerhard Lang

Charcot called himself a 'photographer', nothing more. Gerhard Lang is a photographer and an explorer of human curiosity about the faces of nature. As such, he participates in an age-old obsession with recording and categorizing particularities in terms of synthetic 'types', whether types of faces or varieties of evanescent clouds. He transforms means and ends from older sciences – including the largely-discredited data of physiognomy and craniology – into the stuff of art, without losing the minutely systematic sense of procedure that gave those practices their claim to be 'scientific'. The focus of his work, photography, is viewed by Lang himself particularly in relation to some of its historical applications in science as an 'objective' tool for documenting the human race in a scientific manner, for investigating illness and crime, and ultimately for therapeutic ends.[120]

In 1869, in a search for truthful and telling images, the Darwinian biologist, Thomas Huxley, initiated a project that aimed to map the somatic characteristics of the tribes of the British Colonies (cat. 149)[121]. In the early stages of the project, Huxley had considered approaching the virtuoso of morphometric techniques, Paul Broca. The Parisian anthropologist's collection of often contradictory data included a large quantity of cerebral measurements to determine the degree of intelligence of famously 'good' and notoriously 'bad' men and women, in scholars and criminals alike (cat. 62).[122] At the same time, Cesare Lombroso in Turin was investigating the nature of criminality, looking at the inside and the outside of the head. Lombroso relied heavily on photography to elucidate the characteristics displayed by criminals who were classified, for instance, as 'monkey type', 'relapsed thiefess', 'dangerous and degenerate', 'sister-in-law killer', and so on.

cat. **62**
Paul Broca
Craniometer, 1840–80
wood and metal (brass)

Swaart Boi (Ukábbthin) a Bushman from Koro Uywa. Aged 20. Height 5 feet 0½ inches.

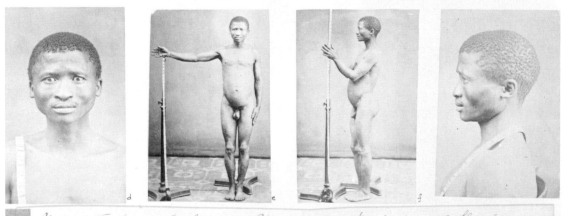

Marino (Thankum) a Bushman from Uxunamma) or Rietfontein on the Hartebeest river (W. of Strontbergen) Aged 26? 30 inches round chest. 4 feet 11 inches high. Unmarried.

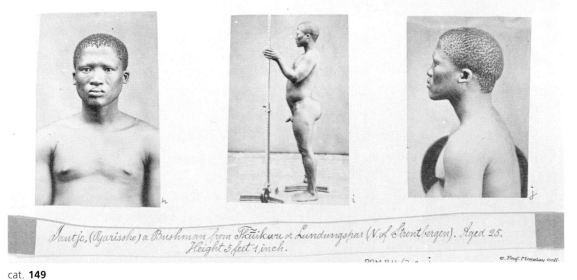

Jantje, (Yarissho) a Bushman from Thuikwu or Lundungspar (N. of Strontbergen). Aged 25. Height 5 feet 1 inch.

e. Prof. Moseley coll.

cat. **149**
Lawrence & Selkirk
*South African Khoisan men. Ten photographs of the measurements
of three Khoisan men: //Kabathin, /Hankum, Yarissho*, 1870–71
photographed at Breakwater Jail. Photographs, albumen print

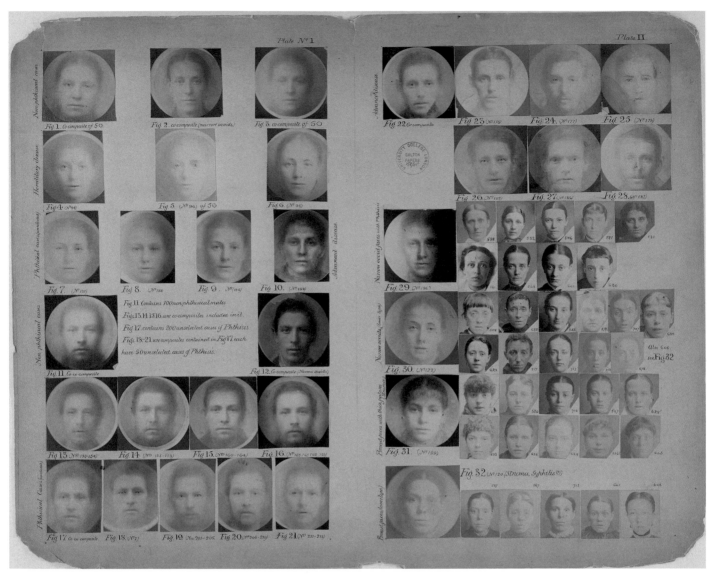

cat. **117**
Francis Galton
*Composite, plate I
and plate II*, 1880s
photographs mounted
on card

During his directorship of the Pesaro 'madhouse', Lombroso compiled an album with collages of photos, drawings, and newspaper cuttings, as a sort of bestiary of deformities (cat. 201, p. 140). As Gerhard Lang points out, Lombroso

amalgamated different fields and concepts of his times such as anthropology, atavism, phrenology, pauperism, pathologism, epilepsy, in a new field of research: criminal anthropology. One of his achievements was to transfer scientific approaches like clinical observation and the scientific experiment to the problem of crime.[123]

One of the founders of criminal anthropometrics, the Paris-based Alphonse Bertillon, concentrated on the scene of the crime and on facial types, legislating on the appropriate way of photographing faces, frontally and in profile, with stipulated alignments between eyes, ears, and noses. Meanwhile Sir Francis Galton in London obsessively documented

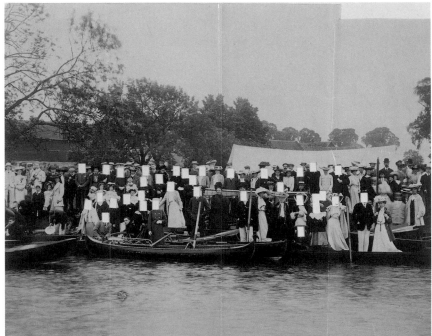

cat. **119**
Francis Galton
Photo of boating party on the Cam with faces cut out, 1880s
photograph

photographically all sorts of social groups, from Jews and phthitic patients, to a boating party on the river Cam and the pupils of Eton college (cat. 116, p. 137; cat. 117; cat. 118, p. 134; cat. 119).

The late nineteenth-century obsession with classification extended from facial human types – an interest inherited from physiognomy and phrenology – to the collection of huge quantities of disparate data relating to all aspects of human and animal nature, in the search for empirically verifiable patterns. For instance, Galton invented a device hidden in his walking stick to measure animals' responses to high-pitched noises at London Zoo. He developed the weather map, fingerprinting kits, and a concealed hand-held device – consisting of a needle and a small card hidden inside a glove's thumb and index finger – for logging the geographical distribution of the most beautiful women in the British Isles.[123]

Lang, somewhat paradoxically, revivifies this history of obsessional taxonomy, and, like a nineteenth-century man, he is simultaneously an artist, an ethnologist, a sociologist, a phenomenal classifier, and a perambulating explorer with his walking-stick – capturing clouds in glass flasks that are stored in specially-constructed wooden travel-boxes. He attributes to clouds gender and such characteristics as 'militant', 'revolutionary', and 'terrifying'. He is interested in the classification of cumulus, cirrus, and stratus cloud formations as defined in 1803 by the 'amateur' scientist, Luke Howard. Even the markings on Swiss cows have been documented by Lang in a serious-humorous work on the 'over-all cow marking' in the Schönthal region. He scrutinizes and photographs human and animal heads and faces, producing compound images of intriguing ambivalence. In the ironic 'seriousness' of his scientific method, Lang imaginatively complements what are

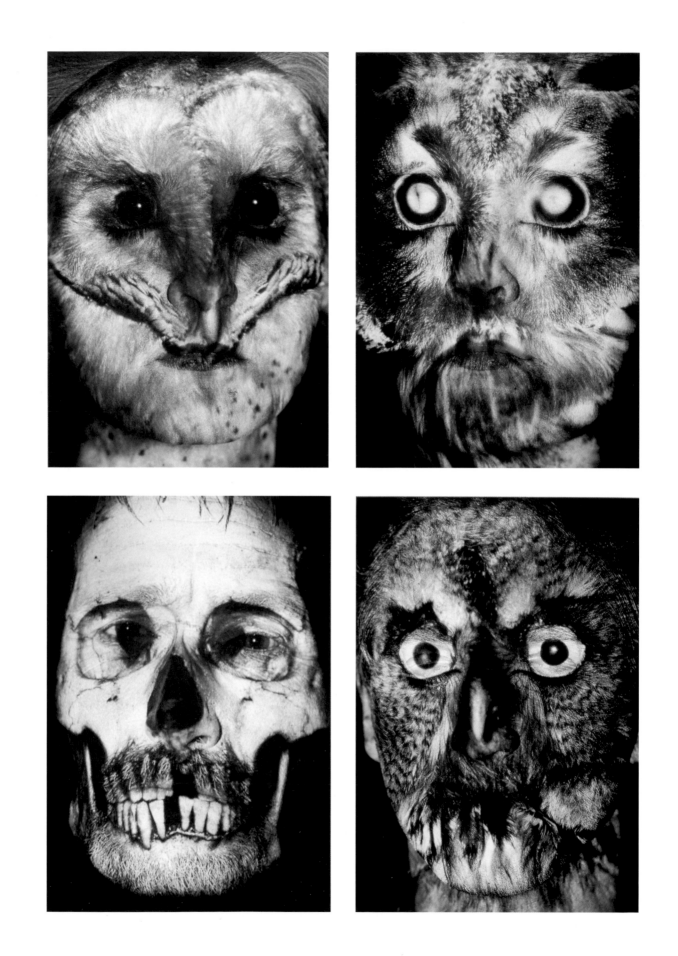

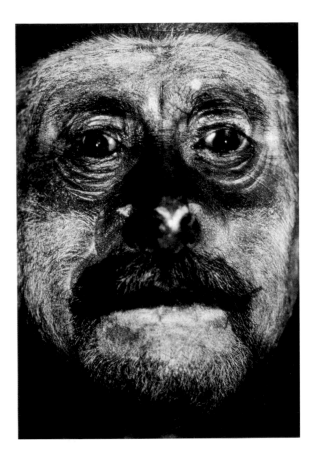
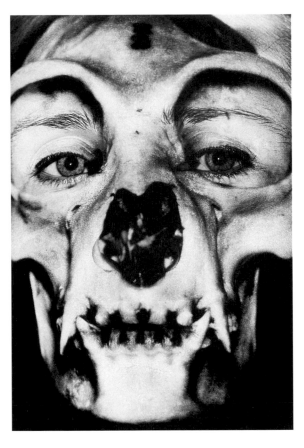

cat. **173**
Gerhard Lang
Palaeanthropical Physiognomy, 1991/2000
projections (details)

195

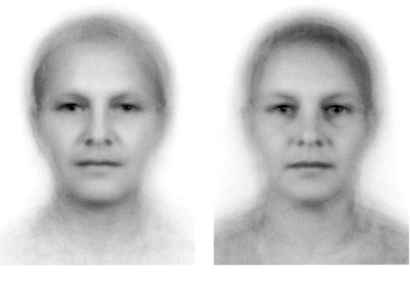

cat. **171**
Gerhard Lang
*The Typical Inhabitant
of Schloss-Nauses*, 1992
(detail)
58 photographs of the citizens
(left-hand columns)
and composite photograph
(bottom left on this page)

cat. **172**
Gerhard Lang
*The Typical Inhabitant
of Schloss-Nauses*, 2000
(detail)
53 photographs of the citizens
(right-hand columns)
and composite photograph
(bottom right on this page)

now seen as the apparently 'crazy' endeavours of Galton. In the light of Lang's work, we look again at Galton with an open mind, as a well-meaning classifier, an eccentric and obsessional, who left behind a colossal amount of data, the purpose and uses of which have become scientifically superfluous. His ideas, however, like those of other physiognomists and phrenologists, still resonate with our views and interpretations of people's faces. It is not an accident that these theories and visual artefacts strongly resemble some contemporary conceptual art.

One of Lang's early projects was designed to delve into the methods and sources of anthropology and palaeontology as scientifically-determined disciplines. The artist coined a name for his own new discipline, *Palaeanthropical Physiognomy*, 1991/2000 (cat. 173, pp. 194–195). The work initially involved projecting photographs of skulls from the department of Palaeoanthropology in the Senckenberg Museum in Frankfurt and animal faces, such as owls, bees, and wasps, on to human faces, producing images reminiscent of della Porta, Le Brun, and Camper.[125]

Lang's *The Typical Inhabitant of Schloss-Nauses*, 1992, (cat. 171, p. 196–197) where the artist exposed, one upon another, photographs of the faces of all the inhabitants of his home-village of Schloss-Nauses in the Odenwald region in Germany, recalls the Galton method of composites (cat. 117, p. 192). The actual staging of the photographic sessions is also strongly reminiscent of Bertillon's carefully-constructed photo sets (cat. 50). To entice all the fifty-two citizens of Schloss-Nauses into his studio, Lang required a strategic approach, which had to take into account crucial social factors. Lang's first investigation into the 'typical inhabitant' (the 'overall citizen') of the village of Schloss-Nauses was initiated in 1992. The artist photographed all the 'Nausischer' and produced three composites by superimposing the photographs of all the men, of all the women, and finally of all the citizens. In the year 2000 he set out to monitor the changes that had occurred in the intervening years (cat. 172, p. 196–197).

Lest we should think that Lang's project belongs wholly with defunct science, it is worth noting that a current project, *The Genetics of the Human Facial Features*, promoted by the Galton Laboratory at University College London, starts from the premise that

> family resemblances are one of the most obvious and striking manifestations of shared genes, yet we still know almost nothing about the underlying relationship of genes to facial features. It is difficult to record and analyse facial features with scientific precision, partly because the techniques of molecular genetics are still relatively new, and partly because facial features are likely to be determined in a complex way.[126]

This complexity is stressed by Gerhard Lang when he reflects upon the concept of the 'void' created by the composites, by the 'non-graspable' nature of the images. Lang notes that the visual impact of the composites as images 'is incredibly powerful, a fact which allowed Galton to succeed for a few years before scientists started to dissociate themselves from him.'

For Lang, the classification of the image of a human face is as compelling and elusive as the taxonomy of clouds or of dark patches on a cow's hide. In their sustained attempts to get closer to the identification of features and therefore to the 'photographic truth', both Lang and Galton ultimately reach out to something intangible. Galton's own words on the ambivalence he felt towards his composites serve equally well for Lang:

> It is strange that we should not have more power of describing form and personal features than we actually possess. For my own part I have frequently chafed under the sense of inability to verbally explain hereditary resemblances and types of features.[127]

Fascinatingly, more than a century since Galton conducted his work, the laboratory which uses his name is now calling for volunteers to help resolve the same dilemmas of individual and type in human physiognomics.

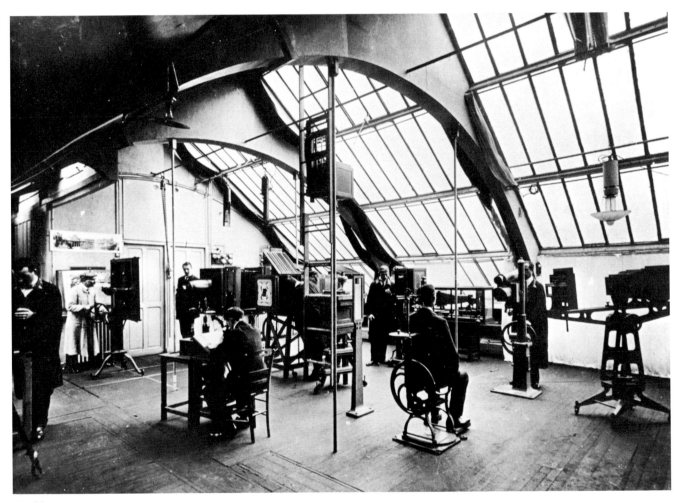

cat. **50**
Alphonse Bertillon
Alphonse Bertillon's Photographic Studio, c. 1900
photograph

Tony Oursler

An excellent observer, in describing the behaviour of a girl at the sudden death of her father, says she 'went about the house wringing her hands like a creature demented', saying 'it was her fault'; 'I should have never left him'; 'If I had only sat up with him', etc. With such ideas vividly present before the mind, there would arise, through the principle of associated habit, the strongest tendency to energetic action of some kind. [Darwin]

I am troubled by attacks of nausea and vomiting. No one seems to understand me. Evil spirits possess me at times. At times I feel like swearing... At times I feel like smashing things.[Oursler]

These are two accounts of extreme emotional states as manifested in human beings, one reported by Charles Darwin in his *The Expressions of the Emotions of Man and Animals* (1873) (cat. 86), and the other spoken by the *Test Dummy* of the American artist Tony Oursler, a hundred and twenty years later.

Oursler declares his fascination with the 'attempts to codify the human mind, as in the MMPI, [the Minneapolis Multi-phasic Personality Inventory] – a test used to determine personality disorders...'.[128] The artist is intrigued by what he calls 'psycho-history' and 'the link between the media and the psychological states it is capable of provoking: empathy, fear, arousal, anger.'[129] The rise of Multiple Personality Disorder

cat. **86**
Expression of Grief
chapter VII, table II from
Charles Darwin
*The Expression of the Emotions
in Man and Animals*, 1873
photographs by Duchenne de
Boulogne and Anon

fig. 33 (right)
Tony Oursler
Hysterical, 1993
from the sublingual series
Private Collection
© Tony Oursler, 2000

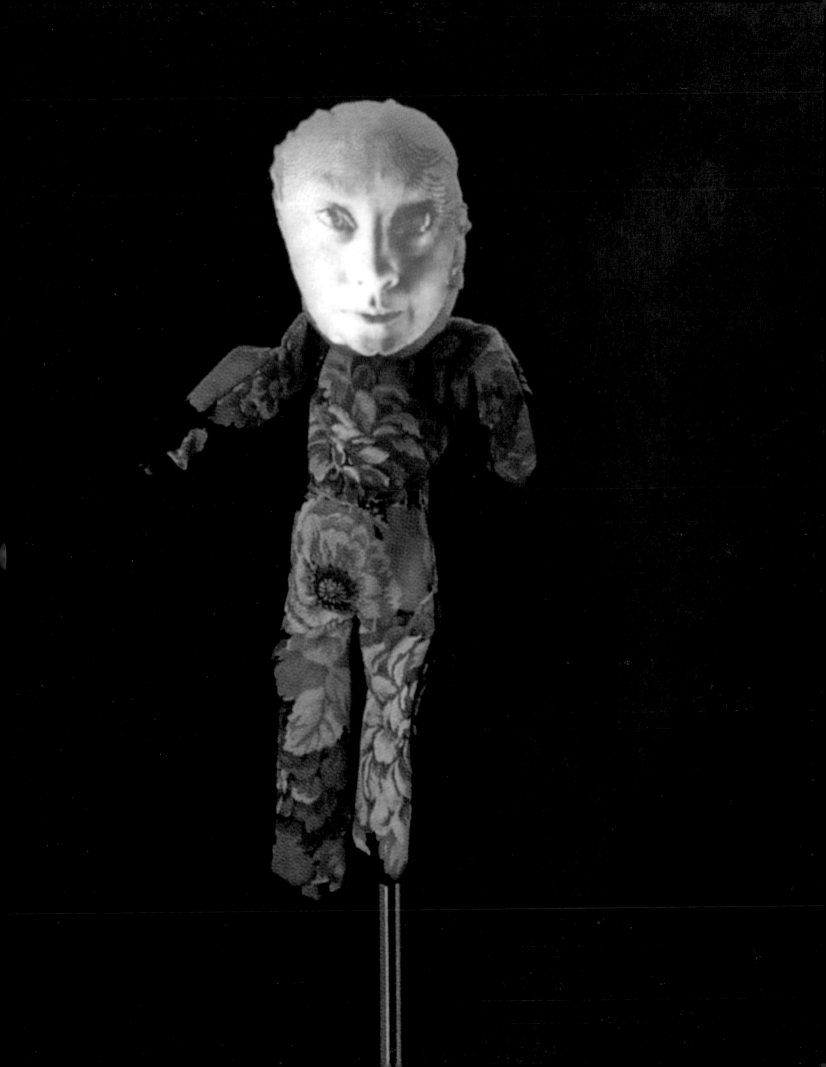

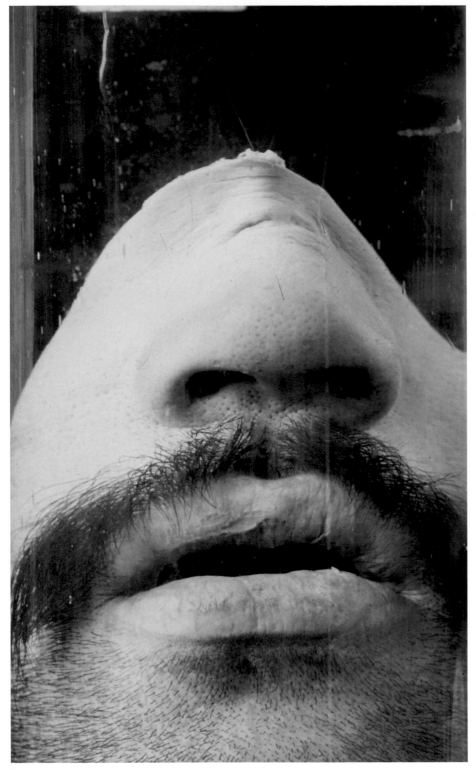

fig. 34
Anon
Mouth and Nose of a Spaniard, early 19th century
specimen preserved in 70 per cent alcohol;
25 × 8 cm
Jan Bleuland collection
Anatomisch Museum, Utrecht University
Photo © Tom Haartsen, 2000

cat. **241** (right)
Tony Oursler
Bull's Balls, 1997
projector, VCR, videotape, glass jar,
bull's testicles, carosafe preservative

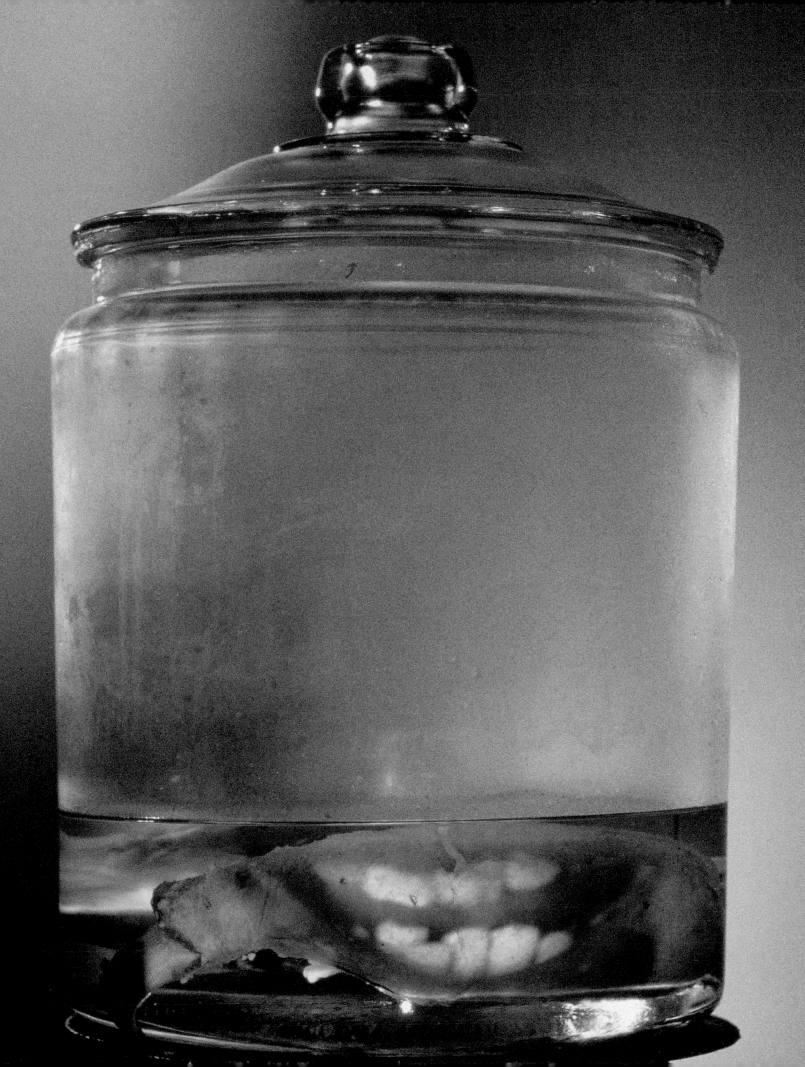

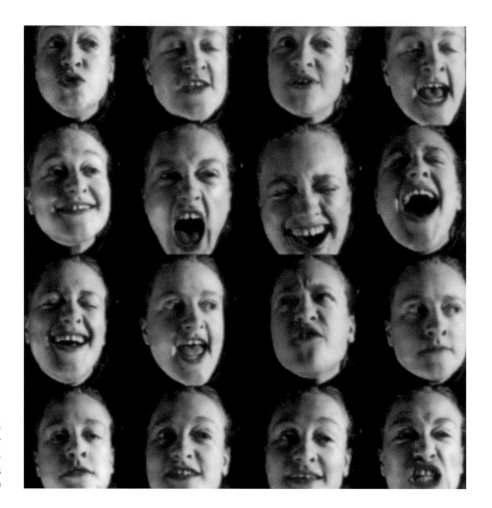

(MPD) in the USA, and the attention given to this condition by the media, lie behind Tony Oursler's crying dolls (fig. 33, p. 201). The visual rendition of MPD in films such as the pioneering *The Three Faces of Eve,* 1957, the first movie about multiple personality disorder, which was based on the best-selling book by the same name, and *The Exorcist,* 1973, were said to have had such a profound impact on audiences as to cause terror and fainting:

> classic symptoms and disabilities are observed in audiences after watching the movie. Psychiatrist Bozzuto suggests that the loss of impulse control depicted in some scenes may threaten people with similar problems by exceeding their 'stimulus barrier.[130]

The extreme, dramatic, and violent behaviour associated with the illness has fuelled the imagination of the general public in America. This 'cinematic neurosis' in a way recalls the nineteenth-century belief in the power of photographic images and their affective function.

One of the most significant of Oursler's works, *Judy,* 1994 (fig. 35), quotes the words of a 'multiple', who, in a lucid account of her condition, stated: 'I only experienced isolation as I flew above the room, watching below me as the invaders tortured the bodies of the

other children I had created so that I could survive.' Oursler uses both amateur and professional performers to re-enact the known manifestations of the illness.[130] Ultimately, the definition of human emotions is dependent largely on the approach taken towards ideas of physiology on the one hand and, on the other, of the psychology of emotions. This is to say that what comes into play is the crucial concept of the relationship between body and mind.

Darwin observed that 'anger and joy are from the first exciting emotions, and they naturally lead, more especially the former, to energetic movements, which react on the heart and this again on the brain. Several other states of mind appear to be at first exciting, but soon become depressing to an extreme degree.'[131] A strong emotion finds its expression in muscular contractions and the physical manifestation of the emotion in its turn affects the mind. It thus follows that body and mind are inextricably linked. Contracting the muscles of the face in an expression of laughter can even promote happiness and, conversely, 'dropping' ones face can provoke sadness. The complex question of cause and effect is a newly central argument in current post-Freudian psychoanalytical debates, with the rise of the cognitive approach to depression which deploys a positive attitude and attempts a re-framing of ingrained perceptions and convictions to ensure an effective and speedy recovery.

Oursler constructs his crying dolls using video projections of faces of actors on to featureless, ovoid heads stuffed with rags. The bodies, typically covered in soft flowery upholstery, are much smaller than the heads, their limbs often truncated, and they hang inertly, delegating to head, face and voice the job of communicating dramatic expressions of angst, isolation, joy and sexual excitement. Exercising their own particular kind of 'body-language', Oursler's dolls reveal a clear focus on the head and face as the centres of human communication. Oursler's use of video and sound reflects his fascination with the potential of new technologies in imitating human states of mind, and in empathetically transmitting emotional states to the viewer. The interplay between 'real', three-dimensional objects – beds, tables, sofas, and chairs – and illusionistic fragmentary projections, causes an uneasy suspension of disbelief in the spectator, who intuitively reconstructs the missing pieces of the psychological jigsaw puzzle.

Bull's Balls, 1997, (cat. 241, p. 203) is a projection of moving human lips 'inside' a glass jar containing an animal organ preserved in formaldehyde. The voices 'emanating' from the jar speak of the angst in relation to the wholeness and fragmentary nature of the human body. *Bull's Balls* looks eerily like an anatomical preparation of human lips, yet endowed with unsettling motion (fig. 34, p. 202). Historical anatomical human specimens often give the sense of aiming to preserve and document the 'body of man' as if the extinction of humanity was just around the corner. The disembodied voice that emanates from the moving lips appears to suggest the 'soul's' preservation, or, more technologically, the pickling of a brain or of living human parts in a sci-fi movie. Photographic, video, and sound recordings are, somehow, our contemporary way of 'preserving' the human species.

Bill Viola

'Know thyself', the ancient 'tag' which exhorts to self-knowledge, finds its reply in the contemporary title of a video work by Bill Viola which declares a sense of loss towards the identification of 'self'. *I Do Not Know What It Is I Am Like*, 1986, is an ethnographic video work divided into five parts. *Il Corpo Scuro* (The Dark Body) shows images of underwater coral structures, and creates visual analogies with the inside of the body. *The Language of the Birds* uses close-up images of birds and fish, their eye and head movements alternating with images of parallel movements in man, providing a sort of comparative anatomy. *The Night of Sense* shows Viola himself, alone at his desk, ostensibly unaware of the camera, eating dinner and editing footage of the bird images, posing like a natural scientist absorbed in his work. This section includes stunning illusionistic footage of a Dutch-style still-life, complete with a fish which is slowly and carefully cut up and eaten by Viola himself, breaking the illusion of the *nature-morte* and constructing powerful metaphors of life and death. The fourth section, *Stunned by the Drum*, presents a series of violent flash-frame images which for Viola generally signify the coming and going of consciousness. Finally, *The Living Flame* shows what looks like genuine ethnographic film footage of fire-walking in Fiji and ritual preparations shot by Bill Viola and Kira Perov amongst the Tamil people of southern India. The images are accompanied by a thumping original sound-track that was recorded throughout all the ceremonial celebrations.

As a colossal moving-image collage of different states of consciousness of the world, Viola's video is an obvious example of the rendition in new media of the age-old concept of microcosm and macrocosm. In the second section we look inside the pupils of birds who seem to be unaware of the viewer's presence. Viola observes that we can see ourselves in the pupil's of animals.

> We see ourselves in *their* eyes while sensing the irreconcilable otherness of an intelligence ordered around a world we can share in body but not in mind. The darkness of the pupil is the darkness of the space within the eyeball – it is just a hole, an opening... the closer you get to look into another eye, the larger your reflected image becomes on that eye, blocking the very view within which you were trying to see. This paradox, and the notion of 'seeing sight', or looking onto the 'soul' of another, was the source of much philosophical speculation in the ancient world, especially by the Greeks, who called the pupil the 'puppet', referring to the little person you see reflected on it. Looking into the eye is the original feedback image, frames within the receding frames, the original self-reflection. [132]

Self-knowledge, in religious and spiritual contexts, was crucial to early investigators of anatomy. The concept of 'knowing oneself', through rites of passages in life and death, underlies all fundamental human rituals. Espousing an essentially spiritual approach, Viola recommends self-containment, even to the extreme of withdrawal from

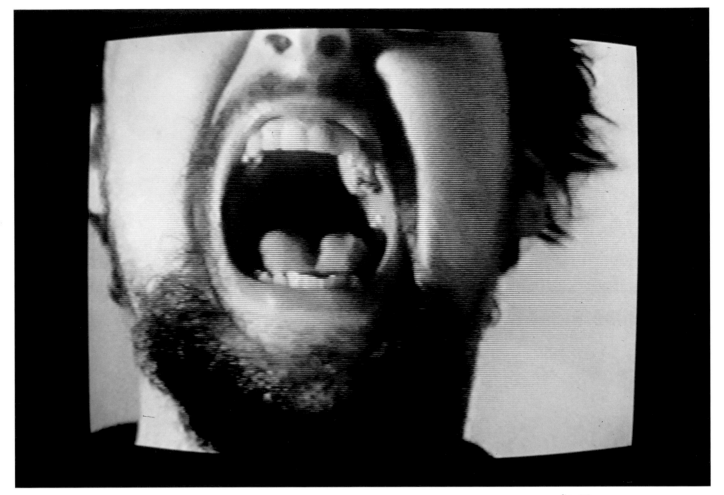

fig. 36
Bill Viola
The Space between the Teeth, 1976
videotape, colour, mono sound;
9:10 minutes
© Bill Viola, 2000
Photo © Kira Perov, 2000

the outside world, as a prerequisite for self-knowledge. Works such as *The Stopping Mind*, 1991, describing in an abstract manner the progressive loss of bodily sensation, and *The Crossing*, 1996, where the violent annihilation of the human figure is enacted through a process of progressive consumption by fire and water, are linked to the artist's tendency to delve into his own world, relying on what is 'inside' for sustenance.

The human figure has featured strongly in Viola's art since 1992. In the *Nantes Triptych*, 1992, a video work in three parts in which the artist records images related to the processes of birth and death on either side of the large wing screens, the human figure is the centre of extreme experiences, of true rites of passage. States of being – *in extremis* – and the most heightened states of mind are inextricable. Vivid expressions are etched on our faces in emotional situations of the deepest intensity. In early works, such as *The Space Between the Teeth*, 1976 (fig. 36), these elements are already apparent. Some of Viola's later images use footage of people asleep, where consciousness is momentarily suspended. *Threshold*, 1992, shows wall projections of the faces of sleeping people accompanied by the sound of regular breathing in darkness. In *The Sleepers*, 1992, seven black and white monitors, submerged in water at the bottom of seven metal barrels, show video recordings of people's faces while asleep (fig. 38, p. 209). With *Nine Attempts*

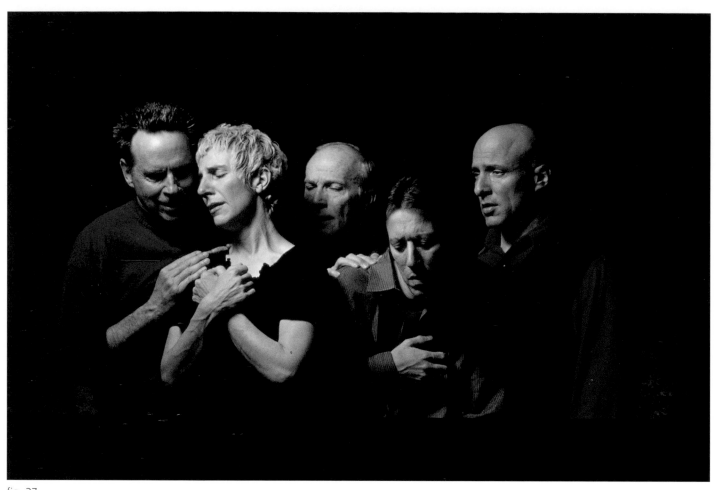

fig. 37
Bill Viola
The Quintet of the Astonished,
1999
video installation,
production still
© Bill Viola, 2000
Photo © Kira Perov, 2000

to Achieve Immortality, 1996, Viola returned to the subject of facial expressions confirming his interest in depicting people undergoing great emotion.

Marco Livingstone's account of one of Viola's latest video works which explicitly deals with extreme human facial expressions, *The Quintet of the Astonished*, 1999, (fig. 37) tells us that

> [in 1999] Viola asked Philip Esposito, an actor who had appeared in several of his works, to make video studies of male and female actors expressing intense emotion. What was important was their ability to convey strong emotion through constantly changing facial expressions, and to do so very precisely on cue.'[133]

The artist soon became aware of just how difficult it was to encapsulate human emotions and expressions, given that the video footage 'struck him as "primitive, grainy and expressionistic" '.[134] His intention was for the five actors

> to be brought together only after they have prepared their roles in isolation. He hoped that the impression of emotional interaction among people locked into their own worlds would give the work a 'strange, uncanny' atmosphere.[135]

The camera, says Viola, is the mind's eye, 'an instrument for the articulation of mental space', the ultimately self-reflective medium. In his skilful combination of installation and video, Viola explores the deepest themes that surround body and mind. The references implicit in *Science of the Heart*, 1983, (cat. 298, pp. 210–211) are of such magnitude and universality in their directness and simplicity that they seem, for once, to justify the cliché that 'all human life is there'. Birth, sex, sleep, illness and death are all alluded to in the perfectly-still apparition of the bed which provides the foreground to the video-projection of a human heart, hovering above the bed head and beating with increasing insistence. The red of the blood surrounding the heart is also the colour of the bedspread. A single centrally-placed pillow invites one person only to lay on the bed. The imaginary body lying on the bed would not see the image of the heart, but would hear the rhythmic sound of its beating, the very sound which, more than anything, symbolizes life. In the extreme moment of deep reflection, our life laid out behind us, the act of knowing ourselves may prove to be the ultimate achievement to which human consciousness can properly aspire.

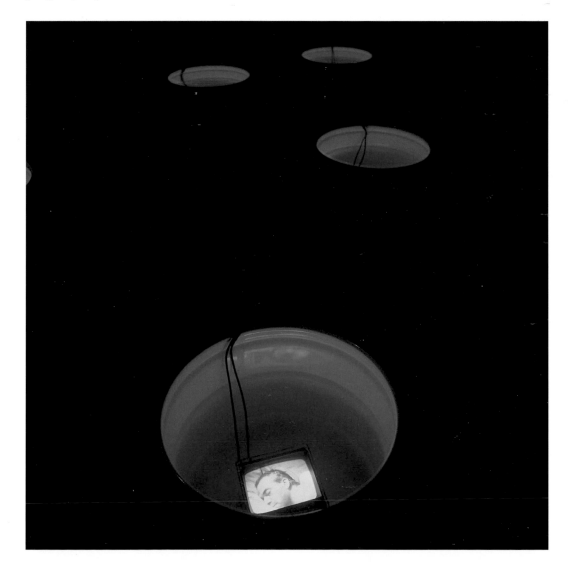

fig. 38
Bill Viola
The Sleepers, 1992
video installation
Collection: Edition 1, Musée
d'Art Contemporain, Montreal
© Bill Viola, 2000
Photo © Nic Tenwiggenhorn,
2000

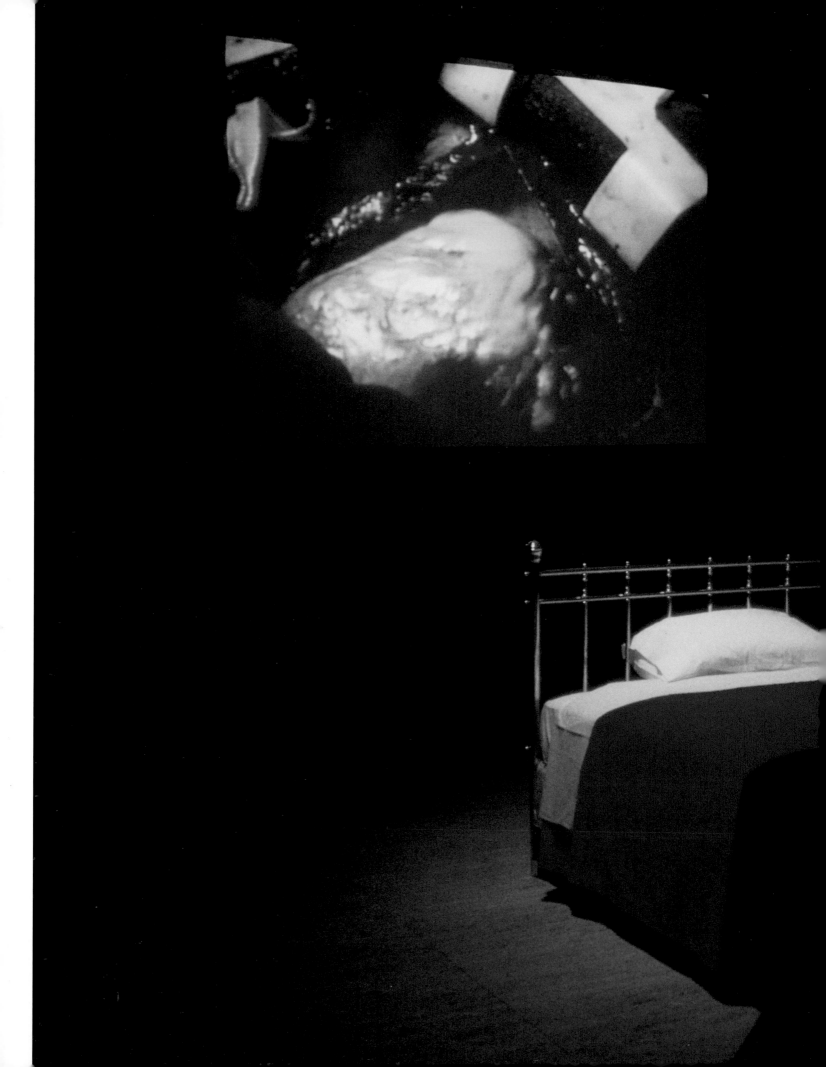

cat. **298**
Bill Viola
Science of the Heart,
1983
video/
sound installation

Notes

1.
William Schupbach, *The Paradox of Rembrandt's Anatomy of Dr. Tulp, Medical History*, Supplement 2, London, 1982, p. 31.

2.
P. Melancthon, *Commentarius de anima*, Wittenburg, 1540, fols., 44v-45r; Andrea Carlino, *Paper Bodies: a Catalogue of Anatomical Fugitive Sheets, 1538–1687, Medical History*, Supplement 19, London, 1999, p. 111.

3.
For anatomy, dissection and representation in general, see A. Carlino, *Books of the Body. Anatomical Ritual and Renaissance Learning*, trs. J. and A. Tedeschi, Chicago and London, 1999; D. Petherbridge, C. Ritschard and A. Carlino, *Corps à vif*, exhibition catalogue, Musée d'Art et d'Historie, Geneva, 1998; Deanna Petherbridge, *The Quick and the Dead. Artists and Anatomy*, exhibition catalogue, Hayward Gallery National Touring Exhibition, London, 1997; Mimi Cazort, Monique Kornell and K.B. Roberts, *The Ingenious Machine of Nature*, exhibition catalogue, National Gallery of Canada, Ottawa, 1996; Brian P. Kennedy, ed., *The Anatomy Lesson: Art and Medicine*, National Gallery of Ireland, Dublin, 1992; and K.B. Roberts and J. Tomlinson, *The Fabric of the Body. European Traditions of Anatomical Illustration*, Oxford, 1992.

4.
Martin Kemp, 'Temples of the Body and Temples of the Cosmos: Vision and Visualisation in the Versalian and Copernican Revolutions' in ed. B. Baigrie, *Picturing Knowledge. Historical and Philosophical Problems Concerning the Use of Art in Science*, Toronto, 1996, pp. 40–85.

5.
N. Middelkoop et al, *Rembrandt under the Scalpel*, exhibition catalogue, Mauritshuis, The Hague, 1999.

6.
W. Schupbach, *The Paradox of Rembrandt's Anatomy of Dr. Tulp*, pp. 57–65 for a selection of key texts on the hand; and M. Kemp, 'The Handy Worke of the Incomprehensible Creator', *Writing on Hands*, exhibition catalogue, Dickinson College, 2000, forthcoming.

7.
Marina Wallace, 'The Anatomy Lesson of Professor Röell, 1728, by Cornelius Troost' in eds. Martin Kemp and Marina Wallace, *Know Thyself: The Art and Science of the Human Body*, University of California Press, Berkeley, forthcoming.

8.
Kenneth D. Keele and Carlo Pedretti, *Corpus of the Anatomical Studies in the Collection of Her Majesty the Queen at Windsor Castle*, 3 vols, Leonardo da Vinci, Royal Library, Windsor Castle, no. 19070v, New York, 1979, no. 113r.

9.
M. Kemp, 'Style and Non-style in the Picturing of Anatomy', *Know Thyself*.

10.
M. Kornell, 'Rosso Fiorentino and the anatomical text', *The Burlington Magazine*, CXXXI, London, 1989, pp. 843-47.

11.
T.H. Clark, *The Rhinoceros from Dürer to Stubbs, 1515–1799*, London, 1986, pp. 47–68.

12.
M. Kemp, 'The Microcosm', *Leonardo da Vinci. The Marvellous Works of Nature and Man*, London, 1989, chapter 2, pp. 91–151.

13.
L.M. Payne, 'Tabulae Harveiamae: a Seventeenth-century Teaching Aid', *British Medical Journal*, 2 July 1966, pp. 38–39.

14.
J. Hansen and S. Porter, *The Physician's Art. Representations of Art and Medicine*, exhibition catalogue, Duke University Museum of Art, Durham N.C., 1999, 48–53.

15.
A. Roy, *Gérard de Lairresse, 1640–1711*, Paris, 1992.

16.
M. Kemp 'The mark of truth: looking and learning in some anatomical illustrations from the Renaissance and eighteenth century' in eds. W.F. Bynum and R.S. Porter, *Medicine and the Five Senses*, Cambridge, 1993, pp. 85–121.

17.
F. Vannozi, ed., *La Scienza Illuminata. Paolo Masagni nel suo tempo*, Siena, 1996; and Francesca Vannozzi and P. Fiorenzani, 'The Anatomy of a Course: Paolo Mascagni (1755–1815). From the *Vasorum Lymphaticorum* to the *Anatomiae Universae*', *Know Thyself*.

18.
M. Kemp in W.F. Bynum and R.S. Porter, *Medicine and the Five Senses*, p. 119.

19.
L. Bonuzzi and F. Ruggeri in *Le cere anatomiche Bolognesi del Settecento*, exhibition catalogue, Accademia delle Scienze, Bologna, 1981.

20.
V. Mezzogiorno et al, *The Anatomical Museum of Naples*, Naples, 1997; and D. Petherbridge, *The Quick and the Dead. Artists and Anatomy*, pp. 91–94.

21.
M. Poggesi et al, *Encyclopaedia Anatomica*, Köln and London, 1999.

22.
L. Cattaneo and A. Riva, *Le Cere Anatomiche di Clemente Susini dell'Università di Cagliari*, catalogue of the museum, Cagliari, 1993.

23.
Julie V. Hansen, 'Resurrecting Death: Anatomical Art in the Cabinet of Dr. Frederik Ruysch', *Art Bulletin*, 4 December 1996, pp. 663–79; and Julie V. Hansen, 'Wondrous Bodies: Frederik Ruysch and the Scientific Still Life', *Know Thyself*.

24.
Alfonso Maria Pluchinotta, ed., *Incanto e Anatomia del Seno*, exhibition catalogue, Palazzo Zabarella (Padua), Milano, 1997, p. 32.

25.
Leon Battista Alberti, *On Painting*, trs. C. Grayson, ed. M. Kemp, London, 1991, para. 36, p. 72.

26.
Leon Battista Alberti, *On Painting and On Sculpture*, ed. and trs. C. Grayson, London and New York, para. 8, pp. 128–29.

27.
L. Ghiberti, *I commentarii*, ed. L. Bartoli, Florence, 1998, para. II.8, p. 48.

28.
P. Emison, 'The Word made Naked in Pollaiuolo's *Battle of the Nudes*', *Art History*, XIII, 1990, pp. 261–75.

29.
M. Kornell, *Artists and the Study of Anatomy in Sixteenth-Century Italy*, PhD thesis, Warburg Institute, London, 1993.

30.
Robert Williams, *Art, Theory, and Culture in Sixteenth-Century Italy. From Techne to Metatechne*, Cambridge, 1997, p. 148, and more generally for *disegno* as the loftiest ideal of art.

31.
K-E. Barzman, *The Discipline of Disegno: the Florentine Academy and the Early Modern State, 1563–1737*, forthcoming; C. Goldstein, *Teaching Art Academies and Schools from Vasari to Albers*, Cambridge, 1992; N. Pevsner, *Academies of Art, Past and Present*, London, 1940.

32.
A. Condivi, *The Life of Michelangelo*, ed. H. Wohl, trs. A. Sedgewick Wohl, Baton Rouge, Louisiana, 1976, p. 99.

33.
L. Price Amerson jnr, *The Problem of the Écorché: a Catalogue Raisonné of Models and Statuettes from the Sixteenth Century and Later Periods*, PhD dissertation, Pennsylvania State University, 1975; and I. Bignamini and M. Postle, *The Artist's Model*, exhibition catalogue, University of Nottingham and Kenwood House, London, 1991.

34.
M. Kemp, *Dr. William Hunter at the Royal Academy of Arts*, Glasgow, 1975, p. 16.

35.
Martin Postle, 'Écorché figures in the English Academy', *Know Thyself*.

36.
L. Price Amerson jnr, *L'Ecorché*, Cahier no. 3, l'Ecole des Beaux Arts de Rouen, p. 33.

37.
Robert Knox in M. Kemp, *Dr. William Hunter at the Royal Academy of Arts*, p. 25.

38.
Leonardo da Vinci, Codex Urbinas, Rome, Vatican, fol. 119v; *Leonardo on Painting*, ed. M. Kemp, trs. M. Kemp and M. Walker, London and New Haven, 1989, p. 131.

39.
M. Kemp, *Dr. William Hunter at the Royal Academy of Arts*, p. 44.

40.
K.D. Keele and C. Pedretti, no. 81v; Windsor, Royal Library, 19037v.

41.
Erwin Panofsky, *The Art and Life of Albrecht Dürer*, Princeton, 1971, pp. 232–35.

42.
Jennifer Montagu, *The Expression of the Passions*, New Haven and London, 1994; and Madeleine Pinault Sørensen, 'Am I a Man, Am I an Animal? The Physiognomic Designs of Charles Le Brun', *Know Thyself*.

43.
Margot and Rudolf Wittkower, *Born under Saturn*, London, 1963, pp. 124–132.

44.
Jean Claire, 'Petit dictionnaire désordonné de l'âme et du corps' in ed. Jean Claire, *L'âme au corps: arts et sciences 1793–1993*, exhibition catalogue, Galeries nationales du Grand Palais, Paris, 1993, pp. 40–67.

45.
M. Kemp 'A Perfect and Faithful Record: Mind and Body in Medical Photography before 1900' in ed. A. Thomas, *Beauty of Another Order. Photography in Science*, New Haven and London, 1998, pp. 120–145.

46.
Essays on Physiognomy, designed to Promote the Knowledge and Love of Mankind, 5 vols, London, 1789, trans. Henry Hunter DD, vol. II, p. 133.

47.
F.J. Gall and J.G. Spurzheim, *The Physiognomical System of Drs. Gall and Spurzheim; founded on an Anatomical and Physiological Examination of the Nervous System in General, and of the Brain in Particular; indicating the Dispositions and Manifestations of the Mind* (2nd edition, 1815), p. 226.

48.
Ibid., p. 262.

49.
M.H. Kauffman, *Death Masks and Life Masks of the Famous and Infamous*, exhibition catalogue, Edinburgh, n.d.

50.
Mary Cowling, *The Artist as Anthropologist: The Representation of Types and Character in Victorian Art*, Cambridge and New York, 1989.

51.
Giulio Barsanti et al, *Misura dell'uomo*, exhibition catalogue, Museo di Storia della Scienza, Florence, 1986.

52.
P. Camper, *The Works of the Late Professor Camper, on the Connexion Between the Science of Anatomy and the Arts of Drawing, Painting, Statuary etc.* (1794), London, 1821, p. 16; and M. Kemp, 'Angles on Faces', *Know Thyself*.

53.
P. Camper, *The Works of the Late Professor Camper…*, p. 32.

54.
Stephen Jay Gould, *The Mismeasure of Man*, London and New York, 1992, pp. 50–69.

55.
Jeanine Durand in *La Sculpture ethnographique*, exhibition catalogue, Musée d'Orsay, Paris, 1994.

56.
Elizabeth Edwards, 'Order Others: Photography, Anthropologies and Taxonomies' in ed. R. Roberts, *In Visible Light: Photography, Classification in Art, Science and the Everyday*, exhibition catalogue, Museum of Modern Art, Oxford, 1997, pp. 54–68.

57.
F. Haslam, *From Hogarth to Rowlandson. Medicine and Art in Eighteenth Century Britain*, Liverpool, 1996.

58.
Sander L. Gilman, *Health and Illness. Images of Difference*, London, 1995, pp. 44–45.

59.
Albert Boime 'Portraying Monomaniacs to Service the Alienist's Monomania: Géricault and Gorget', *Oxford Art Journal*, XIV, 1991, pp. 79–91.

60.
M. Kemp in ed. A. Thomas, *Beauty of Another Order*, p. 136.

61.
G. Didi-Hubermann, *Invention de l'hystérie: Charcot et l'iconographie photgraphique de la Salpêterière*, Paris, 1982.

62.
M. Kemp in ed. A. Thomas, *Beauty of Another Order*, pp. 139–141.

63.
Raymond Fancher, 'Images of the Head in the Life and Work of Francis Galton', *Know Thyself*.

64.
D. Green, 'Veins of Resemblance: Photography and Eugenics', *Oxford Art Journal*, 1985, pp. 3–16.

65.
Ibid., p. 13.

66.
G. Lombroso Ferrero with an introduction by C. Lombroso, *Criminal Man according to the Classification of Cesare Lombroso*, New York and London, 1913, p. 6.

67.
Ibid., p. 19.

68.
Ibid., p. 22.

69.
Ibid., p. 47.

70.
Anthea Callen, *The Spectacular Body: Science, Method, and Meaning in the Work of Degas*, New Haven, 1995, and Anthea Callen, 'Anatomie et physionomie: la Petite Danseuse de Quatorze Ans de Degas', *L'âme au corps*, pp. 360-73; R. Kendall with D. Druick and A. Beale, *Degas and the Little Dancer*, New Haven and London, 1998.

71.
D. Petherbridge, *The Quick and the Dead. Artists and Anatomy*, p. 96.

72.
Ken Arnold, 'Images in Science', *Strange and Charmed, Science and the Contemporary Visual Arts*, ed. Siân Ede, Calouste Gulbenkian Foundation, 2000, pp. 68–83.

73.
Linda Nochlin, 'The Naked and the Dread', *Tate, The Art Magazine*, Tate Modern Special Issue, May 2000, Issue 21, London, pp. 66–77.

74.
Silvia Eiblmayr, 'Cuts and Shocks', *Body as Membrane*, exhibition catalogue, Odense Kunsthalle, 1996, p. 163.

75.
'Obsolete Body/Alternate Strategies – listening to Stelarc', ed. Robert Ayers, *Live Art Letters, a live research journal*, no. 3, February 1998, p. 3.

76.
Ibid., p. 4.

77.
Ibid., p. 8.

78.
Andrea Carlino, 'Discomfort and Theatricality in Renaissance Anatomy', *Know Thyself*.

79.
Chris Townsend, *Vile Bodies, Photography and the Crisis of Looking*, Prestel and Channel Four, 1998.

80.
For a discussion of AIDS and its representation see the catalogue of the exhibition organized and curated by Nicola White, *Read My Lips, New York AIDS Polemics*, Tramway, 1992.

81.
D. Petherbridge, *The Quick and the Dead. Artists and Anatomy*, p. 96.

82.
Ibid.

83.
John Isaacs in conversation with Marina Wallace, June 2000.

84.
Ibid.

85.
K. Arnold, 'Images in Science', p. 68.

86.
Jonathan Sawday, *The Body Emblazoned: Dissection and the Human Body in Renaissance Culture*, Routledge, London, New York, 1995, pp. 12 and 50. Also see Ken Arnold, 'Sculptures in flesh and bone: bodies as exhibits in the history of museums', *Know Thyself*.

87.
Riccardo De Sanctis, 'Troubling Images to Discover the Body. The Anatomical Waxes', *Know Thyself*.

88.
Piero Camporesi, *Le Officine dei Sensi*, Milano, 1991, p. 111.

89.
In her paper 'Visible Bodies: Cartography and Anatomy' in eds. Andrew Gordon and Bernhard Klein, *Literature, Mapping and the Politics of Space in Early Modern Britain*, Cambridge, forthcoming, Caterina Albano effectively compares the title and strategies of Gerard Mercator's atlas of 1595, *Atlas sive cosmographiae meditationes de fabrica mundi et fabrica figura*, to those of Vesalius's *De humani corporis fabrica*.

90.
Ibid.

91.
Ibid.

92.
Leonardo quoted by Martin Kemp in the catalogue of the exhibition held at the Hayward Gallery in 1989, *Leonardo da Vinci*, London and New Haven, 1989, p. 116.

93.
Ibid., p. 194.

94.
For a discussion on this aspect of Katharine Dowson's work see Marina Wallace, 'Art and Science', *Project 8*, Total Museum of Contemporary Art, Seoul, 1998.

95.
Martin Kemp, 'Vision and Visualisation in the Illustration of Anatomy and Astronomy from Leonardo to Galileo' in eds. G. Freeland and A. Corones, *1543 and All That*, Great Britain, 1999, pp. 17–51.

96.
All quotations from Katharine Dowson included here were recorded as part of a conversation between the artist and the author in May 2000.

97.
J. Hansen, 'Wondrous Bodies: Frederik Ruysch and the Scientific Still Life', *Know Thyself*.

98.
Ibid.

99.
Frederick Ruysch, 'Letter to the Reader', *Thesaurus Anatomicus Primus*, Amsterdam, Apud Joannen Wolters, 1701, p. 2.

100.
Marc Quinn in conversation with Marina Wallace.

101.
J. Hansen, 'Wondrous Bodies: Frederik Ruysch and the Scientific Still Life', *Know Thyself*.

102.
C. Albano in eds. A. Gordon and B. Klein, *Literature, Mapping and the Politics of Space in Early Modern Britain*, forthcoming.

103.
Publication and CDRom on the Clemente Susini waxes in Cagliari by Prof. Alessandro Riva, published by the Department of Anatomy, Cagliari, 1999.

103a.
Margot and Rudolf Wittkower, *Born under Saturn*.

104.
J.M. Charcot and Paul Richer, *Les démoniaques dans l'art*, Amsterdam, 1972, reprinted Paris in 1887, p. v.

105.
Ibid., p. vi. Charcot had published on this subject, in 1885, *Leçon sur l'hysterie chez l'homme*.

106.
Elaine Showalter, 'Hysteria, Feminism and Gender' in eds. Sander L. Gilman, Helen King, Roy Porter, G.S. Rousseau and Elaine Showalter, *Hysteria before Freud*, Berkeley, Los Angeles and London, 1993, pp. 286-344; Sander L. Gilman, 'The Image of the Hysteric', *Hysteria Before Freud*, pp. 345-452; Anthea Callen, 'Masculinity, Normality and the Homosocial', *Know Thyself*.

107.
Elaine Showalter, S. Wessely, M. Hotopf and M. Sharpe, *Chronic Fatigue and its Syndromes*, Oxford, 1998.

108.
All quotes from Beth B are extracts from her correspondence with the authors of this book.

109.
E. Showalter, *Histories, Hysterical Epidemics and Modern Culture*, London, Picador, 1997, p. 109.

110.
Ibid., p. 109.

111.
Ed Sikov in *Laughing Hysterically: American Screen Comedy of the 1950s*, New York, Columbia University Press, 1994, pp. 190–91.

112.
The medical instruments worn by the women in the videos are borrowed from the Museum of Questionable Medical Devices, Minneapolis, USA, director Bob McCoy.

113.
Beth B in e-conversation with Marina Wallace, June 2000.

114.
Christine Borland in e-conversation with Marina Wallace, July 2000.

115.
J.M. Charcot, 7 February 1888 in Christopher G. Goetz, Michel Bonduelle and Toby Gelfand, *Charcot: Constructing Neurology*, New York and Oxford, 1995, p. 107.

116.
Ibid., p. 79.

117.
Lecture on muscular dystrophy delivered by Sir William Gowers, published in *The Lancet* in 1817, giving the most detailed descriptions of the clinical features of the disease (as reported by Christine Borland in her correspondence with the author, June 2000). W.R. Gowers, 'Clinical Lecture on Muscular Paralysis', *The Lancet*, 5 July 1879, pp. 1–2.

118.
Ibid., p. 1.

119.
W.R. Gowers, 'Clinical Lecture on Muscular Paralysis', *The Lancet*, 12 July 1879, pp. 73–75.

120.
S.L. Gilman, 'The Image of the Hysteric', pp. 353-54; see also ed. S.L. Gilman, *The Face of Madness: Hugh W. Diamond and the Origin of Psychiatric Photography*, New York, 1976.

121.
Elizabeth Edwards, 'Anthropometric Intentions: Some Photographic Complexities and Confusions', *Know Thyself*.

122.
Stephen Jay Gould, *The Mismeasure of Man*, London, 1981–1992, pp. 82–112.

123.
Gerhard Lang in e-conversation with Marina Wallace, June 2000.

124.
R. Fancher, 'Images of the Head in the Life and Work of Francis Galton', *Know Thyself*.

125.
Palaeanthropical Physiognomy was shown at the Venice Biennale in 1995.

126.
Gerhard Lang in e-conversation with Marina Wallace, June 2000.

127.
R. Fancher, 'Images of the Head in the Life and Work of Francis Galton', *Know Thyself*.

128.
Deborah Rothschild, *Tony Oursler, Introjection: mid-career survey 1976–1999*, Williams College Museum of Art, 1999.

129.
Ibid., p. 73.

130.
Ibid., pp. 73–74.

131.
Charles Darwin, *The Expression of the Emotions in Man and Animals*, Harper Collins, 1998, first edition published by John Murray, London, 1872, p. 84.

132.
Bill Viola, exhibition catalogue, Whitney Museum of American Art, New York, 1999, p. 159.

133.
Marco Livingstone on Bill Viola's 'The Quintet of the Astonished', *Encounters. New Art from Old*, National Gallery, London, June-September 2000, pp. 313–14.

134.
Ibid., p. 314.

135.
Ibid., p. 314.

List of Works

Note: All measurements are given in cm, as height × width × depth, unless stated otherwise

1 (p.90)
Skeleton owned by John Flaxman
human skeleton wired together and hanging in a wooden cupboard
h. 180
By Courtesy of the Trustees of Sir John Soane's Museum

2
Anon
Ivory Anatomical Figure, a Male, with some Removable Internal Organs, c.17th century
ivory, wood, paper and velvet; 4.5 × 7.3 × 23
A642639
By Courtesy of the Board of Trustees of the Science Museum

3
Anon
Ivory Anatomical Figure, a Pregnant Female with some Removable Internal Organs, on Wooden Stand, c.17th century
ivory and wood; 9.7 × 15 × 24
A127699
By Courtesy of the Board of Trustees of the Science Museum

4 (p.67)
Anon
Ivory Anatomical Figure, a Pregnant Female, with some Removable Parts, Lying on Cloth-Covered Bier, in Wooden Box, c.17th century
ivory, wood and cloth, probably Italian;
7.5 × 26.3 × 10
A642636
By Courtesy of the Board of Trustees of the Science Museum
Photo © National Museum of Photography, Film & Television / SSPL, 2000

5
Anon
Marble Anatomical Figure, a Pregnant Female, with some Removable Internal Organs, c.17th century
marble and wood; 10.6 × 23.3 × 5.8
A642619
By Courtesy of the Board of Trustees of the Science Museum

6 (p.43)
Anon
The Four Seasons, early to mid-17th century
4 engravings with flaps and movable parts; each 40.7 × 50.8
Trent Collection, History of Medicine Collections, Duke University Medical Center Library, Durham, NC
Photo © Bill Bamberger, 2000

7 (p.40)
Anon
Harvey Anatomical Tables (×4), c.1640, Padua
1. The Nervous System; 2. Arteries;
3. Veins; 4. Arteries
cedar wood, varnished human veins, arteries and nervous systems; 1: 201 × 75.5, 2: 198.7 × 79.5, 3: 204 × 77, 4: 197.7 × 77
Royal College of Physicians
Photo © Royal College of Physicians of London, 2000

8 (p.63)
Anon
Foetus with beads, 18th century
human preparation in glass jar; h. 31 × 10 diameter
AL37
Leiden Museum of Anatomy
Photo © Leiden Museum of Anatomy, 2000

9 (p.68)
Anon
Wood and Ivory Figure Group representing an Anatomical Demonstration by Dr. Tulp, based on Rembrandt's painting *The Anatomy Lesson of Dr. Tulp*, 18th century
wood and ivory; 19.5 × 38 × 15
A119917
By Courtesy of the Board of Trustees of the Science Museum
Photo © National Museum of Photography, Film & Television / SSPL, 2000

10 (p.24)
Anon
The Anatomy Theatre at Leiden, c.1700
engraving; 13.2 × 16.6
catalogue no. 20254i
Wellcome Library, London

11 (p.83)
Anon
Carved Wooden Male Anatomical Figure Showing Muscular and Arterial System, Right Arm Missing, 1731–70
wood; 43.5 × 16 × 11.9
A653941
By Courtesy of the Board of Trustees of the Science Museum
Photo © National Museum of Photography, Film & Television / SSPL, 2000

12 (p.84)
Anon
Portrait of a Draftsman with an Écorché Statuette, c.1761–70
oil on canvas; 72 × 64
Daniel Katz Ltd

13 (p.83)
Anon
Écorché of Standing Man (in the pose of William Hunter's Life Cast for the Royal Academy), c.1770
bronze; 66.5 × 32
Koos Limburg Jnr

14
Anon
Death Mask of J.-P. Marat, 1793
plaster cast, life-size
Property of the William Ramsay Henderson Trust

15
Anon
Cast of Dean Swift's Skull, early to mid-19th century
plaster; life-size
Courtesy of The Royal College of Surgeons of England

16
Anon
Plaster Cast (Microcephalic Head with Areas Marked Out, Labelled and Numbered) of an Idiotic Woman, Victoire, 24 Years Old, 19th century
plaster; 26.5 × 13 × 16
A137205
By Courtesy of the Board of Trustees of the Science Museum

17
Anon
Skull of Giuditta Guastamacchia, c.1800
preserved skull; life-size
II Università degli studi di Napoli

18
Anon
Death Mask of F. Schiller, 1805
plaster cast; life-size
Property of the William Ramsay Henderson Trust

19
Anon
Paolo Assalini's (1759–1840) Forceps – Straight Parallel Forceps, c.1810
iron with velvet handle; 30.3 × 4.3
The Old Operating Theatre, Museum and Herb Garret, London

20 (p.114)
Anon
Death Mask of J.-L. David, 1825
plaster cast; life-size
Property of the William Ramsay Henderson Trust
Photo © Henderson Trust, 2000

21 (p.114)
Anon
Death Mask of J.-F. Gall, 1825
plaster cast; life-size
Property of the William Ramsay Henderson Trust
Photo © Henderson Trust, 2000

22 (p.115)
Anon
Life Mask of W. Burke, c.1828–29
plaster cast; life-size
Property of the William Ramsay Henderson Trust
Photo © Henderson Trust, 2000

23 (p.115)
Anon
Life Mask of W. Hare, c.1828–29
plaster cast; life-size
Property of the William Ramsay Henderson Trust
Photo © Henderson Trust, 2000

24
Anon
Model of a Foetus with Hands and Forceps,
1830–31
wax, purchased in 1830/31, made in Florence;
41 × 31 × 65
Museo di Anatomia Umana – Università di Torino

25
Anon
Death Mask of J. Bentham, 1832
plaster cast; life-size
Property of the William Ramsay Henderson Trust

26
Anon
Death Mask of J. Adam, c.1835
plaster cast; life-size
Property of the William Ramsay Henderson Trust

27
Anon
Antelme's Cephalometer, 1838–90, invented 1838
mixed media; 7.5 × 35 × 46
1985–1722
Board of the Trustees of the Science Museum

28
Anon
Ivory Phrenological Head, 1850–1914
ivory, wood; 9.3 × 4.3
A642803
By Courtesy of the Board of Trustees of the
Science Museum

29 (p.110)
Anon
Ivory Phrenological Head on Square Wooden Stand,
1850–1914
ivory, wood; 12.4 × 6.6 × 6.6
A89192
Board of Trustees of the Science Museum
Photo © National Museum of Photography,
Film & Television / SSPL, 2000

30
Anon
Exploded view of a Cranium, c.1890
9 photographs, gelatine silver prints; 30.3 × 22.5
PRM AL. 31.21
Pitt Rivers Museum, University of Oxford

31
Anon
*VeeDee vibrator with case and bottle of VeeDee
oil*, c.1900–10
wood, cork, velvet, nickel-plated brass with rubber
attachments, glass, oil, paper, stainless steel;
38 × 17 × 17
The Thackray Museum of Medicine, Leeds

32
Anon
Vibrator, 1930s
electrical motor, steel with wooden handle;
15.24 × 5.08
Museum of Questionable Medical Devices,
Minneapolis

33
Anon
The Psychograph, 1930s
mechanical stand with printer; 91.44 × 91.44 × 152.4
Museum of Questionable Medical Devices,
Minneapolis

34
Bernard Siegfried Albinus (1697–1770)
*Baby's foot dissected; left foot of a newborn injected
with red dye; nails and upper skin removed*, 1730
human preparation in glass jar; 13 × 8
AB14
Leiden Museum of Anatomy

35
Alessandro Allori (1535–1607)
*Anatomical study of a figure with a raised left leg
seen from behind*, c.1560
black chalk on paper; 42 × 28.2
D1635
National Gallery of Scotland, Edinburgh

36 (p.72)
Alessandro Allori
Anatomical study of a leg, c.1504
red chalk on paper; 42.2 × 30.8
Devonshire Collections, Chatsworth. Lent by
the Duke of Devonshire and the Chatsworth
Settlement Trustees
Photo © Photographic Surveys, Courtauld
Institute, 2000

37
Louis François Auzoux (1797–1880)
Standing Figure with Removable Parts, 1830
papier mâché; 81 × 190 × 63
Museo di Anatomia Umana – Università di Torino

38 (pp.177, 180)
Beth B (b.1955)
Hysteria, 2000
foam core, wax, wire, motors, video monitors
and video projection, padded wall, vibrators,
strait-jacket, ovarian compressor, cots, live
performance; dimensions variable
© Beth B, 2000

39 (pp.112–113)
William Bally (active 1832–1846)
*Wooden case containing sixty small phrenological
heads*, 1831
case, wood, heads, plaster; 60 × 56 × 36.5
A642804
By Courtesy of the Board of Trustees of the Science
Museum
Photo © National Museum of Photography,
Film & Television / SSPL, 2000

40
Enea Vico (1523–1567) after Baccio Bandinelli
(1494–1541)
Bandinelli's Academy, c.1535
engraving; 44.9 × 60.1
B.XV, 305.49
The British Museum, London

41 (p.86)
Thomas Banks (1735–1805)
Anatomical Crucifixion, 1801
plaster cast on wooden cross; 231.5 × 141 × 34
Royal Academy of Arts, London
Photo © Royal Academy of Arts, London, 2000

42 (p.108)
Giovan Battista della Porta (1535–1615)
De Humana Physiognomia, 1586
Naples: apud J. Cahhium: Vici Atquensis, plate
pp.78–79
book; 32 × 23
G.2200
The British Library Board
Photo by permission of The British Library

43
Sir Charles Bell (1774–1842)
Essays on the anatomy of expression in painting,
1806
London: Longman, plate II, *Facial Muscles*
book; 16 × 47.4 × 31
EPB/C 13074/C/1
Wellcome Library, London

44
John Bell (1763–1820)
*Engravings explaining the anatomy of the bones,
muscles, and joints*, 1794
Edinburgh: Bell & Bradfute, book II, plate VIII,
*Dissection of the Superficial Muscles of the
Abdomen and Lower Thorax*
book; 27.5 × 35 × 29
EPB/C 13127/C
Wellcome Library, London

45
Jacopo Berengario da Carpi (c.1460–1530)
*Commentaria cum amplissimis additionibus super
anatomia mundini*, 1521
Bologna: H. de Benedictis, fol. cccccix verso,
Crucified Écorché
book; 22 × 29 × 21.1
EPB/781
Wellcome Library, London

46 (p.146)
Alphonse Bertillon (1853–1914)
Left-hand print of Mallet, Arthur Joseph,
7 May 1885
paper; 48 × 33
Musée de la Préfecture de Police, Paris

47
Alphonse Bertillon
*Boite de mensuration anthropométrique d'Alphonse
Bertillon*, c.1890–1910
wood and metal; 74 × 24
Musée de la Préfecture de Police, Paris

48 (p.146–147)
Alphonse Bertillon
Tableau des Nuances de l'Iris Humain, from
'Instructions Signalitiques', c.1890
colour plate; c.40 × 100
cat. no.379.B
Musée de la Préfecture de Police, Paris

49
Alphonse Bertillon
Album Photographique des Individus Signalés,
1894
paperback album of photographs of individuals to
be refused admission to France; photos 8 × 20 and
16 × 20
Musée de la Préfecture de Police, Paris

50 (p.199)
Alphonse Bertillon
Alphonse Bertillon's Photographic Studio, c.1900
photograph; 26.9 × 36
Musée de la Préfecture de Police, Paris

51
Alphonse Bertillon
Cours de Signalement Descriptif, c.1900
photograph; p.22; 39 × 56
Musée de la Préfecture de Police, Paris

52 (p.145)
Alphonse Bertillon
Tableau Synoptique des Traits Physiognomiques,
1901–16
photograph; c. 25 × 40
Musée de la Préfecture de Police, Paris

53
Alphonse Bertillon
Album Photographique des Individus Signalés,
May 1906
album of photographs of individuals to be refused
admission to France; photos 8 × 20 and 16 × 20
Musée de la Préfecture de Police, Paris

54 (p.147)
Alphonse Bertillon
*Photograph of Alphonse Bertillon – judicial model
showing frontal view and profile*, 7 Aug 1912
photograph; 14.6 × 14.6
Musée de la Préfecture de Police, Paris

55 (p.44)
Gottfried Bidloo (1649–1713)
Anatomia Humani Corporis, 1685
Amsterdam: Someren, Dyk et al., *Dissection of
the muscles and tendons of the back of the hand*,
separate plate drawn by Gérard de Lairesse
(1641–1711), 1685, printed 1739
engraving; 53.1 × 37.3
27989i
Wellcome Library, London

56
Gottfried Bidloo
Anatomia Humani Corporis, 1685
Amsterdam: Someren, Dyk et al., *Dissection of the
shoulder with folded hands*, separate plate drawn
by Gérard de Lairesse, 1685, printed 1739
engraving; 53.2 × 38
27744i
Wellcome Library, London

57 (pp.188–189)
Christine Borland (b.1965)
Progressive Disorder, 2000
four-part video projection; dimensions variable
Courtesy of the Lisson Gallery, London
Illustrated by Campbell McAllistair
Edited by Bert Ross and David Archibald
© Christine Borland, 2000

58
Andrea Boscoli (d.1606) (school of)
Drawing of an Écorché Statuette, 17th century
brown ink with brown and white gouache and
black pencil on paper; 39.9 × 19.4
8235F
Gabinetto Disegni e Stampe degli Uffizi

59 (p.81)
Andrea Boscoli (school of)
Drawing of an Écorché Statuette, 17th century
brown ink with black pencil on paper; 40.5 × 17.7
8227F
Gabinetto Disegni e Stampe degli Uffizi
Photo © Raffaello Bencini, 2000

60
Edmé Bouchardon (1698–1762)
L'Anatomie nécessaire pour l'usage du dessin, 1741
plates 8 and 11, *Écorché*
ink on paper; 50.7 × 33.5
Special Collections Department, Glasgow
University Library

61
Jean Baptiste Marc Bourgery (1797–1849) and
Nicolas Henri Jacob (1781–1871)
Traité complet de l'anatomie de l'homme, 1831–54
Paris: C.A. Delaunay, plate 30, *Exploded skull*
book; 25 × 58 × 44
EPB/F.121
Wellcome Library, London

62 (p.190)
Paul Broca (1824–1880)
Craniometer, 1840–80
designed and used by Paul Broca
wood and metal (brass); 34.3 × 17 × 17.2
A658588
By Courtesy of the Board of Trustees of the Science
Museum
Photo © National Museum of Photography,
Film & Television / SSPL, 2000

63
Paul Broca
Mémoires d'Anthropologie, 1871–88
Paris: C. Rienwald et Cie, vol. I, table 1, p.144,
Table on Stereographic Measurements
book; 15 × 28 × 24
ZE/BRO
Wellcome Library, London

64 (p.119)
Paul Broca
Mémoires d'Anthropologie, 1871–88
Paris: C. Reinwald et Cie, vol. III, 10, *Brain
of the Hottentot Venus and of Eleven Young
Chimpanzees*, pp. 136–137
book; 13 × 28.5 × 23.5
ZE/BRO
Wellcome Library, London

65 (p.119)
Paul Broca
*Instructions Craniologiques et Craniométriques
de la Société d'Anthropologie de Paris*, 1875
Paris: Librarie Georges Masson, figs. 5 and 6
book; 25 × 16.5 × 20
Courtesy of The Royal College of Surgeons
of England
Photo © Royal College of Surgeons of
England, 2000

66 (p.73)
Agnolo Bronzino (1503–1572)
St Bartholomew, 1555
oil on wood panel; 155 × 94
Accademia Nazionale di San Luca, Roma

67 (pp.178–179)
André Brouillet (1857–1914)
Une leçon de clinique à la Salpêtrière, 1887
oil on canvas; 300 × 425
Musée d'Histoire de la Médicine, Paris

68
John Burton (1710–1771)
*An essay towards a complete new system of
midwifry*, 1751
London: J. Hodges, plates X–XI., George Stubbs,
Foetus in the womb
book; 24 × 36 × 22
EPB/B 16295/B
Wellcome Library, London

69 (pp.20–21, 60)
F. Calenzuoli (1796–1829)
Female Reclining Figure, 1831
wax; 53 × 56 × 84
Museo di Anatomia Umana – Università di Torino
Photo © Roberto Goffi, 2000

70
F. Calenzuoli
Spinal Axis, 1831
wax; 53 × 60 × 72
Museo di Anatomia Umana – Università di Torino

71 (p.118)
Petrus Camper (1722–1789)
*The works of the late Professor Camper, on the
connection between the science of the anatomy
and the arts of drawing, painting, statuary*, 1821
London: J. Hearne, folded plate, table III, *Cranial
types, arranged by facial angles*
book; 31.7 × 26.3
Private Collection

72 (p.71)
Jacopo Carrucci (1494–1557), il Pontormo
Studies of the Bones of the Shoulders and Arms,
16th century
red chalk on paper; 28.9 × 20.1
6522 F
Gabinetto Disegni e Stampe degli Uffizi
Photo © Raffaello Bencini, 2000

73
Carl Gustav Carus (1789–1869)
Atlas der Cranioscopie, 1843
Leipzig: August Weichard, plate I, *Schiller's Skull*
book; 34.8 × 27.5 × 17
The Royal College of Surgeons of England

74 (p.130)
Jean-Martin Charcot (1825–1893)
Diapason Électrique, c.1870
wood, brass and steel; 7.5 × 12 × 24.8
Musée d'Histoire de la Médecine, Paris

75 (p.44)
William Cheselden (1688–1752)
Osteographia, or the anatomy of the bones, 1733
London: the author, plate XXXVI, *Praying Skeleton*
book; 31 × 64.5 × 55.5
EPB/F.320
Wellcome Library, London

76 (p.78)
Ludovico Cigoli (1559–1613)
Écorché Statuette, c.1598–1600
bronze; h. 62
Victoria and Albert Museum
Photo © V & A Picture Library, 2000

77 (p.51)
Antonio Citarelli (c.1790–1871)
Standing Male Écorché, c.1825
wax; 230 × 92 × 90
II Università degli studi di Napoli
Photo © Fabio Donato, Napoli, 2000

78 (p.64)
Antonio Citarelli
Foetus in utero (breech birth), c.1850
wax; 32 × 26 × 43
Il Università degli studi di Napoli
Photo © Fabio Donato, Napoli, 2000

79
Antonio Citarelli
Foetus with Parasitic Twin, c.1850
wax; 70 × 40 × 40
II Università degli studi di Napoli

80
Antonio Citarelli
Reclining Putto, c.1852
marble; 37 × 60 × 36
II Università degli studi di Napoli

81
Cornelius Cort (1533–1578) after Jan van der
Straet, called Stradano (1523–1605)
An 'Academy of Artists', 1578
engraving; 72.8 × 55.1
li. 5-110
The British Museum

82 (p.105)
Gustave Courbet (1819–1877)
The Desperate Man, 1844–45
oil on canvas; 60.5 × 50.5
Nasjonalgalleriet, Oslo
Photo: J. Lathion © Nasjonalgalleriet, Oslo

83
Henri Dagonet (1823–1902)
*Nouveau traité élémentaire et practique des
maladies mentales*, 1876
Paris: Ballière, p.272, *Monomania and Ambition*
book; 23 × 14.4
07660.K.27
The British Library Board

84
Carl Dammann (1819–1874)
Frederick Dammann (1834–1894)
*Loose miscellaneous photographs, the remains
of Dammann's project*, 1865–70
photographs, albumen prints; 85 × 53
DM 126-1-17 (17 Prints) and DM 130-144
(15 Prints)
Pitt Rivers Museum, University of Oxford

85 (p. 123)
Carl Dammann
Frederick Dammann
*Ethnographic and Photographic Gallery of Various
Races of Man*, 1875
London: Trüber, plates VI and VII showing West
and East India
buckram embossed album, tipped-in albumen
prints; 30 × 40 × 2.5
AL60
Pitt Rivers Museum, University of Oxford

86 (p.200)
Charles Darwin (1809–1882)
The Expression of the Emotions in Man and Animals
(1873 printing)
London: J. Murray, chapter VII, table II, *Expression of Grief*, photographs by Duchenne de Boulogne and Anon
book; 13.9 × 26.8 × 19.6 (open)
XWM
Wellcome Library, London

87
Honoré Daumier (1808–1879)
Physiognomies des Spectateurs de la Porte St. Martin pendant une representation de Richard II, 19th century
lithograph; 42.3 × 57.5 × 2.3
#E5084 – 1960
Victoria and Albert Museum, London

88
Honoré Daumier
Physiognomies Tragico-Classique, 19th century
lithograph; 42.3 × 57.5 × 2.3
Circ 316–1948
Victoria and Albert Museum, London

89
Honoré Daumier
Mr Guizot, 1833
lithograph; 65 × 50 × 3
box 10, GLAHA 2024, LD 74
Hunterian Art Gallery, University of Glasgow, McCallum Collection

90
Honoré Daumier
Mr Vieux-Niais, 1833
lithograph; 65 × 50 × 3
box 10, GLAHA 2022, LD 54
Hunterian Art Gallery, University of Glasgow, McCallum Collection

91
Honoré Daumier
Pygmalion, 1842
lithograph; 65 × 50 × 3
box 13, GLAHA 20613, LD 971 ii/iii
Hunterian Art Gallery, University of Glasgow

92 (p.109)
Honoré Daumier
L'Artiste m'a Representé, 1844
lithograph; 65 × 50 × 3
box 12, GLAHA 2040, LD 1234 iii/iii
Hunterian Art Gallery, University of Glasgow, McCallum Collection
Photo © Hunterian Art Gallery, University of Glasgow, 2000

93
Honoré Daumier
Il y a Trois Mois, 1848
lithograph; 65 × 50 × 3
LD 1686 ii/ii
Hunterian Art Gallery, University of Glasgow, McCallum Collection

94
Honoré Daumier
Repetition de Sourire, 1869
lithograph; 65 × 50 × 3
box 12, GLAHA 3703, LD 3706 iii/iii
Hunterian Art Gallery, University of Glasgow, McCallum Collection

95 (p.101)
David d'Angers (1788–1865)
Sadness, 1811
plaster; 55 × 31 × 30.5
Musées d'Angers
Photo © Cliché Musées d'Angers, 2000

96 (p.142)
Edgar Degas (1834–1917)
Little Dancer Aged Fourteen (cast *c.*1922), 1880–81
painted bronze with muslin and silk;
98.4 × 41.9 × 36.5
Tate, purchased with assistance from the NACF, 1951
Photo © Tate, 2000

97
Hugh Welch Diamond (1808–1886)
Photographs of the Insane, Plate I, (9 photographs of insane women), 1850s
photographs; 66 × 48
By kind permission of the Royal Society of Medicine, London

98 (pp.128–129)
Hugh Welch Diamond
Photographs of the Insane, Plate II, (9 photographs), 1850s
photographs; 80 × 68
By kind permission of the Royal Society of Medicine, London
Photo © RSM Library, 2000

99 (p.169)
Katharine Dowson (b.1962)
Pia Mater, 2000
glass, stainless steel, tubing; 600 × 35
Courtesy of the artist
© Katharine Dowson, 2000

100 (p.106)
Guillame-Benjamin Duchenne de Boulogne (1806–1875)
Appareil Volta-Faradique à double courant de Duchenne de Boulogne, 1855
iron and wood; 28 × 24
Musée d'Histoire de la Médecine, Paris

101
Guillame-Benjamin Duchenne de Boulogne
Méchanisme de la physiognomie humaine ou analyse électro-physilogique de l'expression des passions, 1862
Paris: Yve de Jules Renouard, chap. XI, fig.64, *Fear*
book; 27.5 × 17.4
7410.e.17
The British Library Board

102 (p.42)
Albrecht Dürer (1471–1528)
Melencolia I, 1514
engraving; 60.1 × 44.9
1912-12-20-2, CD 73 I
The British Museum, London
Photo © The British Museum, 2000

103
Albrecht Dürer
Hierin begriffen vier bücher von menlischen proportion, 1525–28
Venice, *Facial Types*
book; 31.5 × 21
c.119.h.7(2)
The British Library Board

104 (p.143)
Havelock Ellis (1854–1939)
The Criminal, 1890
London: Walter Scott, title page and frontispiece
book; 10 × 24.5 × 19.5
Med.WM800/1890E47c
Wellcome Library, London

105 (p.35)
Charles Estienne (1504–*c.*1564)
De dissectione partium corporis humani, 1545
Paris: S. de Colines, p.285, *Dissection of a Woman*
book; 21 × 40 × 36.5
EPB/6076
Wellcome Library, London

106 (p.35)
François Jollat (1490–1550) after Charles Estienne
Dissection of a Man, 1545, printed 1557/1575
from Charles Estienne, *De dissectione partium corporis humani*, 1545
woodcut with letterpress, with watercolour and gold paint, 1545; 27.9 × 20.4
38852i
Wellcome Library, London

107
Agostino dei Musi, called Veneziano (1514–1536)
after Rosso Fiorentino (or Bandinelli) (1494–1541)
Skeletons Pietá, c. 1532
engraving; 55.1 × 72.8
B.XIV, 320, 424, 1857-5-2-18
The British Museum, London

108
John Flaxman (1755–1826)
Anatomical studies of the bones and muscles,
for the use of artists, 1833
London: M.A. Nattali, plate X, *Studies of*
the Muscles of the Arm and Shoulder
book; 41 × 52 × 52.5
EPB/F.185
Wellcome Library, London

109 (p.109)
Eugène Forest (b.1808) after Jean-Gerard
Grandeville
Singeries, Morales, Politiques, from Jean-Gerard
Grandeville, *La Charicature, c.*1831
lithograph; 33.8 × 53.2
epc4901
College Art Collections, University College London
Photo © College Art Collections, UCL, 2000

110 (p.79)
Pietro Francavilla (*c.*1548–1615)
Écorché Statuette, late 16th century
bronze with wood support; 42h
Jagiellonian University, Cracow

111 (p.30)
Lorenz Friesz (*c.*1490–1531)
Speigl der Artzny, 1519
Strasbourg: J. Grieninger, VIII verso, Hans Baldung
Grien (1484/85–1545), *Dissection of a Man*
book; 29 × 32.8 × 28
EPB/2420
Wellcome Library, London

112 (pp.116–117)
William Powell Frith (1819–1909)
The Railway Station, 1862
oil on canvas; 173.74 × 308.15
Royal Holloway, University of London
Photo © Royal Holloway, University of
London, 2000

113
Henry Fuseli (1741–1825)
Satan, 1796–99
black chalk with white highlights on paper;
66.4 × 50.9
Visitors of the Ashmolean Museum

114 (p.111)
Franz Joseph Gall (1758–1828) and Johann Caspar
Spurzheim (1776–1832)
Anatomie et physiologie du systême nerveux en
général et du cerveau en particulier, 1810–19
Paris: F. Schoell, plate IX, atlas, *Brain*
book; 28 × 65 × 56.5
EPB/F.2256
Wellcome Library, London

115
Francis Galton (1822–1911)
The average female faces without phthisis and
the average female faces with phthisis, 1880s
photographs mounted on card; 38.1 × 55.9
Galton papers, 158/2P(20)
UCL Library Services

116 (p.137)
Francis Galton
Photographs cut out from Cambridge boating party
and others, 1880s
photos; 6.35 × 5.08
Galton papers, 162/G
UCL Library Services

117 (p.192)
Francis Galton
Composite, plate I and plate II, 1880s
photographs mounted on card; 63.5 × 76.2
Galton papers (1), phthisis cases, 158/2P
UCL Library Services

118 (p.134)
Francis Galton
Narrow ovoids with regular features: tubercular
type, line of 15; narrow ovoids of a lower type, line
of 12, 1880s
photographs mounted on card; 55.9 × 40.6
Galton papers, 158/2P (12)
UCL Library Services

119 (p.193)
Francis Galton
Photo of boating party on the Cam with faces cut
out, 1880s
photograph; 26.67 × 22.86
Galton papers, 162G (47)
UCL Library Services

120 (p.135)
Francis Galton
6 Medals of Alexander the Great and composite
of them all in the centre and 3 groups of criminals
taken from 4, 9, and 5 different persons respectively
and the composite of all 18 of them in the centre,
1880s
photographs mounted on card; 35.6 × 43.2
Galton papers, 158/2P (18)
UCL Library Services

121 (p.136)
Francis Galton
6 mounted portraits from Bethlem Asylum, 1880s
photographs mounted on card; 53.3 × 66
Galton papers, 158/2D
UCL Library Sevices

122
Francis Galton
Composite photos of Millbank prisoners, 1881
photographs mounted on card; 35.6 × 38
Galton papers, 158/2K
UCL Library Services

123
Francis Galton
Galton's composite of eight Adamanese crania, skull
lateral view, York, 1881
photographs mounted on card; 27.9 × 35.6
Galton papers, 158/2D (17)
UCL Library Services

124 (p.132)
Francis Galton
*Head calipers, c.*1882
Manufacturer: Murray and Heath
wood and brass instrument in cardboard box
covered with purple
leather; 39 × 7.5 × 2.2
GALT 033
Courtesy of the Department of Biology, University
College London

125 (p.144)
Francis Galton
*Craniometer, c.*1885
metal; 25.7 × 44 × 37
GALT 034
Courtesy of the Department of Biology, University
College London

126 (p.144)
Francis Galton
*Finger-printing kit in small display case, c.*1890
mixed media; 8.2 × 8.2 × 18.8
GALT 050
Courtesy of the Department of Biology, University
College London

127
Francis Galton
*Head spanner, c.*1896
Manufacturer: Cambridge Scientific Instrument
Co. Ltd
wood and brass, in wooden box lined with
newspaper; 28.5 × 36.5 × 4
GALT 035
Courtesy of the Department of Biology, University
College London

128
Jacques Gamelin (1738–1803)
Nouveau recueil d'ostéologie et de myologie, 1779
Toulouse: J.F. Desclassan, vol. II, *Écorché male
figure from the back*
book; 32 × 74 × 54
EPB/F.2270
Wellcome Library, London

129 (p.52)
Jacques Fabien Gautier d'Agoty (1716–c.1785)
*Anatomie des parties de la génération de l'homme
et de la femme*, 1773
Paris: J.B. Brunet; Demonville, folded plate VIII,
Dissected Woman and Foetus
book; 47 × 65 × 70
EPB/D 24192/D
Wellcome Library, London

130 (p.131)
Théodore Géricault (1791–1824)
Man with the 'Monomania' of Child Kidnapping,
1822–23
oil on canvas; 64.8 × 54
The James Philip Gray Collection, Museum of
Fine Arts, Springfield, Massachusetts

131
Andries Jacobsz Stock (c.1580–1642) after Jacques
de Gheyn II (1565–1629)
The Anatomy Lesson of Dr Pauw, 1615
engraving; 28.5 × 22
24757
Wellcome Library, London

132 (p.90)
Hendrik Goltzius (1558–1626)
The Farnese Hercules from the Rear, 1617
engraving; 60.1 × 44.9
B.143 1854-5-13-104
The British Museum, London
Photo © The British Museum, 2000

133
Jean-Gerard Grandeville (1803–1847)
*Metamorphosis du Jour; or Les hommes à la têtes
bêtes*, 1836
Vignette Orthopellic
book; 24 × 32 × 4
(71D.71)
Victoria and Albert Museum

134
Hans Hoffmann (1550–1591)
*Study of Two Hands (Copy of Dürer's drawing of
two hands for the Rabbi in 'Christ and the Doctors',
c.1505–1506)*, 1579
brush drawing with white heightening on blue
paper; 30.3 × 20.4
Szépmüvészeti Múzeum, Budapest

135 (p.80)
John Hogan (1800–1858)
Écorché Statuette of a Crouching Man, 1820–23
alabaster; 24.6 × 14 × 13.3
NGI 8047
Courtesy of the National Gallery of Ireland
Photo © National Gallery of Ireland, 2000

136 (p.124)
William Hogarth (1697–1764)
Bedlam, 1735
engraving; 55.1 × 72.8
P.139, S2-49
The British Museum, London
Photo © The British Museum, 2000

137
William Hogarth
Characters and Caricatures, subscription sheet for
Marriage à la Mode, 1743
etching and engraving; 24.6 × 21.4
39181i
Wellcome Library, London

138
William Hogarth
The Sculptor's Yard, 1753
engraving; 55.1 × 72.8
1868-8-22-1602, P.195
The British Museum, London
Photo © The British Museum, 2000

139
William Hogarth
Characters and Caricatures, 1743
engraving; 60.1 × 44.9
1848-11-25-209, P.162
The British Museum, London

140 (p.29)
William Hogarth
The Reward of Cruelty, 1750–51
engraving; 60.1 × 44.9
S.2-126
The British Museum, London
Photo © The British Museum, 2000

141 (p.82)
Jean-Antoine Houdon (1741–1828)
Écorché of a Standing Man, 1792
bronze; h. 203
MU11974
École Nationale Supérieure des Beaux-Arts,
Département de Morphologie

142
William Hunter (1718–1783)
Écorché of Standing Man, 18th century
polychrome plaster; 171.5 × 61 × 47.5
Royal Academy of Arts, London

143
William Hunter
Écorché Statuette modelled and cast by
Michael Henry after Spang, 1750–1800
bronze on marble stand; 27.5 × 11.6 × 9.3
1981–1911
By Courtesy of the Board of Trustees of the
Science Museum

144 (p.65)
William Hunter
The child in the womb in its natural situation,
c.1770
coloured plaster; 63 × 63.3 × 44
48.5
Hunterian Collection, University of Glasgow
Photo © University of Glasgow, 2000

145
William Hunter
*The child in the womb in its natural situation (end
of the ninth month with the anterior wall of the
pelvis removed)*, c.1770
coloured plaster; 60.2 × 63 × 43.5
48.4
Hunterian Collection, University of Glasgow

146 (p.47)
William Hunter
*Anatomia Uteri Humani Gravidi, The Anatomy
of the Human Gravid Uterus*, 1774
Birmingham: J. Baskerville, table VI, *Foetus at term
in womb*
book; 65 × 48
Special Collections Department, Glasgow University
Library

147
William Hunter
*Anatomia Uteri Humani Gravidi, The Anatomy
of the Human Gravid Uterus*, 1774
Birmingham: J. Baskerville, table I, *Pregnant
woman with placenta*
book; 26.5 × 99 × 69.5
EPB/F.438a
Wellcome Library, London

148 (p.122)
Lawrence & Selkirk (active 1866–1880) for Thomas
Huxley (1825–1895)
*South African Khoisan Man, Abraham Lucas
and Pass. Plus two group photographs of Khoisan
prisoners*, 1870–71
photographed at Breakwater Jail
photograph, albumen print; 45.8 × 30.3
PRM B11/13 a-j
Pitt Rivers Museum, University of Oxford

149 (p.191)
Lawrence & Selkirk for Thomas Huxley
South African Khoisan men. Ten photographs of the measurements of three Khoisan men: //Kabathin, /Hankum, Yarissho, 1870–71
photographed at Breakwater Jail
photograph, albumen print; 23.3 × 28.9
PRM B11/2 a-j
Pitt Rivers Museum, University of Oxford

150 (pp.160–163)
John Isaacs (b.1968)
The Cyclical Development of Stasis, 2000
video installation with sound; dimensions variable
Courtesy of 2021 Gallery, Essen
© John Isaacs, 2000
Photo © Nick Daly, 2000

151 (p.164)
John Isaacs
A Necessary Change of Heart, 2000
wax; 110 × 240 × 90
Courtesy Art and Public, Geneva and 2021 Gallery, Essen
© John Isaacs, 2000
Photo © John Spinks, 2000

152
Charles Nicholas Jenty (active 1745–1767)
Demonstration de la Matrice, 1759
Paris: Charpentier, plate IV, *Gravid Uterus*
book; 29.5 × 44.8 × 1.2
Royal College of Surgeons, England

153 (p.50)
Charles Nicholas Jenty
Demonstratio uteri praegnantis mulieris cum foetu ad partum maturi, 1761–65
Nuremberg: Felssecker, plate III, *Gravid Uterus*
book; 41 × 88 × 64
EPB/F.441
Wellcome Library, London

154 (pp.92–93, 104)
Wilhelm von Kaulbach (1805–1874)
Expressive Self Portrait, 1828
oil on canvas; 51 × 45
Museum Bad Arolsen

155 (p.125)
Kaspar Heinrich Merz (1806–1875) after Wilhelm von Kaulbach
Madhouse, c.1834
engraving; 52.6 × 68.3
icv.17445
Wellcome Library, London

156 (p.23)
Johannes de Ketham (active late 15th century)
Fasciculo de Medicina, 1522
Venice: Giovanni e Gregorio de Gregori, *Anatomy Lesson*
book: 30.5 × 21.5
Archivo antico, Università degli Studi di Padova

157 (p.16)
Thomas de Keyser ? (1596–1667)
Osteology Lesson of Dr Sebastiaen Egbertsz, 1619
oil on canvas; 135 × 186
Amsterdams Historisch Museum

158 (p.75)
Godfrey Kneller (1646–1723)
Self Portrait with Écorché Statuette, c.1670
oil on canvas, 105 × 113.5
Mrs A. Alfred Taubman

159 (p.58)
Petrus Koning (1784–1834)
Dissection of the Arm, 1817–34
wax, flax; 12.5 × 21 × 1.8
AEL 673-34
Anatomisch Museum, Utrecht University
Photo © Tom Haartsen, 2000

160
Petrus Koning
Foetus with Open Abdomen, 1817–34
wax; a: 10 × 16 × 49, b: 10 × 16, c: 10 × 11
AEL - 669 a-b-c
Anatomisch Museum, Utrecht University

161
Petrus Koning
Superficial Dissection of the Left Side of the Head, 1817–34
wax, glass, hair, flax; 16 × 35 × 25
AEL-354
Anatomisch Museum, Utrecht University

162
For John Lamprey (active 1860s–1870s)
Male Nude (black man) with tree, left arm raised, 1868–69
photograph, albumen print; 33.8 × 25
PRM Al.31.4
Pitt Rivers Museum, University of Oxford

163 (p.120)
For John Lamprey
Male Nude (white man) from the front, 1868–69
photograph, albumen print; 33.8 × 25
PRM Al.31.5
Pitt Rivers Museum, University of Oxford

164
For John Lamprey
Nubian at 35, upper Nile, 1868–69
photograph, albumen print; 33.7 × 27.2
PRM Al.31.18
Pitt Rivers Museum, University of Oxford

165
For John Lamprey
Pole at 27, 1868–69
photograph, albumen print; 37.7 × 27.3
PRM Al.31.11
Pitt Rivers Museum, University of Oxford

166
For John Lamprey
Profile of Antonio Malagasy at 19, frontal portrait, 1868–69
photograph, albumen print; 19.8 × 12.4
PRM Al.31.20
Pitt Rivers Museum, University of Oxford

167
For John Lamprey
Profile View: Bengali Sailor, 1868–69
photograph, albumen print; 17.1 × 11.3
PRM Al.31. Misc.2
Pitt Rivers Museum, University of Oxford

168
For John Lamprey
Frontal View: Hindu, 1869
photograph, albumen print; 17.8 × 12.7
PRM Al.31. Misc.4
Pitt Rivers Museum, University of Oxford

169
For John Lamprey
Journal of the Ethnographic Society of London, 1869
London: Trübner and Co., p.84, *Ethnographical notes and queries on a method of measuring the human form, for the use of students in ethnography, Figure of a young African (Sierra Leone)*
book, with tipped-in albumen print; 22 × 15 × 3.8
Balfour Library, Pitt Rivers Museum, University of Oxford

170
Charles Landseer (1799–1879)
The trunk of a cadaver with a block below the stomach, c.1817
red and black chalk; 32 × 53.2
icon. anat. 580
Wellcome Library, London

171 (pp.196–197)
Gerhard Lang (b.1963)
The Typical Inhabitant of Schloss-Nauses, 1992
58 photographs of the citizens and composite
photograph; dimensions variable
© Gerhard Lang, 2000

172 (pp.196–197)
Gerhard Lang
The Typical Inhabitant of Schloss-Nauses, 2000
53 photographs of the citizens and composite
photograph; dimensions variable
© Gerhard Lang, 2000

173 (pp.194–195)
Gerhard Lang
Palaeanthropical Physiognomy, 2000
6 × 16mm projections; dimensions variable
© Gerhard Lang, 2000

174 (p.107)
Johann Caspar Lavater (1741–1801)
Essays on Physiognomy, translated by Henry
Hunter, 1789–98
London: John Murray, vol. I, page 186, *Portrait
of Judas Iscariot* after Holbein
book; 23.5 × 55 × 37.5
EPB /D 32422/D/1
Wellcome Library, London

175
Johann Caspar Lavater
Essays on Physiognomy, translated by Henry
Hunter, 1789–98
London: John Murray, vol. II, part I, plate facing
p. 138, *Monkey heads and skulls*
book; 24 × 53.8 × 37.5
EPB/D 32422/D/1
Wellcome Library, London

176
Charles Le Brun (1619–1690)
*Despair, c.*1660–70
pencil on paper; 24.6 × 19.5
GM 6506
Département de Arts Graphiques, Musée du Louvre

177 (p.98)
Charles Le Brun
*Two human heads, resembling lions, c.*1660–70
pencil and ink on paper; 21.7 × 32.2
GM 6712
Département de Arts Graphiques, Musée du Louvre
Photo RMN © Michèle Bellot

178
Charles Le Brun
Two lion heads, one frontal view, one in profile,
*c.*1660–70
pencil and ink on paper; 18.2 × 32.2
GM. 6711
Département de Arts Graphiques, Musée du Louvre

179 (p.99)
Charles Le Brun
*Two human eyes, frontal and side views, c.*1660–70
pencil on paper; 36 × 24.1
GM. 6759
Département de Arts Graphiques, Musée du Louvre
Photo RMN © Michèle Bellot

180 (p.100)
Charles Le Brun
*Three human heads with skulls removed, c.*1660–70
pencil, ink, wash and red chalk on paper;
23.8 × 39
INV 28236
Département de Arts Graphiques, Musée du Louvre
Photo RMN © Gérald Blot

181 (p.100)
Charles Le Brun
Heads representing the various passions of the soul,
1705
album of engravings; 39.9 × 27.3
Special Collections Department, Glasgow
University Library

182
Charles Le Brun
Conferenza del signor Le Brun...sopra l'espressione
generale e particolare delle passioni, 1751
Verona: Augostin Carattoni, p.35, plates f–g
book; 10.3 × 15.6
Private Collection

183
Ercole Lelli (1702–1776)
Anatomical Statuette, 1732
plaster; 77 × 40 × 27
Museo di Palazzo Poggi, Università degli Studi
di Bologna
Photo © Università di Bologna, 2000

184 (p.55)
Ercole Lelli
Self Portrait with an Écorché Statuette, 1732
oil on canvas; 76 × 56
No. 133
Museo di Palazzo Poggi, Università degli Studi
di Bologna
Photo © Università di Bologna, 2000

185
Ercole Lelli or Anna Morandi (1716–1774)
Male Anatomical Figure, 1740–80
wax; 57.8 × 33.5 × 18.2
A 600129
By Courtesy of the Board of Trustees of the
Science Museum

186 (p.54)
Ercole Lelli or Anna Morandi
Male Anatomical Figure, 1740–80
wax; 59.5 × 33.5 × 18.3
A600130
By Courtesy of the Board of Trustees of the
Science Museum
Photo © National Museum of Photography,
Film & Television / SSPL, 2000

187 (p.48)
Antonio Cattani (active 1770–1780) after
Ercole Lelli
Life-size male écorché from the front, 1781
etching on five sheets; 220 × 85.8
47218i
Wellcome Library, London

188 (p.48)
Antonio Cattani after Ercole Lelli
Life-size male écorché from the rear, 1781
etching on five sheets; 220 × 85.8
20318i
Wellcome Library, London

189 (p.72)
Leonardo da Vinci (1452–1519)
*Sectioned Skull, c.*1489
Two drawings, recto & verso, pen and ink on
a light trace of black chalk on paper; 19 × 13.3
RL 19058 r & v
Lent by Her Majesty the Queen
Photo: Royal Collection © 2000, Her Majesty
Queen Elizabeth II

190 (p.32)
Leonardo da Vinci
Vertical and Horizontal Sections of the Human
*Head, c.*1489
red chalk and ink on paper; 20.3 × 15.2
RL 12603 r
Lent by Her Majesty the Queen
Photo: Royal Collection © 2000, Her Majesty
Queen Elizabeth II

191 (p.39)
Leonardo da Vinci
*Studies of the Vessels of the Thorax, the Heart and
Blood Vessels Compared with the Seed of a Plant,*
*c.*1501
pen and ink on a light trace of black chalk on
paper; 19 × 13.3
RL 19028
Lent by Her Majesty the Queen
Photo: Royal Collection © 2000, Her Majesty
Queen Elizabeth II

192 (p.96)
Leonardo da Vinci
*Studies of Rearing Horses with Snarling Man and
Lion, c.*1503–04
pen and ink on paper; 19.6 × 30.8
RL 12326
Lent by Her Majesty the Queen
Photo: Royal Collection © 2000, Her Majesty
Queen Elizabeth II

193 (p.95)
Leonardo da Vinci
*Head of a Man and a Lion, c.*1503–05
red chalk heightened with white on pink paper;
18.3 × 13.6
RL 12502
Lent by Her Majesty the Queen
Photo: Royal Collection © 2000, Her Majesty
Queen Elizabeth II

194 (p.34)
Leonardo da Vinci
*Muscles of the Shoulders and Spine, c.*1510
pen and ink with wash over traces of black chalk
on paper, recto & verso; 28.5 × 19.5
RL 19015
Lent by Her Majesty the Queen
Photo: Royal Collection © 2000, Her Majesty
Queen Elizabeth II

195 (p.26)
Leonardo da Vinci
*Studies of the Hand, c.*1510
pen and ink with wash over traces of black chalk
on paper; 28.8 × 20.2
RL 19009 r
Lent by Her Majesty the Queen
Photo: Royal Collection © 2000, Her Majesty
Queen Elizabeth II

196 (p.33)
Leonardo da Vinci
*Study of the Tendons and Muscles of the Foot,
Ankle and Lower Leg, c.*1510
pen and ink over traces of black chalk on paper;
38.8 × 28
RL 19017 r
Lent by Her Majesty the Queen
Photo: Royal Collection © 2000, Her Majesty
Queen Elizabeth II

197
Leonardo da Vinci
*Studies of a Human Foetus and the Musculature
of a Woman's Lower Abdomen, c.*1510–12
pen, brown ink and chalk on paper; 30.4 × 22
RL 19101
Lent by Her Majesty the Queen

198 (p.39)
Leonardo da Vinci
*Studies of a Human Foetus, the Uterine Wall
& the Pronation of the Arm, c.*1510–12
pen, ink and chalk on paper; 28.5 × 20.6
RL 19103
Lent by Her Majesty the Queen
Photo: Royal Collection © 2000, Her Majesty
Queen Elizabeth II

199 (p.88)
William Linnell (1792–1882)
Écorché Study after Smugglerius, 1840
pencil, pen and ink heightened with white over
graphite; 72 × 44
PD332-1990
The Syndics of the Fitzwilliam Museum, Cambridge
Reproduction by permission of the Syndics of the
Fitzwilliam Museum, Cambridge

200
Cesare Lombroso (1836–1909)
Album of Criminals no.1, 1871
book; 27.5 × 17 × 2.5
1145
Museo di antropologia criminale Cesare Lombroso,
Università degli Studi di Torino

201 (p.140)
Cesare Lombroso
Album of Criminals no. 2, late 19th century
book; 20.5 × 27.3 × 4
1146
Museo di antropologia criminale Cesare Lombroso,
Università degli Studi di Torino
Photo © Roberto Goffi, 2000

202
Cesare Lombroso
Arsonist, late 19th century
photograph; 6.2 × 10.4
3/1704
Museo di antropologia criminale Cesare Lombroso,
Università degli Studi di Torino

203
Cesare Lombroso
Arsonist, late 19th century
photograph; 6.2 × 10.4
4/1704
Museo di antropologia criminale Cesare Lombroso,
Università degli Studi di Torino

204
Cesare Lombroso
Arsonist, late 19th century
photograph; 6.3 × 10.4
5/1704
Museo di antropologia criminale Cesare Lombroso,
Università degli Studi di Torino

205
Cesare Lombroso
Arsonist, late 19th century
photograph; 6.3 × 10.4
6/1704
Museo di antropologia criminale Cesare Lombroso,
Università degli Studi di Torino

206
Cesare Lombroso
Arsonist, late 19th century
photograph; 6.3 × 10.4
8/1704
Museo di antropologia criminale Cesare Lombroso,
Università degli Studi di Torino

207
Cesare Lombroso
Arsonist, late 19th century
photograph; 6.3 × 10.4
9/1704
Museo di antropologia criminale Cesare Lombroso,
Università degli Studi di Torino

208
Cesare Lombroso
Arsonist, late 19th century
photograph; 6.3 × 10.4
10/1704
Museo di antropologia criminale Cesare Lombroso,
Università degli Studi di Torino

209
Cesare Lombroso
Bertello, condemned for threatening behaviour,
1908
photograph; 8.6 × 11.8
4/1787
Museo di antropologia criminale Cesare Lombroso,
Università degli Studi di Torino

210
Cesare Lombroso
Callisto Grandi, late 19th century
photograph; 10.9 × 18.6
1620
Museo di antropologia criminale Cesare Lombroso,
Università degli Studi di Torino

211
Cesare Lombroso
Camorrista, late 19th century
photograph; 6.3 × 10.6
1653
Museo di antropologia criminale Cesare Lombroso,
Università degli Studi di Torino

212
Cesare Lombroso
Chief of the Camorrista, late 19th century
photograph; 6.3 × 10.60
1654
Museo di antropologia criminale Cesare Lombroso,
Università degli Studi di Torino

213
Cesare Lombroso
Foscalina, condemned for violence, 1907
photograph; 8.6 × 11.9
6/1787
Museo di antropologia criminale Cesare Lombroso,
Università degli Studi di Torino

214
Cesare Lombroso
Garnerone, murdered his wife, 1893
photograph; 11 × 16.4
7/1749
Museo di antropologia criminale Cesare Lombroso,
Università degli Studi di Torino

215
Cesare Lombroso
Mazzone, murdered his brother, 1893
photograph; 11 × 16.4
1/1749
Museo di antropologia criminale Cesare Lombroso,
Università degli Studi di Torino

216
Cesare Lombroso
Murderer, 1893
photograph; 6.4 × 10.5
1656
Museo di antropologia criminale Cesare Lombroso,
Università degli Studi di Torino

217
Cesare Lombroso
Murderess, late 19th century
photograph; 6.3 × 10.4
1/1704
Museo di antropologia criminale Cesare Lombroso,
Università degli Studi di Torino

218
Cesare Lombroso
Murderess, late 19th century
photograph; 6.3 × 10.4
2/1704
Museo di antropologia criminale Cesare Lombroso,
Università degli Studi di Torino

219
Cesare Lombroso
Murderess, late 19th century
photograph; 6.3 × 10.4
7/1704
Museo di antropologia criminale Cesare Lombroso,
Università degli Studi di Torino

220
Cesare Lombroso
Rapist and Murderer, late 19th century
photograph; 6.3 × 10.4
1655
Museo di antropologia criminale Cesare Lombroso,
Università degli Studi di Torino

221
Cesare Lombroso
Smuggler, late 19th century
photograph; 7.9 × 12.4
1657
Museo di antropologia criminale Cesare Lombroso,
Università degli Studi di Torino

222 (p.139)
Cesare Lombroso
The Skull of Villella, 1870
human skull; 26 × 28.5 × 20
Museo di antropologia criminale Cesare Lombroso,
Università degli Studi di Torino
Photo © Roberto Goffi, 2000

223 (p.138)
Cesare Lombroso
*L'Uomo Delinquente, Studiato in rapporto alla
antropologia, alla medicina legale ed alle discipline
carcerarie*, 1876
Milano: Hoepli, 2 vols., vol. I, table XIII, *Portraits
of Italian and German criminals with photographs
of a mask in the middle*
book; 16 × 35 × 25.5
WM800
Wellcome Library, London

224
Cesare Lombroso
La Perizia Psichiatrica-Legale, 1905
Torino: Biblioteca Antropologica-Giuridica, serie I,
vol. 37, p.488, Part II, Chapter I, *Table for the
anthropological examination of the 'criminal
and insane'*
book; 24 × 17
6057.1.3
The British Library Board

224a
Cesare Lombroso
The Criminal Anthropologist, c.1910
photograph; 50 × 72.5
Museo di antropologia criminale Cesare Lombroso,
Università degli Studi di Torino

225
Joseph Maclise (c.1815–c.1880) and
Richard Quain (1800–1887)
The anatomy of the arteries of the human body,
1841–44
London: Taylor & Walton. Atlas vol. 2, plate 61,
Dissection of the abdomen
book; 21 × 74 × 55.5
EPB/F.575
Wellcome Library, London

226
Giovan-Battista Manfredini (1742–post 1780)
Female bust with open abdomen with incisions,
1773–76
terracotta; 90 × 55 × 55
Università di Modena e Reggio Emilia – Museo
di Storia Naturale della Strumentazione Scientifica

227 (p.66)
Giovan-Battista Manfredini
Female bust with open abdomen, 1773–76
terracotta; 85 × 55 × 45
Università di Modena e Reggio Emilia – Museo
di Storia Naturale della Strumentazione Scientifica

228
Giovan-Battista Manfredini
Bust of a pregnant woman with a pendulous abdomen, 1773–76
terracotta; 98 × 55 × 50
Università di Modena e Reggio Emilia – Museo di Storia Naturale della Strumentazione Scientifica

229
Giovan-Battista Manfredini
Pregnancy at full term showing foetal posture, 1773–76
terracotta; 40 × 55 × 50
Università di Modena e Reggio Emilia – Museo di Storia Naturale della Strumentazione Scientifica

230 (p.122)
William Marshall (active 1870s)
A Phrenologist amongst the Todas, or a Study of a Primitive Tribe in South India, 1872
London: Longmans, Green & Co., plate 16, *Adam and Eve*
book; 22.5 × 14
10055.ee.24
The British Library Board
Photo by permission of The British Library

231 (p.49 and cover)
Paolo Mascagni (c.1753–1815)
Life-size three part dissection: 'Anatomia Universa', 1823
3 plates showing muscles from the rear; 233.3 × 203.5
3 plates showing muscles from the front; 233.3 × 203.5
Accademia dei Fisiocritici, Siena
Photo © Lensini Fabio, 2000

232 (p.141)
Attributed to Antonio Masello (active 1870s)
The German Pederast, late 19th century
charcoal on paper; 64 × 78
Museo di antropologia criminale Cesare Lombroso, Università degli Studi di Torino
Photo © Roberto Goffi, 2000

233
Attributed to Antonio Masello
German Thiefess, late 19th century
charcoal on paper; 66 × 80
No. 11/no. 12
Museo di antropologia criminale Cesare Lombroso, Università degli Studi di Torino

234 (p.103)
Franz Xaver Messerschmidt (1736–1783)
Physiognomic Head (Old Man Smiling), 1770
plaster; 36h
no.5678
Österreichische Galerie Belvedere Vienna
Photo © Fotostudio Otto, 2000

235 (p.174)
Franz Xaver Messerschmidt
Physiognomic Head (Head of Character no.9), 1775
alabaster; 60 × 26 × 33
no.67.137
Loan of the Museum of the City of Vienna
Photo: Fotostudio Otto © Direktion der Museen der Staadt Wien

236 (p.102)
Franz Xaver Messerschmidt
Physiognomic Head (Head of Character no.18), 1775
lead; 39.5 × 23 × 23
no.59.895
Loan of the Museum of the City of Vienna
Photo: Fotostudio Otto © Direktion der Museen der Staadt Wien

237
Attributed to Michelangelo Buonarroti (1475–1564)
Muscles and Bones of the Lower Limb, c.1515/1520
red chalk on paper; 27.7 × 20.2
26058i
Wellcome Library, London

238 (p.62)
Jan van Neck (1635–1714)
Anatomy Lesson of Dr Frederik Ruysch, 1683
oil on canvas; 141 × 203
Amsterdams Historisch Museum

239 (p.121)
Negreti & Zambra (active 1850s–1880s)
South African Zulus, Model Group at Crystal Palace, 1860s
photograph; 23.3 × 28.9
PRM B10/3
Pitt Rivers Museum, University of Oxford

240
Tony Oursler (b.1957)
Crying Doll, 1993
mini projector and video tape, rag doll, speaker; 154.9 × 46 × 30.5
Skulpturemuseum Glaskasten Marl
© Tony Oursler, 2000

241 (p.203)
Tony Oursler
Bull's Balls, 1997
projector, VCR, videotape, glass jar, bull's testicles, carosafe preservative; 115 × 23 × 23
Courtesy of 1000Eventi, Milan
© Tony Oursler, 2000
Photo: Courtesy of the artist and Metro Pictures

242
James Parsons (1705–1770)
Human physiognomy explain'd, 1747
London: C. Davis, plate IV, *Scorn*
book; 35 × 30.5 × 23.5
EPB/B 39934/B
Wellcome Library, London

243 (p.13)
Aert Pietersz (1550–1612)
The Anatomy Lesson of Dr Sebastiaen Egbertsz, 1601–03
oil on canvas; 147 × 392
Amsterdams Historisch Museum

244
Pietro da Cortona (Pietro Berrettini) (1596–1669)
Tabulae Anatomicae, 1741
ed. Petrioli
Dissection Showing the Womb, drawing, c. 1618
album of drawings in ink, watercolour and gouache; 52.8 × 35.5
Special Collections Department, Glasgow University Library

245 (p.127)
Philippe Pinel (1745–1826)
Demonstration skull, 1796
Wood, metal stand and human skull; 34 × 16
Museé d'Histoire de la Médecine, Paris

246 (p.126)
Philippe Pinel
Traité médico-philosophique sur l'aliénation mentale, 1801
Paris: Richard, Caille & Ravier, plate II, *Stupidity and Degeneration*
book; 15 × 26 × 22
EPB/41302/B/1
Wellcome Library, London

247 (p.87)
William Pink
Smugglerius (Écorché of Man in the Pose of the 'Dying Gaul'), after Carlini for William Hunter, 1834 (original cast 1775)
plaster cast on wooden support; 76.5 × 161 × 70
Royal Academy of Arts, London
Photo Paul Highnam © Royal Academy of Arts, London, 2000

248
André-Pierre Pinson (1746–1828)
Anatomy of the Hand, late 18th century
wax; 32 × 10 × 10
Laboratoire d'Anatomie comparée, Muséum
National d'Histoire Naturelle, Paris

249 (p.57)
André-Pierre Pinson
Anatomy of a Seated Woman, late 18th century
wax; 40 × 25 × 30
Laboratoire d'Anatomie comparée, Muséum
National d'Histoire Naturelle, Paris
Photo © B. Faye, 2000

250 (p.70)
Antonio Pollaiuolo (c.1429–c.1498)
Battle of the Nudes, 1470
engraving; 65.2 × 85.5
Hind D.11, VI-33,
The British Museum, London
Photo © The British Museum, 2000

251 (p.14)
Jan Maurits Quinkhard (1688–1772)
Four Wardens of the Surgeons' Guild, 1744
oil on canvas; 160 × 240
Amsterdams Historisch Museum

252 (p.173)
Marc Quinn (b.1964)
Eternal Spring (red), 1998
stainless steel, glass, frozen silicon, flowers and
refrigeration equipment; 219.7 × 90 × 90
Courtesy of the artist
© Marc Quinn, 2000
Photo © Mike Bruce, 2000

253 (p.175)
Marc Quinn
Emotional Detox (The Seven Deadly Sins VII),
1994–95
lead and wax; 75 × 79 × 45
Courtesy of the artist and White Cube, London
© Marc Quinn, 2000
Photo: Courtesy Jay Jopling (London)

254 (pp.133, 183)
Désiré-Magloire Bourneville (1840–1909) and
Paul Regnard (1850–1927)
Iconographie photographique de la Salpêtrière,
vols I – III, 1876–80
vol. 1, plate XXXVI, *Delerius, hysterical epileptic*
vol. 2, plate XXVI, *Passionate Attitude: Menace*
vol. 3, plate XX, *Lethargy: Patient with Diapason*
each 24 × 20.5
281.h.11, 218.h.12
By kind permission of the Royal Society of
Medicine, London

255 (p.15)
Tibout Regters (1710–1768)
The Anatomy Lesson of Professor Petrus Camper,
1758
oil on canvas; 167 × 327
Amsterdams Historisch Museum

256
Rembrandt van Rijn (1601–1669)
Self-Portrait with a Frown, 1629
etching, three impressions mounted together;
60.1 × 44.9
1973-U-765, 1925-b-15-23, 1843-b-7-5
The British Museum, London

257 (p.97)
Rembrandt van Rijn
Self-Portrait with an Open Mouth, 1630
etching; 60.1 × 44.9
1973-U-769
The British Museum, London
Photo © The British Museum, 2000

258 (frontispiece)
Rembrandt van Rijn
The Anatomy Lesson of Dr Jan Deijman, 1656
oil on canvas; 100 × 134
Amsterdams Historisch Museum

259
T.C. Wilson (active c.1840) after pen and wash
drawing by Thomas Rowlandson (1756–1827)
Dissecting Room, c.1840
lithograph hand-coloured with watercolour;
42.9 × 32.5
25405i
Wellcome Library, London

260 (p.63)
Frederik Ruysch (1638–1731)
Thesaurus animalium primus, 1744
Amsterdam: Jasson-Waesberge, folding plate VII,
Jars with fish and hands
book; c.23 × 34 × 35.5
EPB/B 45333/B
Wellcome Library, London

261 (p.41)
Frederik Ruysch
Thesaurus animalium primus, 1744
Amsterdam: Jasson-Waesberge, *Table of injected
vessels, stones and infant skeletons*, 1709
separate plate drawn by Cornelius Huyberts
(1669/1670 – c.1712) after Frederik Ruysch
engraving; 40.8 × 43.3
icon. anat. 202
Wellcome Library, London

262
Walter Hermann Ryff (d.1548)
*Des aller fürtrefflichsten, höchsten und adelischsten
Gschöpffs aller Creaturen…das ist, der Menschen…
warhafftige Beschreibung oder Anatomi*, 1541
Strasbourg: B. Beck, sig. N4 recto
fig. VI, Hans Baldung Grien, *Dissection of the Brain*
book; c.20 × 32.5 × 28
EPB/7163
Wellcome Library, London

263 (p.45)
Jan van Rymsdyck (1750–1784)
Forceps Delivery, 1754
drawing for table 21 in William Smellie
(1697–1763), *Sett of Anatomical Tables*, 1754
red chalk on paper; 53.5 × 36.6
Special Collections Department, Glasgow University
Library

264 (p.46)
Jan van Rymsdyck
*Foetus in Womb at the Beginning of the Fifth
Month*, 1774
drawing for fig. II in William Hunter,
Gravid Uterus, 1774
red chalk on paper; 81.2 × 55.9
Special Collections Department, Glasgow University
Library

265 (pp.76–77)
Francois Sallé (1839–1899)
*The Anatomy Lesson at the École des Beaux-Arts,
Paris*, 1888
oil on canvas; 218 × 299
The Art Gallery of New South Wales –
purchased 1888
Photo © Christopher Snee for AGNSW

266 (p.89)
Jean Galbert Salvage (1772–1813)
Anatomie du gladiateur combattant, 1812
Paris: the author, plate XI, *Table of Muscles*
book; 30 × 71 × 58
EPB/F.576
Wellcome Library, London

267 (p.71)
Aristotele da Sangallo (1481–1551)
Battle of Cascina (after Michelangelo), 1504–06
oil on panel; 76.5 × 129.5
The Earl of Leicester and Trustees of the
Holkham Estate

268
Cornelis Solingen (1641–1687)
Amputation Saw, 1675–1750
wood and wrought iron; 58 × 13 × 3
951
Museum Boerhaave, Leiden

269 (p.28)
Cornelis Solingen
Amputation Saw, 1650–84
wood and wrought iron; 40 × 9 × 4
8748
Museum Boerhaave, Leiden
Photo © Tom Haartsen, 2000

270
Cornelis Solingen
*Rasp, used for smooting rough edges after
an amputation or a trepanation*, 1650–84
wrought iron; 22.5 × 2.5 × 1
8071
Museum Boerhaave, Leiden

271 (p.28)
Cornelis Solingen
'Raven's Beak' forceps, 1650–84
wrought iron; 16.5 × 6 × 3
831
Museum Boerhaave, Leiden
Photo © Tom Haartsen, 2000

272
Cornelis Solingen
'Raven's Beak' forceps, 1707
wrought iron; 15.5 × 4 × 2
Museum Boerhaave, Leiden

273 (p.172)
Adrianus Spigelius (1578–1625)
De Formatu Foetu, 1626
Padua: J.B. De Martinis and L. Pasquatus, table IV,
Female figure with open uterus
book; 39.4 × 26.2
544.l.10(3)
The British Library Board
Photo by permission of The British Library

274
George Stubbs (1724–1806)
*A Comparative Anatomical Exposition of the
Structure of the Human Body with that of a Tiger
and a Common Fowl: Human Figure, Posterior
View, Partially Dissected*, 1795–1806
graphite on heavy wove paper; 53.7 × 40.6
Yale Center for British Art, Paul Mellon Collection

275 (p.90)
George Stubbs
*A Comparative Anatomical Exposition of the
Structure of the Human Body with that of a Tiger
and a Common Fowl: Human Skeleton, Lateral
View, in Crouching Posture*, 1795–1806
graphite on thin wove paper; 44.8 × 28.3
Yale Center for British Art, Paul Mellon Collection

276
Clemente Susini (1754–1814)
*Wax Anatomical Figure Showing Deep Muscles
and Skeleton, in Case*, 1776–80
wax; h. 19
A 608372
By Courtesy of the Board of Trustees of the
Science Museum

277
Clemente Susini
*Wax Model of Reclining Woman with Removable
Internal Organs*, late 18th century
wax; 23 × 87 × 39.6
A627043
By Courtesy of the Board of Trustees of the
Science Museum

278
Clemente Susini
*Wax Male Anatomical Figure, Showing Deep
Muscles, in Case*, 1776–80
wax; 99.5 × 35 × 47.3
A608371
By Courtesy of the Board of Trustees of the
Science Museum

279 (p.56)
Clemente Susini
Organ of sight, 1803
wax; 34 × 62 × 49
University of Cagliari

280 (p.27)
Clemente Susini
Organ of touch, 1803
wax; 35 × 62 × 61
University of Cagliari

281 (p.59)
Clemente Susini
*Head, trunk and left upper limb of an adult male
with vessels and nerves*, 1804
wax; 47 × 125.5 × 71.5
University of Cagliari

282
Clemente Susini
*Head and body of a young woman with muscles
and blood vessels*, 1805
wax; 35.5 × 61.5 × 98.5
University of Cagliari

283 (p.74)
Michael Sweerts (1624–c.1664)
Interior of a Sculptor's Studio, c.1655
oil on canvas; 65 × 56 × 6
Hunterian Art Gallery, University of Glasgow,
Presented by Miss Ina J. Smillie, 1963
Photo © Hunterian Art Gallery, University
of Glasgow, 2000

284 (p.81)
Willem van Tetrode (c.1525 – before 1588)
Écorché Statuette of a 'Horse Trainer', c.1560
bronze; h. 43
Hearn Family Trust
Photographs supplied by Patricia Wengraf Ltd

285 (p.80)
Willem van Tetrode
Écorché Statuette of a Crouching Man, c.1560
bronze; h. 24
Daniel Katz Ltd

286
Joseph Towne (1808–1879)
Reduced Model of a Skeleton, 1826
wood and plaster; 85 × 38.4 × 32.6
Gordon Museum, GKT and Guy's and St Thomas'
Charitable Foundation

287
Joseph Towne
*Framed Superficial Dissections of the Female
Abdomen*, c.1827–79
wax; 49 × 45 × 12
Gordon Museum, GKT and Guy's and St Thomas'
Charitable Foundation

288
Joseph Towne
*Framed Superficial Dissections of the Male
Abdomen*, c.1827–9
wax; 49.7 × 47.4 × 12
Gordon Museum, GKT and Guy's and St Thomas'
Charitable Foundation

289
Joseph Towne
*Saggital Section of the Head and Neck (resting
on hand)*, c.1827–79
wax; 21.2 × 33.2 × 26.4
Gordon Museum, GKT and Guy's and St Thomas'
Charitable Foundation

290 (p.10)
Joseph Towne
Section of the Thorax at the Level of the Heart,
*c.*1827–79
wax; 39.7 × 50 × 55.5
Gordon Museum, GKT and Guy's and St Thomas'
Charitable Foundation

291 (p.31)
Cornelis Troost (1697–1750)
The Anatomy Lesson of Professor Willem Röell,
1728
oil on canvas; 198 × 310
Amsterdams Historisch Museum

292
J.M.W. Turner (1775–1851)
Study of the Hunter Écorché, *c.*1792
black chalk on paper; 47.3 × 29.2
Tate, bequeathed by the artist 1856

293
Juan Valverde de Hamusco (*c.*1525–*c.*1587)
La anatomia del corpo humano, 1586
Venice: Giunti, liber III, plate VI, p.101,
Dissection of a woman
book; 25 × 40 × 30
EPB/6476
Wellcome Library, London

294 (p.12)
Andreas Vesalius (1514–1564)
Icones anatomicae, 1934
Monachis: ex. officina Bremensi, plate 7,
Muscle Man, 1543
book, 1934; *c.*29 × 76 × 56
DA.AL
Wellcome Library, London

295
Andreas Vesalius
De humani corporis fabrica, 1543
Basel: J. Oporinus, *Flap Anatomy*
book; 45 × 30
Biblioteca Pinali, sezione Antica, Istituto di Storia
della Medicina, Università degli Studi di Padova

296 (p.22)
Andreas Vesalius
De humani corporis fabrica, 1543
Basel: J. Oporinus, title page
book; 27 × 53 × 42.5
EPB/6560
Wellcome Library, London

297 (p.29)
Andreas Vesalius
De humani corporis fabrica, 1543
Basel: J. Oporinus, drawn by Steven van Calcar,
*Andreas Vesalius dissecting the muscles of the
forearm of a cadaver*, 1543
paper woodcut; 22.6 × 17
9397i
Wellcome Library, London

298 (pp.148–149, 210–211)
Bill Viola (b.1951)
Science of the Heart, 1983
video/sound installation; dimensions variable
Paul & Evy Frankel Collection (Edition 1)
(Edition 2: Milwaukee Art Museum; Gift of
the Contemporary Art Society)
© Bill Viola, 2000
Photo © Kira Perov, 2000

299
Jan Wandelaar (1690–1759)
Drawing of heads, early 18th century
offset on paper, and pastel and crayon on paper
in one mount; 332 × 26.6
BPL 1913 I, f 11-12
Universiteitsbibliotheek, Rijks Universiteit, Leiden

300
Jan Wandelaar
Drawing of a female nude, frontal, early 18th
century
ink, crayon, chalk on paper; 43.9 × 27
BPL 1913 I, f.7
Universiteitsbibliotheek, Rijks Universiteit, Leiden

301 (p.37)
Jan Wandelaar
Drawing of a skeleton, early 18th century
Preliminary drawing for B.S. Albinus, *Tabulae
sceleti et musculorum corporis humani*, 1747
ink and crayon on paper; 51.8 × 36.7
BPL 1802: 11
Universiteitsbibliotheek, Rijks Universiteit, Leiden

302
Jan Wandelaar
*Drawing of a figure with one arm raised showing
superficial dissection of muscles, with background
of trees and leaves*, early 18th century
Preliminary drawing for B.S. Albinus, *Tabulae
sceleti et musculorum corporis humani*, 1747
crayon on paper; 52.3 × 37.1
BPL 1802:13
Universiteitsbibliotheek, Rijks Universiteit, Leiden

303 (p.37)
Jan Wandelaar
Drawing of a figure in profile with one arm raised,
early 18th century
Preliminary drawing for B.S. Albinus, *Tabulae
sceleti et musculorum corporis humani*, 1747
ink and crayon on paper; 52 × 37.2
BPL 1802:16
Universiteitsbibliotheek, Rijks Universiteit, Leiden

304
Jan Wandelaar
Drawing of a skull from three aspects, early 18th
century
Preliminary drawing for B.S. Albinus, *Tabulae
ossium humanorum*, 1753
ink, chalk and crayon on paper; a: 15.3 × 20,
b: 15.7 × 20.1, c: 30.9 × 20.6
BPL 1843:01 (a-c)
Universiteitsbibliotheek, Rijks Universiteit, Leiden

305
Jan Wandelaar
Sheet of drawings of small bones, early 18th
century
Preliminary drawings for B.S. Albinus, *Tabulae
ossium humanorum*, 1753
ink, chalk and crayon on paper; 31 × 20
BPL 1843:28
Universiteitsbibliotheek, Rijks Universiteit, Leiden

306
Jan Wandelaar
*Three drawings mounted together, showing
the foot from three aspects*, early 18th century
Preliminary drawings for B.S. Albinus,
Tabulae ossium humanorum, 1753
chalk and crayon on paper; 45: 31.1 × 21.2; 47:
20.7 × 33; 20.8 × 33
BPL 1843:45, 47-48
Universiteitsbibliotheek, Rijks Universiteit, Leiden

307 (p.37)
Jan Wandelaar
Drawing of a male nude, frontal view, 1726
ink, crayon and chalk on paper; 50.7 × 34.2
BPL 1913 I, f 5r
Universiteitsbibliotheek, Rijks Universiteit, Leiden

308 (p.37)
Jan Wandelaar
*Life-size drawing for the skeleton with putto
for tabulae*, 1726
Preliminary drawing for B.S. Albinus, *Tabulae
sceleti et musculorum corporis humani*, 1747
ink and wash over chalk on paper pasted on fabric
stretched over a wooden frame; 196 × 136 × 2.4
BPL 1914 I
Universiteitsbibliotheek, Rijks Universiteit, Leiden

309
Jan Wandelaar
Drawing of a radius, interior view, 1727
ink on paper; 33 × 43
BPL 1913 I, f 37
Universiteitsbibliotheek, Rijks Universiteit, Leiden

310
Jan Wandelaar
Drawing of a radius, exterior view, 1727
ink on paper; 33 × 42
BPL 1913 I, f 38
Universiteitsbibliotheek, Rijks Universiteit, Leiden

311
Jan Wandelaar
Drawing of a radius, frontal view, 1727
ink on paper; 32.9 × 41.8
BPL 1913 I, f 39

312
Jan Wandelaar
Drawing of a radius, posterior view, 1727
ink on paper; 33.3 × 42
BPL 1913 I, f 40

313 (p.36)
Charles Grignion (1716–1810) after Jan Wandelaar
Muscle-man seen from the front with rhinoceros,
1747
after B.S. Albinus, *Tabulae sceleti et musculorum
corporis humani*, 1747
engraving; 92.1 × 73.8 × 2.4
icon. anat. 305.3
Wellcome Library, London

314 (p.118)
Charles White (1728–1813)
*An account of the regular gradation in man, and
in different animals and vegetables*, 1799
London: C. Dilly, plate II, *Gradation of profiles
from bird to human*
book; 25 × 71 × 35.5
EPB/C/WH1
Wellcome Library, London

315
Joseph Wright of Derby (1734–1797)
Study of the Houdon Écorché, 1774
sketchbook; 24.6 × 35.5 (open)
1939-8-14-1 (16)
The British Museum, London

316 (p.38)
Joseph Wright of Derby
Old Man and Death, c.1774
oil on canvas; 101.6 × 127
Wadsworth Atheneum, Hartford, CT
The Ella Gallup Sumner and Mary Catlin Sumner
Collection Fund

317 (p.85)
Johann Zoffany (1733–1810)
Hunter Lecturing at the Royal Academy, c.1772
oil on canvas; 77.5 × 103.5
Royal College of Physicians
Photo © Royal College of Physicians of
London, 2000

318 (p.53)
Gaetano Zumbo (c.1656–1791)
Dissection of the Head, c.1701
wax; 38 × 32 × 25
Laboratoire d'Anatomie Comparée, Muséum
National d'Histoire Naturelle, Paris
Photo © B. Faye, 2000

Lenders

Australia
The Art Gallery of New South Wales

Austria
Museen der Stadt Wien
Österreichische Galerie Belvedere, Vienna

France
École Nationale Supérieure des Beaux-Arts, Paris
Les Musées des Beaux-Arts d'Angers
Musée d'Histoire de la Médicine, Paris
Musée du Louvre
Musée de la Préfecture de Police, Paris
Muséum National d'Histoire Naturelle, Paris

Germany
2021 Gallery, Essen
Gerhard Lang
Museum Bad Arolsen
Skulpturenmuseum Glaskasten Marl

Hungary
Szépmüvészeti Múzeum, Budapest

Ireland
National Gallery of Ireland

Italy
1000Eventi, Milan
Accademia dei Fisiocritici
Accademia Nazionale di San Luca, Rome
Gabinetto Disegni e Stampe degli Uffizi, Florence
Museo di Anatomia Umana – Università di Torino
Museo di antropologia criminale Cesare Lombroso,
 Università degli Studi di Torino
Museo di Palazzo Poggi, Università degli Studi
 di Bologna
University of Cagliari
Università di Modena e Reggio Emilia – Museo di
 Storia Naturale della Strumentazione Scientifica
II Università degli Studi di Napoli
Università degli Studi di Padova

The Netherlands
Amsterdams Historisch Museum
Anatomisch Museum, Utrecht University
Leiden Museum of Anatomy
Leiden University Library
Museum Boerhaave, Leiden

Norway
Nasjonalgalleriet, Oslo

Poland
Jagiellonian University, Cracow

Switzerland
Art and Public, Geneva

UK
Her Majesty the Queen
The Ashmolean Museum, Oxford
Christine Borland
The British Library Board
The British Museum, London
The Duke of Devonshire and the Chatsworth
 Settlement Trustees
Katharine Dowson
The Fitzwilliam Museum, Cambridge
Glasgow University Library
Gordon Museum, GKT and Guy's and St Thomas'
 Charitable Foundation
The William Ramsay Henderson Trust, Edinburgh
Hunterian Museum and Art Gallery, University
 of Glasgow
John Isaacs
Daniel Katz Ltd
The Earl of Leicester and Trustees of the
 Holkham Estate
Koos Limburg Jnr
National Gallery of Scotland, Edinburgh
The Old Operating Theatre, Museum and
 Herb Garret, London
Pitt Rivers Museum, University of Oxford
Marc Quinn
Royal Academy of Arts, London
Royal College of Physicians, London
The Royal College of Surgeons of England
Royal Holloway, University of London
The Royal Society of Medicine, London
The Board of Trustees of The Science Museum
The Trustees of Sir John Soane's Museum, London
Tate
The Thackray Museum of Medicine, Leeds
University College London
University of Glasgow
Victoria and Albert Museum, London
Wellcome Library, London
White Cube, London

USA
Beth B
Duke University Medical Center Library,
 Durham, NC
Paul & Evy Frankel Collection
The Hearn Family Trust
Museum of Fine Arts, Springfield, Massachusetts
Museum of Questionable Medical Devices,
 Minneapolis
Mrs A. Alfred Taubman
Wadsworth Atheneum, Hartford, CT
Yale Center for British Art, New Haven, CT